English
Français
Deutsche
Italiano
Español
Português

www.forgottenbooks.com

Mythology Photography **Fiction**
Fishing Christianity **Art** Cooking
Essays Buddhism Freemasonry
Medicine **Biology** Music **Ancient
Egypt** Evolution Carpentry Physics
Dance Geology **Mathematics** Fitness
Shakespeare **Folklore** Yoga Marketing
Confidence Immortality Biographies
Poetry **Psychology** Witchcraft
Electronics Chemistry History **Law**
Accounting **Philosophy** Anthropology
Alchemy Drama Quantum Mechanics
Atheism Sexual Health **Ancient History**
Entrepreneurship Languages Sport
Paleontology Needlework Islam
Metaphysics Investment Archaeology
Parenting Statistics Criminology
Motivational

ISBN 978-1-331-92972-7
PIBN 10255909

AMERICAN
JOURNAL OF SCIENCE,
AND ARTS.

CONDUCTED BY

BENJAMIN SILLIMAN,

PROFESSOR OF CHEMISTRY, MINERALOGY, ETC IN YALE COLLEGE; CORRES-
PONDING MEMBER OF THE SOCIETY OF ARTS, MANUFACTURES AND COM-
MERCE OF LONDON, MEMBER OF THE ROYAL MINERALOGICAL
SOCIETY OF DRESDEN, AND OF VARIOUS LITERARY AND
SCIENTIFIC SOCIETIES IN AMERICA.

VOL. VI.....1823.

NEW-HAVEN:

PRINTED AND PUBLISHED BY S. CONVERSE, FOR THE EDITOR.

SOLD BY THE PUBLISHER; BY E. LITTELL,

PHILADELPHIA, AND TRENTON, N. J.; AND

By Howe & Spalding, New-Haven; Davis & Force, Washington, (D. C) ;
Huntington & Hopkins, Hartford ; Cummings & Hilliard, Boston ; Good-
ale Glazier & Co. Hallowel, Maine ; A T Goodrich & Co. New-York;
Caleb Atwater, Circleville, Ohio ; Thomas J Ray, Augusta, Geo. ; Henry
Whipple, Salem, Mass. ; Edward J. Coale, Baltimore ; Timothy D. Por-
ter, Columbia, S C ; Miller & Hutchins, Providence, R I. ; Thomas R.
Williams, Newport, (R I.) ; William T. Williams, Savannah, Geo. ; Luke
Loomis, Pittsburgh, Pa ; Daniel Stone, Brunswick, Me. ; Professor D.
Olmsted, Chapel Hill College, N. C. ; John Miller No. 69, Fleet-street,
London.

PREFACE.

THE conclusion of a new volume of a work, involving so much care, labour and responsibility, as are necessarily attached, at the present day, to a Journal of Science and the Arts, naturally produces in the mind, a state of not ungrateful calmness, and a disposition, partaking of social feeling, to say something to those who honour such a production, by giving to it a small share of their money, and of their time. The Editor's first impression was, that the sixth volume should be sent into the world *without an introductory note,* but he yields to the impulse already expressed, and to the established usages of respectful courtesy to the public, which a short preface seems to imply. He has now persevered almost five years, in an undertaking, regarded by many of the friends whom he originally consulted, as hazardous, and to which not a few of them prophetically alloted only an ephemeral existence. It has been his fortune to prosecute this work, without, (till a very recent period,) returns, adequate to its indispensable responsibilities;—under a heavy pressure of professional and private duty ; with trying fluctuations of health, and amidst severe and reiterated domestic afflictions. The world are usually indulgent to allusions of this nature, when they have any relation to the discharge of public duty ; and in this view, it is with satisfaction, that the Editor adds, that he has now to look on formidable difficulties, *only in retrospect,* and with something of the feeling of him, who sees a powerful and vanquished foe, slowly retiring, and leaving a field no longer contested.

This Journal which, from the first, was fully supplied with original communications, is now sustained by *actual payment,* to such an extent, that it may fairly be considered as *an established work;* its patronage is regularly increasing, and we trust it will no longer justify such remarks as *some* of the following, from the pen of one of the most eminent scientific men in Europe.* " Nothing surprises me more, than the

* Who, however, had seen only the four first volumes.

17]10

little encouragement which your Journal," ("which I always read with very great interest, and of which I make great use,") " experiences in America—this must surely arise from the present depressed condition of trade, and cannot long continue."*

* Letter to the Editor, dated Dec. 5, 1822.

CONTENTS OF VOL. VI.

—◆—

GEOLOGY; MINERALOGY, TOPOGRAPHY, &c.

INTELLIGENCE AND MISCELLANIES.

I. DOMESTIC.

II. FOREIGN.

ERRATA FOR NUMBER I, VOL. VI.

This Number of Vol. VI, and indeed the whole volume, was put to press during the unavoidable absence of the Publisher, and was found to contain inaccuracies which he can correct only by noting them in the following manner. Number II, of this volume, it is presumed will be found as free from errors as the nature of a scientific publication will admit. At any rate, the Publisher will effectually guard against a recurrence of a similar misfortune. He could only learn from experience, that a scientific publication could not be left with the same safety as ordinary works.

☞ It is but just to remark, that many of the errors occurred from the illegibility, and some, from the inaccuracy of the manuscript. Some also are alterations from copy.

Errata, in part first of Mr. Hitchcock's Sketch. *

for *when* read *where*
8 10 dele *it*
8 for *altissimus* read *altissimus*
10 19 for *ruins* read *veins*
12 10 top insert *the* before *Connecticut*
 20 for *Saussune* read *Saussure*
14 2 insert *the* before *feldspar*

* We omit a few errata in the spelling of botanical names, as the corrections will be obvious to every botanist.

Page 15	line 15	from	top	for *fine* read *firm*
17	1			for *few* read *face*
18	22			insert *it* after *east*
20	11		bottom	for *if* read *is*
22	19			for *slate* read *state*
	6			for *Hadley* read *Hawley*
24	19			for *particles* read *patches*
27	1			for *Oxford* read *Orange*
	18.			for *Wes:* read *New*
32	12			insert a period after *New-Haven*
	12		top	for *rich* read *rock*
34	3			for *bearing* read *leaning*
37	12		bottom	for *mica* read *mass*
38	13		top	for *none* read *nor*
42	11		bottom	for *form* read *former*
55	12			for *points* read *fronts*
	14			for *ledge* read *ledges* .
59	11			for *amygdaloidal* read *amygdaloid*
62	5			dele the comma after *same*
70	1			for *on* read *and*
84	17		top	for *highest* read *largest*

In two or three instances the secondary greenstone is said to terminate in Northfield–but for Northfield, insert "Gill a little south of the meeting house."

<center>*Errors in the coloring of the Map.*</center>

The most southern hill of greenstone in East-Haven is omitted.

Also a small range of greenstone in the same town, on the east side of Saltonstall's Pond.

Also an alluvial tract in the same town.

In some copies the greenstone and old red sandstone in Sunderland, Deerfield and Greenfield, have been made *to exchange places.*

The western branch of the Mount Carmel range of greenstone, which extends through Cheshire into Southington, is coloured as alluvion.

<center>*Errata in Mr. Barnes' piece on Shells.*</center>

Page 107	title	for *D. W.* read *D. H.*
109	note	for *Goor* read *Geor*
110	line 14 from bottom,	after *multiplier* read *is*
111	13	for *cross* read *brass*
112	4	erase *when*
125	9	for *interiour* read *anterior*
127	17	for *small* read *smooth*
122	3 and 18 from top,	for *heel* read *keel*
119	5 from bottom,	for *Gass's* read *Cass's*

<center>*Errata in Mr. Orr's piece on the Universe.*</center>

Page 129	line 4 from bottom,	for *sun* read *system*
130	16	for *its* read *their*
	10	for *direct* read *inverse,* perhaps *also* should
134	22	for *or* read *on* [be inserted
137	3	for *on* read *or*
139	4	for *atmosphere* read *atmospheres*
140	3	for *parts* read *part s*
143	6	top for *account* read *physical account*
149	13	after *otherwise* the stop should be a period

Page 190, line 15 from top, for *Terebatrulæ* read *Terebatulæ*

Passim for Dr. *Borré* read Dr. *Boué.*

Pa. 240,	line 4 from bottom,	for *can,* read *cannot*
245,	1	top, for *cammunicated* read *communicated*
302,	bottom line,	in a few copies, for *auter,* read *auteur*
330,	line 14 from bottom,	for *12,* read *10*
341,	17	top, for *Dr.* read *Prof.*

THE

AMERICAN
JOURNAL OF SCIENCE, &c.

GEOLOGY, MINERALOGY, TOPOGRAPHY, &c.

Art. I.—*A Sketch of the Geology, Mineralogy, and Scenery of the Regions contiguous to the River Connecticut; with a Geological Map and Drawings of Organic Remains; and occasional Botanical Notices. Read before the American Geological Society at their Sitting, Sept. 11th, 1822; by the* Rev. Edward Hitchcock, A. M. of Conway, Massachusetts.

PART I.

The region embraced by the accompanying map, and to which this sketch is principally confined, is about 150 miles long and 30 broad; extending from New-Haven to Bellows' Falls. A leading object of this map is to give an accurate view of the secondary tract extending from New-Haven 110 miles northerly to Northfield. But it is protracted 30 or 40 miles beyond this, on the north, so as to embrace probably all the argillite along this river. A considerable extent of primitive is also exhibited on the borders of the secondary. The map is not colored according to the Wernerian distinctions of primitive, transition and secondary; nor according to Macculloch's division of rocks into unstratified and stratified : but an attempt has been made to give every particular rock that position and extent on the map which it actually occupies on this portion of the earth's surface. Every geologist knows, that perfect accuracy in these respects, on a map of such extent, would require a degree of labour and research, which, none but those whose whole time is devoted to such pursuits, could bestow. Indeed, so

large a part of every country is covered with geest, and
so imperceptible is the passage of some rocks into others,
leaving the observer in doubt for miles which rock predom-
inates, that after all, two equally good geologists would not
probably fix the limits of different rocks precisely alike.
And to exhibit all the minor salient and reentering angles
which any rock makes on the surface, would require a map
on a scale five times larger than that used in the present
instance. In attempting, therefore, to give every rock
that position and extent on the map which it actually occu-
pies on the surface, I do not suppose I have done any thing
more than to approximate to the truth. It is hoped, howev-
er, that the approximation is sufficiently close to answer
most of the purposes of geology. I trust at least that this
outline will furnish assistance to succeeding geologists.

In constructing this map I have derived very great assis-
tance in the vicinity of New-Haven, from the researches of
Professor Silliman, and of Dr. Percival. Indeed, could
either of these gentlemen have been induced to form a map
of that region, I should gladly have omitted the southern
part. In the northern part of the map, I have been assist-
ed by Dr. J. A. Allen, Lecturer on Chemistry in Middle-
bury College, and by Rev. J. Andrews, of Putney. Dr.
E. Emmons, of Chester, has also communicated facts of
importance.

The sides of the map are not precisely meridians; but
incline 3 or 4 degrees to the right, as is evident from the
fleur de lis attached to the upper right hand corner. The
longitude and latitude are marked from those of Deerfield,
which have been determined by numerous observations.

Having made these preliminary remarks, I now proceed
to describe the several rocks occurring in this district, in the
order in which they are put down in the explanation of the
colours on the upper left hand corner of the map.

1. GRANITE.

*Coloured purple—or a mixture of carmine, red, and
Prussian blue.*

Almost every variety of this rock described by geolo-
gists occurs in the region of the map, except the transition

granite of Norway and Scotland. Its texture varies from the coarsest to the finest grain, and it exists here in most of the forms that have been noticed.

East-Haven Granite.

The deposit of granite marked in East-Haven and Branford, has its southwestern extremity at the Lighthouse, which stands on a sea beaten rock of this description. The grain is intermediate between fine and coarse, and the felspar is usually reddish. In passing from East-Haven to Branford, we find the granite immediately succeeding the old red sand stone, or the slate rocks of the coal formation, or the greenstone; and all these rocks are nearly on the same level. Their actual contact with the granite, however, has not been observed, being hid by geest.

There is no evidence that this granite constitutes a bed in other rocks : On the contrary, it would seem, that it was brought to view along the coast by the abrasion of the gneiss and mica slate, which appear a few miles to the north, and which there lie at a much higher level. On passing east and northeast from this granite deposit, well marked beds of this rock appear; and perhaps all the granite which is found at the mouth of Connecticut river occurs in this form.

I do not know exactly how far the East-Haven granite may be traced along the coast. Certainly the gneiss reaches the sound before we come to Connecticut river.

In the cavities of this granite, when it is washed by the tide, one or two species of *Lepas* and other *testacea,* have fixed their abodes, finding security in those projecting crags which are so appalling and dangerous to the mariner. Some *Ulvae* and *Fuci,* also, are found along the shore.

South Hampton Granite.

Although the granite thus designated extends but a little distance into South Hampton; yet it contains the South Hampton lead mine, which will, no doubt, be long an increasingly interesting focus to which mineralogists will be

drawn—and therefore, the specific name above given, may not be unappropriate for this granite.

A great part of this granite exists in beds in mica slate; gneiss being a rare rock in the vicinity. Indeed, it may be doubted whether the whole range is not in the form of beds. I think, however, it will be found that there is a central ridge which is fundamental, at least two or three miles broad, extending from South Hampton through Williamsburg to the southwest part of Conway and northeast part of Goshen. Certainly, along this line little else appears but granite ; and in some places, as at its northern extremity, this rock forms hills of considerable elevation, and extensive ledges. Beds of granite may indeed be found in the vallies between these ledges; but an observer as he passes over this region and proceeds south to South Hampton lead mine, will find it difficult to persuade himself that he is not traversing an original fundamental* deposit of this rock. Or if it exist in beds alternating with mica slate, it will in some instances be found no easy matter to prove it—the mere fact that mica slate is found on both sides of it not being sufficient evidence : the same being the case with an original deposit.

I would here suggest whether the mica slate of this region, that contains beds of granite, may not be a newer formation, reposing immediately upon that granite nucleus which probably forms the basis rock in New-England. And wherever this mica slate and upper granite is worn away, or there is a projection in the nucleus, the basis rock may appear. Such a supposition will account for all the appearances of the region we are now considering, which is coloured on the map as granite.

As we go east or west from what I have called the central ridge of this granite, the beds of this rock become more and more distinct, the mica slate, however, increasing in

* "The term fundamental, has, it should seem, been gratuitously predicated of a particular description of granite ; for by the terms of the proposition, the bottom of this formation has never been seen, and consequently we have no means of determining whether it be fundamental or not."—*Ed. Rev. Jan.* 1820, p. 89.

But, we should ask, whether it be not proper to say of space, that it is infinite, for the very reason that we cannot limit it? And with equally good reason, it would seem, we may say of granite that it is fundamental, because we have never found any other rock below a particular description of it.

quantity and the granite decreasing. In painting what is denominated the South Hampton granite, I have comprehended most of the Chesterfield and Goshen granite,* which has become celebrated on account of the interesting minerals found in it—although the mica slate in those towns occupies probably as much of the surface as the granite.. The purple colour, or that which represents the granite, has not been extended so far as to embrace all the beds of this rock in this region; but only so far as the granite predominates. Where the mica slate is most abundant, I have put down this rock as covering the whole surface, although it might contain many beds of granite.

The inclination of the mica slate strata, or dip below the horizon, and consequently of the granite beds, varies from 20° to 90°: and thus frequent opportunities are afforded for observing the former rock pass under and over the latter.

the beds varies from the fraction of an inch to 100 rods: nay, perhaps to a mile or two. So that in the narrow beds, a single glance of the eye will present their roof and floor. In these thin beds there is rarely any fissure; but in those several hundred yards in width, are frequently observed regular and irregular divisions, as will be more particularly noticed hereafter.

These distinctly characterized granite beds are not confined to the region of the South Hampton granite. A few miles north, indeed, they disappear; but they may be traced southerly into Litchfield county, where they exist abundantly, and are sometimes found in hornblende, slate, and gneiss. A good example of the former may be seen in Granville, about half way between the churches in the east and west parishes; where the layers of hornblende slate are nearly perpendicular. Instances of their existing in gneiss may be seen in abundance on the east side of Connecticut river, in Pelham, Monson, Chatham, Haddam, &c. Indeed, we think the geologist who traverses New-England primitive rocks will often be led to enquire, whether all our gran-

` * "We have visited these localities more than once, and have no hesitation in saying that more distinct and well marked beds do not exist in this part of the United States or Europe; and what renders the fact more interesting is, the distinctly stratified structure of some of them."—*N. Amer. Rev.* *No.* 29—p. 233.

ite does not occur in the form of beds or veins. We are not yet, however, prepared to believe any one could con- clude that it does. East-Haven granite, Black Mountain, a part of Leverett range, &c. stand as yet in the way of such a supposition. Still less are we ready to adopt the re- cent opinion of a distinguished European geologist,* that *granite is not a primitive rock,* and that the only two rocks that are so, are mica slate and gneiss!

Thus have we in New-England, as in the east of Ireland, granite of a decided character alternating with mica slate. But this ceases to excite any surprize, since Von Buch and and Jameson have given us an account of the strata of Chris- tiana and Haddington.†

The texture of the South Hampton granite is generally rather coarse. There is, however, in this respect, a great variety. The felspar is usually of a fine white colour, and the quartz and mica a light gray. I do not here, however, speak of the granitic veins, some of which traverse the granite itself, and the felspar of which is sometimes flesh coloured. The beds of the South Hampton granite are not rich in minerals, except the lead mine in that town. The veins in this rock, however, contain the fine tourmalines and beryls of Chesterfield, and Goshen, and Haddam.

Black Mountain.

This lies in Dummerston, Vermont, and consists of gran- ite. A geologist standing in Brattleborough on the argillite is surprized on looking northwesterly, and seeing only four or five miles distant, an abrupt mountain 500 or 600 feet

* Dr. Borré.

† Porphyry in immense mountains reposing upon lime stone full of petri- factions; a sienite over this porphyry, consisting almost entirely of coarse granular felspar, and in the same manner, a granite not different in its composition from the granite of the oldest mountains—granite *above* transi- tion lime stone! Granite as a member of the transition formation!"—*Von Buch's Travels in Norway,* p. 45.

Order of the transition rocks around Christiana, beginning at the top and reckoning downwards.
1. Zircon sienite. 2. Granite. 3. Porphyry. 4. Sand stone. 5. Flinty slate. 6. Compact gray Wacke. 7. Compact slate and black orthoceratite lime- stone. 8. Granite. 9. Clay slate and limestone, probably. 10. Gneiss.—*Ibd.*

high, evincing by its white and naked head that it is gneiss or granite. On visiting it, he will find it to be a fine grained granite. In many parts, however, he will perceive such a tendency to stratification, that he may doubt for a moment whether it be not gneiss. But upon examination he will refer it to granite. The same remark will apply to granite in many other parts of New-England. It seems, and probably is, in many instances, intermediate between well characterized granite and gneiss.

Black Mountain is not many miles in circuit, and on the north and west, is succeeded by well characterized gneiss. This gneiss is quarried and forms underpinning and step stones; specimens of which may be seen in the foundation of the Meeting house in Brattleborough, East Village.

On Black Mountain I noticed some interesting lichens. The most monopolizing of these, are the *Gysophoras.* *G. vellea, papulose* and *muklenbergii;* (Acharius) in some instances actually cover precipices 30 or 40 feet high, and crowd one another notwithstanding, so as to force up their broad margins, giving them the appearance of a *chapeau de bras.* These species are found also on the granite in Montague, and on the greenstone in Deerfield, where occurs also g. *deusta.* On Black Mountain I likewise noticed in abundance *Enclocarpon miniatum Ach.* and several species of *Parmelia* and *Lecidea.* Near its top grows *Milium involutum (nov. sp. Torrey,* MSS.*)*

I cannot but detain the reader a moment to explain the strange nomenclature by which those were governed who originally gave to this granitic peak the name of *Black* Mountain. Every body in passing is struck with its snow *white* aspect, and cannot help enquiring the cause of it. I was told that in early days, it was burnt over and derived its specific appellation from this circumstance. Thus an accidental and ephemeral fact has fastened a name upon it which its constant appearance belies.

A similar remark might be made in regard to the name of another mountain in the same vicinity. A person standing in Brattleborough East Village, perceives directly *east* of him, on the *east* bank of Connecticut river, a venerable mountain 800 or 900 feet high, seeming almost to threaten him with its overhanging fragments. On enquiring the

name of it, he will be told it is *West* River Mountain. And
on examination he will find that West River empties into
the Connecticut from the west, nearly opposite this mountain.

Granite range passing from Amherst through Leverett, &c.

This granite is generally found at a low level. Almost
every other rock in the southern part, excepting the alluvi-
on, rises higher than this. Along the central and eastern
parts of Amherst it is mostly covered by geest and alluvion.
It appears, however, two miles south east of the Collegiate
Institution, and I have no doubt that Seminary stands on
this rock; although some bowlders of pudding stone ap-
pear there. Two or three miles north of the College, it
emerges in abundance, and becomes broader through Leve-
rett, which is perhaps one of the best places for examining
it; especially when we consider its proximity there to pud-
ding stone. Mount Toby, which is 800 or 900 feet high,
lies on the western border of the granite and consists prin-
cipally of a peculiarly conglomerate rock which appears to
belong to the coal formation. This pudding stone rises
400 or 500 feet higher than the granite, and in the interve-
ning valley the two rocks approach very near each other;
although I have never been able to find the actual junction.
The granite, however, near the pudding stone, occurs in
beds in mica slate, and is separated from the pudding stone,
by this mica slate, or by hornblende slate, which appears in
the valley above named, or by an imperfect variety of sie-
nite. The mica slate in this place, and indeed along the
whole western border of this range of granite, near the
northwest corner of the town, it becomes mere *quartzose
slate*, having a slight glazing of mica, or mica in small scat-
tered scales. This quartz is divided in two directions by
seams oblique to the face of the layers, so as to separate the
rock into very regular rhombs with different degrees of ob-
liquity. In hand specimens, indeed, it seems to be limpid
quartz in very perfect distinct concretions.

In the valley between these rocks appears to have been
for ages a war of *avalanches* between the pudding stone
and granite; in which

————"hills amid the air encountered hills,
Hurl'd to and fro with jaculation dire,"

And evidently too to the advantage of the pudding stone:
for this is several hundred feet the highest, is more steep and
more easily broken up from its bed, so that its debris has
evidently gained upon the older rocks, and subjected some
of them to its dominion.

In this valley the lichens, mosses and fungi, have planted
themselves thickly upon the bowlders and decaying logs
where they are secured by the dense foliage of the trees
from the too powerful rays of the sun and moistened by
the vapour of a small brook which here finds a passage.
You there see *Sticta pulmonacea (Ach.) and Jungermannia
platyphylla*, fantastically fringing the rocks, while the ever
verdant *Polypodium vulgare* frequently crowns the top.
Parmelia saxatilis, caperata, and others, several *Lecanoræ*
and *Lecideae, Peltidea canina, Poiena pertusa Ramalina
fraxinea* and *Cenomyce coccifera* and *rangiferinæ* of *Achari-
us, Hedwigia filiformis, Bartramia crispa, Polytrichum
perigoniale*, several species of *Hypnum, Dicranum, Ortho-
trichum*, and many other genera grow there. On the de-
caying trees along this valley, you not unfrequently may
see the delicate *Boletus versicolor* and *betulinus*, the elegant
B. cinnabarinus and *lucidus*, and the useful *B. varius, velu-
tinus* and *igniarius, (Persoon.)* Here too may be found
Agaricus alneus (Pers.) Dædalea cinerea and *Polyporus
abietinus* of *Fries;* various *Thelephorae, Hydra, Clavariae,
Pezizæ*, &c. And the margin of the brook has in many
places a carpet of *Marchantia polymorpha* and *conica*.
Near the northern extremity of this valley is a pond, in and
around which are many rare and interesting phenogamous
plants—such as *Drosera rotundifolia* and *longifolia, Nu-
phar advena* and *Kalmiana Nymphea odorata, Utricularia
striata* (n. sp. Le Conte) *Myriophyllum verticillatum*, one
or two *Charae, Cnicus lanceolatus, attissimus arvensis, dis-
color* and *muticus; Rhynchospora glomerata* and *alba Na-
jas Canadensis* and *Scirpus subterminalis* (n. sp. Torrey
MSS.) In the outlet to this pond grows the singular *Spon-
gia fluviatilis* of Linnaeus.

But to return to the granite. Along the southern and
central parts of Montague, it is greatly hid by the gneiss and
mica slate. In the northern part of the town, however,

near the mouth of Miller's river, it appears in one or two detached eminences of considerable height; directly west of which, only a few rods, is another hill of puddingstone similar to that of Toby. The granite can be traced nearly all the way through Northfield at a low level, and in the north of this town it seems to pass under the geest and higher rocks, and to appear again in Winchester and Chesterfield, of greater width, and here it is beautifully porphyritic. ‒ As we go north, the rock exists in distinct beds in mica slate and gneiss, and also it appears at the tops of mountains sometimes forming conical hills almost naked. Witness the west part of Surrey and Alstead.

The texture of this granite is coarse, in some instances very coarse, the plates of mica being several inches across. Its usual colour is white. A beautiful variety, however, occurs in Leverett, in which the felspar, which is abundant, is of a light blue; the quartz of a dark blue, approaching to black; and the mica the usual light gray. This a rare variety, and a fragment of a crystal of this blue felspar measured in its longest direction 8 inches.

This range of granite contains several veins of metals, such as galena, copper pyrites, blende and iron ; which will be more particularly described hereafter.

Much of this range exists in the form of beds and ruins: yet so far as I have examined it, it will not be easy to prove that the whole of it can be referred to this form. I am yet of opinion that along the central parts of the range may be seen emerging an original fundamental deposit of granite.

These are all the depositories of granite of considerable extent, which I have discovered in the region embraced by the map. Granite exists in many other places along this river in beds and veins ; but not of sufficient extent to claim to be represented on the map. It is possible, however, that what I call beds and veins, may not in all cases be such : For it is generally allowed, I believe, that the basis rock in all New-England is granite, and this nucleus, if I may so call it, is doubtless very uneven, having many prominences and corresponding hollows. In some places, perhaps, these projections have never been covered by other rocks, such for instance, as black Mountain. In other cases there is every appearance to indicate that the higher rocks have been worn away, and thus the granite has been disclosed :

for in general, the granite along the Connecticut appears much lowei than the neighbouring rocks, such as gneiss and mica slate. No person who examines the East-Haven granite, or that running thiough the Leverett, or even the South Hampton deposit, will doubt that some powerful agent has swept away an immense mass of superincumbent rocks of some description or other. Whether this was a primeval northeasterly current as Mr. Hayden maintains, I shall not undertake to decide. Be it, however, what it may have been, wherever it has acted powerfully we may expect to find the granite laid bare. If these remarks are correct, we need not be surprised to find this rock any where, even if we cannot make it form any thing like continuous ranges, and perhaps some of those small masses of granite, which every one who has examined New-England knows, appear so frequently, and which being surrounded by gneiss or mica slate, we are apt to refer to beds or veins may, after all, be the top of a projection of the nucleus of the globe which the abrading agent has laid bare.

Bellows Falls Granite.

This is of quite limited extent; but the interesting nature of the spot where it occurs induced me to colour it and notice it thus particularly. Fall mountain on the east bank of the Connecticut at Bellows Falls, consists of a coarse, not very perfectly stratified mica slate. At its western foot in the bank of the river, the stratification becomes less distinct, and is at length, about the middle of the stream, entirely lost; and the rock becomes an imperfect granite. In other words, there is a graduation from the mica slate into the granite. In the western bank, in the village, the characters of the granite are more decided; though even here, I should have no hesitation in calling it a sienitic granite, did it contain any hornblende; but I could discover none. The mica is black and abundant, thus giving the rock a sienitic aspect; and it is also traced by veins of felspar and granite like the sienitic granite of Northampton and Belchertown, to be described hereafter. The ingredients of this rock are arranged when viewed on a small scale somewhat in distinct layers; but when regarded as a whole, I never

saw a rock farther from *stratification*. Sometimes the fels-
par is wholly wanting, and the rock appears to be mere
unstratified mica slate, if such a term does not contain a con-
tradiction. It is of no great extent, being evidently laid
bare by the waters of the Connecticut, which here urge their
way in foaming fury over its ragged cliffs. The same rock
occurs two miles east of the falls; but, as far as I examin-
ed it, it seemed to occupy no great space.

Stratification of Granite.

Probably the granite of Connecticut will leave the ques-
tion* on this subject undecided. For some of it is evident-
ly stratified and some of it is not. That which exists in
not very extensive beds exhibits, so far as I have examined
the subject, the most decided marks of stratification. It is
not unfrequent to see the bed divided into layers parallel to
its roof and floor, and from one foot to two feet thick. This
is readily distinguished from gneiss by the much greater
thickness of the layers and the want of a stratified arrange-
ment of the ingredients. In other instances, more rare,
however, we observe what Saussune would call vertical
plates *(feuillets)*—that is, thick tables of granite perpendi-
cular to the horizon, crossing the bed sometimes at right an-
gles and sometimes obliquely. These plates are also found
making a dip to the horizon—In all these cases, however,
the plates being parallel, or nearly so, the rock would be
properly denominated stratified. Examples of these vari-
ous kinds of arrangement may be seen in Conway, Wil-
liamsburg, Goshen, and Chesterfield. Yet the greater part
of our granite is divided by numerous fissures into these ir-
regular blocks that bid defiance to precise description.

Granitic Veins.

By veins I understand those zones of any particular
rocks, or mineral, which traverse another rock, either rec-
tangularly or obliquely to the direction of its strata. In
crossing the strata they differ from beds.

* See Greenough's First Principles of Geology.—Essay 1.

Granitic veins are very numerous in many parts of the map, especially in the region of the South Hampton granite. In width they vary from a mere line to 30, and perhaps even 40 feet. But I have not observed any that exceed this breadth. They traverse mica slate, hornblende slate, limestone of a peculiar character, sienite, gneiss and granite. Those which traverse the latter rock differ from it only in being of a finer, or a coarser grain. Yet they are as really veins as those zones of granite traversing other rocks. Examples of these are frequent—as near the South Hampton lead mine.

In these veins all the ingredients of granite are · usually present, but in variable proportion. I have seen some that were nearly or quite graphic granite : But usually the mica is in superabundance, especially in the narrower ones, and often it is of a delicate straw or light green colour, as in Goshen and Conway. The felspar is sometimes of an elegant flesh colour, especially in those veins occurring in the gneiss northeast of New-Haven, in Chatham, Haddam, &c. These veins frequently divide and subdivide like the top of a tree, some of the branches being smaller and some larger. These branches rarely go off from the main stock at right angles, but generally oblique. At one place you will see a vein retaining its width for several feet, or even rods, with mathematical exactness—at another, its width will gradually increase or decrease; and I have seen, in some instances, a sudden reduction of two or three inches, by which a shoulder was produced. The course of many of these veins is serpentine, resembling that of a river on a map—yet often they scarcely deviate at all from the right line. Sometimes they make large curves to the right or left. They usually descend into the rock obliquely to the horizon. They frequently intersect, but I have never noticed any displacement of the strata, or mass of the rock, except in the sienite. Some of the veins traversing sienite, (between Belchertown and Ludlow for example,) are so numerous and their intersections so many, that they form what the Germans call a *stock worke*, except that they are not metalic. By these cross veins the surface of the rock is sometimes divided into triangles, rhombs, or rhomboids; and sometimes it is tesselated.

The veins traversing seinite are most frequently granite, felspar being of a flesh colour. They are more numerous in this than in any other rock, and are often intersected by one another and by thin veins of epidote. The crossing of these veins has produced many very interesting and singular displacements of portions of the rock. Where one vein is cut off by the intersection of one that is newer, it is not unfrequent to observe a lateral removal of the former with the whole mass of the rock surrounding it, from one to six inches. The vein itself, which is thus removed, is rarely altered or injured.

One of the most complete and curious cases of this kind is exhibited in Fig. 6. It was sketched by the eye without accurate admeasurement. A. B. C. is a triangular mass of sienite; the sides of which are 6, 4, and 10 feet. A. B. is a fissure in the rock : B. C. a vein of epidote and A C: the line marking the lowest limit of the rock above the soil. The whole rock is unbroken and as firmly united as any rock of this character ever is. There appear originally to have been two veins of granite traversing the rock in its longest direction, the smallest an inch wide at one end and widening towards the other, and the longest 2 or 2 1-2 wide. These have been cut through and strangely displaced by numerous veins of epidote crossing obliquely.

a, a, a, and *b, b, b,* &c. represent the granite veins as displaced.

d, d, d, &c. represent the veins of epidote which are rarely more than one quarter of an inch thick, and a few of which are represented on the plate.

c is a mass of gneiss or mica slate imbedded in the sienite and crossed by the granite vein *b.*

The locality of this rock will be described when we come to speak of sienite.

In those rocks that are stratified these veins make every possible angle with the direction of the strata. And if I do not mistake, the nearer they approach to the same direction as the strata, the broader they become, and have a nearer resemblance to beds. Sometimes they approach so near the same course as the layers of the rock they traverse, that it requires nice examination to determine whether they deviate at all. A good example of this occurs in a locality which many geologists have visited, and which many more

will probably visit. I refer to the main body of that enor-
mous vein containing the green tourmalin, rubelite, &c.
in Chesterfield. We think it might even admit of a ques-
tion whether this be a bed or a vein.

 The veins of which we are now speaking are doubtless
contemporaneous ones—that is, such as were consolidated
at the same time with the rocks they traverse. There is no
seam or layer of another rock at their sides, but they are
usually so firmly united to the rock which contains them,
that they are separated from these with as much difficulty
as they are broken in any other direction. I have, how-
ever, frequently noticed a seam traversing the middle of the
vein—so that if the rock they traverse be broken up, one
half will cleave to one side and one half to the other.

 A real *lusus naturae* exhibiting the fine cohesion of these
veins to the rocks they traverse, now lies before me. A slab
of granite being a vein $2\frac{1}{2}$ inches thick, 10 inches broad, and
20 inches long, curved a little upwards at one end, forms
the base of the specimen. From the centre of this, rises
perpendicularly a bladed, taper-pointed column of a pecu-
liar limestone, only 2 inches thick, 10 inches broad at the
base, and 26 inches high, appearing as if mortised into the
granite. The contrast between the light coloured granite
and the dark gray limestone, is very striking. The secret
of its having been brought into this singular form appears
to be this. It was found in a mountain torrent in Conway,
and the granite doubtless once formed a vein in the lime-
stone. On one side the limestone has been entirely worn
away by the water—and on the other side, it is worn so as
to leave only the bladed column above described, which
still adheres firmly to the granite.

 I have said that these granitic veins are contemporane-
ous ones : And it would seem that the judgment of no man
could be so warped by theory, as to believe, after examin-
ing them, that they were once fissures made in the rocks
they traverse, *after these were consolidated,* and that these
fissures were filled by a solution of water above, or by a
fiery furnace beneath. There is just as much reason for
believing that one of the constituents of granite, quartz for
instance, was introduced into the rock in this manner after
the other constituents were consolidated; or that the imbed-

ded crystals of porphyry are not of the same age with the base.

Granitic veins are numerous in many parts of the map. Commence at Conway and go south, and they will be found in abundance nearly to the ocean. North of this town I have never noticed any. On the east side of Connecticut river, also, they are not unfrequent, particularly in Connecticut. Many of the interesting minerals of Haddam and Chesterfield occur in them.

Veins of quartz are sometimes seen in this region traversing granite, as in Conway. But they are not extensive, or numerous. I have noticed also that sometimes the granite contains, imbedded in it, masses of mica slate having a curved form and not rounded ; as on the top of the high hill between Williamsburg and Chesterfield.

Graphic Granite.

This is a rock not uncommon in the region of the map. I shall notice two of the finest localities. The first is in the red conglomerate, or coarse sand stone, passing through Deerfield. The imbedded masses in this rock are sometimes the most beautiful graphic granite. The felspar, although it retains its lustre most perfectly, appears to be thoroughly penetrated by the colouring matter of the conglomerate so as to become of a deep flesh colour. The quartz is gray and limpid, or a little smoky, and being arranged somewhat graphically, many of the specimen are truly elegant.

The other locality of this rock, is the Goshen granite, in the northeast corner of the town. The felspar is of a snow white, and the quartz limpid; and so perfectly graphic is its arrangement, that it bears a close resemblance to the Chinese or Hindostanee characters which are frequently observed on goods from the East-Indies.

Porphyritic Granite.

This handsome rock occurs in great abundance in loose rolled pieces along the range of granite passing through Leverett, &c. The crystals of felspar are from one to two inches long, and a half or three quarters broad, and some-

times the few presented is a square. Thus an idea is con-
veyed to the observer, at first, that the crystals are rectan-
gular parallelopipeds and cubes; although it is well known
that felspar never crystallizes in either of these forms.
The felspar of these imbedded crystals, when broken, ex-
hibits the pearly lustre of the folia very well. The granite
containing these crystals is almost uniformly of a coarse tex-
ture.

This porphyritic granite is carefully to be distinguished
from glandulous gneiss, which also occurs abundantly along
the Connecticut. Let any one pass from Hinsdale, New-
Hampshire to Winchester and he will see numerous bowlders,
often ten feet diameter, of a rock having the granite constit-
uents and exhibiting no appearance of a schistose structure.
In one place at least he will cross the rock in place ; and he
will have no doubt that it is the most decided granite. And
yet it is elegantly porphyritic. This rock occurs also in
Chester where Dr. Emmons has traced a range of it five or
six miles. Numerous bowlders of this rock are scattered
over the town of Woodbridge near New-Haven ; but I do
not know from whence they originated.

Pseudomorphous Granite.

I put this adjective to a variety of granite that occurs along
the Connecticut, not to show my dexterity at coining new
terms, put to make myself understood. I am inclined, how-
ever, to think that the rock to which I refer is not exactly de-
scribed in the geological books which I have seen, unless
it be by Cleaveland, when he says, " some varieties (of gran-
ite) are divisible into imperfectly columnar or tabular con-
cretions." (Mineralogy, vol. 2, p. 732.) It is a coarse
grained granite with light coloured quartz and feldspar, ar-
ranged in the usual manner. The peculiarity lies in the mi-
ca. This is usually dark coloured, and arranged in plates
from one to three inches across. The manner in which
these are disposed, may be thus explained. Suppose the
quartz and felspar to have been cemented together so as
to form a perfect graphic granite. Next suppose the mass
to be cut in various directions by a fine saw ; and in the
spaces thus made, imagine thin plates of mica, not more
than $\frac{1}{50}$ of an inch thick, to be fitted. It is obvious that the

mass will thus be cut up into segments of pseudomorphous crystals. And so it is in the natural specimens: and it seems as though the hand of nature had really made use of a saw in their construction. The plates of mica meet at various angles, yet never cross each other; and the smallest piece of quartz or felspar is sometimes bisected, so that a part appears on one side of the plate of mica and a part on the other. This rock occurs in the S. Hampton granite; and may frequently be found in other parts of the region extending fifty miles south from Conway. At a little distance the dark bronze coloured mica appears like prisms of some imbedded mineral: and the travelling geologist is often tempted from his carriage in the almost certain expectation of obtaining from this rock shorl or titanium.

2. Gneiss.

Coloured Orange.

Although this is the most abundant rock in New-England, yet the map includes no very extensive portion of it. It stretches over a broad region without the limits of the map on the east and west, especially on the east. On the west it forms a part of the Hoosack or Green Mountains; though a much less part than has been usually supposed. On the east appears with some interruptions of granite, mica slate, &c. within twenty or thirty miles of the coast, and on the north it spreads over a considerable part of New-Hampshire. The White hills are said to consist chiefly of this rock: though they have not, I believe, been thoroughly explored.

The dip of the layers of gneiss in this region varies from 20° to 90°—and it dips, like most other stratified rocks along the Connecticut, to the east. When it approaches to hornblende slate the dip is generally greater than when pure. This rock often contains crystals of hornblende; in every proportion, indeed, until the characters of gneiss are lost in hornblende slate. Especially is this the case on the east side of Connecticut river. More, however, will be said on this subject when we come to describe hornblende slate. Good examples of this gneiss containing detached crystals and even veins of black hornblende may be seen in the basement of the new Collegiate Institution in Amherst. It fur-

nishes an admirable stone for such purposes; and many quarries are opened in it. Immense tables of it may be procured, and should the mania for constructing pyramids ever seize the inhabitants of New-England, this gneiss might produce masses of stone rivaling in magnitude the immense limestone blocks of the pyramids of Egypt.

The gneiss of the Connecticut, often alternates with mica slate, and passes into it. In Granville, may be seen gneiss, hornblende slate and mica slate, in various stages of approach to each other, and making various alternations.

This mixture of gneiss with other rocks, and the consequent indistinctness of character, render it, in some instances, not very easy to give its limits. I have felt this difficulty especially in regard to the northern part of that gneiss range which occupies the eastern part of Litchfield County and appears so decided in its characters in Bristol, Plymouth, and Canton. In the west part of Granville, I feel confident gneiss is the prevailing rock—although mica slate alternates with it. Yet between Chester and Westfield there is nothing but mica slate, as the prevailing rock, which extends twelve or fourteen miles west of Chester, before we come to gneiss. And north of this we find very little gneiss within the limits of the map except a narrow stratum as we ascend the hill from Cummington to Goshen. I do not, therefore, feel exactly satisfied with the northern termination of the Litchfield gneiss as given on the map : but at present it is not in my power to re-examine it.

I would here, however, suggest that I have been rather inclined to believe that some of the stratified rocks along the Connecticut pass gradually into other rocks *laterally,* that is, *in the direction of the strata:*—mica slate, for instance, into gneiss, or hornblende slate; and argillite into mica slate. To establish this fact, however, requires a long series of very close and accurate observation. I merely suggest it, therefore, and do not assert it.

In some instances, the ingredients of our gneiss are pretty equally mixed: in others they are arranged in somewhat distinct layers, which are generally straight. It is not a rock that is rich in minerals with us. Veins of granite traversing it, however, sometimes contain interesting specimens. Witness the Haddam minerals.

Glandulous Gneiss.

This is very abundant, especially in the gneiss east of Connecticut river. Indeed, a considerable proportion of that range is occasionally glandulous, presenting numerous oval masses, chiefly of felspar. The layers of this variety of gneiss are usually very distinct, and it contains a large proportion of mica, which is usually of a blackish colour; and thus it is easily distinguished from the porphyritic granite above described.

3. HORNBLENDE SLATE, CLEAVELAND.

Coloured Vermillion, Red, and clouded with India Ink.

This is an anomalous and perplexing rock. It is not generally well characterised in this region: but I have put it down, because a rock approaching nearer the characters of this than of any other, occurs in considerable abundance along the Connecticut. I have no confidence however that I have given in all cases its exact situation or extent. Yet I believe that wherever this stratum is coloured on the map, the rocks may be found in the vicinity. Thus in the range extending from Belchertown to Guilford, Ct. a person will generally find this rock more or less abundant in crossing from the secondary rocks to the gneiss: but sometimes he may thus cross and miss of it, unless he make an excursion to the right or left; and sometimes he must cross a portion of the gneiss before he reaches it. The continuity of the strata of this rock seems to be much less perfect than in the gneiss or mica slate, and the direction of the strata if often oblique to that of other rocks:—a remarkable instance of which occurs in the south east corner of Halifax, Vt. The dip of the strata varies from 45° to 90°, and the schistose structure in the purest specimens is very perfect, the layers varying in thickness from half an inch to three inches.

But there is another difficulty in ascertaining the limits of this rock. It is no easy matter to draw the line between it and gneiss, all, or at least, two of the ingredients of the latter rocks being sometimes present, while more than half of the rock is hornblende. Indeed, I have sometimes been dis-

pósed to regard this rock as gneiss containing an accidental proportion of hornblende; and this would have been a satisfactory description of a considerable part of the rock which I have called hornblende slate. But another part appears to be decidedly that species of Werner's primitive trap described under the name of hornblende slate in Rees Cyclopedia, *Article Trap*—that is, it consists of hornblende, generally fibrous and crystalline, having a very distinctly slaty structure. For localities of this well characterized hornblende slate I would mention the eastern part of Halifax, Vermont, also New Fane and Belchertown, two miles north of the meeting house on the west side of the road, and in the western part of Tolland and Monson.

I think however that the largest part of this rock will be found to consist of hornblende, quartz and mica—the latter being usually black and very apt to be confounded with the hornblende, so that perhaps it deserves the name of a granitic aggregate. In some instances, also, this rock contains chlorite, and verges towards greenstone slate. It is often strangely intermixed, and alternates with gneiss and mica slate.

Another portion of this rock has a porphyritic aspect. I use the term porphyritic in this place, not in the usual sense, as denoting a compact ground with imbedded crystals, but as a "granite ground, in which some crystals are much larger than the rest." (*Bakewell's Geology*, p. 28.) The slaty structure of the rock, though less distinct, is not lost: but the imbedded fragments, or imperfect crystals of quartz or felspar, most frequently the former, give it a porphyritic appearance. These imbedded fragments are frequently granular, while the base is distinctly crystallized. A good example of this variety of rocks occurs in the west part of Chatham and in Shelburne. Sometimes this rock becomes the real sienitic porphyry of authors—its slaty structure being lost. This occurs in Plainfield, in Hawley, a few rods west of the meeting-house, and at the falls in Deerfield river in Shelburne.

These porphyritic rocks, however, must be quite different from any thing occurring in Europe by this name, if a remark of Brongniart be correct, that "we are not at present able to find a sienite or porphyry which is evidently primitive." For we have as much evidence of the primitive char-

acter of the rocks above described, as of the mica slate and gneiss with which they are associated and in which they sometimes form beds.

Hornblende slate occurs on the west side of Connecticut river, south of Shelburne, in Massachusetts and Connecticut, also at Plainfield and Hawley. But it is not abundant or well characterized generally, and is much mixed with, and passes into other rocks; and therefore I have coloured it only in the range from Belchertown to Guilford and from Shelburne northward. Good examples of the rock containing quartz and some mica may be seen in the flagging stone of the side walks along the eastern side of the Public Square in New-Haven, and in other parts of that city.

4. Mica Slate.

Coloured Green.

This is an extensive stratum in the northern part of the map. On the west side of the river it forms the prevailing rock; and its width continues to increase northerly, so that it occupies the principal part of Vermont. Prof. Silliman in his " Tour between Hartford and Quebec," says that he crossed this slate obliquely from Burlington to Hanover, a distance of 84 miles, and found mica slate by far the most abundant rock on the route. (*Tour*, &c. p. 386.) In Connecticut, however, along the river, this rock constitutes no very broad ranges. Those which are coloured immediately in contact with the secondary on both sides of the Connecticut are in most places quite narrow, often not more than half a mile, or even but a few rods wide, and sometimes they wholly disappear and we pass from the sandstone immediately to the hornblende slate or gneiss.

The dip of our mica slate is variable from 20° to 90°. In Vermont it is usually less than in Massachusetts; especially where we first strike it in passing from the river. Farther south, as in Hadley, Plainfield, Chesterfield, &c. it approaches 90°. East of Chesterfield the layers of this rock lean to the west. Beyond Chesterfield, on the west, they lean the contrary way—that is, to the east. The same is the case between Chester and Westfield. This fact looks like an indication of a fundamental ridge of granite, extending in

that direction, as we have already 'suggested; although it may not yet have made its appearance above the later rocks the whole distance.

This rock is somewhat Protean in its appearance; yet not very difficult in most cases to be distinguished by careful observation. The following varieties have been noticed in this region. 1. A variety already referred to, as occurring in Leverett, near the pudding-stone; which is scarcely any thing more than imperfectly limpid quartz, divided into distinct rhombic concretions, about an inch thick, and three or four across the outside, slightly spangled or glazed with mica. 2. Very much like the last, except that it does not divide into complete rhombs, but is only separated by seams oblique to the direction of the strata, and nearly perpendicular to the horizon*—Locality, West-River mountain in Chesterfield New-Hampshire. 3. Divided as the last by two sets of parallel planes, forming angles with each other a little oblique: But the mica is intimately disseminated in fine scales through every part of the rock, and the quartz becomes a mere siliceous sand, blended closely with the mica. Surface rarely waving—Locality, Whately, Conway, &c. 4. Not regularly divided in any direction, except that of the strata, and much less fissile than the last. Mica scattered in fine scales through the mass, and the silex more abundant than the 'last—Rock breaking into huge blocks, from one to three feet thick, and often forming, like greenstone, abundance 'of debris. Locality, West-River mountain and Deerfield. These four varieties occur on the borders of the secondary rocks. 5. Tortuous, wavy and extremely irregular, embracing numerous beds and amorphous masses of quartz—Mica, very imperfectly characterised, forming a kind of glazing with the aspect of plumbago. Locality, Conway, Shelburne, Colrain, &c. 6. Quartz and mica in somewhat distinct layers—quartz predominating, and mica not very well characterised—abounding in garnets —Locality, Plainfield, Hawley, Conway, &c. 7. Passing into talcose slate—mica abundant, having somewhat of a fibrous aspect and connected with talc. Northfield and Hawley. 8. Passing into argillite. Locality, Leyden, Ches-

*"When one set of parallel planes crosses another, are both sets to be called strata, or neither, or only one of them ?"—*Greenough's Geology, Essay* 1.

terfield, (N. H.) Putney, &c. 9. Not very fissile—breaking into thick blocks. Mica, abundant but poorly characterised—having somewhat the aspect of argillite—surface
slightly irregular, appears as if grooved—Abundant in Cummington, Chesterfield, (Mass.) Vernon, Bolton, &c. 10.
Quartz granular, abundant and white—resembling gneiss
or granite—scarcely stratified at all—Locality, Buckland,
Granville, &c. 11. Mica in distinct and abundant plates—
layers very little tortuous or uneven. This usually lies next
to granite. 12. Passing into gneiss—often rendered porphyritic by crystals of feldspar. Locality, Litchfield county.

The quartz that occurs in this mica slate, especially in
the wavy and tortuous varieties, is commonly the white
limpid: frequently it is the fetid, and sometimes a rich variety of a delicate red color. The coloring matter, however,
is apparently iron, and therefore it is not the rose-red quartz.
This variety of quartz occurs on the west side of the Connecticut.

It has already been remarked, under granite, that numerous beds of this rock are contained in mica slate. Indeed, our mica slate more frequently rests immediately upon granite, without the intervention of any other rock, than
does gneiss. It also alternates with gneiss, hornblende
slate, argillite and chlorite slate. Small particles of it, indeed, occur in very many places throughout the whole extent of the primitive along the Connecticut.

It is a common remark in geological books, that hills
composed of mica slate are usually less steep and more
rounded than those of granite. But the reverse is the fact
in most cases along this river. The granite hills are generally low and rounded, while some of the most Tarpeian
precipices to be found in this region are composed of mica
slate. Take for examples West River Mountain, and the
high hills of Heath, Hawley, Chesterfield, &c.

Mica slate is not wanting in a variety of minerals in this
section of the country—such, for instance, as staurotide and
garnets in immense quantities in Goshen, Chesterfield,
Mass. and from Bolton, Conn. one hundred miles north, to
Chesterfield, New-Hampshire. Also the fine Chesterfield
sappare. Also the red oxid of titanium, found almost every where between Conway and Brattleborough, a distance
of thirty miles—and the Leyden tremolite—the Putney

green fluor spar, and the Wardsborough zoisite. The Chatham Cobalt mine occurs in mica slate.

The cryptogamous plants that usually overspread a great part of the mica slate of this region, though perplexing to the mere geologist, are yet interesting to the botanist. Among those which adhere to these rocks, or to the little soil that collects in their cavities, may be named, *Bartramia gracilis, Smith, B. longiseta, Mx? B. crispa, Swartz, Hedwigia filiformis, P. Beauv.* in great abundance; *Arrhenopterum heterosticum, Hedw. Buxbaumia aphylla, Lin. Fissidens adianthoides, Bryum roseum, Diphyscium foliosum, Spreng. Polytrichum perigoniale, Mx. Jungermannia complanata, L. J. platyphylla L. Cenomyce phyllaphora, and pyxidata, Ach. Stereocaulon paschale, Parmelia herbacea, saxatilis and caperata, Porina papillosa, and pertusa, Peltidea aphthosa and scutata,* and *Sticta pulmonacea,* all of Acharius. In the region of the mica slate, especially in Brattleborough and Conway, we frequently find *Bryum cuspidatum, Brid. Hypnum minutulum, Mx. H. flexile, Brid. H. serpens, L. H. cupressiforme, Hedw. Jungermannia nodifolia, Torrey, Maschalocarpus trichonitrion, Hed. Pterigonium subcapillatum, Brid. Neckera minor, Brid. N. pennata, Hed. N. viticulosa, Hed. Cenomyce coccifera, rangiferina, botrys, &c.—Parmelia colpodes, ulothrix, cyclocelis, parietina, plumbea, &c—Lecanora tuberculata, subfusca, brunnea, albella, &c.—Lecidea parascena, cameola, demissa, &c.—Usnea florida and plicata, Cornicularia fibrillosa, Collema tunaeformis,* and *Alectoria jubata,* all of *Ach. Nephroma resupinata, Spreng. Glonium stellare, Muhl. Polyporus abietinus and squamosus, Fries. Hydnum quercinum and cyathiforme, Fries. H. imbricatum, occanum, coralloides and gelatinosum, Pers. Thelephora quercina and terrestris, Cyathus olla and striata, Stemonitis fasciculata, Boletus citrinus, badius, brumalis, nigro-marginatus, cinnabarinus, velutinus, betulinus, &c.* all of Persoon, and many scores besides of *Agaricus, Amanita, Sphaeria, Peziza, Daedalea, Helvella, Lycoperdon, Bovista, Scleroderma, Tremella, &c.* too numerous to mention in this place.

Scattered among the mica slate rocks we frequently find the *Helix allolabris, Say,* or common snail; and also, in some situations, *H. alternata, Say.* In a pond in Ashfield is found *Planorbis bicarinatus, Say,* and *Cyclas similis, Say.*

In springs occurs a species of *Lymnaca, Say,* and in our larger streams, *Planorbis trivolvis* and *Unio purpureus, Say,* or common river clam.

5. TALCOSE SLATE. *Rees Cyc. Bakewell.*

Talcose Schist. Maccullock.

Talcose Slate. Eaton.

Colored Gamboge yellow, and dotted with India Ink.

Bakewell defines this rock to be "slate containing talc," (Geology, p. 491,) and Eaton calls it "that kind of mica slate which is distinguished from mica slate by a kind of talc glazing." In this term I do not include soapstone.

There is but one stratum of this rock in the region of the map, of sufficient extent to render it necessary to delineate it. I have sometimes noticed on the east side of Connecticut river a kind of talco-micaceous slate: but not in abundance, and rarely in place. I have crossed the stratum which is colored on the map in Whitingham, Vt. where it is not less than a mile and a half in width. I have traversed it also in Hawley and Plainfield, and Professor Eaton says it extends into Worthington— so that on his authority I have extended it thither. The rock is of a much lighter color than mica slate. At a distance, indeed, it has the aspect of gneiss. The talc is nearly white, though sometimes of a light green, and it contains a large proportion of silex. The strata are but little undulating and nearly perpendicular, leaning a few degrees to the west. On its east side, where it passes into mica slate, an intermediate talco-micaceous rock is found, containing numerous distinct crystals of black hornblende, thrown in promiscuously, and exhibiting the most elegant specimens. One variety has a ground that is green; another has a white ground, and the contrast between these and the imbedded crystals is striking. Large slabs of this rock may easily be obtained; and if it will admit of a polish, it would certainly be a beautiful addition to those marbles and porphyries that are wrought for ornamental purposes. The varieties of this rock may be seen in any direction a few rods from the meeting house in Hawley; as likewise many-

other singular and curious aggregates which I have never seen at any other place. Among these is sienitic porphyry—and sometimes the talco-micaceous rock has its surface covered with delicate fascicular groups of hornblende.

The micaceous iron ore occurs in the talcose slate, and I have never seen any of this sort of ore in any cabinet that will compare at all for beauty with that in Hawley.

6. CHLORITE SLATE. *Cleaveland.*

Uncolored, but dotted with black.

In the region under description, I know of but two deposits of this rock of sufficient extent to be marked on the map; viz. at West-Haven and Milford* and in Whitingham, Vt. At the former place it is but imperfectly characterised, especially at its Northern extremity. As we approach the coast, in West-Haven, its characters become more decided, and here we find numerous small crystals of octahedral magnetic iron ore disseminated through it. Where the cliffs of this slate have long been buffeted by the waves of the ocean, these crystals have been worn out, and are deposited in large quantities, in the form of iron sand, on the beach. On the east side of West-Haven harbour, at the Light House, also, this sand appears in equal abundance— and tons of it may easily be collected. On that side of the harbour there is no chlorite slate; and whether the iron sand found there is the remnant of former chloritic strata now wholly disintegrated, or whether it is washed up from the bottom of the Sound, where these rocks doubtless exist, remains problematical. The latter supposition, however, seems most probable.

The chlorite slate of West-Haven is extremely tortuous and undulating, and is traversed by numerous irregular seams of white quartz. It alternates with greenstone slate and passes into it; and also with mica slate. These three rocks are often so blended together that the distinctive characters of each are lost. And as we approach the strata of the Verd Antique, they seem to embrace also some of the prop-

*West-Haven and a part of Milford have recently been incorporated in-
to a separate town by the name of Oxford

erties of this, and often to pass into it. Hence it is no easy
matter, in many instances, to give a name to the Milford
slate rocks, and the alternations above named, and also
with unstratified primitive greenstone, are numerous—so
that it was not possible in coloring the map to give to each
of these rocks the precise situation which they occupy on
the surface.

The direction of the chlorite slate strata, of which we
have been speaking, is from north-east to south-west. They
dip to the south-east, and their angle of depression below
the horizon rarely exceeds 30°. Sometimes, however, it is
90°. I think it will be found that the rocks of Woodbridge
and Milford pass laterally into one another. Thus, the
chlorite slate at its northern extremity is usually somewhat
talcose in its appearance, approaching to argillite, and as
you pass south, its characters continue to be more and more
developed.*

The chlorite slate colored in Whitingham, is the best
characterised I have ever seen in New-England. It seems
to be nearly pure chlorite, yet distinctly stratified, the lay-
ers being nearly perpendicular, leaning, however, a few de-
grees to the west. I know but little concerning the extent
of this stratum. Where I have crossed it, it was less than
half a mile in width. I have given it a place principally to
excite an attention to it.

This rock also occurs in beds in argillite in Guilford, Vt.
but they are not extensive.

7. Sienite. *Cleveland.*

*Colored Gamboge Yellow, and crossed by oblique parallel
black lines.*

This rock is marked in three places on the map. The
first is in Whateley and of very small extent—the second
extends from Whately to the south part of Northampton ;
and the third is in Belchertown and Ludlow. The rock in
the two last places is very much alike, being for the most
part a kind of sienitic granite. In the first mentioned lo-
cality the rock is considerably different from that in the oth-

*I am indebted to Prof. Silliman for this suggestion.

ers. I shall confine my remarks principally to that range extending from Whately to Northampton, because I have examined this most.

As above remarked, this range appears to be mostly a sienitic granite, that is, a modification of granite; and very different from that sienite which is associated with graywacke and greenstone. A person coming from the west or north-west towards the village of Northampton, will pass over the most decided granite, associated with mica slate, till he comes within four or five miles of that place. He will then find the texture of the rock to be finer, and in some instances it contains a portion of hornblende, while the proportion of quartz is somewhat diminished, the felspar frequently becomes red. Veins of graphic and common granite, epidote, &c. are more numerous, and the rock appears more disintegrated than the coarse grained granite. In one part of a mass of this rock, may frequently be observed a considerable proportion of hornblende, thus giving the rock a sienitic aspect, while in another part, only a few feet distant, this mineral is wholly wanting. Coming nearer Northampton, however, we find the hornblende more and more abundant, until we arrive at the eastern edge of the range, where we find a rock containing little else than felspar and hornblende, forming a real sienite. I have never yet seen a specimen, however, in which careful inspection could not discover both mica and quartz. The felspar is usually deep flesh colored, and the hornblende sometimes black and sometimes green. On the eastern border of this range, especially about two miles north of the village of Northampton, on the west side of the stage road, this sienite assumes a trappose and somewhat columnar form, both among the loose masses and those in place.* Among the *debris*, the three sided pyramidal form is most frequent; sometimes we find a three sided prism, and sometimes, both among the loose masses and those in place, two, three or four faces of a prism of a greater number of sides.

Another spot for observing some interesting facts in regard to this rock, is the south part of Whately. Two miles south of the congregational meeting-house, on the road to

*This fact was first mentioned to me by that indefatigable and able naturalist, Mr. Thomas Nuttall.

Hatfield, is a manufactory of common earthen ware, and
here a small stream, running east, has cut across the great-
er part of the sienite range, and laid the rock bare nearly
the whole distance, which does not much exceed half a
mile. Let a person follow up the south side of this stream,
and in some of the ledges he will perceive a distinct strati-
fication of the sienite, though of little extent; one part of
the same ledge being often stratified and the other amor-
phous. In this place he will see, also, numerous intersec-
tions of granitic and other veins by which a part of the rock
has been displaced. In one of the ledges a little distance
from this stream, on the south side of a pond, may be seen
the prototype of Fig. 6.

Another interesting fact may be noticed in the sienitic
granite along this stream, especially on the northern side,
near the earthen ware manufactory. *The rock here contains
numerous imbedded masses of other primitive rocks, as gneiss,
mica slate, quartz, hornblende, and a finer kind of sienite.* And
what is peculiar, is that these imbedded fragments are almost
uniformly *rounded*—as much so as those contained in the
eonglomerated rocks along the Connecticut; and they are
often so numerous that the rock appears like a real second-
ary conglomerate. The masses are very firmly fixed in the
base, and often there appears a mutual impregnation and
sometimes the veins of granite cut through the imbedded
fragments, as in Fig. 6.

Thus we have a real conglomerated sienite, and I had al-
most said a conglomerated granite : for much of the rock
containing these fragments is destitute of hornblende, while
all the ingredients of granite are present. And the instan-
ces in which this conglomerated rock occurs, are not confin-
ed to the particular locality above named—but it is to be
found in many other parts of the range. I have seen bowl-
ders of it in Surry, Alstead and Walpole in New-Hamp-
shire, but I did not there see the rock in place.

The Northampton sienitic range lies at a very low level.
A considerable part of it is hidden by a deposit of sand
through which it sometimes projects. The sienite in Bel-
chertown is also rather low. All the remarks above made,
in relation to the Northampton range, except that in regard
to its conglomerated character, will apply to this. The best
route which I have found for viewing this sienite, after cross-

ing it in several places, is to pass by the right hand road from Belchertown, congregational meeting-house, to the meeting-house in Ludlow.

The narrow deposite of sienite which is first mentioned above, as occurring in Whately, is somewhat different in its characters. Let the observer proceed northerly on the main road from the congregational meeting house one mile, till he comes to the farm of a Mr. Crafts. On the left hand side of the road he will find a ledge of rocks which are greenstone slate, nearly allied to hornblende slate, and sometimes to chlorite slate. Let him cross these strata westerly, about fifty rods, and he will come to a deposit of decided unstratified primitive greenstone, about twenty rods wide. Immediately succeeding this rock, he will find the sienite above named. It consists of nearly equal proportions of felspar and hornblende, the latter of a dark green and of a distinctly crystalline structure; and the former white and compact or very finely granular, entirely destitute of a foliated structure, or pearly lustre. These ingredients seem to be promiscuously blended, and the rock appears to be peculiarly well adapted for being wrought and polished for useful and ornamental purposes. The bed is not very extensive, only about six rods wide at the place above mentioned, and I have never been able to trace it more than one or two miles. It is separated from the mica slate by a narrow stratum of greenstone slate.

Sienite, or sienitic granite, occurs in many other places along the Connecticut; but in no other place have I found it extensive enough to deserve a place on the map, except perhaps in Chatham, and with the relative situation of this I am not sufficiently well acquainted. Where I have crossed it, it appeared to form a bed in porphyritic hornblende slate.

8. PRIMITIVE GREENSTONE.—*Cleaveland.*

Colored Carmine or Rose Red, and marked {by parallel lines crossing each other.

This is one of Werner's varieties of primitive trap. If it be asked what that is, I should suppose Mr. Maclure's supposition to be not an improbable one, that "what Werner calls primitive trap may perhaps be compact hornblende; or per-

haps the newest floetz trap when it happens to cover the
primitive." (Journal of Sci. Vol. 1. p. 212.) Yet there are
two circumstances in regard to the rock here denominated
primitive greenstone, along the Connecticut, which have led
me to doubt its exact indentity with our newest floetz trap,
or secondary greenstone. 1. The primitive greenstone is
never amygdaloidal; while a great part of the secondary is
so. 2. The primitive greenstone not merely covers other
rocks, but forms beds in them. An example of this may
be seen one mile east of the Milford marble quarry on what
is called the old road leading to New-Haven ; where the
greenstone lies between strata of a rich intermediate, between
greenstone slate and mica slate, and the rocks have every
appearance of being contemporaneous.

Primitive greenstone is colored in the following places on
the map, viz. at West-Haven and Milford—at Wolcott—at
Whately, in the western part of Northfield and north part
of Gill. In regard to that in Wolcott, or the Eastern part
of Waterbury, I know but little, it being several years since
I observed it, and some snow being on the ground at the
time. I put it down merely for the sake of pointing out its
locality.

The most extensive deposit of the rock is at West Haven
and Milford; on both sides, but especially on the east side,
of the Verd Antique stratum. The hummocks of it that
appear very frequently, but irregularly, very much re-
semble the detached hills of secondary greenstone, except
that they are less elevated and the blocks of debris are usual-
ly larger. A little south of the Derby turnpike, this is the
first rock that shows itself as we ascend from the alluvial
plain of New-Haven on the Humphreysville turnpike also,
there is but a narrow stratum of chlorite slate separating it
from the alluvion.

This greenstone often becomes stratified on both sides of
the ridge, forming greenstone slate. At first, we perceive
a partial and interrupted stratification ; and in a few feet it
becomes decided, extending through the whole mass.
There is also frequently seen a double stratification; one set
of planes crossing the other rectangularly or obliquely. Well
characterized greenstone slate, however, is not abundant in
Milford or West Haven. It usually soon passes into chlo-
ritic slate, or even into a bastard mica slate. An account of

these slates has been long since given to the public by Prof. Silliman in President Dwight's Statistical account of New-Haven, page 11. Their strata run N. E. and S. W. and dip to the S. E. The angle of depression below the horizon rarely exceeding 30° or 40°.

Let hand specimens of this primitive greenstone and of the secondary greenstone from East or West Rock be exhibited to a geologist who had never visited the localities, and he would not hesitate, I think, to pronounce that from East and West Rock to be primitive, and the other to be secondary; and for the reason, that he would find the secondary greenstone to be much the coarsest and most crystalline. The primitive greenstone of this locality is finely granular, and agrees, in this respect, with Jameson's description of transition greenstone. Indeed, it has already been suggested (Journal of Science, Vol. 2. p. 165.) that the Verd Antique of Milford *may possibly* belong to a transition series; and if so, this greenstone, greenstone slate, and chlorite slate, and even that bastard mica slate which is sometimes found between this marble and the secondary, may belong to the same class. The finely granular texture of transition greenstone, is however, by no means a distinctive character: since both the primitive and floetz greenstones are described as possessing the same.

The range of primitive greenstone in Northfield and Gill, commences about two miles north of the northern termination of secondary greenstone, and extends into Vernon. Its characters are very similar to those of the same rock at Whately and Milford. Some of it however approaches rather nearer the nature of sienite: but still the hornblende predominates. It is often stratified and often semi-stratified, becoming greenstone slate. Near the southern point I observed a vein or dike of limpid quartz several rods long and one foot wide, traversing this rock, having, a part of the distance, *saalbandes* of felspar.

The primitive greenstone occurring in Whately is somewhat different in its characters from that in Milford. It is coarse and usually highly crystalline in its texture, being sometimes rendered almost porphyritic by the imbedded pieces of compact felspar, and sometimes being little else than pure hornblende. It is not extensive and alternates in one instance with sienite, the locality of which has been pointed out in treating of the latter rock.

The greatest part of this greenstone is greenstoné slate, the strata having the same direction as that at Milford, and being nearly perpendicular to the horizon, bearing a few degrees one way or the other occasionally. This slate is also more crystalline than the same rock at New-Haven. It is however a less degree of crystallization that chiefly distinguishes it from hornblende slate, towards which it verges and into which it probably passes. Notwithstanding the very decidedly fissile character of this slate, I have noticed in some instances a tendency in it to the trappose form ; some of the specimens having a cleavage, like many crystals, in two directions, one coinciding with the direction of the strata and the other running across the strata. The proportion of felspar in this rock is small, often almost imperceptible. Chlorite, however, abounds as in the greenstone slate of Milford ; and often it becomes real chlorite slate. Seams and beds of quartz are common in the Whately rock and also granular epidote.

Some of the rock colored, as hornblende slate in Shelburne, &c. much resembles certain varieties of this greenstone slate ; and were the two rocks contiguous, it would be difficult to draw the line between them. Indeed, by some, this Whately rock would probably be denominated hornblende slate : but I think there is a distinction between the two rocks; and so long as any of the stratified rocks of Milford retain the name of greenstone slate, it would seem the Whately rock, from its resemblance and similar associations with unstratified primitive greenstone, demands the same appellation. An observer will be struck with the resemblance of the greenstone strata at these two places, and with their similar situation in regard to mica slate; and he will be disposed to enquire whether these rocks were not once continuous between these two places ;—and in the intermediate space, he will find sufficient evidence in the great quantity of mingled detritus of other rocks, that the higher strata have suffered much from some levelling agent in former days.

9. ARGILLITE.

Colored Brick Red.

The remarks last made in regard to the primitive green-stone, chlorite slate, &c. will apply to this rock. For we find it near the two terminations of the secondary tract and on the same side of it--viz. in Woodbridge at the south end, and commencing on the north at Leyden and extending at least as far as Rockingham, Vermont. The northern deposite is much the most extensive and is best characterized. In both places, however, it is often tortuous and slightly undulating, especially when passing into mica slate. It embraces numerous beds and "tuberculous masses" of white quartz—perhaps the milky quartz. The passage into mica slate is usually very gradual, the characters of the argillite losing themselves by imperceptible changes in those of the mica slate, so that for a considerable distance, the observer may be in doubt to which rock to refer the aggregate. The Woodbridge argillite occasionally alternates with mica slate, (Journal Sci. Vol. 2. p. 203.) and I have ascertained that this is the case also with that of Vermont. That which is just beginning to pass into mica slate, alternates also with a peculiar coarse limestone to be described under the next article; or rather, the limestone forms beds in the argillite—for instance in Putney.

A principal object in extending the map so much beyond the secondary region on the north, was to include all the argillite to be found along the Connecticut. Whether I have effected this object I am not certain. The Rev. E. D. Andrews, who communicated to me several facts on this subject, is of opinion that the northern limit of the argillite is on the south side of Williams' river in Rockingham, three miles north of Bellows Falls; but he had not examined the regions beyond with sufficient care to decide the point with certainty.

In Guilford, Vermont, this argillite alternates with a peculiar rock which Professor Dewey remarks appears " to be a talco-argillite with much quartz." Its stratification is less perfect than the argillite; or, rather, it has more of the irregularities and tortuosities of mica slate. Its small extent

and imperfect characters prevented my putting it down as a distinct rock. The stage road from Greenfield to Brattleborough passes over it in the southern part of Guilford. At the same place occurs well characterized chlorite slate; but not constituting any extensive range.

One mile south of this spot, another rock occurs, which an observer, at first sight, would pronounce to be granite. It is unstratified* and has the color of granite; but seems to be made up chiefly of quartz with a little mica interspersed. It seems to be an aggregate to which no particular name has as yet been applied; although the proportion of mica is so small that it might almost be called quartz simply. It appears to form a large bed in argillite, or talco-argillite.

The strata of argillite, both in Connecticut and Vermont, run in a direction nearly N. E. and S. W. and are highly inclined, generally varying but little from perpendicular. They are undoubtedly primitive—that is, the evidence of this is as great as in regard to the mica slate; both being highly inclined, and destitute of organic remains. Indeed, Bakewell, who has transferred argillite to the transition class, says "mica slate has a near affinity to clay slate; and as I have arranged the latter with rocks of the second class, it may perhaps be doubted whether mica slate should not also have been transferred to the same class." (Geology p. 83.) Do we not here see to what temptations the system maker is exposed, when pressed with difficulties? However, as Professor Kidd remarks,

* "By stratification we understand the divisions of a mass of rocks into many parallel portions whose length and breadth greatly exceed their thickness." *North-American Rev. No.* 29, p. 232.

"Where a rock is stratified, is it necessarily bounded by parallel surfaces? If so, let us hear no more of mantle-shaped, saddle-shaped, basin-shaped, trough-shaped stratification." *Greenough's Geology, Essay* 1.

I would beg liberty to enquire, whether some of these difficulties might not be removed by defining stratification to be the division of a mass of rock into many parallel or *concentric* portions? But after all, this, like a thousand other definitions in natural history, is only an approximation to the truth: For if mathematical exactness be essential, we have never yet seen any rock whose divisions were either parallel or concentric. Bakewell's distinction (Geology p. 31.) between "the structure which is caused by chemical agency, or by crystallization, and mechanical depositions," would perhaps give relief to some of the difficulties in regard to stratification, were geologists agreed what rocks have a structure caused by chemical agency and what ones are mechanical deposites. But they are not agreed on this point, as is evident from the very example he brings to illustrate his principle, when he says, that the division of slate rocks into layers, is the result of their chemical composition.

it seems "the terms primitive and transition are daily be-
coming of less importance."

Quarries have been opened in the Woodbridge argillite
and it is employed in New-Haven for building. In Ver-
mont also, they have been wrought in Guilford, and Vernon,
two also in Dummerston, S. E. of the centre of the town, two
in Putney, one and a half miles north of the meeting-house,
and one in Rockingham, a mile north of Bellows Falls. In
most of these the slate is of a good quality and easily ob-
tained; but at present they are not much wrought on ac-
count of the little demand for it, and consequent low price.

10. LIMESTONE.

Granular Limestone, Eaton, Index, &c.

Colored with India Ink.

This rock, in the country covered by the map, always
exists in beds in mica slate and argillite : never occu-
pying, however, so much as half the surface. I have co-
lored it in that region where it occurs most abundantly,
that is, in the mica slate nearest the argillite and the sand-
stone ; although its beds exist in nearly all the mica slate
north of Northampton on the west side of the river. It is
remarkably uniform in its appearance. Its exterior, when it
has long been exposed to the weather, is of a dark brown
color, showing more marks of decomposition than any
other rock in this region. The carbonate of lime is usual-
ly worn away at least an inch deep on the surface, and
the silex and mica are left in coarse grains, or warts, or in
projecting ridges. When newly broken the mica is uniform-
ly of a light gray, and the texture is coarsely granular and
dull, except the glimmering of scales of mica. The con-
stituents of the rock are carbonate of lime, mica and silex,
in somewhat variable proportions. In a specimen sent to
Prof. Dewey, he found about fifty per cent of carbonate of
lime and fifty of silex and mica. He judged that the silex
constituted about thirty five per cent and the mica fifteen :
and he judiciously adds, " the mica is in so great proportion,
you cannot call it silicious limestone. At least, ought it
not to be called a granitic aggregate, or silicious limestone
mixed with mica ?"

The beds of this rock vary in width from a few inches to 20 feet, and they rarely exceed this. They are unstratified, are sometimes traversed by veins of quartz, or more frequently granite, and sometimes the rock becomes so mixed with the mica slate, as, to form one of its constituent parts. Rhombic crystals of carbonate of lime, of a yellowish brown color, and agreeing by goniometrical admeasurement with the primitive form, are found imbedded in this limestone, and sometimes these are connected with irregular masses of quartz, and larger plates of mica. It forms, when blasted, a good stone for underpinning. I have never seen it along the Connecticut, except in the mica slate at the northwest part of the map—none in any part of New-England, nor in any mineralogical cabinet,—yet it seemed to deserve a place on the map, and a description.

11. Verd Antique.—*Cleaveland.*

Ophicalce Veinée. Brongniart.

Colored blue, and marked with oblique parallel lines.

The rich and elegant marble obtained from this rock has induced me to give it a place on the map, although its extent is very limited. It extends northerly from Milford harbour, 9 or 10 miles, apparently terminating two miles west of Yale College. It constitutes an extensive bed in chlorite slate, with which it sometimes alternates. I am inclined, however, to the opinion, that the slate lying immediately contiguous to the Verd Antique, although not well characterised, approaches nearest to greenstone slate. Yet, decided chlorite slate, appears usually only a few rods distant. In some places, the Verd Antique is a quarter of a mile in width, and forms ledges of considerable elevation and extent. It is stratified—the layers being thick and parallel to the slate rock enclosing it. The grain is fine; the rock is traversed by veins of calcareous spar, magnesian carbonate of lime, and asbestus; and is associated with chromate of iron and magnetic oxide of iron, diffused, more or less, through the entire body of the marble, and forming dark spots and clouds. The serpentine is twisted and entangled in the limestone in almost every form, and the green color of the rock may in gene-

ral be imputed to oxid of chrome—sometimes to the presence of serpentine, colored however, probably by the same oxid.

This rock has been extensively quarried in two places, one in Milford, 7 miles from New-Haven, and the other only $2\frac{1}{2}$ miles from the city. From these are obtained a marble which vies for elegance with any in the world. Indeed, in the extensive collection of marbles and porphyries in Col. Gibbs' cabinet in Yale College, we appeal to those who have seen them, whether any specimens exceed, or even equal in beauty and richness the Verd Antique from Milford. The varied clouding and shading of the gray, or blue ground of this marble with white, black, green, orange and gold yellow, indeed, with varieties of almost every color of the prism, give it an elegance that can be realized only by those who examine it. The working of this marble is difficult and expensive, and it is earnestly hoped that the patrician part of our community will not, by resorting to Europe for marbles, which, to say the least, are no more elegant than this, compel the proprietors of these quarries to abandon the undertaking. Specimens of this marble may be seen in most of the dwellings of the wealthy citizens of New-Haven; and many of the monuments in the grave yard of that city, are of the Verd Antique. Several chimney pieces of it may be seen in the Capitol at Washington.

Most of these facts in relation to this rock, I derive from the published accounts of it by Professor Silliman. (See Cleaveland's Mineralogy under Gran. Limestone, Marble, and Verd Antique, 2d Edit. Also, Journal Sci. vol. 2, p. 165.) A minute account of this interesting formation is still wanting; and Mr. Silliman has promised it. (See Jour. Sci. vol. 2, p. 166.)

12. OLD RED SANDSTONE. *Werner. Cleaveland.*

It is agreed I believe among Geologists who have examined this region, that an extensive deposite of this rock exists along the Connecticut. (See Cleaveland's Mineralogy, 2d Edit. p. 759. Eaton's Index 2d Edit. p. 207. Tour between Hartford and Quebec, p. 21, and Maclure's Geology of the United States.) It is probably the oldest secondary rock in this region, and generally lies beneath all

the rest. So that it does not, I apprehend, occupy so much
of the surface, as is generally supposed. There is much
slaty sandstone, red and gray, and some of it very argilla-
ceous, found along this river, which does not appear to be
the old red sandstone of Werner ; but to be a different
formation, which I have denominated the Coal Formation ;
and which others have called gray wacke slate. I know of
no instance in which I am certain that decided old red
sandstone lies above the coal formation; although they
evidently pass into one another. This coal formation,
with the secondary greenstone and alluvion, occupies, I
should judge, nearly two thirds of the secondary tract
along the Connecticut; leaving not more than one third for
the old red sandstone. This rock occupies the greatest
extent of surface, as the map will show, in the vicinity of
New-Haven. Along the western side of the secondary, it
may be found all the distance, (occasionally covered by
alluvion,) from New-Haven to Bernardston, Mass. Yet,
it forms but few ridges or peaks of much altitude until we
come to the south part of Deerfield. There it rises ab-
ruptly from an alluvial plain in the form of the frustrum of
a cone, five hundred feet above the Connecticut; and the
peak is called Sugar Loaf ; being but a few rods in diame-
ter at the top, and forming a striking feature in the scene-
ry of the country. This is the commencement of a range,
which, five miles north, rises 700 feet above the adjoining
plain, and then slopes to the north, almost disappearing in
Greenfield ; but rising again in the northern part of the
town and sending off one or two spurs into Gill.

The grain, even of the finest variety of this sandstone,
may be called coarse. Its colour is dark reddish, some-
times presenting spots or veins, of light gray, as in Hat-
field, Mass. Its cement is argillo-ferruginous, and the rock
usually exhales an argillaceous odour when breathed upon.
It contains a large quantity of light gray mica, the plates
being sometimes half an inch, or more, across, and insert-
ed promiscuously. This description applies to the finest
varieties of old red sandstone. But this passes into and
alternates with conglomerates of the same general charac-
ter and of various degrees of coarseness. The imbedded peb-
bles, vary in size from that of a musket ball to four or five
inches in diameter. They are usually quartz, felspar, graphic

and common granite, and rarely gneiss or mica slate. The coloring matter of the rock, in most instances, has penetrated through these pebbles, giving the granitic nodules the same color as the rock, and the quartz a bluish aspect. This conglomerate frequently alternates with the sandstone, and one half of the layer of a rock is sometimes sandstone, and the other half conglomerate, no fissure being between them. Generally speaking, however, the puddingstone increases in quantity and coarseness as we ascend a mountain of this rock, and all the upper part of the hill is sometimes composed of it. Probably more than one half of the old red sandstone in the northern part of the range is this conglomerate; yet, as it is evidently a mere variety of the sandstone, it was thought altogether unnecessary to attempt a division by different colors on the map.

A considerable part of the range of this rock colored on the east side of Connecticut river, is somewhat different in its appearance from that I have been describing on the other side. At least, there is one very abundant variety that is not found on the west side. It consists of a fine, siliceous, red sand, adhering together with but very little visible cement. It has, however, an argillaceous odour. The coherence is not as strong as in the coarser sandstone, it being slightly friable. This rock may be seen in place in the southwest corner of Ludlow, and the east part of Long Meadow, Enfield, Somers, Ellington, &c.; and it forms a neater and handsomer building stone than any other rock of the sandstone family which I have ever seen.

A part of this range of red sandstone, east of Connecticut river, appears also to be verging towards the sandstone constituting the coal formation. Examples of this may be seen at the extensive quarry in Chatham, and also in Middletown—there seems to be a gradual passage of one rock into the other—and the strata of both these rocks have their dip in such a direction, as to lead one, at first, to conclude that this old red sandstone lies *above* the coal formation. The dip of both rocks is to the east. It does not follow, however, from this circumstance, alone, that the red sandstone does in fact repose on the other rocks. Thus, let A B be a profile crossing the valley of the Connecticut, and exhibiting the strata of old red sandstone, having

a dip as represented by the parallel lines. Let C D be a
deposite of the coal formation lying upon the old red sand-
stone, the strata of which have the same dip. Now, to
an observer passing along the surface from A to D, the red
sandstone, between A and C, appears to lie upon the coal
formation between C and D, whereas, the reverse is the
fact. This might apply to the rocks we are considering in
Connecticut, were it not for what I think to be the fact,
that there is a gradual passage of the old red sandstone in-
to the coal formation.

A. C. D. B.

These, and some other circumstances, made me suspi-
cious, for a time, that this range of sandstone east of Con-
necticut river, might not be the real old red sandstone, but
a member of the coal formation ;—and it was not till I had
traversed it the third time, that I felt entirely satisfied.
But much of it certainly does not differ, at all as I could
discern, from the old red sandstone on the western side of
the river; and we find likewise the very same conglome-
rate. The strata also, are of a similar thickness and dip,
varying as to the form, from six inches to two or three
feet; and as to the latter from 10° to 30°; usually, how-
ever, not more than 10°. This dip, in all the red sand-
stone of the Connecticut, is below the eastern part of the
horizon, with the single exception of a ledge that appears
in the west street of Hatfield, where the dip is to the
west.

This rock is extensively quarried for the purpose of
building, in almost every town along the river. Noble
specimens may be seen in the vestibules of the churches in
New-Haven.

Organic Remains.

These are very rare in our old red sandstone. I found, however, in Deerfield mountain, one or two specimens that belong to the *petrifacta* of Martin ; there being a perfect substitution of a finer grained sandstone for the original substance. I found only fragments, about four or five inches long, and they appear to belong to the genus *phytolite* of Gmelin's Linnaean System, and to the species *lignite*. They are a third of an inch in diameter, and a little flattened ; and seem to agree with Professor Eaton's description of certain petrifactions found in red sandstone on the Catskill Mountain ; (Index p. 211.) which he is inclined to refer " to the tribe of naked Vermes."

Fossil Bones.

These occur in East Windsor, east parish, one hundred rods south of Ketch's Mills. They belong to the *conservata* of Martin, and, without much doubt, to the genus *zoolithus* of Gmelin. The animal must have been about five feet in length, and lay horizontally in the rock, eighteen feet below its top, and twenty-three below the surface of the ground. The tail bone, as Dr. Porter, who lives near the spot, informed me, projected beyond the general mass containing the body of the skeleton, about eighteen inches in a curvilinean direction. This, of which that gentleman gave me a specimen, was easily distinguished by its numerous articulations. On exposure to the air, the bones begin to crumble and lose the appearance they presented when first dug up.

The rock in which these bones were found, is decidedly the old red sandstone. It agrees exactly with 'that rock as it exists at New-Haven, and to the distance of one hundred miles north from that town. The rock enclosing the bones is a little coarser than the finest varieties of this rock, and in the rock above the bones, was found some moderately coarse conglomerate. Whatever doubt I had with regard to some other varieties of rock in that vicinity, being the real old red sandstone, I could have no doubt in regard to this, after examining it.

13. SECONDARY GREENSTONE. *Cleaveland.*

Colored Carmine, or Rose Red.

To give the ranges of this rock, was one of the princi-
pal objects in constructing the accompanying map. For
although it be an anomalous, it is a highly interesting
formation. The high mural precipices that almost uni-
versally show their naked faces in the ridges and hil-
locks of this rock—the immense quantity of *débris* that
frequently slope up half, or two thirds the distance to
their summits—and the thin tufts of trees that crown their
tops, form much of the peculiar scenery of the Connecti-
cut. They remind the European of the basaltic and
other trap ridges of Scotland, Ireland, Saxony, Auvergne,
Italy, &c.

In regard to the greenstone* north of Hartford, I feel
confident that every range of it to be found in place, is in-
serted on the map. South of Hartford some small and low
hillocks of it may have been overlooked, notwithstand-
ing all the assistance I have received from Prof. Silliman
and Dr. Percival. For, in some places, this rock seems to
be but a few feet in thickness above the sandstones, and to
be less continuous than in the northern part of the map.
In East-Haven and Branford especially, there are so many
ridges of greenstone, and these so irregular, that it is diffi-
cult, on a map of such a scale, to make them all distinct
and accurate.†

The most southerly point of greenstone on the map is
the bluff in East-Haven, which fronts Long Island Sound,
and is about one mile and an half north of the Light-House.
The most northerly points of this rock are in Gill and in
Northfield. The greenstone which occurs in the upper
part of Northfield, is more crystalline and of a coarser tex-
ture than in the intermediate distance, and is undoubtedly

* To save room, I shall omit, in the remainder of this article, the term
secondary, as applied at the head of the article.

† There ought to be a geological map of the region about New-Haven,
on a larger scale than the one I have given : and we could name more than
one gentleman in that city, who is amply qualified for its construction.

primitive greenstone. Some of the specimens scarcely differ from pure hornblende.

Between the two extremities of granite above named, there is not a mile, except in Amherst, where this rock may not be found in some part of the valley of the Connecticut. The most continuous and lofty ridge is that of which West-Rock may be considered as the southern termination—although the west rock range is broken off a few miles between Mount Carmel and the Meriden or Berlin mountains. This ridge from West-Rock to Cheshire, presses hard upon the primitive rocks, often approaching the slate within a few rods. It presents, on the west, a lofty naked wall, appearing as if nature had erected this mighty rampart to guard the secondary region of the Connecticut from the encroachments of the primitive; while the great quantity of broken fragments along its base and scattered in abundance for four or five miles over the chlorite slate and argillite, evince that these ridges of greenstone were once much more elevated than at present. This range divides in the northern part of Hamden, the eastern branch forming Mount Carmel, and the western branch continuing into Southington, where it chiefly disappears, although immense bowlders of greenstone are scattered over the surface until we come to the north part of Farmington. Here the ridge again commences, and inclining considerably to the right, terminates in the north-east corner of Granby, Connecticut, in the Menitick or Manitick mountain, on the top of which runs the line between Granby and Suffield.

Mount Carmel terminates a little east of north from New-Haven, and until we reach the Meriden or Berlin mountains, the greenstone disappears. Commencing with these mountains, we find an almost uninterrupted ridge of greenstone, continuing into Massachusetts. Its elevation decreases, for the most part, as we go north, until we come to East-Hampton, when it suddenly rises, like the coil of a huge serpent, and forms Mount Tom, probably the highest point in the greenstone ranges of New-England. I do not know that its height has ever been accurately measured: but, comparing it with Holyoke, it cannot be much less than a thousand feet above Connecticut river. Connecticut river crosses

this range at the north end of Mount Tom, and on the op-
posite bank it rises again precipitously and forms Mount
Holyoke. This I found, with a nice sextant, to be eight
hundred and thirty feet above Connecticut river. North
of Holyoke the greenstone is curved towards the right and
continues of nearly the same elevation until it terminates,
near the north-west corner of Belchertown, having reach-
ed the primitive region.

Nine or ten miles north-westerly from this point, we find
a narrow ridge of greenstone commencing, and pursuing a
course considerably west of north, it passes through Sun-
derland, crosses Connecticut river, runs through Deerfield,
crosses Deerfield river, and extending through a part of
Greenfield, terminates at the falls in Connecticut river. A
few rods east of this termination another range commenc-
es and runs east of north through Gill, with some interrup-
tions, till it reaches its extreme northern point in North-
field, two miles south of the primitive greenstone.

It will be seen by the map, that these greenstone ridges
separate the old red sandstone from the coal formation
nearly the whole distance from Berlin to Northfield; and
the rocks of the coal formation are frequently found lying
above the greenstone. The range of green stone in Sun-
derland is very narrow, and being in an unfrequented spot
along the western margin of Mount Toby, it was a long time
before I discovered its existence. Having once found it,
however, it was traced, without much difficulty, except
what an almost impassable precipice presented. It is from
ten to eighty rods wide. As you ascend the mountain from
the west, you first pass over a formation of old red sand-
stone, which is here a coarse pudding-stone. Next you
come upon the greenstone, most of which is amygdaloidal,
and is, so far as hand specimens will enable us to decide,
the real toad stone of Derbyshire. Immediately east of
the green-stone you find the coarse, brownish red, and the
fine, fissile, argillaceous, gray and red sandstone slates of
the coal formation. These uniformly rise in higher ledges
than the greenstone; even one hundred or one hundred
and fifty feet above it. As you pass along in the direction
of the greenstone ridge, these precipices are not more than
ten feet from you on one hand, and the greenstone at no

greater distance on the other. The broken fragments of the two rocks are confusedly mingled together, the sandstone breaking into large tables, and the greenstone into pieces only a few inches across. These huge tables are covered and fringed with a great variety of cryptogamous plants, such as various species of *Pamelia, Juggermannia, Sticta, Collema, Bartramia, Hypnum, Polypodium, Aspidium, Asplenum, &c.*; most of which are evergreen. And if the geologist be also a lover of this department of botany, he will find the wild and confused blending of such a variety of interesting objects to repay him amply for the labor and even danger of clambering over the fragments. I have never seen any rocks that seemed so congenial to the growth of cryptogamous plants as those constituting Mount Toby.

But to return from this digression. As the observer follows this greenstone southerly, commencing at its northern extremity on the banks of Connecticut river, and sees the lofty precipices of sandstone overhanging it, little doubt will remain in his mind that the greenstone actually passes under the sandstone. Yet any one acquainted with the anomalies of trap rocks will have the question arising in his mind, may not this greenstone, after all, here constitute an extensive dike? and he will hardly be satisfied until he sees the actual contact of the two rocks in place. One mile north-east of Sunderland meeting-house, the greater part of the greenstone ridge disappears and seems to run under the sandstone; but here a few feet of *débris* hide the actual junction. A little farther south an actual junction is seen; but the huge table of sandstone resting on the trap is removed a few feet from its original position. And, indeed, I never knew expectation so frequently disappointed, just at the moment when it seemed about to be realized, as in examining this range. It seems as if nature intended here to teach the geologist a lesson of patience. But, at length, one mile and a half south-east of Sunderland meeting-house, the observer comes to a valley worn by a brook, where finding the greenstone, which thus far has preserved almost a right line, widening towards the east, and forming a reentering angle in the sandstone, the angular point being in the brook; he will have little doubt that

the greenstone is here disclosed by the abrasion of the superincumbent sandstone—and on following the line of junction a few rods on the south side of the brook, he will find the sandstone in place lying directly on the greenstone, also in place. To one who has been accustomed to see this latter rock mounting above every other and monopolizing so muchspace for its broken fragments, it must be gratifying to see it at last pressed down by a superior stratum, and buried by the debris of a higher rock. In two places south of the point above described, other brooks have worn away the sandstone, and the greenstone forms in it a like reentering angle ; but the actual contact of the rocks is hidden.

But Sunderland is not, after all, the best spot for observing the rocks of the coal formation lying above the greenstone. I have been thus particular in describing the range of greenstone in that place, rather to exhibit the difficulties and *trials* to which the geologist is subject in examining the trap ranges of the Connecticut, than because it was necessary for this particular purpose.

Let the observer follow the Sunderland greenstone ridge northerly across Connecticut river into Deerfield, and he will here find it widening and increasing in altitude, presenting a mural precipice on the west, and a gradual slope on the east. Where it crosses Deerfield river it has every appearance of a vast dyke : although the sandstone rocks do not appear immediately in contact with it. From the top of the greenstone to the bottom of the river is more than two hundred feet. The range continues to the falls in Gill, where, as before observed, it terminates, and is succeeded by the red sandstone or conglomerate. And here would I mention another fact in regard to the greenstone and rocks of the coal formation. The latter do not merely lie above the former, but *they alternate with one another.* Let the observer pass round the northern termination of the greenstone range first mentioned, and follow down a small river called Fall river, to its mouth, and just at this point he will see the fine-grained, red, fissile, argillaceous sandstone of the coal formation, mounting up fifty feet upon the back of the greenstone at an angle of forty-five degrees. And if he follow down the west bank of the Connecticut

two miles, he will have repeated opportunities of observing the same fact ; the river having worn away the ro ks so as ·to afford a fine chance for observation. Let him now re- ·turn and cross the mouth of Fall river eastward, following up the north bank of the Connecticut, and he will find the same red slate, cropping out about fifteen rods, when he will come to another ridge of greenstone, *under* which the slate passes. If he follows the junction of the rocks ob- liquely up the hill, on the east side of Fall river, a hundred rods in a northeasterly direction, he will observe the green- stone lying upon the slate more distinctly. Let him return to the bank of the Connecticut, where the sandstone slate passes under the greenstone, and he will observe them both extending in the same manner into the stream. If he now go eastward along the bank of the river, he will find green- stone twenty rods, and then the same or nearly the same slate, rising on the back of the greenstone at an angle of forty-five degrees. Thus will he have conclusive evidence of the alternation of these rocks. This alternation, cross- ing this same spot, is represented in the profile accompa- nying the map. No. 8 is the first ridge of greenstone above mentioned: No. 9 the sandstone slate, rising on its back: No. 10 the second ridge of greenstone; and No. 11 the second stratum of the slate. This second ridge of green- stone, as already marked, extends northeasterly into Gill and terminates in the west part of Northfield.

. Another spot for observing the alternations of greenstone and the coal formation is one hundred rods south-east of Lyman's tavern, on the north-east side of Mount Tom, in Northampton. A small stream here crosses the road, and in its bed and banks several distinct beds of greenstone, some of them not more than one or two inches thick, may be observed at low water.

In the southern part of that extensive greenstone ridge ex- tending from Amherst to Meriden, the sandstone of the coal formation may often be seen on the west side of the greenstone, lying underneath it. The shaft of the copper mine at Newgate prison passes through the greenstone and enters the sandstone: and Dr. Percival informs us (Jour. Sci. Vol. 5, p. 42,) that in Southington, "sometimes the sandstone can be very distinctly seen cropping out below the greenstone on the west side of the ridges." At the

outlet of Salstonstall's pond in East-Haven, I have observed a grey micaceous sandstone of the coal formation, passing under the greenstone with a considerable dip; and also two miles south of Durham village, on the side of the turnpike leading to New-Haven.

Dr. Percival, who has examined most of the greenstone ranges in Connecticut on foot, illustrates his views of the relative position of this rock and the coal formation as follows—referring particularly to the vicinity of Berlin. As you ascend the mountain ridges from the west, the lowest rock you find, after leaving the alluvion, is the old red sandstone, represented below by A. Above this lie the argillaceous sandstones of the coal formation, represented by B. The cap of the ridge C is greenstone; precipitous on the west side, but gently sloping on the east. Passing on we come to another stratum of the coal formation; as D. Next, perhaps, succeeds another ridge of greenstone, E—similar to C; and on its back, we find again the coal formation, F; And sometimes the cap of greenstone is insulated, as G.

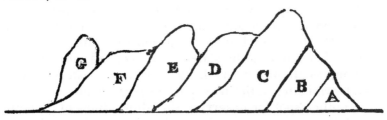

Sometimes we find the greenstone resting immediately upon the old red sandstone, without the intervention of a third rock; as at East and West Rock near New-Haven.

From all that I have seen and learned concerning these rocks, I feel therefore, warranted in concluding, that, as a general fact, our greenstone alternates with, or forms beds in, the peculiar rocks of the coal formation; and it seems very probable that both these repose upon the old red sandstone. As the slates of the coal formation dip below the eastern horizon, it would seem we are furnished with the reason why the mural faces of the greenstone are almost universally on the western side of the ranges.

When greenstone rests on the coal formation, the lower part of the greenstone seems to consist of little else than a greyish black, indurated, ferruginous clay. Perhaps even

wacke* may be found lying between the greenstone and the
sandstone, as at Gallows-Hill near Hartford, and on the
west side of the Berlin ranges of greenstone. Some of the
greenstone occurring in the dykes of this rock in old red
sandstone, has a similar aspect. At the junction of the
coal formation and greenstone below the falls in Gill, the
columnar tendency of the latter rock entirely disappears,
and for several feet, the greenstone is distinctly, though
somewhat irregularly, stratified; the strata being parallel
to the sandstone. This may be seen to most advantage at
very low water; and the same may be seen, though less
distinctly, along the whole eastern border of this range of
greenstone ; and something of it on the east side of all the
greenstone ranges along the Connecticut. It ought here
to be remarked, also, that this rock appears quite different
in its composition on the eastern side, especially of the
range passing through Deerfield and Greenfield. The in-
durated clay seems in a great measure to take the place of
the hornblende, and the basis of the rock has a wacke-like
appearance. Much of it is amygdaloidal; but the imbed-
ded minerals are usually quite different. On the east side,
the most abundant is chlorite, having a radiated aspect, and
green earth ; whereas, on the west side, this is scarcely to
be found. The radiated zeolite on the west side is finely
fibrous; on the east side, the crystals are larger and trans-
parent, resembling the Thomsonite of Dumbarton in Scot-
land. The rock on the eastern side is, also, more decom-
posable than on the opposite side.

The eastern side of this rock is not, however, all amyg-
daloidal. Near where Deerfield river passes through the
range, on the north bank, this rock contains distinct crys-
tals, or rather plates of felspar; and thus becomes a porphy-
ritic greenstone. "It even approaches to ophites," says
Professor Dewey. The same rock contains good prehnite,
and in the prehnite may be found pyritous copper.

I should judge that about one half of the greenstone of
the Connecticut constitutes the base of amygdaloid, and
very much of it appears to be genuine toadstone. The cavi-
ties are usually spheroidal or almond shaped, sometimes
reniform, and frequently cylindric. Those of the latter

*I have recently found *wacke* perfectly well characterised, and very
abundant, at the foot of the very lofty mural precipices, two miles north
of Monte Video, on the Talcot mountain, ten miles W. of Hartford.—*Editor*

form are often a foot or more in length, and arranged parallel to one another; the rock appearing as if bored through repeatedly by an augur. The imbedded minerals are calcareous spar, analcime, chlorite,quartz, chalcedony, chabasie, zeolite, and Professor Silliman has recently discovered gypsum* in a specimen sent him from Dr. Cooley ; a new fact we believe in Geology, and one which renders it not improbable that this valuable mineral may be found in abundance along the Connecticut.

This amygdaloidal greenstone is probably most abundant at the lower part of the greenstone ridges ; while the upper part is solid and usually columnar. Frequently, however, the columns are amygdaloidal to their top, and sometimes, as in Deerfield, in passing in the direction of the ridge, you will find alternate successions of amygdaloidal and solid greenstone columns. On breaking into the interior of the former, we often find them a rich reservoir of rare minerals. The cavities are usually small; but sometimes several inches in diameter, occupied by quartz and amethystine geodes, or chalcedony, or agates, or a peculiar pseudomorphorus quartz to be described when we come to treat of particular minerals. The largest and best agates occur usually among the greenstone that is not much amygdaloidal, sometimes occupying a cavity, part of which is in one column and part in another. They are very frequent, and some of those recently discovered by Dr. D. Cooley, in Deerfield, are probably the finest yet found in this country. A particular account of them will be given in the proper place. Prehnite sometimes forms a thin incrustation on the columns that are not amygdaloidal; and between the joints of those that are so, is sometimes interposed a thin coating of various minerals, among which epidote frequently predominates.

Some of the amygdaloid is very vescicular, bearing some resemblance to the slag of an iron furnace or lava. The cavities, in certain rare varieties, are various in form ; and the base is whitish brown, reddish, and even brick red ; containing, in the cavities, much prehnite, and this mineral, together with calcareous spar, seems, in some instances, to be mixed with the greenstone to form the base. An enthusiastic Huttonian would doubtless be gratified to find

*This gypsum was perfectly fresh—crystalized—white, and retaining its water of crystalization.—*Editor.*

such a variety. A locality of it may be found one hundred rods north of the Deerfield river bridge in Deerfield, at the western foot of the trap range.

The columnar tendency of our greenstone has often been noticed. It may be seen in almost every ridge in a greater or less degree, on the mural face—and these columns are sometimes remarkably regular. Good examples of them occur on the south-west face of Mount Holyoke ; and still better ones a mile east of the village of Deerfield, a quarter of a mile north of the locality of chabasie, analcime, &c. mentioned in the Jour. of Science Vol. I. p. 115. They have from three to six sides, are articulated, the points varying from one to three feet in diameter, and of the same height, exhibiting handsome convexities and corresponding concavities. Half a mile south of this spot may be seen columns curving to the right and left as they ascend ; thus forming a portion of an arch. The geologist, who traverses this ridge, can hardly avoid traversing in imagination the giant's causeway, Staffa and the Hebrides.

Some of the less perfect columns have a remarkably fissile tendency ; forming good hand specimens of pseudo-green-stone slate. Globular distinct concretions of this rock are not unfrequent among the amygdaloid ; composed of concentric coats of greater specific gravity than the rest of the rock. I have noticed them in Deerfield, and on the New-Haven turnpike between Durham and Northford, they are abundant, and from two to twelve inches in diameter.

The general aspect of our greenstone, where it has been long exposed to the weather, is reddish brown. When newly broken it is greenish, often somewhat lively. Sometimes it is greyish black, and, very rarely, has the color of a brick that has been burnt very hard. This variety is compact and the felspar imperceptible. It is often the fact, indeed, that the two ingredients in other varieties, are not to be discovered by the naked eye, or with an ordinary lens.

A question then occurs, whether some of the varieties of this rock are not genuine basalt ? Certainly some of them answer the description of that rock, so far as external characters are concerned, to say the least, as well as of greenstone. And, indeed, if "greenstone and basalt may not unfrequently be seen passing into each other in the same stone, as D'Aubuisson and Dolomieu have observed," (Bakewell's Geology, p. 119,) there seems no rea-

son to doubt that this fact may exist in this country as
well as in Europe. Were I to refer to particular localities
for rocks resembling basalt, I should mention the foot of
Mount Tom on the north-east side, and a part of the range
passing through Deerfield. It would not surprise me, should
future geologists make a division of our greenstone, calling
a part of it basalt; dividing the upper part of the ridges from
the lower, or the eastern side from the western, or both.
A geologist, to be able satisfactorily to make these divi-
sions, or to decide whether any of our rock is basalt, ought
to have traversed extensively and observed minutely the like
rocks in Europe; and, therefore, I leave the subject to
abler hands.

A good locality for observing many of the varieties of
greenstone above described within a narrow compass, is on
the north bank of Deerfield river, about sixty rods from the
bridge. Let a person cross the bridge to the north, and
take the right hand road, until he comes to where the road
passes round the end of the greenstone ridge. Here he
will first see the most common variety, having a columnar
tendency; and a few rods beyond, the reddish brown vari-
ety,* and in a wall, supporting the road on the right hand,
he will find abundance of the porphyritic greenstone, hav-
ing a somewhat stratified structure. Here, too, he will
find some specimens covered with a ferruginous coating;
so much charged with iron, indeed, that efforts have been
made to smelt it. Indeed, a mass of four or five pounds
from almost any part of this greenstone range, when held
by the side of a compass, will move the needle.

It is not always the case, nor even generally, that the
greenstone ridges that are marked as continuous on the
map, are strictly so. They are often composed of numer-
ous peaks or ridges, partially detached, but yet constitu-
ting a single range when viewed at their bases. And some-
times, when there appears to an observer passing along the
western side of the range to be an uninterrupted wall, clos-
er examination will show, that it is made up of several dis-
tinct ridges, so lapping on upon each other, and so near one
another, that they appear continuous. The mural face of
the ridges and hillocks is usually on their western side :
but sometimes on the opposite side, as in the high moun-

*I have a specimen of greenstone from a vein in Scotland resembling this,
except that the Scottish rock is much coarser.

tain between Durham and Northford; and sometimes on both sides, as Menitick mountain in Granby, Ct. Mount Carmel in Hamden, and Mount Tom in East-Hampton, at its southern extremity. The broken fragments of the greenstone, of almost every shape, seldom of any regular figure, and of various sizes, usually slope up more than half the distance from the bottom to the top of the ledge. This débris is highly interesting to the chronologist, because it furnishes him with a decisive

Cosmogonical Chronometer.

Every one who lives in the vicinity of these greenstone ridges knows, that every year adds to the loose masses at their base, at the expense of the columns above. The water infiltrated through the thin soil on their tops, finds its way into the narrow seams between the columns, and there freezes in the winter, and by its expansion, removes the rock a little from its place. This operation is repeated, year after year, and thus some part of the rock is pushed so far over the precipice that its center of gravity falls without the base, and it comes thundering down, usually dividing into very many pieces. Sometimes, if the foot of a column gives way in this manner, the whole column above, perhaps twenty or thirty feet long, is precipitated, like a glacier, on the loose rocks below. Sometimes only one or two of the lower joints fall out, leaving the principal part of the column suspended, the shuddering observer can hardly tell by what. He will also see evidences in very many places, both in the ledge above him and in the ruins beneath them, of recent instances of this kind. Indeed, in almost any place along these mural points, two or three of the outer columns are easily removed by the application of a lever, being loosened by the ice of preceding winters.*

Now every one must see that this levelling work cannot have been going on forever; and when we consider how

*On tearing down some of these columns a few years since, during the winter, in search of chabasie, &c. I found the spaces between them occupied by an immense swarm of the common *musquito.* Poor insects! it was all over with them as soon as the avalanche thundered. The Hon. Elihu Hoyt informs me he found a swarm of these creatures in the winter, in a hollow tree.

very considerable is the quantity of rock yearly detached,
and compare this with the whole amount of the débris, the
conclusion forces itself upon us that the period when this
process began could not have been vastly remote ; in oth-
er words, that the earth has not existed in its present form
from eternity. Its precise age cannot, indeed, be deter-
mined by this chronometer ; but I have often thought that,
judging from this alone, we should be led to conclude that
Moses placed the date of the creation too far back, rather
than not far enough.

Greenstone Dykes in Old Red Sandstone.

Professor Silliman conducted me to an interesting locali-
ty of these in East-Haven. They occur on the main road
from New-Haven to East-Haven, less than half a mile from
Tomlinson's bridge. We measured their width, and that
of the intervening sandstone, as they appear on the north-
easterly side of the road. The road here passes over a
small eminence, and the bank, on the north side, in its high-
est part, is almost fifteen or twenty feet above the road.
The dykes, occurring at this place, are exhibited on the pro-
file accompanying the map ; and are laid down from a scale
of fifty feet to an inch, with the intervening sandstone. In
describing them I shall begin at the north western extremity,
that is, at the point nearest New-Haven : but a person wish-
ing to find them, will do best to go first to the other end of
the profile ; because the dikes are there more distinct.

No. 1. (See Profile.) Old red sandstone, coarse and con-
taining pebbles so as to form a conglomerate. The dip of
the strata is from 6° to 10° below the eastern horizon. The
sandstone is very similar throughout.

No. 2. Greenstone dike, 4 feet thick.

No. 3. Sandstone, 114 feet. This distance was measur-
ed by pacing ; the other distance by a rule.

No. 4. Greenstone, one foot thick.

No. 5. Sandstone, 9 feet.

No. 6. Greenstone, 9 feet.

No. 7. Sandstone, 40 feet.

No. 8. Greenstone, 10 feet. The soil has so covered this
spot, and we having nothing with which to penetrate it, we
did not actually see the dike. But the walls are distinct,

having small peices of the greenstone attached to them, and exhibiting somewhat of an altered appearance, like the other walls, so that little doubt could remain of this being a genuine dike.

No. 9. Sandstone, 52 feet.
No. 10. Greenstone, 5 feet.
No. 11. Sandstone, 45 feet.
No. 12. Greenstone, 10 feet.
No. 13. Sandstone, 19 feet.
No. 14. Greenstone, 7 feet.
No. 15. Sandstone, 7 feet.
No. 16. Greenstone, 4 feet. Here the greenstone is hid by the soil as is also the sandstone at the other end of the profile: so that by removing this, probably other dikes might be discovered.

Thus we have eight dikes in a distance of 21 rods. Some of them require a little attention to discover them; but most of them are very distinct. Some of them we traced several rods on both sides of the road, in a direction perpendicular to the profile. Their width is sometimes suddenly decreased, or increased, several inches, so as to form shoulders. They are not exactly perpendicular, but lean a few degrees to the west; and thus they are made to form an angle considerably obtuse on their eastern side with the sandstone. The latter rock is often somewhat glazed, having a specular aspect at the place of junction with the greenstone, and the two rocks are not unfrequently mutually impregnated, for several inches, with each other's properties.

I did not notice that the dikes at this place dislocate the strata of sandstone: but I paid little attention to this point.

Several dikes, similar to the above, (three at least,) occur in the old red sandstone on the right hand side of the turnpike from New-Haven to Middletown, on the east margin of the salt marsh lying east of East Rock. One of these is remarkably distinct, cutting through a precipice twenty or thirty feet high, and maintaining an uniform width of about a foot. This crosses the strata nearly at right angles; but makes an angle with the horizon of about 45° dipping to the south west. On its roof, or upper side, near the lower extremity, a part of the sandstone strata are thrown upwards two or three feet; and they are affected laterally about the

same distance. The dike along with the sandstone appears to pass under a hill of greenstone.

On the same turnpike, a few rods north-easterly of North-ford meeting-house, four or five dikes occur; but they are so hidden by the soil as not to be particularly instructive. In passing from Durham to New-Haven on the same road, the first low ridge of greenstone, which we cross, exhibits something, which I was almost disposed to denominate a dike of coarse pudding stone, of the coal formation, in greenstone. Certainly, there appears a peculiar juxtaposition of the two rocks; but probably they exist in beds.

Two or three miles north of the dikes of which a profile is given, Dr. Percival found several others; and perhaps they are a continuation of the same. He found one also on the road from Farmington to Hartford in the rocks of the coal formation.

The greenstone found in these dikes has usually the dark compact aspect of basalt—resembling, however, much of the greenstone found along the Connecticut. Yet it seems to want the characteristics of greenstone, and specimens which I collected from the most perfect dike above described, half a mile east of East Rock, even approach to wacke. This rock gives an argillaceous odour, is of a greenish grey color, has an uneven fracture, is dull, and much softer than common greenstone; so that it may be cut with a knife:—and on comparison with a specimen of pure wacke from Calton Hill, (Edinburgh,) which was analyzed by Dr. Webster, it does not appear to differ, except in its greater hardness and perhaps less softness to the touch. I have little doubt that these dikes will ere long be denominated basaltic dikes: but, for the reason formerly alleged, I forbear to name them thus. They are an interesting feature in our geology, and deserve more attention; and it is peculiarly fortunate that they should be situated so near a geological school and the first mineral cabinet in our country.

Juxtaposition of Secondary Greenstone and Primitive Rocks.

The actual contact of these has never been observed along the Connecticut; and I know of but three places where there is a probability of finding the junction—viz. in the northeast part of Belchertown, in East-Haven and Bran-

ford, and in the east part of Woodbridge. So far as I have examined these places, I have always found a valley of geest between the rocks. But this is often very narrow; as for example half a mile west of Branford meeting-house, where granitic ledges lie on one side of the road and a greenstone ridge on the other. Further examination of this and the other points mentioned above, might discover associations similar to those occurring in the Hebrides.

Origin of Greenstone.

Does the greenstone of the Connecticut afford evidence in favour of the Wernerian or of the Huttonian theory of its origin? Averse as I feel to taking a side in this controversy, I cannot but say, that the man who maintains, in its length and breadth, the original hypothesis of Werner in regard to the aqueous deposition of trap, will find it for his interest, if he wishes to keep clear of doubts, not to follow the example of D'Aubuisson, by going forth to examine the greenstone of this region, lest, like that geologist, he should be compelled, not only to abandon his theory, but to write a book against it. Indeed, when surveying particular portions of this rock, I have sometimes thought Bakewell did not much exaggerate when he said in regard to Werner's hypothesis, that, "it is hardly possible for the human mind to invent a system more repugnant to existing facts."

On the other hand, the Huttonian would doubtless have his heart gladdened, and his faith strengthened by a survey of the greater part of this rock. As he looked at the dikes in the old red sandstone, he would almost see the melted rock forcing its way through the fissures; and when he came to the amygdaloidal, especially to that variety which resembles lava, he might even be tempted to apply his thermometer to it, in the suspicion that it was not yet quite cool. And without doubt he would see many a volcanic crater on the top of these ranges, where, with our dull eyes, we see only a pond or a quagmire. Even the occurrence of this greenstone in beds in sandstone would present no obstacle, since the discoveries by Dr. Macculloch in the isle of Skye of similar beds, of whin stone; concerning which he says, "there are no instances but where the alternating beds of trap detach veins or dikes from the lower to the upper beds;

or the trap, quitting the interval between two given beds
of limestone or sandstone, makes its way across the one
immediately above or below, and then proceeds with a reg-
ularity as great between some other pair of proximate
strata"* (Transac. Geol. Soc. Vols. 3 and 4.).

By treating the subject in this manner I mean no disre-
spect to any of the distinguished men who have adopt-
ed either side of this question. To President Cooper es-
pecially, who regards the greenstone of the Connecticut as
volcanic, I feel much indebted for the great mass of facts he
has collected on the subject. And were I to adopt any hypoth-
esis in regard to the origin of our greenstone, it would be one
not much different from his. But I confess myself somewhat
given to scepticism in regard to any general geological sys-
tem extant; and Greenough on the First Principles of Ge-
ology has not aided much to remove my doubts. These
systems have been productive of great good by spurring for-
ward geologists to the collection of facts with a rapidity al-
most unequalled in any other science. When these shall
be still farther accumulated, it is hoped and may be expect-
ed, that a second Werner will arise, who, having not merely
the rocks of Germany but of the whole world before him,
and following the inductive method of Bacon, will be able
to construct a system of geognosy that will stand, like the
Newtonian system of gravitation, on a foundation too firm to
be moved. Perhaps such a system, after all, will prove
to be an amalgamation of the theories of Werner and Hutton,
and those names, which now form the watch words of op-
posing ranks, may descend to posterity, engraven side by
side, in harmonious union, on the column that supports the
system. If geological enquiries are not tending to this point
we are much mistaken.

President Cooper was led from the profile inserted in the
first Vol. of the Journal of Science, page 105, to conclude,
the Deerfield greenstone to be a dike disrupting the old red
sandstone. No distinction is there made between the sand-
stone of the east and west range; but since I have ascertain-
ed that on the one side is old red sandstone and on the oth-

* It is by no means improbable that similar connecting dikes may be
found between the greenstone beds along the Connecticut. In all the places
where I have examined these beds, circumstances were unfavourable for
discovering the dikes had they existed.

er a sandstone of the coal formation, this greenstone must
be regarded as a bed between them.*

14. COAL FORMATION.

Variety of Psammite. Brongniart.

Grey Wacke Slate. Eaton.

Colored brown by Umber.

It has long been known to mineralogists that coal was
found along the Connecticut; and I denominate the rocks
containing it the coal formation, simply because its beds
occur in them, and in no other rock; the old red sandstone
containing none at all, but lying *below* it. The coal forma-
tion embraces numerous varieties and sub-varieties of rocks,
most of which alternate with one another and the principal
of which are the following. 1. *Greenstone.* This strictly
belongs to this class because it alternates with the other va-
rieties and in Berlin contains coal. But there were suffi-
cient reasons for giving it a separate color and description,
which it is unnecessary here to mention. 2. *Trap, Tuff.*
(*Trap Breccia,* Cleaveland.) This occurs on the east side of
Mount Tom on the west bank of Connecticut river, and ap-
pears to lie between other rocks of the coal formation and
the greenstone, and perhaps alternates with the greenstone;
though I cannot say much as to its geological relations, as I
have but recently discovered the rock and have had little op-
portunity to examine it. It consists of rounded or angular
fragments of greenstone, quartz and sandstone, united by
a reddish brown abundant cement of comminuted and de-
composed sandstone, greenstone or wacke. Scales of mica
appear scattered in the rock which seem to have belonged to
the sandstone. It exhales an argillaceous odour, is difficult to
break, and is about of the hardness of old red sandstone. The
imbedded masses of greenstone are larger than the quartz
or sandstone. I noticed some, six, eight, and even twelve inch-
es across. Perhaps this rock is not the real trap tuff of Eu-
rope. If not, it certainly deserves the name of *greenstone
conglomerate:* although many of the imbedded masses and

* Some other corrections needed to be made in the essay accompanying
that profile and map. But as I intend to comprehend all that is important
in that paper in this Sketch, a particular specification of corrections seems
unnecessary.

the greenstone in the vicinity very much resemble basalt. The sandstone imbedded is that fine-grained argillaceous variety next to be mentioned. 3. *A red, very fissile, friable, argillaceous sandstone.* It generally contains small scales of mica and is abundant almost every where, frequently lying immediately upon the greenstone and alternating with it and with many other varieties of rock hereafter to be mentioned. 4. *A Gray Micaceous Sandstone Slate,* not argillaceous, grit coarse, very fissile, layers even, some varieties much resembling mica slate, others containing vegetable remains. 5. A similar slate; but much finer, harder and the layers undulating. 6. A slate approaching in appearance to shale, but very silicious, harder and very fissile, layers straight, surface not smooth, dark gray. 7. *Shale,* generally bituminous, very fissile, frequently micaceous with and without Ichthyolites. 8. A slaty rock of the aspect of shale, and sometimes much resembling coal, dividing into numerous small pieces of irregular form, and disintegrating when exposed to the air and moisture. At the falls in Gill.' 9. A slate made up chiefly of indurated clay, sometimes micaceous, easily scratched by the finger nail, liable to disintegration. Falls in Gill, and cave in Sunderland, not abundant. 10. *A fragmented rock,* the fragments chiefly a reddish brown quartz, appearing as if burnt, cement silicious and apparently ferruginous, rock very hard, and appearing almost like porphyry, unstratified, not abundant. In Gill. 11. *Gray pudding-stone,* distinctly stratified, layers from six inches to a foot thick. Imbedded nodules, quartz, felspar and mica slate, rarely more than an inch in diameter, but very abundant, cement same minerals comminuted. Island in the falls at Gill. 12. *Reddish stratified pudding-stone,* coarser than the last, and scarcely differing from the conglomerate accompanying the old red sandstone. Mount Toby, Belchertown and Granby. 13. *Very coarse dark gray pudding-stone,* scarcely stratified. Imbedded masses often very large, even a foot in diameter, and very abundant, consisting chiefly of mica slate, argillite and chlorite slate; but containing quartz, hornblende, talcose slate, and sometimes granite, cement the same, rocks comminuted. Gill, Montague, Mount Toby, and Durham. Most of the preceding rocks are often found alternating with one another. 14. *A gray imperfect limestone,* very silicious, in beds in sandstone slate, not fetid, not abundant, Gill. 15. *Fetid*

carbonate of lime. At Northford. I do not know its exact relative situation. 16. **Bituminous carbonate of lime*, in the coal formation at Southington and Middletown.

In this series of rocks, and in this only, has coal been found along the Connecticut. It occurs at Durham, Middletown, Chatham, Southington, Berlin, Somers, Ellington, Enfield, South Hadley, and Southampton. In most instances it is highly bituminous and burns freely. The seams of it are usually quite thin, rarely exceeding an inch in thickness, yet often they are numerous. In Berlin, the coal occurs in greenstone in a vein of crystallized quartz. (Journal of Science, Vol. 5, p. 44.) In Southington it is found in shale—in Somers, Ellington and Suffield, in friable argillaceous slate, (No. 3 above) in Enfield, in beds in gray micaceous sandstone; (No. 4. above) also in the same rock, ("granulated schistose aggregate" of Eaton, vide Journal of Science, Vol. 1. p. 136,) in the drift of the S. Hampton lead mine.

The Connecticut river, in its passage between the towns of Gill and Montague, has cut through the coal formation, except a single ridge of greenstone on the west, as may be seen by referring to the map. Through a considerable part of this distance, especially in the most interesting part, the bassetting of the strata is completely laid bare; and I have annexed to the map a profile of their order and dip, which I shall now proceed to describe. It is a vertical section, crossing the map at the falls in Gill and the strata nearly at right angles, extending on the west to the western part of Shelburne, so as to include a few other rocks beside the coal formation, and on the east, to the mouth of Miller's river. The chief object of this profile is to give a better idea of the coal formation than could be obtained by mere verbal description. That part of it, therefore embracing those rocks, is put down from a larger scale than the other parts, otherwise the numerous alternations could not have been represented. Especially that part between No. 8 and 40, is laid down from a larger scale than the rest of the coal formation, because this is the most interesting part of it and most distinctly laid bare on the north bank of the Connecticut, extending from the falls to the high greenstone ridge 100 rods west of it. This part was observed most attentively, and a quadrant converted into a clinometer, was used for determining the

** Bituminous marl slate?—Ed.*

dip. · The distances were all estimated by the eye, but it is presumed they will in general be found not far from the truth. From No. 1 to 56, inclusive, the stratified rocks all dip to the east, as is evident from the section. The Nos. included in parenthesis, refer to the general descriptions of the rocks of the coal formation in the beginning of the article.

No. 1. *Horblende Slate*—Strata highly inclined, often becoming an aggregate of hornblende, quartz and mica, having a porphyritic aspect.

No. 2. *Mica Slate*—Dip 20° to 30°, undulating and tortuous, passing on the east into argillite.

No. 3. *Limestone*—In beds in mica slate, already described in the preceding pages. Unstratified.

No. 4. *Argillite*—Dip 60° to 90°. The southern limit of this rock hardly reaches the line of the section : but a mile or two north, its relative position is as represented on the profile.

No. 5. *Old Red Sandstone*—With red conglomerate. Dip usually as much as 20°, being greater than is usual for this rock.

No. 6. *Alluvion*—A swamp.

No. 7. *Old Red Sandstone*—Dip between 20° and 30°.

No. 8. *Secondary Greenstone*—It is probable this forms a bed between the old red sandstone and the coal formation : but the former rock is never seen passing under it in this vicinity ; and, therefore, it must not be thus represented on the profile. Width about half a mile. On the eastern side it has, for a few feet in width, somewhat of a stratified structure.

No. 9. *Red, Fissile, Friable, Argillaceous, Sandstone, Slate*—(No. 3.) It is fine grained and often micaceous, of the color of brick, is easily cut by a knife, yields an argillaceous odour, has an undulating surface generally, and is liable to disintegration. This is probably the most abundant of the rocks of the coal formation; and it usually lies next to the greenstone and alternates with it. It is found over a large extent of country on the east side of the greenstone ridge, stretching from Amherst to Berlin; although in Connecticut it more frequently is wanting in the mica and its surface is more uneven. It forms much of the flagging stone in Hartford and exists in place a foot or two below the surface in that city; though it seems here in some instances to approach to the nature of shale. The surface of the layers often appears a little glazed and is sometimes traversed by numerous little ridges a mere line in thicknes and of the

substance of the rock, which I have sometimes suspected might be petrifactions; and perhaps they are so. When this rock is disintegrated it forms an admirable material for the construction of roads; a good example of which may be seen in the road between Hartford and Weathersfield.

Where the profile crosses this rock, it has a dip of 45° ; and, as already observed under the article greenstone, it here mounts upon the back of the greenstone forty or fifty feet. If we follow the junction of these rocks southerly, on the west bank of the Connecticut, we shall find *the slate conforming to the irregularities of the greenstone,* thus forming saddle shaped strata. In some instances we notice a sudden curve from this cause, of 90°. At the first copper mine we find on passing down the river, a narrow spur of the greenstone extends a short distance into the slate, and the vein of ore here passes from the greenstone into slate. Half a mile south of this point we find the slate crossed obliquely to the direction of the strata by parallel seams dividing it into strips from one to six inches wide and often five feet long. Sometimes we find in these divisions six sided prisms of quartz, lying partially imbedded and exhibiting both terminations in great perfection. I have seen seams very narrow containing green carbonate of copper, the sides of the vein being beautifully glazed, having a highly specular aspect, and forming the *saalbande* of the Germans. The width of the rock on the section is about fifteen rods, extending across the mouth of Fall river.

No. 10. *Greenstone*—(No. 1.) This has been already described when treating of that rock. Thickness of the formation, 20 rods.

No. 11. Same as No. 9. (No. 3.) Thickness of the stratum, 6 rods, dip 45°.

No. 12. *Red Slate*—resembles the last, but is more micaceous, is divisible into thinner laminæ, the surface of which is even, and the color is less red. A beautiful rock. Thickness 6 feet, dip 45°.

No. 13. *Reddish micaceous sandstone*—Somewhat conglomerated, the imbedded pebbles of quartz and flesh colored felspar; small and rounded, less fissile than the last, layers thicker. Thickness twelve feet, dip 40°.

No. 14. Same as No. 12. Thickness 15 feet. dip 40°.

No. 15. Same as No. 9. Thickness 15 rods, dip 40°.

No. 16. *Reddish gray, friable, argillaceous sandstone slate*—Irregular, tortuous, disintegrating at the surface, a little micaceous, containing numerous small specks of carbonate of copper, and appearing to be an imperfect copper ore. Thickness 4 feet, dip 40°

No. 17. *Hard, compact limestone*—(No. 14.) Fracture dull, containing a large proportion of silex, feebly effervescing with the acids. Thickness of the stratum only a foot, dip 48°, not divisible into layers. This very imperfect and small bed of limestone is the only locality of limestone rock I have ever found in the secondary region north of Hartford.

No. 18. *Gray, Micaceous sandstone slate*—(No. 5.) Irregular, tortuous and undulating, not as easily and as handsomely separating into layers as the red slate, resembling some varieties of the mica slate, scarcely argillaceous. Thickness 6 feet, dip 40°.

No. 19. Same as No. 9. Thickness 12 rods, dip, 43°.

No. 20. *Coarse, reddish conglomerated sandstone*—Containing imbedded pebbles. Scarcely different from No. 13, except somewhat coarser. Thickness 6 feet, dip 43°.

No. 21. Same as No. 12. Thickness 3 rods, dip 43°.

No. 22. *Gray, micaceous, sandstone slate*—Rough to the touch, coarse, granular, scarcely argillaceous, not separating into so thin layers as the red slates. Surface not undulating or tortuous. Thickness 15 feet, dip 43°. An excellent flagging stone.

No. 23. (No. 9.) *Soft argillaceous slate*—Surface smooth, scarcely undulating, divisible into thin plates, easily scratched by the finger nail, and consisting of little else than clay moderately indurated. Thickness 5 feet, dip 45°, easily disintegrated, rarely micaceous.

No. 24. *Gray micaceous sandstone slate*—Similar to No. 22, but softer to the touch and finer grained, more undulating and divisible into thinner layers, containing vegetable remains converted into perfect coal. These were so numerous in one spot, that I thought I had found a bed of coal. Thickness 3 rods, dip 40°.

No. 25. *Geest.*—2 rods.

No. 26. *Shale*—Color very dark, containing sometimes small scales of mica, surface a little knobby, containing abundance of sulphuret of iron and spheroidal nodules from half an inch to two inches diameter, of *argillaceous iron ore?*

very similar to the shale containing the ichthyolite at Sunderland. Thickness 1 rod, dip 40°.

No. 27. Same as No. 24. 2 feet thick, dip 40.°

No. 28. A stratum of coarse grayish sandstone, or rather conglomerate, 2 feet wide, dip 40°.

No. 29. Same as No. 24. Thickness 5 rods, dip 40°.

No. 30. *Geest*—10 feet. It may be well, perhaps, here to remark, that shale usually forms the roof and floor of coal beds, and that this geest and that of No. 25 lie immediately below shale. Connect this fact with another, " that the seams or strata of coal rise up to the superficies of the globe as well as all other strata, only they do not always push up so boldly to the very surface of the ground as many hard stones and other indurated strata are found to do; for on account of the tender and more friable texture of the coal, the superficies of the stratum is often mouldered down and lies concealed under a thicker or thinner bed or cover of clay, gravel, sand, or earth." (Williams Mineral Kingdom, Vol. 1. p. 135 2d edition.) If then coal can be found along the section here described, (which I suspect to be quite doubtful,) the best spots to search for it are Nos. 25 and 30.

No. 31. *Shale*—10 feet thick, dip 40°, containing abundance of nodules of *argillaceous iron ore?* Rock rather hard for pure shale, not liable to much disintegration.

No. 32. *Coarse, gray, sandstone or conglomerate*—Rock harsh to the touch, imbedded masses not large, layers thick. Thickness two rods, dip 40°.

No. 33. Same as No 24. Thickness 3 rods, dip 43°.

No. 34. *Shale*—Alternating with, and passing into, a bluish, gray, fine grained slate, harder than the shale, though perhaps only a variety of it. A little micaceous. Thickness 3 rods, dip 43°.

No. 34. *Blackish gray slate*—Similar to that mentioned under the last No. but less fissile and much harder, indeed, it breaks with nearly as much difficulty as greenstone, and where it is worn by the water it somewhat resembles that rock. For it contains numerous irregular cells, sometimes two inches in diameter, formerly filled, probably with *argillaceous iron ore?* On breaking the rock its structure is slaty and it is a little micaceous. Thickness 2 feet, dip 40°.

No. 36. *Coarse grayish sandstone or conglomerate*—like No. 32, layers 2 feet thick. Thickness 20 feet, dip 40°.

No. 37. *Red slate*—As No. 9, but harder and coarser and less irregular on the surface of the layers. Thickness 3 rods, dip 40°.

No. 38. Same as No. 22. Thickness 20 feet, dip 40°.

No. 39. Similar to No. 38, but more micaceous and divisible, into thinner layers; resembles much, certain varieties of mica slate, except that the silex has a more earthy aspect. But it would not be difficult to deceive almost any geologist by labelling hand specimens, mica slate. Thickness 2 feet, dip 40°.

No. 40. Same as No 37. Thickness 10 feet, dip 40°. This carries us to the dam across the Connecticut.

No. 41. *Hard gray sandstone slate*—Like No. 22, but more undulating and irregular. Thickness 5 rods, the remaining distance the scale is much reduced.

No. 42. Very near No. 41, but coarser and not so undulating. Thickness 8 rods.

No. 43. *Coarse gray conglomerated sandstone*—layers thick. Thickness 12 rods.

No. 44. Same as No. 40. 3 rods thick, dip 35°.

No. 45. *Alluvion*—20 rods.

No. 46. Same as No. 32, about 2 rods thick.

No. 47. Same as No. 40, 1 rod thick.

No. 48. *Alluvion*—a quarter of a mile; beyond this the section is continued on the south bank of the river.

No. 49. Same as No. 37, one half a mile.

No. 50. (No. 10.) *A singular fragmented rock*—unstratified, 20 feet thick, very hard and tough, imbedded fragments, chiefly reddish brown quartz, appearing as if it had undergone the action of fire, a little micaceous, cement often blackish, appearing like veins, apparently ferruginous, rock resembling some varieties of porphyry.

No. 51. (No. 6.) *Dark gray, very fissile sandstone slate*— Harder than shale, somewhat argillaceous in its odour, a little micaceous, surface rough and grit coarse, slightly sonorous when struck, 1 rod thick, dip 40°.

No. 52. Same as No. 50, 1 rod thick.

No. 53. Similar to No. 39, 5 rods thick.

No. 54. Alluvion between half and three quarters of a mile.

No. 55. Same as No. 9, half a mile.

No. 56. Same as No. 51, extending nearly a mile, dip at first 35°, but gradually decreasing to 15°. The direction of the strata of this rock is quite different from the other varieties, which generally have a direction between north and northeast. But this variety is so much wheeled that it runs not far from east and west; and in passing up the river we sail for a time nearly parallel to the direction of the strata. I do not see why this rock might not be employed for roofing; and if so, the situation of the quarries would surely be very advantageous.

No. 57. Same as No. 9, strata nearly perpendicular, but leaning a little to the east, and their direction nearly the same as that of all the varieties mentioned except the last. Thickness 10 rods.

No. 58. (No. 8.) *Blackish tortuous slate*—Stratification irregular and the layers dividing into numerous shapeless pieces by fissures in every direction. The surface of these amorphous pieces is frequently a little glazed. Rock, friable, scarcely micaceous, argillaceous, strata leaning a few degrees to the east, 20 rods thick. This rock forms a bed at the island in the falls in the Connecticut three miles below this spot, and there it is exposed to the occasional action of the water and is disintegrated so as to leave the superincumbent strata projecting over it several feet, and it very much resembles impure coal: but I could not determine that it contains any. It is probably a variety of shale.

No. 59. *Very coarse, dark gray puddingstone*—A general description of this rock has already been given in the beginning of this article. (No. 13.) Imperfectly stratified at this place, rather harder than the old red sandstone conglomerate, yet appearing as if composed of little else than a mass of pebbles, the cement being not abundant, extending at least a quarter of a mile. The Connecticut at this place has worn a passage between this rock and the primitive, and high ledges appear on both sides of the river, which, on comparison, seem to differ almost *toto coelo*. The puddingstone extends through Montague, sometimes assuming a reddish aspect, and in Sunderland forms a considerable part of Mount Toby. Here it alternates with the red and gray slates above described; and it is curious to observe the frequent sudden changes from this coarsest of conglomerates to fine grained slates.

Where the profile crosses this rock, some of the imbed-
ded masses appear at their surface as if they had undergone
the action of fire. On breaking a mass of gray quartz con-
taining a little mica, a zone of half an inch wide appeared at
the outer edge, of a brick colour, indicating a chemical
change either by fire or water, for the specimen was some-
times covered by water.

I have observed little of this peculiar puddingstone in
Connecticut, though so abundant in the northern part of the
coal formation. It appears, however, in the south part of
Durham.

No. 60. *Geest*—covering a narrow valley.

No. 61. A narrow stratum of gneiss.

No. 62. *Granite*—This does not appear in abundance on
the bank of the river. The best spot for examining it is
half a mile south, where it forms a hill 100 or 200 feet high.

From the preceding description of this profile, it appears,
that after crossing the first ridge of greenstone there is a
gradual decrease of the dip from 45° to 15°, and after pass-
ing this point, which is not exactly central, but nearer the
granite than the greenstone, we find the dip in *a contrary di-
rection*, and almost 90°. Precisely such would be the ef-
fect, the Huttonian would say, if we suppose the granite and
the greenstone to have been forced up through the strata by
a subterranean fire, after these strata were consolidated.
And we might expect, also, that this convulsion would pro-
duce that wheeling of the strata observed in the central parts.
There is something peculiarly striking in this explanation,
and an inquiry arises, whether any corresponding facts oc-
cur in any other part of the coal formation. At mount To-
by, a few miles south of Gill and the highest point of the
coal formation, the strata dip to the east at an angle usually
less than 10°. And here the greenstone ridge on the west
is small, but the granite on the east, at no great distance, is
abundant. On the south east side of Mount Holyoke in
Belchertown and Granby, the strata dip to the south east,
near the mountain, at an angle not less than 45°, and the
greenstone ridge here is large. But the rocks that lie on
the back of Mount Tom, the highest point of greenstone
along the Connecticut, have a dip not generally larger than
20°. And the same remark will apply to many greenstone
ridges on the accompanying coal formation in Connecticut.

The highest point of the coal formation is Mount Toby in Sunderland, which rises between eight and nine hundred feet above the Connecticut. Beginning at Whitmore's ferry, the locality of the ichthyolites, to be hereafter described, and passing up the mountain obliquely to the south-east, we find alternations of most of the rocks described in the above profile. The different varieties of conglomerate are most abundant, and cannot, except that variety which is reddish, be easily confounded with the conglomerate accompanying the old red sandstone. They differ from this latter rock, 1. By being of a light or dark grey color, sometimes a little red. 2. In the greater abundance of imbedded nodules, and less quantity of cement. 3. In the different nature of these nodules, those in the old red sandstone conglomerate being chiefly quartz, felspar and granite, and those in the coal formation pudding-stone, being chiefly mica slate, argillite, chlorite slate, talcose slate, and quartz with felspar and granite rarely. 4. The coal formation pudding stone often contains thin incrustations of carbonate of lime in the seams and crevices. The red sandstone is wanting in this.

As a general fact, I feel prepared to state that the rocks of the coal formation *lie above* the old red sandstone. In most cases these rocks are separated by greenstone, so that their exact situation cannot be easily ascertained. Along the western face of the greenstone ridge, extending from Meriden into Massachusetts, the rocks of the coal formation are often seen cropping out below the greenstone; and the old red sandstone occurs at a still lower level. This may be seen in the space of a few rods in descending the hill northerly, from Newgate prison; and although the actual junction of the rocks is not here observable, yet they appear only at short distances from one another. The fact, that the coal formation alternates with greenstone, and that this latter rock always lies above the old red sandstone, is a strong presumptive argument that all the coal formation lies above the old red sandstone, and conclusive evidence that a part of these rocks lie above it. The situation of the rocks about Middletown, Chatham, &c. which might be urged as an objection to this fact, has been already considered, and I leave it for further examination.

. There are many instances, also, in which the rocks of the
coal formation *pass into the old red sandstone.* Let a per-
son go to the mouth of Fall river in Gill, where, as already
described, he will find the red argillaceous sandstone slate
of the coal formation cropping out below the greenstone.
Let him ascend Fall river, and he will find this slate be-
coming coarser, the layers thicker and the aspect changing,
until, within a mile and a half, it becomes decided old red
sandstone or conglomerate; the dip, also, diminishing. Or,
let him follow the road that leads from the mouth of the
river to Greenfield, and as he ascends the hill, he will ob-
serve a gradation from the slate above named into decided
fine grained red sandstone. Much of the rock occurring
along the east side of Connecticut river in Somers, Elling-
ton, Chatham, in Middletown and Durham, appears to be
intermediate between old red sandstone and this slate of the
coal formation. Even in Somers and Ellington, where a
strip is marked as coal formation, I found little else but this
intermediate rock. But as coal has been found there, (Am.
Journal of Science, vol. 3, p. 248,) a strip has been colored
brown, rather to mark out the locality than the extent, of
the coal formation. It is not improbable that some more
experienced geologist than myself, may hereafter include
the rock I have marked old red sandstone on the east side
of Connecticut river as one of the members of the coal for-
mation—but I could not do it without doing violence to my
own convictions.

It may be of importance in a geological view to mention
the veins of copper ore so frequently found along the Con-
necticut greenstone ranges. All these veins which I have
seen, or of which an account has been published, are found
on the margin of the greenstone and coal formation; and
*the veins always pass, either laterally or perpendicularly,
from one rock into the other.* They are quite numerous,
and we have already remarked that copper ore and iron
pyrites are not unfrequently disseminated in the slates.

. To avoid mistake: I will just mention different spots on
the map that are colored as the coal formation. 1. A large
extent in Gill, Montague and Sunderland; 2. In Granby,
Mass. and Ludlow; 3 A small patch in Somers and El-
lington; 4. An extensive range extending from West-
Springfield to Berlin; 5. In Hartford, Westhersfield, Mid-

dletown and Durham ; 6. A small patch in East-Haven ; 7. A narrow range in Southington ; 8. The same in West-field and South-Hampton. The latter, in the northern part, is penetrated by the drift to the South-Hampton lead-mine; but scarcely appears at the surface. In Westfield, however, it is wider.

It would seem from the preceding description that all the rocks essential to Werner's Independent Coal Formation are to be found along the Connecticut, viz a friable-mica-ceous sandstone, shale and pudding-stone, (Cleaveland, vol. 2, p. 508,) and also the greenstone and amygdaloid Professor Jameson has added Still, however, there are some other circumstances which may leave the geologist in doubt whether the real independent coal formation occurs along this river.

Some may suppose the rocks above described to be grey wacke and grey wacke slate ; and if the definition of grey wacke be so broad as to include those pudding-stones *whose cement is merely a comminuted portion of the imbedded frag-ments,* it will indeed include not only the pudding-stone of the coal formation above described, but, for aught I can see, *even the old red sandstone;* and, indeed, what fragmented rock will it not include ?* And besides, many of the argilla-ceous sandstone slates described above, cannot,without diffi-culty be distinguished from certain varieties of greywacke slate in hand specimens. But the rock usually called grey wacke in Europe has never yet, I believe, been found lying above the old red sandstone, as does the coal formation along this river. It is usually traversed, says Jameson, by quartz in the form of veins, which is rarely, if ever, the case in our rock. It has never been found alternating with beds of any sort of coal, except the coal blende; but our rock con-tains many beds and veins of that which is highly bitumin-ous. Again, the icthyolites and other organic relics that are found at Sunderland have almost all the rocks of the coal formation lying above them, as may be seen by the sketch of Mount Toby, that will be given when we come

*Some judicious remarks on this subject are contained in the North-American Review, No. 29, p 235. There we find the following sentence concerning the Roxbury and Dorchester plumb-pudding-stone, which some-what resembles a certain variety described above. "This rock forms one vast bed, which we have examined in various parts and feel no hesitation in saying that it is not the grey wacke of Europ« »a geologists."

to describe these remains. But in other countries "these fossil remains of fishes are found only in strata of very recent origin." (Rees. Cyc. Art. Icthyolites.)

The great dip of many of these rocks may be thought to afford evidence of their being older than the old red sandstone, or the independent coal formation. But to show that the dip of rocks is a very equivocal criterion of their age, I need only to refer to the recent work of Greenough on the first principles of geology. And besides, it is no uncommon thing in real coal fields for rocks to be highly inclined. "This inclination or dip of the (coal) strata is found every where; in some places it varies very little from the level; in others considerably, even so much as to be nearly in a perpendicular direction;" (Rees Cyclopedia, Art. Coal,) and still farther, as already hinted, there is reason to believe that Mount Toby, the strata of which are almost horizontal, exhibits the original dip of these rocks, and that those cases in which they are more highly inclined are the result of some Plutonian convulsion. Such irregularity in the dip of coal fields is no uncommon occurrence. "In some coal fields," says Mr. Williams, (Nat. Hist. Min. Kingd. vol. 1, p. 93,) "the strata acquire this horizontal and waving position, and afterward, towards the south-west or toward the north-east, the declivity becomes again so steep as to form an angle of 45°, and in some particular instances to approach still nearer to the vertical position." Upon the whole, I think there are insuperable objections against referring the rocks of our coal formation to grey wacke and grey wacke slate.

Another opinion already advanced on the subject is more probable. It is that of Mr. Brongniart, who gave it after having seen only the rocks containing the Westfield fish impressions. "This formation," says he, "appears to me to have the strongest resemblance to that of the bituminous marl slates of the copper-mines in the country of Mansfield and Hesse." (Journal of Science, vol. 3, p. 220.) The arguments in favor of such an opinion are, 1. The great similarity in the appearance of the German and American rocks on which the fish are found—one species, at least, being the same in both. 2. The occurrences of copper ores, and similar ones too, along with native copper in both rocks. 3. The fact that both these varieties of rocks lie immediately above the old red sandstone. Perhaps there are oth-

er points of resemblance, but I have not been able to find any minute account of the bituminous marlite formation.*

On the other hand it may be said that no real bituminous marlite occurs along the Connecticut—provided the grand distinction between this rock and bituminous shale consists, as Professor Cleaveland says, (Mineral. vol. I, p. 191,) in its effervescence with acids; for our rock, certainly that at Sunderland, does not effervesce with acid, unless it contains, as it sometimes does, a slight incrustation of carbonate of lime. Mr. B. does not consider the occurrence of thin beds or veins of coal as opposed to his opinion; but the strata penetrated at Riegelsdorf in Hesse, in order to reach the fish impressions, are totally different from those occurring along the Connecticut. They are as follows: " No. 1. Ferruginous clayey mould, from one to two fathoms. No. 2. Greyish white limestone, from six to eight fathoms. No. 3. Blue clay, with imbedded fragments of selenite crystals, from eight to ten fathoms. No. 4. Bluish limestone, called *Rauchwacke*, from eight to nine fathoms. No. 5. Grey compact gypsum, traversed by ferruginous loam, from seven to eight fathoms. No. 6. Black and grey stinkstone, from one to one and an half fathoms. No. 7. Sand, sometimes loose, sometimes cemented, from one to one and an half fathoms. No. 8. A kind of limestone, called *Zechstein*, of a greyish brown color, and soft above towards the sand, but blacker and more compact below; from three and a quarter to three and an half fathoms. No. 9. A black slaty stratum, containing pyrites and forming the roof of the bituminous marl slate, from eighteen to twenty inches. No. 10. Black cupriferous bituminous marl slate, from three to eight inches: this is the principal depository of the icthyo-

*Extract of a letter from Dr. J. W. Webster:—

"The bituminous marl slate has been one of the most troublesome rocks for years: some have placed it here and some there. From its effervescence with acids we should perhaps more properly put it among the limestones. Again, from the richness of some specimens of it in copper, they would be classed as copper ores—indeed, we know that it is worked for copper. It occurs in the secondary limestone. Its external characters are very little different from those of bituminous shale of the coal formation; but from all I have learned of it, I am pretty well satisfied that it is distinct from and *above* the rocks of the coal formation. You will note one striking difference between the two—vegetable impressions are abundant in bituminous shale of the coal field; but rare in the B. M. slate—it is more abundant in fresh water remains."

lites. No. 11. Gneiss like greyish white rock, consisting
of small rounded quartz pebbles, and sometimes of co er
and mica, cemented by indurated clay. No. 12. old
'red sandstone, or the dead rock, being the fundamental
rock of these floetz strata." (Rees Cyc. Art. Icthyolites.)

Under these circumstances I have thought it safe to de-
nominate the peculiar rocks under consideration along the
Connecticut, the coal formation. A more complete set of
them has been forwarded to Mr. Brongniart, and we wait
anxiously for his final opinion. The suspicious circumstan-
ces attending them and the occurrence of the coal hitherto
discovered in thin beds and veins only, render it very doubtful
whether extensive beds of this valuable mineral will ever be
found in them. They have been unsuccessfully explored
at South-Hadley, Southington and Westfield, Ct. But I
would not wish to discourage further search. The decision
of the question above discussed, concerning the precise
rank they ought to hold in the rock formations of the globe,
is one of considerable importance, since it will depend on
that decision whether coal or copper or gypsum may be
sought after with the greatest prospect of success. They
have long been to me a fruitful source of perplexity, and
again and again have I returned from traversing them in
utter despair of ever determining their real geological rela-
tions. To denominate them the coal formation relieves,
for a time, most of these difficulties: but that name will
cheerfully be resigned whenever a more correct one shall
be proposed.

Organic Remains in the Coal Formation.

1. Icthyolites.

These occur at Westfield, Ct. and at Sunderland, Mass. ;
and it is said also at some other places, as at West-Spring-
field ; but I have never seen any, except from these two
localities. At Westfield they were found in exploring for
coal, lying upon bituminous shale. Two species at least
were recognized, one of which Mr. Brongniart calls the *Pa-
læthrissum freislebenense* of Blainville. These impressions
have been so repeatedly and accurately described by Prof.
Silliman in Cleaveland's Mineralogy and the American
Jour. of Science, that it is unnecessary to be more particular,

At Sunderland these impressions occur in bituminous shale, which often contains a little mica, and generally a quantity of iron pyrites, disseminated through the rock. They occur at Witmore's ferry in the north part of Sunderland, in the bank of the river. They are found most abundant at the lowest water mark, at which time two men, in less than half a day, dug out for me nearly fifty specimens. Sometimes a layer of semi-crystalline dark colored carbonate of lime, less than one twentieth of an inch thick, lies between the layers of slate. The substance of the fish is usually converted into coal, the thickness of which is rarely more than one tenth of an inch in any part, and the color is black. In some instances, however, the carbonate of lime above mentioned covers the fish, and has taken the place of the matter of the fins and scales and their original light grey color is preserved so perfectly as to resemble a fish just taken out of the water. Some of the specimens appear contorted; in others the form of the fish is wholly lost, the fins and scales and bones, being scattered about promiscuously, as if the fish had perished in violent struggles, or the rock had been disturbed after its imprisonment. Yet, in the same specimen that contains one thus mutilated, another will appear not more than a foot distant which is whole. I have found four or five specimens in which the fishes (both of them distinct,) lie across each other; sometimes a very thin layer of shale, and sometimes none, separating them. I have another specimen, three feet long and fifteen inches wide, containing seven distinct impressions. The shale in which these ichthyolites occur, when rubbed or held in a flame, exhales a strong bituminous odour.*

Among the impressions hitherto obtained, I can easily discover three distinct species that have scales.* Two of these are represented on the accompanying plate ; but the third was so much mutilated, that I did not attempt to delineate it. For at the best it is no easy matter to represent them so exactly as to be of use. They are usually a little indistinct on their border, and not unfrequently injured by pyrites.

Fig. 1. represents a species that is rare.

Fig. 2. shows the most common species. There can be no doubt that this differs generically from the last.

*Precisely such a smell is exhaled from the bituminous limestone in Southington.

*See the end.

Fig. 3. is probably the same as Fig. 2.; but perhaps not. The outline is given because the fins were more distinct than in the specimen from which Fig. 2. was copied.

These are all of the natural size. Concerning their names, feeling altogether incompetent, I do not even attempt to decide. I have not had an apportunity to compare them closely with the Westfield icthyolites, and do not know whether they coincide.

Another petrifaction occurs with these fishes, which resembles the common silver eel, *(Muraena anguilla,)* or some other species of the eel tribe. The width varies from half an inch to a whole one, and the length from one to two feet. The substance of the eel (if indeed it be one,) is not converted into coal, but there is a substitution of the shale of a finer grain, except the head, which is coal. No fins appear, except, perhaps, in one instance, a pectoral one. Sometimes, along the centre of the impression, there is a small relief, answering to the place of vertebrae. The course of the impressions is usually serpentine.

The geological situation of these icthyolites is interesting. The shale containing them passes under Mount Toby, there being a gradual ascent from this spot to the top of the mountain, two miles distant : so that they lie beneath rocks of the coal formation at the depth of nearly nine hundred feet, most of the varieties described on the profile annexed to the map here alternating with one another. The following sketch exhibits a section of the shale of Mount Toby, so far as the geest would admit of examination, on a line passing from the locality of the icthyolites to the highest point of the mountain. I do not suppose it perfectly accurate , but it is probably sufficiently so to answer the intended purpose, viz. to exhibit the situation of the ichthyolites. The numbers in a parenthesis refer to those on the profile that are synonymous. The dip of these strata rarely exceeds ten degrees, and is usually less.

No. 1. (No. 59.) *Very Coarse dark grey pudding-stone,* for an account of it see the reference to the profile, on plate No. 8. at the end.

No. 2. *Bituminous Shale.* This contains icthyolites—strata nearly horizontal—dip never exceeding five degrees. Thickness of the stratum, about ten feet.

No. 3. Same as No. 1. except sometimes alternating with

a pudding-stone, less coarse and more distinctly stratified. Thickness, between two and three hundred feet.

No. 4. (No. 9.) *Red fissile argillaceous sandstone slate,* ten feet in perpendicular thickness.

No. 5. Same as No. 1. Thickness ten feet—dip six degrees.

No. 6. Same as No. 4. Thickness four feet.

No. 7. Same as No. 1. except not so coarse, and more distinctly stratified, agreeing nearer with No. 43 of the profile. Thickness fifteen feet.

No. 8. Same as No. 4. two feet thick. Where this rock alternates with the pudding-stone the change is very striking.

No. 9. Same as No. 7. Thickness fifteen feet.

No. 10. Same as No. 4. five feet thick.

No. 11. Same as No. 7. twenty feet thick.

No. 12. Same as No. 4. graduating into the conglomerate—ten feet thick.

No. 13. Like No. 1. sixty feet thick.

No. 14. *Grey argillaceous sandstone slate,* sometimes micaceous. Somewhat like No. 23. of the profile, but coarser—liable to decomposition and containing many water-worn pebbles. Thickness ten feet. This carries us to the Sunderland cave.

No. 15. Same as No. 4. fifteen feet thick.

No. 16. Same as No. 1. about one hundred feet thick.

No. 17. Same as No. 4. except that it is coarser and the layers thicker—about ten feet thick.

No. 18. A pudding-stone not differing essentially from No. 1. but frequently of a reddish cast and more distinctly stratified. This continues with little interruption to the top of the mountain; though the soil hides it in most parts, and there may be other alternations which I did not observe.

2. *A Clam Shell?*

I found a specimen at the cave in Sunderland, imbedded in an argillaceous slate, which resembles the common river clam. There was a perfect substitution of siliceous matter. A single specimen only was found, which was forwarded to Mr. Brongniart, and he will be able doubtless to decide whether it is a petrifaction or a peculiar water-worn pebble.

3. *Vegetable Remains.*

These appear to be either the branches or roots of trees, or the relics of culmiferous plants, and therefore may be called *lignites* and *rhizolites*. They are usually converted into a thin vein of coal, similar to the fish. They are commonly broken into pieces from an inch to two feet long, in the manner represented in Fig. 4. Their width varies from a mere line to two inches. They are not jointed—found in abundance at the falls in Gill; also with the icthyolites at Sunderland. The rock in which they occur at both places is hardly bituminous shale; but a greyish micaceous sandstone. The longest specimen of rhizolite I have seen occurs on the road side, one half mile south of Newgate prison; being not less than seven or eight feet in length.

4. *Unknown Relic.*

This is represented as well as it could be in Fig. 5. It is difficult to give a perfect idea of the thing, because there is a relief or swelling along the middle. It sometimes resembles the *ament* of the chesnut, (*Castanea americana Mx.*) but still more the vertebrae of a fish. But in no ichthyolite I ever found, did I see any remains of the vertebrae, and it is not probable, therefore, that this belonged to a fish. It is rare—found with the icthyolites at Sunderland.

15. Alluvion.

Colored Gamboge Yellow.

By this term I understand those accumulations of gravel, clay, sand, mud and salt, which are post-diluvian, or have probably been deposited since the Noachic deluge by causes at present acting on the globe. Some varieties may be seen along the Connecticut which we shall mention in the probable order in which they were deposited.

1. *The alluvion on the sea-coast.* This is probably the oldest; because the sea would begin its depositions immediately after the deluge, if the situation of any particular place were favorable—even before it had subsided suffi-

ciently for rivers to have found their channels. On the map it embraces the alluvial plain around New-Haven and the salt marshes extending· some distance on both sides of the city.. The plain of New-Haven is made up of coarse sand with some gravel and an intermixture of broken shells and sea weed. The marshes consist of sand, mud and salt.

The region about New-Haven, embraced by this alluvion, is interesting to the botanist, as he here finds many plants not growing in the interior. Among these, we may mention *Salsola kali, Salicornia herbacea, Triglochin maritimum, Statice limonium, Iva frutescens* of Lin. and *Ammi capillaceum* and *Conyza camphorata* of Muhl. *Limnetis polystachia* and *juncea* of Ph. *L. glabra,* Muhl. *Holcus odoratus,* Mx. and *Limosella subulata,* Ives. Here also, occur the other new species of Prof. Ives, *Gnaphalium decurrens* and *Asclepias lanceolata,* along with *Plantago maritima, lanceolata,* and *Virginica* of Lin. *Eriocaulon pellucidum,* Mx. *Cassia chamaecrista* and *Uniola spicata* of Lin. &c. &c. On the beach we find *Fucus nodosus* and *vesiculosus* of Lin.* and adhering to the latter, *Mytilus striatulus?* (Donov. in Rees.) Here also occur *Venus mercenaria,* (common clam) *Ostrea edulis?* (oyster) and one or two species of *Arca* and *Anomia,* with others I do not know.

2. *Gravel.* This usually lies beneath all other alluvial deposits along the Connecticut: though it sometimes alternates with beds of sand. It is arranged in somewhat regular strata. The pebbles rarely exceed two or three inches in diameter.

3. *Clay.* This is a coarse kind, such as is used for making brick; and generally lies above the gravel and beneath the sand and mud, or loam. It probably underlies those extensive sandy plains that occur in Suffield and Windsor, on the West, and in Springfield, Longmeadow, Enfield, East Windsor, and East Hartford, on the east of the Connecticut. In some places the clay appears at the surface, as in Hartford, Windsor, Deerfield, &c.

* On Long-Island, fifty miles east of New-Haven harbor, I found *Sphaerococcus confervoides,* Agardh.

4. *Sand.* This commonly lies the highest of the alluvion, except in some low meadows that are yearly receiving a deposite of a loamy sediment. The region in which sand occurs most abundantly, has just been mentioned. It is sometimes seen in alternating beds with gravel, clay and loam.

b. *Loam* and *mud.* This is the most recent of our alluvion, and depositions of it are frequently made. The Connecticut indeed, seems, with some exceptions, to have nearly reached its maximum of depositions, rarely flowing over more than a small part of the alluvion along its banks. But its tributaries, such as the Farmington, Westfield, Deerfield, and Chickapee, still continue annually, and often semi-annually, to flood the adjacent meadows, and to leave there an additional soil, from half an inch to six inches deep, and though the agriculturalist has sometimes to lament the destruction of his crops by these inundations, yet without them his fields would soon become comparatively unproductive.

The depth of the alluvion along the Connecticut has never been accurately measured; but I should judge it sometimes to be as great as one hundred and fifty feet: but in general it is much less. It is not unfrequent to find ten or fifteen feet below the surface of the most recent of this alluvion, logs, stumps of trees, leaves, butternuts, walnuts, &c. in a partially decaying state, and sometimes we meet with skeletons of the aborigines of the country. But no aurock, mastodon, or megatherium, has yet been discovered to give an interest to this alluvial formation.

I have found a difficulty in some instances in drawing the line between genuine post-deluvian depositions and geest. In some cases there appears to be a mixture. In other cases the rocks are entirely hid by the soil, and yet the predominant characteristic of the soil is derived from the rock underneath it, although there is a mixture of alluvion. The old red sandstone for instance, and the red slate of the coal formation, are very liable to decomposition, and thus a reddish soil is produced, so manifestly composed of the ruins of the rock, that one is able often to determine from the appearance of the soil at the distance of two or three miles the particular rock that lies beneath it. I have not,

however, intended to put down the alluvion in all such cases, but have colored the spot according to the subjacent rock. And on this ground I am sensible that there are a number of small parts of the alluvion that ought, in strictness, to have been colored as old red sandstone ; as in East-Hampton and Deerfield ; but being so small they were neglected.

16. GEEST. *Jameson.*

Déluvian Detritus. Buckland.

" By geest," says Jameson, "is understood the alluvial matter which is spread over the surface both of the hilly and low country and appears to have been formed the last time the waters of the ocean stood over the surface of the earth. And it is probable that Professor Buckland refers to the same deposition by the above synonym. By deluvian detritus, he means "fragments of neighboring and distant rocks, and with bones not mineralized—generally in valleys." Whatever objections may lie against these definitions, every geologist knows that much deposition exists on the globe which no one refers to what is commonly understood by alluvion, and which could result from no processes nature is now carrying on. This is scattered over the most mountainous tracts, and in all cases of considerable extent, occupies at least three quarters of the surface. It is usually denominated soil, comprehending, however, the bowlder stones and organic remains that soil contains. As a general fact, this geest, in primitive regions, consists of comminuted particles and rolled stones of primitive rocks. In secondary tracts it consists of secondary detritus, though more frequently mixed with portions of rocks of a primitive character.

Along the Connecticut in the primitive region, large bowlders in great numbers are not commonly found removed many miles from the spot where they originated. Stragglers of this description may indeed be found almost every where ; and among all the rocks none seems to be more scattered than granite : though perhaps the numerous beds and veins of this rock found almost every where may ac-

count for this. But in general along this river, the char-
acter of the rolled masses corresponds to the rock in place
underneath them ;—that is the greatest number of the
loose stones are of the same description as the rock that
underlies them. But to this there are many exceptions—a
most remarkable one occurs a few miles west of New-
Haven in Woodbridge and Milford. The surface is cover-
ed with rolled masses, sometimes quite large, of primitive
and secondary greenstone, mica slate, gneiss, granite, and
almost every other rock, except that which is in place
viz. chlorite slate, or argillite. In many places on the map
which are highly mountainous, the geest is so abundant
as to occupy most of the surface ;—the subjacent rock
rarely appearing ;—as in the east part of Plainfield and in
Shutesbury. The diameter of the loose fragments varies
from an inch to twenty, or even thirty feet, and they are
usually rounded, indicating attrition. Some of the highest
of these bowlders are found insulated on the pinnacles of
our mountains.

There is a particular kind of geest, which I have al-
ready mentioned, occurring along the Connecticut, that
does not seem to be comprehended in Professor Jameson's
definitions. It is that kind of soil that results from the
slow disintegration and decomposition of certain rocks,
with a mixture of decaying vegetables. This, as already
observed, is not uncommon above the old red sandstone
and the red siliceous sandstone slate of the coal forma-
tion. And the epithet *deluvian* seems to exclude this kind
of soil from Prof. Buckland's *deluvian detritus;* and so the
epithet *fluviatile* excludes it from the *fluviatile detritus* of
the same author. (Rees' Cyc. Art. Geology, Addenda.)

Hayden's Hypothesis of a primeval northeasterly current of
· water.

I allude to Hayden's Geological Essays, in which he ex-
presses the opinion that the alluvion of our middle and
southern states was formed by a current or currents that
formerly flowed across this continent from the northeast to
the southwest; and I am inclined to believe, (without in-
tending, however, to adopt altogether his theory on the

subject,) that a careful examination of the bowlder stones along the Connecticut would favor the supposition. Masses of greenstone are found at a greater distance, and in much greater quantities on the western side of the ridges than on the eastern. As we ascend the primitive region on the west side of the river, secondary rolled stones are seen for one or two miles; but on the eastern side, if I mistake not, nothing of this kind appears; and I should suppose the bowlders of Woodbridge and Milford, being evidently brought from the country to the north, would testify in favor of such an hypothesis.

Suggestion concerning rolled Stones.

Is it not a fact that rolled masses are more abundant and more perfectly rounded along the limits between the primitive, and transition, or secondary? This question has often occurred to me when travelling in the south eastern part of Massachusetts, when going over the country along the Connecticut in Bernardston and its vicinity, when descending the Hoosack and Green Mountains on the west, and when passing over the country west of New-Haven. If such be the fact it may, when it occurs in the geologist's tours, be a warning to him to expect a change in the rocks in place.

Fact relating to the detachment of large bowlder stones from their bed.

Deerfield river in the greater part of its course is a mountain torrent, very rapid and powerful. It has worn a passage often four hundred feet deep, the banks being almost perpendicular. Its winter floods are most powerful in effecting this work. The ice freezes three or four feet thick, and when a sudden rain melts the snows on its banks, it rises rapidly and lifts up and urges forward with tumultuous fury, this immense body of ice. As the banks among the mountains are steep and rocky, they prevent the accumulation of water and ice from spreading to the right or left, and it is raised proportionally higher; and thus an immense force is exerted upon obstacles in the bottom of the

stream, which, in winter floods, is filled with huge masses
of ice to the very bottom.

In the west part of Shelburne this river descends a cata-
ract thirty or forty feet high. The rock in the bottom of
the river is an aggregate of quartz and mica with horn-
blende intermixed, and below the falls it is unstratified, al-
most without seams and very hard. Yet here we might
expect the force of the torrent would be most powerful ;
and accordingly we find masses of this rock from one to
ten feet in diameter, raised from their bed, and some of
them removed down the stream one or two miles, some only
a few rods, and I saw one or two of the largest but just be-
ginning to be raised from their bed. Previous to viewing
this spot, I had no just ideas of the enormous force exerted
by a mountain torrent.

[Part II. in the next Number.]

ART. II.*—*A Memoir on the Catskill Mountains with notices
of their Topography, Scenery, Mineralogy, Zoology, eco-
nomical resources, &c. By* JAMES PIERCE, ESQ.

THE Catskill Mountains or ranges connected with them,
extend from the vicinity of the St. Lawrence to the Alle-
ghany ridge. In the neighborhood of the Hudson they
sweep in a semicircular form, presenting wild and irregular
eminences which rise to a greater altitude than any moun-
tains in the United States, some in New-England excepted.

The eastern face of the ridge is steep or precipitous, dis-
playing numerous mural precipices of great extent, and of-
ten of sufficient width to be distinguished at the distance of
twenty miles. They appear encircling the mountain like
enormous bands.

From the summit ledges, superb views are presented of
the great valley of the Hudson, and distant mountains of
New-York and New-England; for extent, interest and di-
versity, they are unequalled in this country.

In the waving profile of the Catskill mountains many su-
gar loaf eminences tower above the general range. Among

*Originally read before the Catskill Lyceum, but forwarded with additions
and corrections, for insertion in this Journal.

these the height near Cairo and the Round Top of about equal elevation, are the most conspicuous.

Several prominent spurs run from the eastern chain of the Catskill mountains, in a north-western direction, for several miles. The intermediate mountain vallies are mostly of a good deep medium soil, and afford, when cleared, fine grazing ground.

In a state of nature these intervals present towering forests of hard maple, beach, hemlock, birch, cherry, spruce, and balsam fir. The surface in general is not too strong for the purposes of agriculture.

The most considerable of the ranges which take a western direction, border the elevated vallies and ravines through which the rivers Kauterskill, Schoharie and Platterkill, take their course.

The clove passages formed by the Kauterskill and Platterkill in their eastern descent, present as sublime and picturesque scenery as this or almost any country exhibits.

Though there is considerable similarity in the appearance of these cloves, yet some peculiar features make an interesting diversity.

The road through the Kauterskill clove ascends gradually near the river, where there appears scarcely space for the road and stream.

In many places the traveller looks down from a perpendicular and dizzy height upon foaming waters that pursue a raging course among the rocks falling with a deafening noise from precipice to precipice.

On the northern side of the river the mountain is lofty and precipitous, exhibiting near its base stupendous perpendicular walls of argillaceous red sandstone and grey wacke slate—the strata in nearly a horizontal position. Frequently but a small section of the horizon can be seen. Mural precipices rise in succession and tower above the forest. The mountain's top, which seems almost to overhang the spectator, is crowned by enormous ledges resembling castles or fortifications in ruins, on which a few scattered pines preserve their bleak station in defiance of tempests, and wave their dark verdure over the cliffs like nodding plumes.

About two miles from the entrance of the clove the Kauterskill is passed by a bridge thrown from crag to crag over

the brawling stream, which here presents considerable cas-
cades—The mountain seems torn asunder to give passage to
the river leaving lofty perpendicular walls of rock on its bor-
ders—A short distance above, the stream falls in a circular
column near one hundred feet. South of the clove the
mountain rises to a great height—its steep northern side is
thickly clothed with trees of varied verdure—Rivulets are
seen winding rapidly down the glens or sporting in cascades.

The most considerable branch of the Kauterskill has its
origin in two mountain lakes situated near the Delaware turn-
pike, between two and three thousand feet above the Hudson.
They cover about two hundred acres of ground, and are
very shallow—no where of greater depth than ten feet.
They contain cat-fish, and great numbers of the brown va-
riety of leeches, some of them six inches in length.

The river from its outlet at the lake descends by rapids and
falls, through a romantic ravine to the great clove. In one place
it is precipitated perpendicularly about two hundred feet.
This fall is often visited by the curious, A road has been
recently worked from its vicinity down a wild glen parallel
with the Kauterskill, to the clove, to facilitate access to a
mountain mass of very friable, fine grained argillaceous red
sandstone, supposed by the proprietors of the ground, to be
valuable as a paint, although softer, and of a deeper color
than the red sandstone observed in almost every ravine of
the mountain, yet it does not appear to have sufficient oxide
of iron to give it such a body as to form a useful pigment.

At the head of the great clove the western branch of the
Kauterskill falls perpendicularly one hundred and twenty
feet from projecting cliffs, and descends in rapids and cas-
cades four hundred feet in about one hundred rods.

The Platterkill clove, situated about five miles south of
the Kauterskill, is little known, except to the inhabitants of
its vicinity. I recently passed up this glen by a narrow dug
way which rose to a midway region of the mountain, north
of the river Platterkill.

For two miles you look down the precipitous side into a
deep ravine near one thousand feet, where the Platterkill
pursues a raging course among the rocks, presenting numer-
ous rapids and falls. Lesser streams are seen descending
the precipitous south mountain from an altitude of two thou-

sand feet in cascades,—sometimes concealed by the forest, and then flashing to light through the evergreen foliage, leaping from ledge to ledge, until they mingle their waters with the Platterkill.

, Few evergreens were observed on the north mountain, but the elevated ridge south of the clove presented an entangled forest of hemlock, balsam fir and spruce, with plats of hard maple, beach and birch. The glen of the Platterkill was filled with sugar-maple, beach, oak, chesnut, ash, birch, cherry, hemlock and spruce. Near the head of the clove the ravine suddenly rises, and the Platterkill, which on the mountain affords water sufficient for mill-seats, descends from the valley of the summit one thousand feet in a few hundred yards of its progressive course, by a succession of falls over ledges. One of these falls, which is in view from the road, is said to be one hundred and fifty feet in height. From a lofty mural precipice situated at the head of the clove, a striking view is presented of this fall and of the deep gulf below.

A saw-mill has been recently erected near the road of the summit, on the brow of a precipice overlooking water-falls and wild scenery.

The mountain valley, at the head of the clove, is tolerably fertile, but not extensively cultivated. Large tracts of pretty level ground are situated to the north and west, thickly clothed with hard maple and beach, which, if cleared, would afford a fine grazing region for sheep and cattle. Unfortunately, most of the residents on this part of the mountain are not proprietors of the soil. They prefer stripping the land of its best timber rather than resort to the regular toils of agriculture. A considerable proportion live in log huts without floor or furniture. Bread is rarely seen among them; and but few have gardens. Their principal food, in addition to wild meats and fish occasionally obtained, consists of potatoes and pumpkins. They have as few comforts as Rob Roy's band, or the Children of the Mist. Adjacent to the Platterkill road on the mountain table land, there are a few small farms under tolerable cultivation.

The ascent from the Platterkill to the base of the mountain summits, called Round Top and High peak, is gradual through thick groves of maple, birch, beach, cherry and hemlock.

The elevated valleys and regions adjacent to those peaks are peculiarly interesting. Groves of lofty spruce and balsam fir, straight as the white pine, and presenting a beautiful never fading verdure, occupy, almost exclusively, extensive tracts. Little under-brush obstructs the passage and view, but the earth and flat rocks are covered by a handsome carpet of diversified colors composed of a thick and soft velvet moss of a delicate light green, ornamented by gay flowers and tufts of white coral like silvery moss, with other species, —mountain sorrel varying the verdure.

The region north of the Platterkill mountain valley, is accessible for waggons to the base of the Round Top and from thence the ascent is easy.

I passed a night on this peak at an elevation of near 4000 feet above the level of the sea. Its circular summit is nearly flat, but slightly descending on every side, and presents about an acre mostly wood-clad.

Although the heat of the river valley was oppressive, yet the mountain temperature rendered a large fire comfortable.

Invigorated by cold and by breathing freely the pure mountain air, a traveller ranges with less fatigue than in the valley of the Hudson, and seldom fails of possessing a good appetite.

Having enjoyed a refreshing repast, and amused ourselves sometime in conversation, we increased our fire as a protection from beasts of prey, and retired to rest on beds of moss upon which small branches of spruce were spread, forming a soft and dry couch. We viewed through the thinly scattered branches of the balsam fir, the blue arch of heaven spangled with stars. The azure of the sky appeared darker from our elevation than from below, and the heavenly bodies to move more brilliantly in their course.

The atmosphere which gives a light blue coloring to distant objects, becomes more rare and pure in proportion to its elevation.

Placed far above the haunts of men, no sound was heard save that of a light air, gently breathing through the fine leaved tops of the evergreens.

We were, at times, during the night enveloped by passing clouds, but the breeze would soon free us from our dewy mantle. The starry lamps, as if newly trimmed, seemed then to shine with additional lustre. The moon partly shorn of her beams, calmly glided through the sky, motling

the woodland steeps and dispensing her influence over hills and plains.

We rose at dawn from a refreshing slumber, to view the beauties of rising day. The eastern sky and clouds glowed in the morning light. The sun soon rose with a dazzling splendor over the distant Taconnock mountains, but the immense valley of the Hudson was still clad in gloom.

Twilight is of shorter duration on elevated tracts than in valleys. This probably arises from the rare air of the mountains having less refractive power. Objects in the valley were gradually disclosed. Here and there white fogs appeared, resting on the waters. But they were soon raised in clouds by the expansive power of the sun, and, tinged with gold and purple, sailed far below us, brushing the mountains with their dewy wings, and dispensing refreshing moisture to the vegetable world.

Our prospect, from an eastern ledge of the Round Top, was indescribably grand. We had beneath us, a vast expanse like a world in miniature, which we viewed as upon a map. The Hudson, fourteen miles distant, appeared to us near the base of the mountain, diminished to the size of a rivulet or canal. It was in view from the Highlands to Albany, together with every city and village on its banks. Sloops, with all their canvass spread, appeared no larger than small sail-boats. The rising sun, gleaming on the waters of the Hudson and its auxiliary streams, and on the lakes of mountain and valley, rendered them very conspicuous. They appeared like crimson floods or lakes of fire.

The mountains adjacent to Lake George, the Green Mountains of Vermont, the elevated ranges of Massachusetts and Connecticut, were in view, and their blue cloud like summits seemed mingled with the distant sky.

The Fishkill mountain, a continuation of the primitive ranges of the Connecticut;—the Highlands of New-York and New-Jersey, and the Shawangunk ridge were distinctly traced. The intervening space or valley of the Hudson, exhibited the appearance of an immense plain, an alternation of groves and cleared fields. "The hills were laid low and the valleys exalted."

Northward, looking down on the Pine orchard and other prospect elevations, which from their base appeared of gigantic size, they now seemed depressed almost to a level with the plain. We viewed the summits, ravines, lakes

and streams, upon the broad back of the chain, to great advantage. To the west, wild wood-clad ranges and mountains piled on mountains met the eye.

A considerable diversity is presented in the views from the Catskill heights, sometimes the valley is filled with clouds resembling a boundless ocean, while the insulated summits are in the enjoyment of sunshine and a clear sky— put in motion by the wind, the clouds of the valley roll like the waves of a tempestuous sea, and storms are often seen sweeping far below, shrouding a part of the landscape in midnight darkness. You may hear the thunder roll, and see the lightning play beneath your feet, while the mountain heights and parts of the valley are cheered by the sun's rays. The mountain woodland scenery, is particularly interesting— dressed in the gay diversified colors of autumn, when the foliage of the Maple, Beach, Oak, Birch, &c. is dyed with scarlet, purple and orange, intermingled with the dark verdure of evergreens.

From the Platterkill table land, some of the peaks to the south west appear almost as high as the Round top. The prospects from their summits to the south and southwest is represented as being very striking. The quantity of hemlock in the southern section of the mountains seems inexhaustible. A tannery on an extensive scale might be advantageously established at the base of the Platterkill clove—several fine mill seats are there unoccupied; the distance from that place to the nearest landing on the Hudson, is about eight miles, and there are no heavy intervening hills. Trout are abundant in many parts of the Platterkill, Kauterskill, Schoharie and most of the mountain streams.

About three miles south of the Platterkill and at a great elevation above the Hudson, a deep body of water one mile in circumference, called Shues lake is situated, and is environed by an amphitheatre of wild, rocky, and steep mountains. It contains trout of large size.

A mineral spring of a chalybeate character, is said to occur in its vicinity. A mill stream called Saw-mill Creek has its origin in this lake and winds rapidly for five miles down the mountain glens without presenting any considerable falls. Passing through the valley of Woodstock, it becomes auxiliary to Saugerties creek. A beautiful circular basin of water four miles in circumference, called Shandago lake is situated in the southern section of the moun-

tains adjacent to the Bristol turnpike and glass manufactory. It is deep, containing Pickerel, Trout, Perch, and other fish.

Several streams which have their source in the mountains to the westward of this lake, and pass through romantic ravines, are uncommonly well stored with trout. Five hundred of these fish have been caught by an angler in a day.

Residents of the mountains informed me they had observed a large cave in the region south of the Platterkill into which a boy had been introduced twenty feet perpendicularly by a rope before he reached the bottom. He explored a considerable distance without finding a termination. The fact is interesting from its indicating either a limestone region, or a rock decomposing readily from its containing much sulphuret of iron, alum or coal. Caves of considerable extent are rarely found except in secondary or transition limestone, the excavations being made in the soft calcareous rock, by the friction of water.

Panthers, wolves, bears, wild cats, and deer are occasionally seen in the southern section of the Catskill mountains, but are not so numerous as in the middle region. A Panther measuring in length about nine feet, was recently killed in the southern range; this animal is rarely seen; but from its strength size and ferocity, it is regarded with terror and considered the most formidable beast of the forest; their color is grey, the head small in proportion, the general form indicating agility; they have been known in ascending a ledge or tree, to rise at a leap twenty feet from the ground.

Of wolves, two varieties inhabit the Catskill mountains; one called by hunters the deer wolf, from his habit of pursuing deer, for which his light grey hound form adapts him. The other of a more clumsy figure with, short legs and large body, more frequently depredates upon flocks under the protection of man. Foxes and rabbits are numerous, and white hares, martins and hedgehogs sometimes seen, squirrels seldom.

Rattlesnakes frequent the warm sides of the Catskill mountains, but are rarely observed on the summits or northern declivities and ten miles in the interior of the range are never seen. They are in general about 4 feet in length—the skin of one recently killed near Shues lake was exhibited to me; it measured between five and six feet. The color of the male is darker than that of the female, they live to the age of twelve and fifteen years.

Copperhead serpents inhabit the lower parts of ravines and eastern face of the mountain, but are not found on the summit.

The black, water, striped, and milk snakes are among the harmless reptiles.

The Catskill mountains, in wild grandeur and romantic beauty, can compare with the highlands of Scotland, without presenting their barren heath-covered aspect, being from the base to the summit thickly covered by forests.

The eastern face of the mountain, though steep and precipitous, supports an almost impenetrable forest. The ledges form natural terraces that arrest the vegetable mould.

In the valleys and gradually declining mountain surface of the interior, trees of great size appear, indicating a considerable depth of good soil.

Gradations of elevation on the mountain are in some degree marked by a change of vegetation both as it respects the species and periods of blossoming, and the maturity of fruit. The lower districts and the warm southern exposure of ravines, exhibit trees and plants common in the river valley—oak, chesnut, soft and hard maple, ash, and cherry, mingled with a few evergreens. On the peaks, on the cold northern sides of ranges, in moist shaded ravines and elevated valleys, the trees and plants of the green mountains and northern parts of New-England occur. You there see thick groves of hemlock; spruce, balsam fir and pitch pine, mingled with hard maple, beach, white and black birch, and cherry. The white pine is not observed on the eastern range of the Catskill mountains but is found in the valley of the Schoharie and adjacent hills of moderate elevation.

Among the mountain shrubs, the blackberry, thimbleberry, gooseberry, and moose-bush, are noticed; the whortleberry is very abundant on the rocky summits, and is the favorite food of bears. The plants of the mountain blossom much later than those of the valley, and a botanist can collect plants of different latitudes, or which blossom at different periods in one day's research.

There are three descriptions of rocks on the Catskill mountains common to the whole chain, and which alternate with each other, viz. red sandstone, gray wacke, slate and puddingstone. The sandstone is of a fine texture, highly colored by oxide of iron and contains much alumine. It is

found at various elevations, but most frequently as a lower stratum, and is observed in deep ravines. It is least abundant in the section south of the Platterkill. This argillaceous sandstone, exposed to air and moisture, decomposes easily and forms a good soil.

A second and most common variety is a coarse gray wacke slate, which lies in regular strata, the position in some places horizontal, but in general with a small inclination to the west. It is composed of silicious grains with an argillaceous cement. The third description of rock is a puddingstone containing smooth, and apparently water worn pebbles of different sizes of white, red, and gray quartz, combined by argillaceous, and fine silicious materials. The ledges of pudding-stone which are often of great height and extent, are most frequently remarked in the upper regions of the mountains.

Ledges of gray wacke slate and argillaceous sandstone, richly impregnated with alum and often embracing sulphuret of iron, are of frequent occurrence.

Native alum is abundant near the Schoharie in the town of Blenheim. It is found in a ledge near the foot of the Kauterskill clove, and in the rocks of the eastern side of the mountain north of the Kauterskill for several miles, sometimes pendant in stalactical form. Alum often occurs in the southern section, both on the eastern face of the range, and in gray wacke slate of the interior ravines, sometimes in incrustations, lumps and stalactites. Profitable manufactures of alum may perhaps be established in the Catskill mountains. The salt can in some places be extracted from the decomposing rock by lixiviation alone, but in general a calcination would probably be necessary.

Sulphuret of iron has been frequently noticed in the southern part of the mountains, and plumbago in a few places. There are indications of copper. Several tons of iron said to resemble that of the highlands were procured from the Catskill range, in the vicinity of the Bristol glass manufactory, but diminishing in quantity, the mine was abandoned.

I have observed narrow strata or seams of coal at several places in the southern part of the Catskill ridge. The widest is situated in a perpendicular ledge of gray wacke slate on the eastern face of the mountain, in the town of Woodstock, Ulster County, at an elevation of about 1000 feet above the

Hudson. This seam which has been recently explored, is
eight inches wide on the surface, and is observed for some
distance on the face of the ledge. The coal is stratified,
and inclines with the rock at an angle of near fifteen degrees.
Narrow strata of argillaceous slate, imbedded in the gray
wack ledges, form the roof and floor of the coal bed. This
slate contains alum, and cubic crystals of sulphuret of iron, and
sometimes presents a dark surface glistening with carburet
of iron.

The coal bed, in exploring, widened to twenty-two inches;
but diminishing in the interior to a narrow seam and the ad-
jacent rock being of difficult fracture, the pursuit has been
abandoned for the present. Another vein of coal is located
in a higher ledge of the same mountain, and coal has been
noticed to the south west in this range for three miles.
The coal of the Catskill mountain appears of a good quality
for upper strata. It is light, shining, and burns with a mod-
erate flame proceeding from bitumen or sulphur.

If beds of coal of this description could be found five feet
in thickness they might be penetrated without breaking the
rock, and would be valuable. Vegetable impressions and
narrow seams of coal have been found in gray wacke slate, in
the Catskill range bordering the river Schoharie.

Flames, from spontaneous combustions, generated in beds
of coal or sulphuret of iron have been seen issuing from the
ledges of the Catskill mountains by the neighbouring inhab-
itants. Combustions of this character often occur in the
coal districts of Europe and America.

Adjacent to, and forming a threatening canopy over the
entrance of the coal excavation in the mountain near Wood-
stock, is a rock of several hundred tons weight. It is sepa-
rated from the ledge and balanced on a narrow base of de-
caying alum slate by an opposite projection of equal weight.
From progressive decay this base is lessening, and the rock
will before long be precipitated down the steep side of the
mountain. The ledges in this neighbourhood are fast de-
composing in many places, from the quantity of alum and
sulphuret of iron they contain.

The eastern side of the Catskill mountains south of the
Kauterskill clove is steep, but thickly clothed with wood;
near this clove at a considerable elevation is noticed an im-
mense circular basin resembling a volcanic crater. A basin

of similar appearance, is situated near the Platterkill ravine. Numerous small precipices are presented on the mountain's eastern face, some of them of great altitude; those of a southern promontory bordering on the town of Woodstock, are particularly striking; they rise tier above tier in amphitheatric order from the base to the summit of the mountain, in quick succession and great regularity. Upon the summit of each natural terrace is a narrow plain on which the soil accumulates. Many of the ledges of this promontory are in a crumbling state from embracing saline minerals. In some of the higher rocks, wide strata had mouldered away, leaving tabular masses of firm gray wacke slate, projecting twelve and in some places twenty feet. It is probable that this mountain is uncommonly rich in materials for the manufacture of alum and copperas.

From the above-mentioned promontory which is situated about ten miles south of the Kauterskill clove, the Catskill mountains tend to the south west and sweep with diminished height to the Delaware. About four miles to the west of the village of Woodstock, a spur of considerable elevation strikes off to the south east, leaving a rich and extensive interval of semi-circular form. At the angle of intersection of these ranges, the Bristol glass works are situated. Window glass is the principal article manufactured, and four miles north east of this establishment in an elevated and secluded mountain valley, another manufactory of glass has been erected. Sand for these manufactories is procured from Philadelphia and the sea coast, and the other materials from a distance. The advantage resulting from the cheapness of wood and soil, will not compensate for the enhanced expence incurred in transporting the ingredients of glass, and the bricks, stone lime and clay, for the furnaces and crucibles, and many of the necessaries of life, sixteen or twenty miles over mountain roads.

A small hamlet of about thirty houses has been erected adjacent to the upper or mountain glass house, on ground favorable for gardens and meadows. North of this village, an elevated, wood clad and steep mountain, ranges to the westward; its wildly irregular waving summits are several miles in view.

ART. III.—*Some speculative conjectures on the probable
changes that may have taken place in the Geology of the
Continent of North-America east of the Stoney Moun-
tains ; by* WILLIAM MACLURE, *Esq. President of Acade-
my of Natural Sciences, at Philadelphia, and of the
American Geological Society.*

<div align="right">MADRID, July 9, 1822.</div>

IN the present state of our geological knowledge, there
are, perhaps only a few facts from which we are permitted
to draw conclusions respecting the former state of the earth ;
amongst which is our entire ignorance with regard to the
origin or formation of the primitive class of rocks, we having
as yet had no opportunity of observing nature in the act
of aggregating or forming such rocks : the other four class-
es of Vulcanic, (Volcanic?) Alluvial, Secondary, and Trans-
ition, we have either caught nature in the act of aggregating
or forming such rocks, or rocks that from direct analogy
are so similar in their construction, relative situation, &c.
&c. as to warrant a deduction that they were most proba-
bly formed after this same manner.

Water appears to be the principal agent in changing the
form of the earth's surface, and by the sea, lakes, and riv-
ers, (the most extensive mode of operation ;) when we see a
river running between two precipices of rocks in a deep
channel, whose stratification and arrangement are the same
on both sides of the river, we are naturally led to suppose
that the action of the running water wore down that chan-
nel, and that at some former period, the two sides of the
river, now separated, were contiguous and unbroken : when
we cast our eyes over immense tracts, such as the steppes
in Russia, the prairies in the United States of America, or
on plains that are nearly horizontal, we are tempted to con-
jecture that the earth took that form from the depositions
from water, &c. &c. &c.

The continent of North-America, east of the stoney moun-
tains consists of a ridge of primitive mountains, springing out
of the great northern primitive formations, covered to the
east and south-east by extensive beds of alluvial, apparently
the depositions of the ocean, and on the west side overlayed
by Transition and Secondary, filling the immense basin
through which the Mississippi now runs with all its attend-
ant streams.

The utmost stretch of imagination or conjecture can form no idea of any period of time, when that primitive chain of mountains called the Alleghany, did not exist; but direct analogy, and perhaps logical reasoning, authorises us to conjecture that there must have been a period, though beyond the date of our records, when neither the alluvial of the ocean, nor the Transition or Secondary depositions covered or overlaid either side of said range of mountains, and that the chain of mountains called the Alleghanies stood alone, and from the nature of the depositions which we now find covering each side, we may have a right to conjecture that it was surrounded by water; into which run all the rivers that drained said mountains, forming channels deep in proportion to the immense length of time they may have run, and consequently much more profound than the channels they afterwards wore in the level country at the foot of the mountains on the retreat of the waters; at this present time all the waters that fall into that immense basin west of the Alleghany mountains are drained off principally by the Mississippi and St. Lawrence, and a small part now by the Hudson, although it is probable that formerly a greater proportion used to pass by that channel; these then are the only rivers that break through the whole chain of the Alleghany mountains, and run into the ocean.

If on a review of any existing series of phenomena, it is permitted to form conjectures on the past, and to look back on the probable changes, that may have preceded the present state, we presume that the situation of this continent will warrant such conjectures, and we should be naturally led to suppose, that at some former period, the continuity of the great chain of mountains was unbroken, by any of the three rivers that now drain the great basin; and that the waters confined by the high surrounding ridge would form an immense lake, the surplus of which would naturally fall over the ridge into the ocean, and would in the course of time cut those passages, which would drain said lake, and leave the great interior basin, with all its secondary or deposition formation, as we now find it: as the waters that would fall over the ridge into the sea, must have previously left the sediments in the lake, there would be little or no matter fit for alluvial depositions; and more probably that great alluvial formation, from the bay of Mexico to Long-

Island, would not have been accumulated at this period, and the current now called the Gulf Stream, would have then most probably run along the foot of the chain of mountains.

The continent east of the Stoney Mountains, and south of the north edge of the great lake, would then consist of an immense lake, surrrounded on the east and south side by a strip of high land from one hundred to two hundred miles broad; the rain falling upon which would partly fall into the lake and partly into the ocean, through small rivers, along the mouths of which navigators might have in vain searched for rivers proportionate to the apparent extent of the continent, as they now do on the coast of New South Wales, for rivers capable of draining so extensive a country.

The passage of the St. Lawrence through the high ridge between Quebec and Montreal, must either have been torn asunder by an extraordinary convulsion, been always in that state, or it must have been worn down by the gradual but continued action of running water, aided by the friction of all the substances it carries along with it; the undisturbed regularity of all the surrounding strata both on the banks of the St. Lawrence and Hudson, renders the first supposition improbable ; on the second supposition that the river had always run freely through the passage in those mountains, it must follow that the river had always run in its bed from Lake Ontario to Montreal, and from the weight of water and rapidity of its current, for so long a time, must have worn down a deep channel, and buried itself between high and perpendicular banks; but this does not correspond with the actual state of the river, which from the lake to the rising ground above Montreal runs in a bed very little below the level of the surrounding country, nor does either the present situation of the river or its banks, warrant the supposition that the action of the current had continued so long: by the same supposition the level of Lake Ontario must have always remained as far below the level of Lake Erie as at present, and the waters must have constantly fallen over the ridge at Niagara ; but the small progress it has made in wearing away that ridge, compared with the effects of other rivers, (for instance, the Rhine below the lake of Constance with a tenth part of the water has worn a deeper bed ten times the distance through the high lands composed of harder materials) is against the probability of such a supposition;

the small distance that the falls of Genesee river have worn its bed from the lake, with the shallow beds of the Oswego and all the other rivers that run into the lake, as well as the general nature of all the Genesee country, opposes the probability of the supposition or conjecture.

The above observations are equally applicable to the beds of the Hudson and Mohawk, before they fall over the ridge, from which it would appear that the most rational conjecture would be, to suppose the St. Lawrence wore down a passage through the high lands between Quebec and Montreal, as well as the Hudson, through the high lands above New-York, and until they had effected such a cut, the whole basin on the west side of the mountains, was the bottom of an immense lake.

A similar mode of reasoning supports the conjecture that the basin of the Mississippi made part of the said lake, for the Tennessee river, while in the mountains under the name of the French Broad, has worn down its bed one hundred to two hundred feet in solid primitive and transition rocks, but when it comes into the basin, it is obstructed in its passage, at the Muscle Shoals, by a soft secondary sandstone; the sources of the Ohio, under the name of New River, &c. &c. &c. have likewise cut deep beds in the mountains before they reach the great basin, but after their union into one great stream, the Ohio is obstructed at its falls near its mouth by a secondary limestone; from all which it would appear probable, that, had those rivers run as long through the secondary formation of the great basin, as their sources must have done to wear these beds so deep in the primitive mountains, the accumulated waters of both the Ohio and Genesee would, long ere this, have worn away all the obstructing secondary rocks, and like all other great rivers that have run long in the same beds, would have been obstructed only by alluvion of their own formation. The Rappahannock, Potomac, James River, Roanoke, &c. &c. &c. that run into the Atlantic, have cut deep beds in their course through the mountains, through the level country their channels are shallow, and they all fall from twenty to thirty feet over the granite ridge into tide water, without having removed, the fall half a mile from where they begun, which could not have been the case had they run as long in the low country, as they had in the mountains.

That the branches or sources of these rivers should have run longer in the mountains than they have in the great basin or lower country, can be satisfactorily accounted for, only by supposing that they had long been wearing down these beds in the high lands before the great basin or lower country emerged from the waters, and that it has been only since the draining of those waters that their accumulated junction in the bed of the great basin under the level country began the formation of the channels they now occupy.

This conjecture may likewise account for some of the particularities in the state of the animals, originally found on this continent, such as the small number and wild condition of the wandering herds found on this part of the continent, when compared with their neighbours inhabiting the elevated plains of Mexico; the great deficiency in Terrestial Quadrupeds, compared with the vast abundance of Beavers, Otters, Muskrats, and other amphibious or aquatic animals; the great proportion of Grammivorous and the small number of Carnivorous; the immense flocks of aquatic birds, and the very few terrestrial; might be mentioned as some of the problems solved by the foregoing supposition.

The accounting for the existence and extinction of the mammoth would not be difficult, by supposing with Mr. Peal that it was not amphibious, and though originally inhabiting the southern parts of the great lake, might in summer occasionally emigrate to the north, and leave their bones on the borders; being deprived of its element by the evacuation of the great lake, might perhaps be considered as sufficient good reason for their extinction.

The large masses of granite, some of them weighing tons, scattered over the secondary between Lake Erie and the Ohio, while there is not an atom of granite in place nearer than the north side of the lake, would seem to point at the only mode by which they could probably be transported; by supposing the lake extended thus far, and that the large pieces of floating ice from the north side might carry those blocks attached to them, and drop them as the ice melted in going south; few or none being found south of the Ohio, shows that the southern sun melted the ice before it got so far.

BOTANY.

Art. IV.—*Description of a New Species of Botrychium; with a drawing ; by the* Rev. Edward Hitchcock, A. M. *of Conway, Mass.*

This species grows, not very abundantly, in Conway, Massachusetts. It was first noticed, two years since, and with some doubt, referred to Botrychium lunaria of Swartz and Wildenow. But upon a suggestion of Dr. Torrey that it might be a new species, I have several times re-examined it during the two past summers, and feel so confident that it is specifically distinct from any described Botrychium, that I take the liberty to propose for it the name *B. simplex.*

Specific Character.

Botrychium simplex: Frond simple, 3 lobed, or 3 cleft ; segments unequal ; spike sub-compound, interrupted, unilateral, bearing sessile capsules, in the last part of June, of the size of a mustard seed. In dry hilly pastures.

Frond solitary, from a torn membraneous sheath, erect, two to four inches high, glabrous, pale green, consisting of a small spatulate leaf, an inch long, and one third of an inch broad, usually divided into three—rarely four—unequal, somewhat rounded segments, with their margins a little notched. From the base of the leaf, about an inch from the ground, springs a stalk, twice or thrice the length of the leaf, bearing a sub-compound, unilateral, interrupted spike of capsules, sub-two rowed. Root sending forth stout simple fibres.

This species is closely allied to B. lunaria of Europe : but it differs in having a simple, instead of a pinnate leaf " with six or seven pairs of obliquely imbricated, fan-shaped, entire, or notched leafets." (Smith in Rees' Cyc.) And this difference exists in all the specimens, (more than 100) which I have seen—not one being pinnate, or even " pseudopinnate." (Nuttall.) Also, in having a spike hardly com-

pound; the small branches, that appear along its sides, being
scarcely any thing more than an expansion of the common
receptacle—whereas in B. lunaria, the spike is "twice or
thrice compound." Also, in the capsules being twice as
large, and the plant half as large. If I am correct, there-
fore, this species will take its place as the first under the
genus; all the other Botrychia having compound fronds.

ART. V.—*Description of a new species of Usnea, from New
South Shetland; by* JOHN TORREY, M. D. *of New-
York, (with a drawing.)*

TO PROFESSOR SILLIMAN.

Sir,

THE following account of a new cryptogamic plant from
New South Shetland, with an explanatory letter from Dr.
Mitchill, I send for insertion in your valuable Journal.

Letter from Dr. S. L. MITCHILL, *to* JOHN TORREY, M. D.

New-York, July 1, 1822.

My Dear Sir,

AMONG the subjects of rational attention at this time, is
the land lately found, and now much frequented, beyond
Cape Horn.

Having received from several of my friends, who have
visited that antarctic region, articles of a zoological and min-
eralogical kind, which they had brought home, I was nat-
urally induced to inquire for botanical productions. In an-
swer, I was informed that, notwithstanding the frequency of
lava and volcanic slag, and the occasional eruption of smoke
from the earth in different places, the surface was generally
covered with ice and snow, even during the southern sum-
mer. There is not a shrub, nor a tree to be seen; nor any
appearance of verdure to cheer the prospect.

Captain Napier however improved the opportunity of ex-
amining a rock upon an island of the group called New

South Shetland, from whose top the snow had been melted; and of gathering specimens of a small vegetable which grows upon it. These he presented to me for consideration. I beg you to accept some of them for your herbarium, with a request that you would communicate to me your opinion respecting them. I show you also another sample of this vegetable, brought from a different place by another person, that you may compare them.

Captain Mackay, informed me, he had seen a few tufts of dwarfish grass; but as this is rare, it may have been introduced by some visitor or from some ship.

According to this view of the matter, the Flora of this new world consists of a single species; which I hope you will be very particular in describing.

While I thus lay before you this interesting production, I congratulate you on the receipt of numberless other productions from foreign climes, which our spirited navigators are incessantly presenting to us.

The specimens presented to me by Dr. Mitchell, evidently belong to a species of Lichen. Several of them were covered with small tubercles very much resembling the fruit of Roccella, which, with the *habitat* of the plant, induced me to refer it to that genus. On a closer examination, however, I have no doubt of its being a species of Usnea without the proper fruit, merely having the *cephalodia* which are not uncommon in *U. florida*, &c. It has the central hyaline thread, so constant and important a character in this genus. According to Acharius, all the Usneæ are found exclusively on trees: so that this species, which grows on rocks appears to form an exception to all the rest. In the Flore Francais, however, the *U. florida* is said to occur sometimes on rocks and the *U. articulata* on the ground. The present species does not appear to be described in the Synopsis- Methodia Lichenum of Acharius; I have therefore considered it as a new one, and have called *U. fasciata*.

USNEA Acharius.

Receptaculum *universale* subcrustaceum teretiusculum, ramosum plerumque pendulum, fasciculo ductulorum filiformi elastico centrali hyalino percussum. *Partiale* orbi-

culatum terminale peltatum totum a thallo formatum ejus-
que substantia corticali similari undique obductum subcon-
colorum, ambitu immarginato plerumque ciliato. *Ach.* Syn.
Meth. Lich. p. 303. ejusd. Lich. Universal. p. 127. t. xiv.
f. 5.

<center>USNEA *fasciata* mihi.</center>

U. thallo pendulo scabriusculo tereti glauco virescente
ramosissimo, ramis rectis nigro-fasciatis quasi articulatis,
ramulis ultimis capillaceo-attenuatis, fibrillis lateralibus nul-
lis, cephalodiis sparsis hemisphericis atris.

Description.—From two to three inches long, and proba-
bly pendulous, roughened by minute papillæ. Common trunk
short, about one line in diameter; branches dense tapering to
a filament at the extremities and appearing beautifully articu-
lated by transverse black bands; the joints rather longer
than the diameter of the branches. Apothecia—none in
the specimens I have seen. Cephalodia scattered, some-
times crowded and irregular.

Habitat.—On the perpendicular volcanic rocks of New
South Shetland.

Observations.—This species is nearly allied to *Usnea ar-
ticulata* of Hoffman and the Flore Francais, which is con-
sidered as a variety of *U. barbata* by Acharius, but the lat-
ter is distinguished by its gray colour, dichotomous branches
and ventricose joints, &c.

<center>EXPLANATION OF THE PLATE.</center>

Fig. 1. The plant of its natural size.
" 2. A branch magnified.
" 3. A cephalodium magnified.
" 4. A transverse section of the same highly magnified.

CONCHOLOGY.

—

ART. VI.—*On the Genera Unio and Alasmódonta; with Introductory Remarks: by* D. W. BARNES, M. A. *Member of the New-York Lyceum of Natural History.*

[Read before the Lyceum.]

INTRODUCTORY REMARKS.

THE family of the *Naiades*, according to *M. Lamarck*, contains four genera of fresh water Bivales, viz. *Unio, Hyria, Anodonta and Iridina.* To this family belong the *Dipsas* of *Dr. Leach*, and the *Alasmodonta* of *Mr. Say.* Several undescribed species of the Genera *Unio* and *Alasmodonta*, were brought to our knowledge by the expedition sent by our government in the summer of 1820, under *Gov. Cass*, to explore the North Western Territory; and others have since been obtained from various sources.

Little has hitherto been done by our countrymen in describing these interesting productions of our lakes and rivers. The only American work, of the kind, at present known, is that of *Mr. Thomas Say*, who published at Philadelphia in in the year 1819, "A description of the land and fresh-water shells of the United States." This treatise had been previously published in *Nicholson's Encyclopedia.* It deserves the thanks, and ought to be in the possession of every American lover of Natural Science. It has been quoted by *M. Lamarck*, and adopted by *M. de Ferrusac*, and has thus taken its place in the scientific world.

But *Mr. Say's* tract, though a very commendable performance, was necessarily imperfect. The author himself has described *thirty new species* of univalves since the publication of his book, and a great part of the splendid collection, brought from the N. W. Territory, was unknown to him. For our first view of them we were indebted to the zeal and

liberality of *Mr. H. R. Schoolcraft,* Mineralogist to the expedition, who collected them at the expense of much voluntary fatigue, transported them a thousand miles, and generously distributed them among the lovers of Natural Science, in New-York and Philadelphia.

A second parcel was soon after received from *Capt. D. B. Douglass, Professor* in the Military Academy at West-Point, and topographical engineer to the expedition, whose avowed object, in sending his collection, was that it might be arranged and described for the American Journal of Science and Arts. To this gentleman we feel ourselves much indebted, for his valuable and detailed account of the *localities* of his specimens. What adds to the value of these collections, is, that independent of the numerous *species* and *varieties* before *unknown*, the specimens of the previously ascertained species are in many instances, *remarkably large and beautiful.*

M. Lamarck, in the sixth Volume of his "*Animaux sans Vertebres,*" has described *twenty-six** species of North American Uniones. He was, moreover in doubt of the localities of several others, which will probably be found to be American. Whether he has, as we strongly suspect, described some of our species under four or five different names, cannot be certainly determined, as his book contains no figures, and the descriptions are short and equivocal. *The Unio purpureus* of *Mr. Say, purpurascens* of *M. Lamarck,* is common in all our *eastern* waters, and has a different appearance from every locality. In the Hudson it is small and short; in the Housatonick, long and slender; in the Saratoga Lake, of middling size; in the Kayaderosseras, thick and heavy; in the Lakes of New-Jersey, large and ponderous. If these are to be made different species, we may as well make four or five different species of the common clam, *Venus mercenaria, Linn.* from as many different localties around New-York. They are really unlike. Not only is the appearance of the shells different to the eye of the naturalist, but also the taste of the included animals, to the palate of the epicure. Who does not know that the Indian corn, *Zea Mays,* assumes a different appearance in every latitude from Quebec to Florida? Yet whoever thought of

* For *eight* of these, he quotes Mr. Say's book, which contains *nine.*

making these varieties, different species? We have examin-
ed shells from the localities mentioned by *M. Lamarck*, and
compared them with his descriptions, and, if we do not mis-
take, he has fallen into the error of making distinctions with-
out a specific difference. But, even if this is admitted, we
shall not be disposed very severely to censure, so long as
anatomical dissections have not been, and in many cases
cannot be called in to decide the question ; for it is, after
all, upon the *knife* that we must depend for perfect accura-
cy in this and similar cases. In the mean time, it has
been agreed upon by naturalists, to arrange these ani-
mals by their shells ; presuming always that a different
form and figure of covering belonged to an animal of
a different organization. It is impossible to decide wheth-
er they are "the common children of common parents," or
otherwise. This is a case precisely similar to that which
occurred between *Linnaeus* and *Lamarck* concerning the
Olives. "The former expressed a doubt whether there is
more than *one* species of the Olive, and the latter has des-
cribed *fifty-nine*."*

In most cases wherever *M. Lamarck* can find a differ-
ence, though by his own account; "*nothing remarkable,*"†
he makes a different species. Too many as well as too few
distinctions undoubtedly defeat the object of the Naturalist,
which is to make his readers acquainted with the produc-
tions he describes. In the present state of our knowledge
we cannot perhaps do better than to take a mean course,
and where the discriminations are sufficiently obvious, *in
important parts and essential particulars,* to apply a different
specific designation. This course has been attempted in the
following notice of undescribed species. We have had the
opportunity of examining and comparing a great number of
specimens, and very rarely have we given a new specific
name to a solitary individual. In cases where the contrary
has, from necessity, been done, the specimens were by no
means of a dubious character ; but healthy, well-grown and
perfect individuals, so strongly marked and distinctly char-
acterized, as to leave no doubt.

* Dillwyn, page 514.

† See U. Georgina and Glabrata of *Lamarck*

M. Lamarck has confessed the great difficulty of determining the species of the genus Unio on account of their "shading and melting into each other in the course of their variations." This difficulty is surely not obviated by short and equivocal descriptions. Short definitions may have an appearance of scientific neatness, but their brevity is an insuperable obstacle to a learner, especially when, as it commonly happens, the same terms are applied to different species. *M. Lamarck* applies the term *ovate*, either by itself or compounded with another word, to the description of *thirty-two*, out of his *forty-eight* species. Now it will be apparent to every one that, as this is made a leading feature in his descriptions, it must be the cause of endless perplexity to the unlearned, and of constant uncertainty even to the experienced. For the purpose of *discrimination* it is useless, and might almost as well have been omitted, unless it had been placed at the head of a section.

M. Lamarck dwells most on the external form, and with a great latitude of compound epithets, he has not succeeded in making his descriptions intelligible, without danger of mistake to those who have not seen *his* specimens. Ten or twelve latin words cannot so describe a Unio as to identify it, and distinguish it from all others. We have therefore adopted full descriptions, the obvious utility of which needs no comment. If short definitions are insufficient, full descriptions become absolutely necessary. *M. Lamarck*, generally mentions the breadth of shells in Millimetres, which we have reduced to inches and lines, or what is the same thing, to inches and decimals. The multiplier ·039371, which multiplied by any number of Millimetres gives the corresponding English expression, as, *Unio Crassidens* ·105 Millim. $105 \times ·039371 = 4·133955$ or four inches and 1 line. Dividing the English inches by the multiplier, will reduce *Mr. Say's* measures to *M. Lamarck's* by which means they may be more readily compared. For ordinary purposes $12\frac{1}{2}$ Millim. to half an inch, and 4 inches to 100 Millimetres, will be sufficiently exact.

But the breadth, or as *Lamarck* often says the "*apparent length*" of the shell is nearly useless without the length; for two shells may be of the same breadth, and yet differ totally in their other dimensions. For instance, the U. Crassus and U. Nasutus may each be 26 lines broad; but the Cras-

sus may be as long as it is broad, while the Nasutus is only
1 inch, or 10 lines long. The former may weigh more than
half a pound, the latter less than half an ounce. The for-
mer may be half an inch thick, the latter, as thin as paper.
And to say that one is broad and the other narrow, does not
obviate the difficulty; for these terms are altogether com-
parative, and, without something for a standard, convey no
definite ideas.

We have therefore adopted an improvement which we
hope to see become general in the description of Bivalves,
that is, to give the length from the summit to the opposite
margin; the breadth between the lateral extremities, and the
diameter through the disks, at right angles to both the length
and the breadth; that is, the thickness through the most
prominent part of the body of the animal. We prefer the
term *diameter* to *thickness*, because the latter is often applied
to the substance of the shell; the former never. In deter-
mining these dimensions with ease and accuracy, we have
constructed a convenient instrument of the following de-
scription;

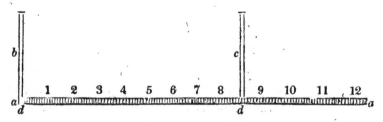

a, a, is a box-wood ruler, one foot long, graduated on its up-
per side, in inches and lines. *b, c,* cross bars, made to stand
at right angles, and drop down by hinge joints, *d, d,* upon
the ruler, for the convenience of packing. The bar, *c, d,*
slides upon the ruler by means of a clasp. The shells, to be
measured, are placed between the bars, and the length is
read off from below. The instrument measures any irreg-
ular body or figure, from one line to one foot in diameter.
When used for measuring shells, it may be called a *Con-
chometer.*

One advantage of thus measuring shells, is, that those of
the same species, or the same variety, will be found to have
very nearly the same proportions which will hold good as it
regards all the varieties of age. These proportions may be

called the *law of the species,* and every Unio which has the same *proportions,* may be presumed to belong to the *same species.*

Another obvious advantage of this method will appear in the following remark. The Unio which we have designated *praelongus,* is perhaps the *Unio purpurata* of *M. Lamarck,* all the terms of his description may be applied, and probably with truth, to our shell But then, he "believes that his shell came from the great Rivers of Africa." This caused a doubt. Had he stated the very remarkable proportions of our shell, the identity would have been instantly determined. Had he stated the proportions at all, there could have been no doubt. We have put it into *his* power to settle the question with certainty.

Writers *on Conchology* differ very much concerning the *right* and *left,* and the *base* of Bivalves. *M. Lamarck* and the authors of the New Edinburgh Encyclopedia consider the *beaks* as the *base,* and the opposite parts, the upper margin: and they give the following direction for right and left. If the shell is placed upon its base or hinge, with the ligament *behind,* then the right and left sides of the shell will correspond with those of the observer. Burrow on the contrary considers the opposite part to be the base, and the *beaks,* the *summit,* and says, "If the shell be placed on its base, with the area *in front,* and the valves be then divided, the right valve will be opposite the left hand of the examiner, and the left valve opposite the right." By placing a Bivalve in the manner directed, it will be perceived that the two are directly opposite, the right of one is the left of the other. The view which we have hitherto had of these parts, and with which *Mr. Say* agrees, is expressed in the following directions : Place the shell upon its base with the beaks upward, and the ligament *before,* (that is *from the observer,*) the right and left valves of the shell will correspond with the hands of the observer. With due deference to the high authority of *M. Lamarck,* there seems to be a propriety in calling the *base* of a Bivalve, that part which is *downward,* and from which the *foot* projects when the animal is in motion. But when the Unio does not, as some authors seem to suppose, move on its beaks. The beaks are upwards, and should therefore be called the *back* rather than the *base.* This makes a simplicity, in the language of Con-

chology, which is very desirable in every science, that *the same terms should have a uniform meaning.* Having learned in univalves what is the mouth and what is the base of a shell, we apply the same terms to bivalves; but to call the thin, sharp, unconnected edges of a shell, the dorsum or back would sound very strangely. *M. Lamarck* has not ventured on so strange an expression; but says commonly the *upper margin*, the same that *Mr. Say* calls the "basal edge." According to *this* view of the subject we should agree with *M. Lamarck* and the *Encyclopedia* as to *right* and *left;* but not as to *base;* and with *Burrow* as to *base*, but not as to *right* and *left*. *We call the connected part of a bivalve the back and the opposite the base.*

If this is determined, there will remain another point to be settled. Authors have very generally agreed in calling that side of the beaks in which the ligament is situated, the *anterior*, and the opposite, the *posterior*. "But rigidly speaking," says *Mr. Say*, "we seem to be all wrong in our adaptation of these relative terms, because the latter is used to indicate that part of the shell which covers the mouth of the included animal, and which is foremost in its progressive movements. In order to be correct in descriptions where the animal is referred to, these terms must be reversed, and if in descriptions which have reference to the animal, certainly the principle applies to all other bivalves, in which the mouth is similarly situated. The mouth ought *always* to be considered as in the *anterior*. For this reason, Cuvier reverses the terms *right* and *left*, applying the former to that valve of the Uniones which has but a single lamelliform tooth, and which is our *left* valve.* He of course, reverses the *anterior* and *posterior* as now applied."†

It would surely be deemed safe to follow an author so pre-eminent as *M. Cuvier*, and this mode of viewing the shell is doubtless most conformable to nature; but as all other authors have a different view, we have resolved, *for the present*, to adopt the established usage of the term *anterior* and *posterior*, and to follow *M. Lamarck* as to *right* and *left*.

If we rightly understand the celebrated French Naturalist, he is under a mistake in saying that the Uniones "keep

* This agrees with Burrow. † *Mr. Say's* MSS.

themselves buried in the mud, having their beaks turned downward."* If he means by this that they are *usually concealed*, or that they lie *on their beaks;* we remark that, as it regards those of *our* country, such is not the fact. In winter they may bury themselves, but in summer we have found them, generally, when at rest, standing with the posterior side inserted obliquely, and the hinge margin the anterior slope, and a small portion of the basal edge exserted. Even when they sink below the surface the place of their retreat is conspicuous. In streams which have a rough bottom, and rapid current, they choose the narrow crevices between the stones or under the edges of rocks, and thus defend themselves from injury. We have never found a live Unio on its *back*, or on what *M. Lamarck* and his followers would call the *base*.

While standing in the position above described, they have the anterior side slightly gaping, but on being touched they instantly close. They are usually found in company, rarely solitary; and the sand of the bottom is often marked with little furrows made by their passing from place to place. They advance with the posterior end foremost, and the decorticated beaks, seen through the water, bear a strong resemblance to the eyes of a large animal. *Deterville* says "they have been observed to live for several months of the summer in clay too hard to be cut by the hoe, and with but momentary showers to refresh them." This, if it be a fact, must rest, for the present, on his authority; as we know of no one who has confirmed it by observation,

We know but little concerning the *generation and propagation* of the species of Molluscous animals that inhabit these shells. They are generally supposed to be hermaphrodite *per se*. If they are really and absolutely so, the number of species must be exceedingly great. *M. Lamarck* supposes that they are propagated by means of a fecundating fluid emitted into the water. If so, they must be male and female. What reason he has for this supposition, we are not informed, but if it be admitted, it will readily account for the numerous varieties of these animals, and it will show also that they are merely *varieties*, and not different *species*, that is, they will prove to be the " common

* Ils se tiennent enfoncés dans la vase, ayant leur crochets tournés en bas."
—*Lam An S. Vertebres, Vol. VI. page 70.*

children of common parents, and as much like them as they are like each other." . If the fecundating fluid, emitted by the male, be received by the female, a variety intermediate between them, will be produced. By a second, propagation, by one of the parents and the intermediate, a new variety, less different from the former one, than that was from its parents, will be again produced, and so on, in an endless succession of innumerable varieties. The admission of *M. Lamarck's* supposition would confirm the thought which has frequently and very forcibly struck us, that, properly speaking, there is but *one species* of the whole *genus;* and perhaps of the whole *family.* But this subject is covered with a veil of obscurity. There is yet wanting a series of minute and well-directed observations on the habits and manners of this interesting tribe of molluscous Bivalves. In the mean time we must follow our guides at the hazard of being sometimes misled.

Brugière established the genus Unio, but his original observation on this subject we have not been able to find. The word signifies *a pearl,* because " many of them produce very fine pearls,"* and nearly all of them have a pearly inside called naker or mother-of-pearl. *Pliny* in his Natural Hist. Lib. IX, Cap. 35, entitled Quomodo et ubi inveniuntur, margaritae, uses the word, gives the reason of its derivation, and makes it constantly masculine. In this he is followed by our countryman *Mr. Say* who makes it always of the masculine gender except in that species for which he gives credit to *M. Le Sueur.* Why the celebrated and accurate *M. Lamarck,* has chosen to make it feminine, we cannot even conjecture. *Order of description.* No certain order has hitherto been adopted by Naturalists in their description of Bivalves. The descriptions both of *M. Lamarck* and *Mr. Say* are without a definite method. Though they generally begin with the outline of the shell, yet they throw together promiscuously the other parts, both internal and external. I propose to reduce this subject to order in the following manner. In examining a bivalve, the first thing that strikes the eye of the observer is the *outside,* the second is the *inside.* Hence the description will be divided naturally into two parts, the *External* and the *Internal.* As it is by the interior that we determine the genera of the *Naiades,* as

* *M. Lamarck.*

well as of many Oceanic Bivalves, it might seem most proper to commence with that part in describing. But as the generick characters, standing at the head of the genus are supposed to be known, and are therefore not enumerated in the description, and as the method of commencing with the exterior has been generally adopted, we have not deemed it necessary to depart from the established usage. The parts are two, viz.

(A.) External. (B.) Internal.

Each of these comprehends three divisions, viz. I, Form, II, Color, III, Surface. With sub-divisions as follows, viz.

A. External.

I. Form and Substance includes

1. General outline or circumference.
2. Substance of the shell.
3. Disks, right and left.
4. Sides, anterior and posterior.
5. Umbones or bosses
6. Beaks.
7. Ligament.
8. Lunules, anterior and posterior.
9. Eight margins viz.
 a. Hinge, or dorsal.
 b. Basal.
 c. Anterior.
 d. Posterior.
 e. f. Anterior, dorsal and basal.
 g. h. Posterior, dorsal, and basal.

II. Color of Epidermis.

III. Surface.

B. Internal.

I. Form of

1. Cardinal teeth.
2. Lateral teeth.
3. Muscular impressions, or Cicatrices.
4. Cavity of the beaks.

II. Color of Naker.

III. Surface.

The eight margins explained. *Every* Bivalve shell may be supposed to be circumscribed by an octagon, which will be more or less irregular, according to the shape of the shell. The eight sides of the octagon will represent the eight margins, as will be seen by the following figure.

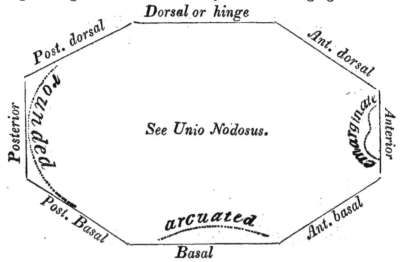

This distribution of the circumference of the shell, tends very much to precision in the language of description, for if it be said that any particular margin is *rounded, arcuated* or *emarginate,* the part intended cannot be mistaken. To go into an explanation in general, of terms used in description, would carry us too far from our present purpose. We refer to *Burrow.*

We come now to the description of species of the *Unio,* which we propose to distribute into five* sections, by the form of the Cardinal teeth.

UNIO.

Generick character from *M. Lamarck.*

Shell transverse,[1] equivalve, inequilateral, free, beaks decorticated,[2] somewhat carious, (presque rongĕs) Posterior

* *M. Lamarck* makes *two* sections, the principal distinction of which is, *non en crête* and *en crête,* applied to the Cardinal tooth.

muscular impression compound, hinge with two[3] teeth in each valve; the Cardinal one, short, irregular, simple or divided into two, substriated; the other elongated, compressed lateral, extending beneath the corselet. Ligament exterior.

1 & 2, Generally, but not always when young.
3, Others consider the divisions as separate teeth.

Divisions.

A. Cardinal teeth direct.

B. Cardinal Teeth, Oblique

Sections.

A. { *Cardinal teeth, very thick.
 { **Cardinal teeth, moderately thick.
 { ***Cardinal teeth, small.
B. { ****Cardinal teeth, broad, compressed.
 { *****Cardinal teeth, narrow, compressed.

*Cardinal teeth, very thick, direct.

Species.

1. *Unio Crassus.* Fig. 1. { a. inside.
 { b. outside.

Shell very thick, tumid; Cardinal teeth, lobed, angulated; Posterior cicatrix, deep, rough.

Unio Crassus. *Mr. Say.*
Unio Crassidens. *M. Lamarck.*
Mya ponderosa? *Mr. Dillwyn p.* 51.
Mr. Say's Amer. Conch. pl. 1, fig. 8.
Habitat. The Ohio, Mississippi, and the Lakes.
Diameter 2·4 Length 3·2 Breadth 4·8 inches.

My Collection.

Shell oval, ponderous, rounded behind, angulated before; Epidermis blackish brown; surface waved. Cardinal tooth deeply sulcated; anterior cicatrix wrinkled and striated; Naker pearly white and iridescent.

Remarks.—The varieties of this shell are numerous, and they differ considerably in form and surface. In some, the beaks are large, prominent, re-curved, projecting backwards

with a deep cavity beneath. In others, the beaks are flat, slightly elevated, having only a small cavity within.

Varieties.

(*a.*) Oval. *Mr. Say's* book, pl. 1. fig. 8.
(*b.*) Ovate. *Mr. S. B. Collins's* collection, hab. Ohio.
(*c.*) Triangular, do. do. do.
(*d.*) Quadrangular. My collection.
(*e.*) Orbicular. *Mr. Collins's* collection.
(*f.*) Undulate. do. do.
(*g.*) Rugose. do. do.
(*h.*) Radiate. *Mr. Say's* collection Philadelphia, Ouisconsin.
(*i.*) Unio, giganteus. Mississippi. *Dr. Mitchill's* collection.
(*k.*) Deeply folded. *Maj. Delafield's* collection.
(*l.*) With the cardinal tooth oblique. *Mr. Collins's* collection.

Variety (*c.*) has the beaks projecting and recurved : cicatrices deep ; primary tooth deeply sulcate ; lateral tooth long, high, and crenulate. It approaches our *Unio Undatus.*

The variety (*i.*) deserves particular notice. A single valve sent by *Professor Douglass* to *Dr. Mitchill,* weighs fifteen ounces. It is in every respect, a gigantic shell. The distance between the points of the two lobes of the cardinal tooth, is one inch ; the length of the lateral tooth, three inches ; diameter of the posterior cicatrix, one inch, and its depth one fourth of an inch. This shell of which four specimens were obtained by the N. W. Expedition, might perhaps constitute a separate species under the designation of *Unio Giganteus.* It is *three times* the size of the largest *Unio Crassus,* mentioned by *Mr. Say* and *M. Lamarck.* Three specimens.

Diam. 2·9 Length, 4·8 Breadth, 7·2 inches.
 3·0 4·6 7·0
 3·1 4·7 7·1 are preserved in *Dr. Mitchill's* cabinet. Another specimen

Diam. 2·9 Length, 4·9 Breadth, 7·0 and weighing fourteen ounces, is preserved in *Gov. Gass's* collection, Detroit. Hab. The Mississippi near Prairie du Chien. *Prof. Douglass.*

Variety (*k.*) has the Epidermis dark brownish red, and the shell is deeply folded like U. Plicatus. Hab. Lake Erie.

Maj. Delafield's collection.

Diam. 1·7 Length, 2·3 · Breadth, 3·1
Remark.—This shell is thinner than specimens of the same size usually are.

2. *Unio Undulatus.* Fig. 2. { *a.* inside.
 { *b.* outside.

Shell rhombick ovate, with numerous waving folds radiating from the beaks.

Unio Peruviana ?· *M. Lamarck.*

Taken by *Mr. Collins* in the Ohio and preserved in his collection.

Diam. 1·9 Length, 3·4 Breadth, 4·6

Shell thick, very short and obtusely rounded behind ; beaks slightly elevated ; hinge-margin sub-alated, compressed, carinated, distinct with a furrow on each side ; anterior dorsal margin sub-truncate ; Epidermis blackish brown ; surface finely wrinkled transversely ; wrinkles becoming lamellar on the anterior side ; *oblique folds* deeply indenting the anterior margin ; *waves* largest and deepest below, not extending to the anterior dorsal margin, fine, numerous, curved upwards, and extending to the ligament above ; *longitudinal* furrows extending from the beaks to the anterior dorsal margin ; decussating the oblique waves ; the lowest furrow deepest, the other somewhat obsolete ; disks tuberculated below the beaks. Cardinal teeth sulcated ; posterior cicatrix very rough and deep ; Naker pearly white, irregularly spotted with brownish green.

Remark.—A large and very beautiful shell.

3. *Unio Plicatus.* Fig. 3. { *a.* inside.
 { *b.* outside.

Shell sub-quadrangular, tumid, sinuous before with distant oblique folds ; hinge-margin elevated, compressed, carinated.

Unio plicata. *Le Sueur.* *Mr. Say.*
Unio Rariplicata. *M. Lamarck.*
Hab. Ohio, Mississippi, and Ouisconsin.

My collection. Cabinets of *Lyceum* and **Dr.** *Mitchill.*
Mr. Say's cabinet, Philadelphia.

Diam. ·75 Length, 1.0 Breadth, 1·3 inches.
 1·35 1·9 2·4
 1·9 2·3 3·2

Shell thick ; posterior side very short, obtusely round-
ed ; anterior side compressed, wedge-shaped ; beaks very
prominent, large rounded and projecting backwards nearly
as far as the posterior side ; ligament passing under the
beaks, anterior lunule distinct and marked with longitudin-
al furrows ; hinge margin alated, compressed, carinated ;
epidermis green, becoming blackish as the shell advances
in age ; surface glabrous, deeply folded ; folds indenting
the anterior basal edge. Cardinal teeth crenate, sulcate ;
posterior cicatrix rough ; cavity of the beaks deep and di-
rected backwards. Naker very white, tinged on the an-
terior side with rose colour; surface polished and on the
fore part iridescent.

Remarks.—In young specimens the folds are visible on
the *inside*, but in older ones the edge is not even indented.
This shell very much resembles the variety (*d.*) of the *Unio
Crassus.* Both shells will stand erect when placed on the
posterior side, being supported by the projecting beaks. *M.
Lamarck* observes that his *Rariplicata* is nearly allied to his
Peruviana, but if we have not mistaken his short definitions,
they are much more unlike than the two above mentioned.
Our undulatus will not stand on the posterior side, as the
beaks project very little.

 4. *Unio Undatus.* Fig. 4. $\begin{cases} a. \text{ inside.} \\ b. \text{ outside.} \end{cases}$

Shell, sub-triangular, sub-longitudinal, very tumid, waved ;
lateral teeth, *two* in each valve.

 Unio Obliqua? *M. Lamarck.*

Hab. Ouisconsin and Fox Rivers. *Mr. Schoolcraft.*
Dr. Mitchill's cabinet. My collection. *Mr. Say's* col-
lection.

 Diam. 1·5 Length, 2·1 Breadth, 2·2

Shell thick, disks swelled behind ; depressed before ;
anterior side slightly produced, rapidly narrowed, angulated ;
beaks projecting backward nearly as far as the posterior

side, elevated, and recurved, with the ligament passing be-
tween them; anterior lunule long-heart-shaped, and sepa-
rated by a slightly elevated heel; hinge margin depressed,
between the beaks; basal margin waved and rounded be-
hind, compressed in the middle, angulated before; epider-
mis horn-color, exhibiting a light yellowish green where the
surface is worn or rubbed, wrinkled and finely striated trans-
versely; surface glabrous. *Cardinal teeth* deeply sulcated
and crenated; *lateral teeth two in each valve!* internal or
lower one of the left valve small, but distinct and elevated,
and both marked with fine dotted striae. *Muscular impres-
sions* deep, posterior one rough. *Naker* pearly white.

Remarks.—This shell, as will be seen by its dimensions,
has a more globose form than perhaps any other Unio. It
will stand erect on the posterior side, and in this position
has something of a pyramidal appearance.

Variety (*a*.) Shell less, very slightly compressed, anterior
lunule much flattened, and the separating heel more eleva-
ted. No posterior lunule; transverse wrinkles deeper;
hinge bent to nearly a right angle. Teeth somewhat com-
pressed. Naker, pink or flesh colored; surface polished
and iridescent.

Diam. 1·0 Length, 1·4 Breadth, 1·6

Dr. Mitchill's Cabinet.

Remarks.—This shell differs in so many particulars from
the former that we might have given it a different specific
designation, had we not been averse to doing that in the case
of solitary specimens. *The double lateral tooth of the left
valve is distinct.*

5. *Unio Cornutus.* Fig. 5. $\begin{cases} a. \text{ inside.} \\ b. \text{ outside.} \\ c. \text{ Posterior slope.} \end{cases}$

Shell sub-orbicular, divided longitudinally by a regular
row of large, distant tubercles.

Hab. Fox River. *Schoolcraft.*

My Collection.

Diam. 1·0* Length, 1·7 Breadth, 1·8

* Exclusive of the horns.

Mr. Collins's collection contains a specimen from the Ohio of the following dimensions.

Diam. 1·0 , Length, 1·5 Breadth, 1·8

Shell thick, rounded behind, sub-biangulate before. *Beaks* somewhat elevated and nearly central, with the ligament passing between them; anterior lunule long-heart-shaped, compressed, distinct by a roundish elevated ridge which ends in a projection on the anterior margin, and marked by small transverse, sub-nodulous wrinkles, and obsolete longitudinal furrows; *surface* waved and on the fore part compressed; a regular row of large, distant, elevated and transversely compressed tubercles, extends from the beaks to the basal edge, dividing the shell into two nearly equal parts. *Cardinal teeth*, sulcated. *Naker*, pearly white, and iridescent.

Remarks.—This shell resembles the last in its color, outline, and glabrous surface. The teeth very much resemble those of the last, and there is also in the left valve, the rudiment of a *second* internal lateral tooth. The principal difference is in the smaller size of the present shell, and the remarkable *row of horns*, which furnish the specific designation. These horns are not opposite to each other, but alternate, and the highest one is in the right valve, nearly as high as the summit. In both the above mentioned specimens, the number of horns is three on each valve, and the rudiment of a fourth on the extremity of the basal edge. We rarely find shells from different and distant localities so much alike. Almost the only difference is in the elevation of the beaks of the former being greater than that of the latter. Exclusive of the beaks, the length, breadth and diameter of the shells, is precisely the same.

6. *Unio Verrucosus.* Fig. 6. $\begin{cases} a.\ \text{inside.} \\ b.\ \text{outside.} \end{cases}$

Shell sub-longitudinal, sub-truncate before; irregularly tuberculated; tubercles transversely compressed; inside brownish red.

Hab. Ouisconsin River. *Mr. Schoolcraft.*
Lake Erie. *Major Delafield.*
The collections before mentioned.

Diam. ·9—1·6 Length, 1·7—3·05 Breadth, 1·95—3·15

Shell sub-quadrangular, thick, rounded behind, biangulate and sub-truncate before; beaks elevated and recurved

ligament deeply inserted between the valves;- *hinge-margin* nearly straight, compressed alated, heel-shaped, and making an obtuse angle with the anterior -margin; basal margin rounded; epidermis light green, tinged with reddish brown; surface of the anterior part studded with irregular transversely compressed tubercles. . *Cardinal teeth* crenated or sulcated; *cavity* of the beaks very deep, compressed angular and directed backwards under the cardinal tooth; *Naker* brownish red with a tinge of blue, or light chocolate colored, slightly iridescent on the anterior part; the other dull and not highly polished; posterior muscular impression deep and rough.

Variety (*a.*) has the epidermis of an uncommonly light green without the brown tinge.

Hab. Lake Erie. *Major Delafield's* collection.

Diam. ·8 Length, 1·65 Breadth, 1·9

Variety (*b.*) is a slender and rather thin shell; epidermis very pale green; *Naker* pearly *white*, polished and iridescent.

Diam. ·9 Length, 1·6 Breadth, 1·9

Locality and authority as before.

- *Remark.*—If a straight line is drawn from the beak to the base, through the cardinal tooth, it will divide the tuberculated from the smooth part of the shell, in all except the variety (*b.*) in which the tubercles extend a little farther back.

7. *Unio Nodosus.* Fig. 7. { *a.* inside.
 { *b.* outside.

Shell, sub-quadrangular, sub-longitudinal, emarginate before, knotted, ridged, corrugated; lateral tooth terminating abruptly.

Hab. Ouisconsin. *Mr. Schoolcraft.*
Collections of *Lyceum* and *Dr. Mitchill.*
My Collection.

Diam. 1·8 Length, 2·5 Breadth, 3·0

Shell, thick and ponderous, short and very obtusely rounded behind; beaks distant, elevated, eroded, chalky or greenish white, with the ligament passing between them: Anterior lunule, compressed, wedge-shaped, separated by a deep groove, ending in the emargination in front. *Hinge-mar-*

gin, straight with the beaks projecting above it; anterior dorsal margin rounded; anterior margin emarginate; anterior basal margin; compressed and a little shortened, basal and posterior margins rounded. *Epidermis* horn color, surface irregularly corrugated and tuberculated all over, except a small portion of the posterior side. Tubercles largest near the centre of the disks, and often eroded; a strong, elevated and nodulous ridge extending from the beaks to the anterior margin and projecting in front. *Cardinal teeth* sulcated and crenulated. *Lateral teeth* short, thick, rough, crenated and terminating abruptly at both ends. *Cavity* deep and angular admitting the end of the fore finger.

Remarks.—The breadth from the emargination to the posterior side is equal to the length of the shell. Two specimens in the Lyceum's cabinet are wrinkled regularly and beautifully across the transverse striæ on the anterior lunule, giving to that part, a feather-shaped appearance. Other specimens have the lunule wrinkled and granulated. This shell will stand on the posterior side though not quite erect, but leaning towards the hinge.

8. *Unio Tuberculatus.* Fig. 8. {

Shell, long-ovate, surface corrugated, waved tuberculated, ribbed. Disks compressed, base falcated.
 Hab. Ouisconsin, *Prof. Douglass.*
 Cabinets of *Lyceum and Dr. Mitchill.*

Diam.	·7	Length, 1.3	Breadth, 2·4
	1·3	2·3	4·2
	1·3	2·4	4·5

Shell thick and rugged; anterior side compressed, narrowed thin; posterior side rounded, short, obtuse, and broader than the interiour. *Beaks* flat, placed about two ninths from the posterior end; *ligament* higher than the beaks; *hinge-margin* nearly straight, elevated, compressed and carinate before; basal margin compressed, falcated; anterior dorsal emarginate, anterior basal, projecting; anterior margin narrow and rounded. *Epidermis* dark brown or horn color. *Surface* thickly and irregularly tuberculated, tubercles elongated longitudinally; those near the base larger; an elevated ridge extending from the beaks and

projecting on the anterior basal edge; irregular profound, nodulous undulations radiating from the elevated ridge to the hinge and anterior margin. *Cardinal teeth* crenated; lateral teeth long and striated; posterior muscular impression deep, and the anterior half of it rough. *Cavity,* angular compressed, directed backward under the cardinal tooth, admitting the end of the finger. *Naker* pearly white, with irregular spots of greenish, iridescent on the fore part.

9. *Unio Rugosus.* Fig. 9.

Shell broad ovate; surface wrinkled tuberculated, ribbed, waved; disks swelled; base falcated.
Hab. Ohio. *Mr. Collins.*
Mr. Collins's Collection.
Length, 2·3 Breadth, 2·9 Diam. 1·5

Shell narrowed, compressed and thin before; short, obtuse, rounded and wider behind; *beaks* slightly elevated; ligament more elevated than the beaks; *hinge-margin* compressed, carinate; basal margin falcate, emarginate, and compressed; anterior margin sub-angulate; anterior dorsal margin sub-truncate, nearly straight; anterior, basal margin projecting. *Epidermis* dark brown, under the epidermis pearly white. *Surface* rough and scaly, wrinkled transversely and waved longitudinally, having distant irregular transversely compressed tubercles; a broad nodulous elevated somewhat double ridge extending from the beaks to the anterior basal edge, and projecting on that part; a broad furrow or wave behind the ridge ending in the emarginate basal edge; and a furrow before separating the anterior lunule; small oblique waves radiating from the ridge to the hinge and anterior dorsal margin. *Cardinal teeth* sulcated; lateral tooth striated rough and in the left valve somewhat double: Posterior muscular impression deep and partly rough. *Cavity* of the beaks angular, compressed and directed backward under the cardinal tooth. *Naker* pearly white, and on the fore part iridescent.

Remarks.—This shell agrees in some parts of its description with the U. Tuberculatus. It is, however, while of the same length, of only a little more than half the breadth, and yet of longer diameter. The tubercles, also are very different. In the U. Tuberculatus they are compressed *lon-*

gitudinally, in this *transversely*, in that they are crowded and small: in this they are distant and rather *large*. The elevated ridge in that is higher and narrower; in this it is broader and more depressed; in that it continues of nearly the same breadth to the base; in this it diverges at the base, to about four times its breadth at the beaks. The shell above described has the appearance of age. The tubercles, as well as the beaks are much corroded, and the epidermis is cracked and broken in many places.

<center>*Remarks on the first section, viz.*</center>

<center>* Cardinal teeth, very thick.</center>

To this section belong the *U. Peruviana, ligamentina* and *obliqua* of *M. Lamarck*, and the *U. Cylindricus?* of *Mr. Say.* The shells in this section bear in many respects, a resemblance to each other. They are all thick, and have a very strong hinge, with, in most cases, deeply sulcated cardinal teeth, and a cavity under the beaks, more or less angular and compressed, extending under the cardinal tooth. They are nearly all waved, wrinkled, or tuberculated on the outside. From the last two characters, however, some varieties of the *U. Crassus* are excepted, which have little or no cavity under the beak, and a small external surface.

It may perhaps be thought that we have made too many distinctions in this section, and that several of the foregoing ought to belong to the *U. Crassus*, but they are much more unlike than many which are admitted to be distinct species, and therefore they require a separate description. And when it is observed that we have not yet enumerated all that have been supposed to belong to the numerous family of the *Crassus*—that the ascertained varieties of that species have already been described to the number of eleven from (*a*) to (*l*) inclusive; and that among these varieties are several which *M. Lamarck* has described as different species—and that the foregoing are all very distinct from each other, so as to be instantly recognized by even an inexperienced observer—we shall perhaps be justified in discriminating the above, and several others also, which belong to the next section.

<center>(*To be continued.*)</center>

PHYSICS, CHEMISTRY, &c.

——◆——

ART. VII—*An Essay on the formation of the Universe:* by
Isaac Orr, *one of the Professors in the Asylum, for the
Deaf and Dumb, at Hartford, Conn.*

TO THE EDITOR.

Dear Sir,

If it is admissible in the explanation of appearances, to ad-
duce a theory, whose absolute and invariable characteristics
are wholly coincident with fact; aand whose variable charac-
teristics admit of such a construction, as to be also coincident;
and whose allowable irregularities usually exist in those ap-
pearances; the present attempt to illustrate one of the most
difficult physical subjects will not want an apology, though
it should eventually be numbered with other similar at-
tempts, that have sunk with their projectors into their own
oblivion.　It is far from being the least difficulty, to be met
by a theory, professing to account for the motion and rela-
tive position of the heavenly bodies, that such theories have
been so numerous and so utterly visionary, as to stamp seem-
ing futility on all.　In view of so formidable an array of ad-
verse public opinion, it seems sufficient to collect, arrange,
and exhibit the proofs of such a theory, and leave it for oth-
ers, who are not personally interested in the decision, to
judge of their validity.　Whatever is asserted in this me-
moir, although perhaps, sometimes passed over rather too
briefly, can, I believe, in all cases, be amply substantiated.
In several instances where it is said that assertions are de-
monstrable, the demonstrations are omitted, on account of
their length, or comparative want of importance.　They will
be given hereafter, if they should be demanded.　For sev-
eral remarks and demonstrations, with regard to the separa-
tion into strata of a finite ocean of concreting aerial matter,
when particular gravitation is supposed infinite ; the con-
struction of strata by accumulation at their edges; the diur-

nal motion of the satellites; and the relative position of the orbit of Mercury and the equator of the sun, as well as a variety of other useful suggestions, I am indebted to Mr. Fisher, the late able Professor of Mathematics and Philosophy in Yale College; and while with the remembrance of his former assistance, I mingle regret that he was not permitted privately, as he intended, to lay the following speculations before European minds powerful and acute like his own, and to aid further in rendering them more lucid and satisfactory; I cannot omit to add, that America, and the world have great reason to regret the premature and tragical death of this distinguished young man.

In the examination of the solar and the stellar systems, various phenomena occur, which are much too regular to be considered the pure effects of accident, while on the other hand, they are not sufficiently so to be attributed to the immediate operations of an intelligent designing agent. To such operations they have heretofore been attributed, solely because, on any other ground, they seemed utterly inexplicable, and the ends aimed at in their existence have been taken for granted, although the human mind could discover nothing respecting them. Of these phenomena the most obvious are,

1. The primitive parts of the earth, so far as they have been examined, are apparently the result of purely chemical precipitation. There are sufficient reasons to believe, that the quantity of water above their surface has been very greatly diminished.

2. The sun revolves on its axis, and all the planets in their orbits, in the same direction, and nearly in the same plane : and likewise all the planets that have satellites, revolve on their axes in the same direction as their satellites in their orbits, and nearly in the same plane.

3. The planets *generally* revolve on their axes in the same direction with the sun : and the satellites, so far as their diurnal motion is known, and probably in most instances, revolve on their axes in the same direction with their primaries. The most remarkable irregularities are near the sun, at the superior extreme of the sun, and probably at the orbits of the asteroids.

4. The velocity of each planet on its axis, has a *general* direct proportion to its quantity of matter, and distance from

the sun : and an inverse proportion to the number and mass of its satellites. The revolution of each satellite on its axis, and its periodical time, are probably equal.

5. The planets, taken with respect to their masses and intermediate distances, exist in two distinct series, the upper one of which gradually increases, and the lower one gradually increases and diminishes in quantity of matter as we descend toward the sun : and on the contrary, the eccentricities of the successive orbits have in the upper series a gradual diminution, and a gradual diminution and increase in the lower series. The planets of the upper series are much the largest and most distant apart. With regard to intervening distance an analogy is known to exist between the planetary and lunar systems, and there are reasons to presume that it exists also with regard to eccentricity and quantity of matter.

6. The asteroids appear to exist in pairs, two of them having atmospheres similar to each other, but much greater than the atmospheres of the other two ; and the individual of each pair which has the most oblique orbit, is in very nearly the same degree the most eccentric, and its mean distance from the sun is in a different degree the greatest.

7. The rings of Saturn are nearly in the same plane with its equator and satellites : The inner ring is much larger than the outer one, and their angular motion is a little slower than that of the planet, but much more rapid than that of a satellite at the mean distance of its parts. Saturn in contradistinction from all the other planets, and from the form which it would naturally assume if it were fluid, is considerably depressed about its equator.

8. The densities of the various planets and satellites are *generally* in inverse proportion to their quantities of matter, and in a direct proportion to their distance from the sun.

9. Comets move indiscriminately and almost equally in all directions. The perihelia of all of them are between the sun and the orbit of Jupiter ; and the orbits of the intervening planets are, with regard to their obliquity, the most irregular.

10. The stars are not uniformly scattered over the firmament, but appear in nebulae, which are generally arranged into strata, and run on to a great length. Some of these strata appear parallel to each other, and some in the shape

of a fan. With the exception of these strata, and numerous subordinate circular collections, the figures of the various clusters seem to be wholly fortuitous.

If the primitive rocks were precipitated from water, the precipitation, according to all our experience on the subject, must have been gradual. At the time of such precipitation the earth must have had a diurnal motion, because it evidently partakes of the spheroidal form derived from such motion, far below the general level of any rocks with which we are acquainted. This motion, in connexion with the influence of the other bodies in the system, would produce a disturbance in the water around the earth, similar to what the tides now exhibit, but much greater in degree. The unavoidable inequalities in the surface of the accumulating rocks, would subject them, at least in some degree, to trituration at the prominent parts, and to alluvial deposites in the cavities. But no such deposites can be found. Besides, from our knowledge of their constituent parts, we have every reason to conclude, that many of them are not at all soluble in water, whereas by heat and electricity they can all be dissipated. There is, therefore, at least good reason to presume, that by these and other elastic agents they were once separated, and came together either partially by the aid of water, or wholly without it.

In the process of the argument it will be necessary to take several things for granted, of which the proof is cumulative, or most appropriate in another place. Suppose the component particles of the matter in the solar system to have never come together, but to be mixed indiscriminately, and distributed by means of light and heat, in a flat spheroid, having its greatest diameter some millions of miles longer than that of Herschel's orbit, and revolving with such rapidity as to throw off portions from its circumference. As the heat and light abandoned it, its various parts would condense either by explosion or sudden combustion, according to the different forces of attraction among their component particles. Suppose that by some means or other its motion should be increased to such a degree, that by the time it had shrunk to about midway between the orbits of Saturn and Herschel, it would have thrown off from its circumference as much matter as is contained in Herschel and its satellites. Suppose that its motion should be still in-

creased, so that by the time its circumference had arrived about midway between the orbits of Saturn and Jupiter, it would have thrown off as much matter as is contained in Saturn and its satellites. Make the same supposition for Jupiter, and so successively for all the planets below Jupiter. This ejected matter, unless the cause of motion were variable in its direction, would be left moving nearly in the same plane. Having lost its equilibrium the mutual attraction of its parts would unavoidably draw it together. It would first collect into small bodies, and these into greater. As soon as reaction took place at the centre of a body, unless the matter were perfectly dense, there is an infinity of chances against one, that it would commence a circular motion similar in some degree to that of eddies and of whirlwinds. The circular motion of whirlwinds is produced by air proceeding, while unresisted, in a direct course towards a central line. In a condensing insulated body the circular motion would be produced by the force of the matter proceeding in a direct course towards a central point. This motion would recede from the centre no faster than the reaction between the central wheels, and the aerial matter collecting towards it. When the central wheel had commenced its motion, the collecting matter would proceed, not all the way in a direct course towards its centre, but in curved lines eventually becoming tangents to its circumference. This curved direction would be produced by friction among the extreme concentric strata of the wheel, whose great rarity would render the deviation very gradual. There are cases with which we are familiar, where the motion of non elastic matter would be annihilated, while that of elastic matter is almost wholly retained; and it seems in the case before us, as if the matter would be turned into a circular course without any very great loss in its acquired rectilinear motion. As the matter accumulated on the central wheel, there would be a constant increase of compression throughout the whole, which would be always least at the surface and centre, and greatest at some point between them; and from the centre this point would constantly recede. For at the extreme circumference, or the place where the matter commenced a curvilinear motion, there would be no increase of compression; and the strata near the centre having the same *increase* of weight or pressure

upon them as the higher strata, and having on account of their greater *degree* of compression, a greater power of resistance, the spaces which they occupied would not be so much reduced in a given time, as the spaces of the higher strata. By this increase of compression the matter which at any one moment seemed in equilibrium, would continually advance toward the centre, and retaining the same actual velocity, its angular velocity would be increased, and the increase of angular velocity would be constantly transmitted from the whole wheel toward the circumference ; in the greatest degree from the point of the greatest increase of compression, and from all parts in a degree proportioned in some measure to their distance from that point. Here we perceive a double and nearly contemporaneous source of increase in the angular velocity at the circumference ; the force of the falling matter, and the increase in the compression of the central wheel. The action of the falling matter would be immediate : the effect of the consequent compression would instantly commence, but would be rather more dilatory in their termination. There is another compound source of angular velocity considerably similar to this, but much less in degree and in the rapidity of its operation. According to the known properties of matter, considerable portions of the aerial wheel would concrete by instant explosion or sudden combustion, into a densely fluid or plastic state, and would proceed towards the centre of the wheel, and there form a nucleus, which being aided in the commencement of its motion by the aerial part of the wheel, would revolve in the same direction. With regard to these condensed portions of the wheel, there are two difficulties to be obviated; the resistance which they would meet in proceeding to the central nucleus, and their liability to strike it in a direction differing from a tangent to its circumference. With respect to the first we may suppose, that the density of the aerial and condensed matter might be very greatly different ; and the supposition is perfectly consonant with our experience. The cohesion of the falling bodies might be so great as to prevent their being dissipated, while at the same time their fluid or plastic state would enable them to assume all the length of form which is necessary to reduce their resistance to its smallest degree. The other difficulty is no less easily obviated, for the state of the case renders it

necessary that the condensed parts, most remote, should by the motion of the aerial parts, be most turned out of a direct course towards the centre of the nucleus ; and the supposition is perfectly reasonable, that the deviation might be so regulated, that all, or nearly all of the condensed bodies would strike the central nucleus in a tangent to its circumference. By the expulsion of heat and light a compression would take place in the nucleus a little different from that in the aerial part of the wheel, but the same in effect. The various portions of the nucleus, having acquired a degree of actual velocity, would merely by their approach to the centre, increase the angular velocity of the nucleus. It is obvious that the motion derived from this complex source in the nucleus, would not stop at its surface, but would be constantly conveyed by means of friction between the concentric strata, to the extreme circumference of the aerial wheel, till the angular velocity become uniform throughout. While this complex process was going on in the planetary wheel, it would collect a belt of the ejected matter from all parts of its orbit, whose width would depend on the extent of that orbit, or the quantity of matter ejected within given limits from the solar wheel, and likewise in some degree on the rapidity of condensation. Great extent of orbit, great quantities of matter ejected within given limits, and rapid contraction in the solar wheel, would tend proportionally to increase the width of the belt ; while rapid contraction in the planetary wheel would tend to diminish it. It is obvious that all the causes favourable to great width of belt, except slow contraction in the planetary wheel, would belong peculiarly to the higher planets. If the planetary wheel should acquire sufficient magnitude and motion, it would in its turn eject portions from its circumference, in the same manner as the solar wheel, and these portions would form its satellites.

The motion of the planets and satellites, both on their axes and in their orbits, would be *generally* in the same direction with each other, and with the equator of the sun. Suppose P, fig. 1*, an accumulating planetary wheel, at the same distance from the solar wheel as b. A body at b would be equally liable to fall to the right or left towards P, and of course the whole of the matter in the same circle as b, would leave the direction of P's diurnal motion doubtful. But as the solar wheel shrunk from P, its emitted portions

* See Plate at the end.

would be more and more rapid, both in their angular and real velocity. Therefore a body at r would strike P before, and the general tendency of the matter in the vicinity of P would be to commence its motion the wrong way. It is necessary then to find some force sufficient to reverse the motion. Suppose a body at m has an excess of velocity above that of P, a little greater than what it would acquire in falling to m, from a point a little above the point nearest to b, in the circle of m's emission : it would evidently rise and fall to the right. As the body is supposed to start from points nearer and nearer to the centre of S, it would trace out the curved line b n of projectile separation ; till the difference of angular velocity between P and the supposed body, would be equal to the velocity acquired in falling from near b to n, and then all the ejected matter on the left side of S would pass over to the right towards P, or not pass at all towards it. It is evident that all this excess of matter passing to the right, would strike P or its outer hemisphere, on account of its tendency to continue in a right line, and of course the motion of P on its axis, would be *generally* in the same direction as in its orbit ; and if P should produce any satellites, they also, both on their axes and in their orbits, would revolve in the same direction. It will doubtless be observed, that this, as well as the other demonstrations, shews a want of exactness, which leaves the mind somewhat dissatisfied ; but it will also be observed, that as it aims only to prove general truths, because no others are necessary, so it enables the mind to perceive those truths with the utmost certainty. The first in the series of planetary wheels would obviously be most liable to derangement in its equator, because there would be nothing above it to aid in regulating its position, whereas all the succeeding ones would be more and more influenced by the solar wheel, and would also be influenced by the planetary wheels above : so that the plane of their equator would on that account be more likely to approach the plane of the solar equator.

It may be objected to this mode of formation, that it would require an immense quantity of heat and light, which would be of no use but merely to aid in forming the system, while the energies of an intelligent spirit might supply its place as well, and prevent this profusion of materials. But it appears to be by no means certain, that such an abundance

of heat and light would afterwards be useless. The heat by
a general diffusion might maintain the system in a mild tem-
perature for an immense length of time after its internal heat
was almost exhausted; and the light by its being very slight-
ly latent on account of its abundance, might enable an acute
organ to observe surrounding objects by the smallest motion
of the atmosphere, after the system was enveloped in dark-
ness; in the same manner as we now see the dashing of the
waves, or the motion of meteoric rocks in the sky. In a
metaphysical point of view, there is no reason why the sys-
tem might not have been formed by the immediate agency
of an intelligent spirit, as well as by the agency of light and
heat; but there are phenomena actually existing which are
perfectly consistent with its formation by light and heat, but
which on the supposition that it was formed by the immedi-
ate agency of an intelligent spirit, are utterly inexplicable.
The relative diurnal motion of the various bodies in the sys-
tem, present not the most distant indications of design; and
yet they are about such as they must be, on the supposition
that the system was produced by condensation from an aeri-
al state. These motions in case of such a formation, would
be proportionally increased by magnitude of orbit, and
quantity of matter, and diminished by the mass, number and
distance of the satellites. Saturn's diurnal motion is not
quite so rapid as that of Jupiter; its orbit is much larger,
but its mass is less, and its ring and satellites are heavier and
extend to a greater distance than those of Jupiter. Mars is
less than the earth, but its orbit is greater, and it has no
moon: its diurnal motion is a little slower than that of the
earth. Venus is about equal in size to the earth, and it has
no moon, but its orbit is less than that of the earth: their
diurnal motions are about equal. The orbit of Mercury and
its quantity of matter are much less than those of Venus;
and so is its diurnal motion. The moon to acquire its pre-
sent velocity, must have fallen to its present distance from
its primary, through a space about equal to $\frac{1}{780}$ of the diam-.
eter of the orbit of its primary; the highest satellite of Jupi-
ter through $\frac{1}{775}$; and the highest of Saturn through $\frac{1}{780}$. It
may be remarked with regard to all the satellites, that if they
acquired no motion at all by the collection of their parts, they
would notwithstanding have a diurnal revolution exactly co-
inciding with their revolution round their primaries: and if

by collection they acquired a very considerable degree of motion round their axes, their constituent wheels would immediately assume a shape elongated on a line drawn through them from their primaries, and would tend to remain in this position; so that however great the velocity of the internal parts might be, it would be continually diminished by friction proceeding from the exterior, till the wheel became stationary on the abovementioned line, or the whole became solid.

Multiplying the width of the rings of ejected matter which it is reasonable to suppose was about taken up by each of the planetary wheels, into the length of their orbit; and dividing its comparative quantity of matter by this product, we shall obtain the proportionate average quantities of matter ejected in a given space from the solar wheel, through the various steps of its progress. The result gives for Herschel 0,093, Saturn 1,552, Jupiter 14,812, Pallas 0,075, Ceres 0,054, Juno 0,016, Vesta 0,010, Mars 0,086, the earth and moon 2,946, Venus 4,357, Mercury 1,490. From the state of the case the calculations are unavoidably loose; but if we vary the premises within any rational limits whatever, the same general result is inevitable. If the two sources of emission described above, were regular in their increase and diminution; and if the ejected matter composing the two series of planets, instead of collecting together, be supposed to remain at the same distance from the common centre at which it was emitted, and to be distributed in two concentric rings of equal density, a section of these rings by a perpendicular plane passing through the common centre, would be lenticular, having the widest parts nearer the inner than the outer extremes. If we take the quantity of matter included between two such sections meeting at S, fig. 2, and suppose the velocity of each part to be the same that it had when separated from the solar wheel, the parts from m to a, and from n to S, would be *nearly* in the shape of a pyramid; and from e to m, and from a to n, in the shape of a wedge. In the part J, the centre of its gravity, or the place where the whole of that part would meet in case of condensation, would be about g, near its base; whereas the point of average velocity, on the point where the matter should meet to move with the same velocity as the portions there emitted from the solar wheel, that is, to move in a circular orbit,

would be about v, nearer the vertex. In the part H, those points would obviously be reversed, so that somewhere between the parts J and H, they must coincide. What would hold true of such a portion of the ring, would, in respect of gravity and velocity, be true of the whole. Planets formed at the place where these points coincide, would move in circular orbits ; and the éxcentricities in the various orbits would have a general proportion to their distance from the place of coincidence. This is the case with the eccentricities in the solar system. The cause of emission being much more rapid and powerful in its operation, and the orbits being larger in the upper than the lower series, the planetary wheel in the upper series, as was shown above, would of course be the largest.

Between the upper and the lower series of planets there is a large space, where the quantity of matter thrown off from the solar wheel must have been comparatively small. Suppose that two distinct bodies were formed in the same circle of this diminutive portion of the great belt, at opposite sides of the circumference. Many such bodies of a smaller size must of necessity be formed, and must proceed to meet and combine with the one that commenced the formation, and had acquired a superior influence above the rest. Those which came in last would of course be the largest : and it is perfectly reasonable to suppose, that the last of all might be nearly equal to the principal one. The smaller body in proportion to its inferiority to the larger one, would have a tendency to strike it on its higher hemisphere, or the one most distant from the solar wheel. If it should strike the larger one so far up as to bound off from it, the smaller one would obviously be thrown in a direction diverging from its natural course, and from the solar wheel. If the smaller body should strike the larger one on its posterior bemisphere, the original motion, or the motion which it had when thrown off from the solar wheel, would be accelerated and that of the larger one retarded. But if the smaller should strike the larger one on its anterior hemisphere, the original motion of the larger one would be accelerated, and that of the smaller one retarded. This is evident from the fact, that the force of percussion could not have so great an influence to accellerate or retard their motion, as the force of their mutual attraction prior to percussion, or else they would remain together. Here then we find three causes of eccen-

tricity ; the general one arising from the difference in the rapidity of emission ; the change of direction by percussion, and the change of velocity by the same cause. But the cause of the obliquity of their orbits is one, and therefore renders that obliquity a surer basis of calculation. If the point of percussion were not in the plane of the equator of the solar wheel, the two bodies would evidently be thrown out of that plane, and the relative obliquities of the two bodies in each pair, would at least approach an inverse proportion to their quantities of matter. With regard to the coincidence among their nodes and perihelia, it may be remarked, that the greater asteroid of the lower pair would, in all probability, commence its formation near the greater one of the higher pair ; and likewise the smaller one of the lower pair near the smaller one of the higher. This would obviously be true on the very probable supposition that not a very long space of time intervened between the formation of the upper and the lower pair. The same remark may be extended to the other planets ; for it is obvious, that on account of mutual attraction, each planet would commence its formation as near as possible to the one next above it. It may also be remarked, that the smaller asteroid of each pair would take the direct course towards the greater one, and of course immediately after percussion, it would have the most rapid motion, and eventually the largest orbit. On this subject a close inspection of the demonstration respecting the rotary motion of the system, will be conclusive. In this respect theory agrees with the actual state of the asteroids. The explosive theory proposed by Dr. Olbers, is indeed practicable : but if the asteroids had been separated from a solid planet, they would still float through the heavens, the obvious fragments of spheres ; and if they had been separated from a pulverulent or plastic or fluid planet, they would have been driven into a multitude of parts, unless the planet had been thoroughly divided by regular and uniform strata of the exploding substance, a most wonderful device in an omnipotent Creator to split a planet, and make its parts move irregularly. But it would seem as if the circumstance alone respecting the atmosphere might put the subject at rest.

The ring of Saturn, while in its present situation with regard to the planet, could never have been in a state wholly

fluid, or aerial; for, being destitute of an equilibrium, the mutual attraction of its parts would immediately have reduced it to a spherical figure. But suppose the matter contained in Saturn and its ring, when condensing from an aerial state, had been retained by the force of its satellites, in the form of a flat spheroid; it would gradually stiffen by the expulsion of light and heat, and most rapidly at the edge on account of its tenuity. Eventually the edge, by reason of its greater increase of density, and excess of velocity above what would keep a satellite at its distance from the centre, would be abandoned by the interior part of the wheel, and form a ring around it. The slender edge of the planet, as soon as released from its connexion with the ring, would fall into the planet, and inevitably produce a depression about its equator. The planet being in a plastic state, could not restore itself to the form which it would naturally assume if it were fluid; so that it must still remain at least in some degree depressed about its equator. Such is Saturn's form in reality. Astronomers have accounted for the forms of all the other bodies in the system, by the principles of gravitation. This stands a single anomaly, and by all the principles of gravitation and motion in which it is now concerned, it is wholly inexplicable. If we suppose half the quantity of matter contained in the ring of Saturn to be solid, and perfectly regular, and the other half to be fluid, the fluid parts having an attraction for each other, the lateral perpendicular action of the solid part could do nothing to prevent accumulations from commencing, and when they had once commenced, they would unavoidably continue, till the whole would be collected together; and the most of the solid part, being much more distant from the fluid parts, than the fluid parts from each other, its comparative action would of course be feeble. From this example it is easy for the mind to perceive, that however small the fluid part might be, it would have a similar tendency to accumulate in a degree proportioned to its quantity. If the ring, after its formation, remained entirely regular, the least bias possible, as La Place has shown, would destroy its balance, and it would be certainly and inseparably attached to the planet. For if the planet P, fig. 3, receive a bias toward the parts of the regular concentric ring m n r s, the parts m, n, r, having the same force as s, could not by revolving change the

direction of P's motion, which would be continued toward the stationary point at s, because toward that point the force would be instantly and constantly increased, while toward that at m it would be in like manner diminished. But if the part of the ring at s were considerably more massive than the other parts, then as s passed round, P would incline to follow it: but s constantly changing the direction of its force on P, would tend to draw it from its original direction; while the momentum, acquired by P, would tend to continue it in that direction; and P would eventually move in a small orbit within the ring. For sometime after the commencement of P's motion, s would act upon it in some chord of P's orbit. The direction of its action would continually move toward the centre of motion, till it arrived at it, and there it would stop; and the centre of motion would coincide with the centre of gravity. For P having acquired its greatest possible motion, and that of s being reduced to its least degree, s would have no tendency to vibrate to the other side, and of course could not draw P backward in its orbit. The same reasoning will apply to the sun and planets, and to the primary planets and their satellites, and the general centres of motion and of gravity, in every case that has been assumed in explaining the formation of the system, would in like manner be adjusted. The account which Dr. Robison has given of the formation of Saturn's ring, is incomparably more natural than the explosive theory of the asteroid. Notwithstanding, there appears to be considerable difficulty attending it. The form which glass assumes, by whirling when in a viscid state, gives it a very considerable degree of plausibility ; but the mutual attraction between the parts of a small glass plate must be very trifling compared with that in the ring of Saturn, so that the analogy is very incomplete. The distance between the limits of the smaller and greater spheroids, which may be produced in the same body of fluid or aerial matter, by the same angular velocity, is very great; and the body while passing between these limits could not maintain an equilibrium. Its parts must of course while passing through the whole of that distance tend to collect together irregularly. Besides, a whirling plate of glass is thicker at the circumference, than at the parts between the centre and circumference ; so that the analogy, imperfect as it is, militates against the theory. But if the case were attended with no difficulty, Dr. Robison has, at least in some degree, gone

counter to one of the laws of investigation laid down by
Newton; by assigning causes more than sufficient to pro-
duce the effects in question; for it would obviously be as
easy for the Deity to create a body of whirling viscid mat-
ter in the greater as in the smaller spheroid; and then the
process of driving it out from the centre would be unneces-
sary. This is only taking a wide step toward the theory of
condensation from an aerial state; for it would be just as
easy for the Deity to create whirling spheroids of aerial, as
of plastic or fluid matter, and then a mechanism for the
motion of the satellites is contrived, as well as for that of the
ring.

To account for the relative densities of the various bodies
in the system, seems at first beyond the grasp of the theo-
ry, because we cannot inspect the interior even of our own
planent, much less can we that of the rest. But it is a well
known fact that all large bodies of condensing homogeneous
substances, stiffen first on the out side; and the supposition
is perfectly reasonable; that the bodies of the solar system
might so stiffen near their surface, while the interior remain-
ed very much heated and expanded. Beneath this crust,
the interior parts would collect and condense upon it, as
water on the lower surface of ice, until it became strong
enough to support itself by its own density. It would then
cease to sink any further toward the centre, and the remain-
ing fluid or viscid parts of the body, as the heat gradually
abandoned them, would shrink so as to form immense cav-
erns, or would collect together on a central globe, which
might eventually become entirely disunited with the exter-
nal shell. In such a case it is easy to see, that it would first
be disunited from the polls of the external shell, because
they would cool most rapidly on account of their distance
from the great solar fire, and the obliquity of the rays from
that fire, which aided in continuing their heat. It would
then gradually be detached from the equator of the shell,
till it adhered only at a single point; and eventually, if it
separated from the whole, and its centrifugal force from
the common centre of gravity of the two parts, were,
by disturbance, in the least diminished, it is rigidly de-
monstrable, that the internal globe would immediately move
toward one of the poles of the external shell, and there is
an infinity of chances against one, that it would change both
the direction and degree of its diurnal velocity. The inter-

nal globe also would have a tendency to form the external fluids of the shell into an oval figure, which would be most raised at the place where the internal globe was situated, so that whenever this globe changed its situation, the situation of the external water would also be changed. This is probably the best account of the deluge, that it is possible to give. The comparative density of the bodies in the system, would depend on their nearness to the central fire; their magnitude; and their liability to be disturbed during formation. The bodies most distant from the central fire would cool most rapidly, and their permanent external shell would be formed while the interior remains much more heated and expanded than if they had been nearer it. Also large bodies would stiffen on the outside while their interior remained more expanded, than the interior of smaller bodies at the same distance from the sun; and therefore their density would be less in proportion to their magnitude. Bodies subject to disturbance, would of course have their shells broken up, when if they had been free from disturbance those shells would have remained permanent. Disturbance, therefore, would increase the density. It is needless to remark, that so far as we know the relative densities of the system, with this theory they are perfectly coincident.

The motion in the great solar aerial wheel, assumed at the commencement, has not yet been accounted for: but by an inspection of the argument respecting the motion of the planetary wheels, it will be seen, that the assumed motion of the solar wheel might have been produced in the same manner. All that is necessary, is to suppose, that the matter in the system was diffused equally through a space extending to an immense distance, perhaps half way to the nearest fixed stars; and it is worthy of remark, that the power of gravitation would bring the whole to the centre very nearly in the same period of time: a circumstance without which, the formation of the system as explained above, could not have been effected. The great length of this period, probably about 28,000,000 years, seems at first a very considerable objection to the theory: but when the vast resources of eternity are opened to view, and when it is considered, that the matter might as well be moving during that period, as to be at rest or not in existence, the ob-

jection cannot be deemed insuperable. The comets may be supposed to have been formed from the lingering portions, that did not come in soon enough to be combined with the system; and with this supposition their characteristics perfectly agree. They would be liable to come equally from all directions, and their elliptic orbits must have been produced principally by percussion on the solar wheel. Agreeably to this, the planes of the planetary orbits about the perihelia of the comets, are the most irregular. The plane of Mercury's orbit and that of the solar equator make nearly the same angle with the ecliptic, and it is reasonable to conclude, from the motion of Mercury's nodes, that at the time the system may have come into existence according to the theory, the plane of Mercury's orbit about coincided with that of the solar equator.

If the matter in the solar system has once been diffused about half way to the nearest fixed stars, there is good reason to believe, that the milky way at least, and perhaps the whole or a great portion of the universe, was at that time in one vast aerial ocean; and that it began to separate and form into clustres and systems, as soon as it was created, on account of an immediate tendency to such a result; or that it remained in a quiescent state for some time at least, till by the arrival of a disturbing force, such a result was effected. It is a well known fact, that the component particles of matter *may* be in such a state, as to remain separate while quiet, when the least disturbance would produce instant concretion. Keeping this in mind, it will be easily seen, that if the ocean of matter were finite, and so created that it would concrete without a disturbing force, the concretion would commence throughout all parts at once, and the collective forms of the clusters must be principally or wholly accidental, if we except the tendency which they *might* have, to become spherical: For though a regular principle of formation into parallel strata, would proceed from the exterior through the interior, in case the inner stars in the mean time remained perfectly stationary; yet on account of its dilatory progress, most of the ocean of stars, if left to unrestrained mutual attraction, would have acquired accidental forms too decided to be broken up by so weak a regulating force. But if the finite ocean required a disturbing force to effect its concretion, it would evidently begin to

concrete on the outside only, and on all sides at once. In-
fluenced by the attraction of the interior, the parts near the
outer surface would proceed towards it; and when suffi-
ciently accumulated, if particular gravitation were finite,
that is, the gravitating power of a definite body of matter,
it is rigidly demonstrable, that under given circumstances it
would produce a far distant disruption in the aerial ocean,
somewhere about the limit of the particular gravitation of
the exterior. The demonstration will not at present be giv-
en; but it will perhaps be sufficient to remark, that if the
particles of aerial matter were held together by a force
merely sufficient to prevent their disunion ; by the arrival
of forces which had not acted upon them before, that is,
the particular gravitating forces of the approaching surface
of the aerial ocean, such a disunion would then be inevita-
ble. At the place of disruption, the two surfaces would
separate with the greater force as their distance increased:
the separating stratum would break up into systems, and
the new formed surface of the ocean would advance toward
the interior as before. If the ocean were sufficiently large,
the strata would have a constant tendency to regularity; for

if they were crooked as $\underset{* \quad * \quad *}{\overline{\text{a} \quad \text{b} \quad \text{c}}}$ the parts about a and c

would continually retard those at b, till the strata approach-
ed very near to a regular figure. If the ocean were infinite,
and of such a nature as to concrete without a disturbing
force, its formation into worlds would of course be simulta-
neous throughout, and the collective forms would be wholly
and inevitably accidental, without any immediate or subse-
quent law whatever to effect regularity. If the ocean were
infinite, and if particular gravitation were not infinite, there
appear to be two *possible* modes, in which the formation
might be effected. The strata, as accident made them so,
might be flat, prismatic, and cylindrical, formed by accumu-
lations at their ends, and continued in a direction parallel to
each other, and to the course of progress. These nebulae,
having the greatest power of attraction at their ends, would
continue generally in a rectilinear direction; for if it were
otherwise, they would indicate a tendency to accumulate at
the sides rather than the edges. It is obvious from celestial
appearances, that such has not been the actual mode of for-

mation. Under the last mentioned conditions, only one other mode of formation is possible. It might take place in plane parallel strata, perpendicular to the course of progress, in the same manner as in the finite ocean, where a disturbing force was required; and it is alike obvious in both cases, that the strata would be regular. With this latter hypothesis the structure of the heavens appears to agree. The fanshaped arrangement of strata, mentioned by Dr. Herschel, may appear at first to indicate the contrary; but a moment's reflection on the principles of perspective will show, that these strata may, notwithstanding, be parallel. We are accustomed to find a correspondence between the power and the operations of a wise moral agent; and it is certainly no weak argument in favour of an infinite universe, that a finite one would fall infinitely short of the power of the Deity. It would leave his angelic subjects without any practical proof of his complete omnipotence. It seems also the most consistent and exalted conception respecting a wise moral agent, that his work is never terminated, and that the power which he possesses is for ever exerted. From reasoning a priori, then, it seems a very natural conclusion, that each act of creative power is expanded through an infinite plane, and that the successive acts form an eternal series. If this idea appears too grand, let it be remembered that it is formed respecting the works of the Deity. Metaphysical reasoning, however, is not the only ground on which our opinions on this subject may be founded. We see the celestial systems arranged into forms which are utterly unaccountable, unless their formation has been progressive. The account which Dr. Herschel has given, is only placing one difficulty on the shoulders of another: for it is not less impracticable to account for the position of those ruling luminaries, which he supposes may have marshalled the starry hosts of smaller magnitude, into their present regular arrangement, than to account for that arrangement without such assistance. If the formation into systems has been progressive, we are perfectly at a loss to say where it began, or where it will terminate. By far, the most natural supposition, is, that it will have no termination, and had no commencement. If the universe is finite, it is obvious, that without a constant miracle, of which we find not the least indication, so far as observation

can carry us, it cannot be permanent, till the whole is collected together in one vast mass at the common centre of gravity. In like manner, if the creation of matter from nothing, constantly preceded its formation into worlds, a constant miracle would be necessary to prevent them from forever approaching each other, by gravitation from empty space towards the boundless ocean of worlds already created. If we suppose that matter has been eternal, and still perfectly dependent on the Deity for its existence and its properties, and that on one side of the infinite progressive plane of formation, it is in a quiescent aerial state, and on the other side collected into worlds, nature obtains a balance, and unless particular gravitation is absolutely infinite, the ultimate systems must be permanent : and our minds instead of being lost in a chaos of conjecture, form the same conceptions of order, through the boundless fields of space, that we derive from observation on the portions which are within our view. These opinions will undoubtedly be adverse to the belief of many with regard to the meaning of scripture ; but whether they are opposed to its real meaning, is a question of quite a different character. The contests and the results respecting the Copernican system, cannot be forgotten. If such opinions are clearly and decidedly contrary to the meaning of scripture, it would be madness and disgrace as well as impiety and ruin to harbor them. The floods of sophisticated argument by which scripture has been assailed, have successively subsided without doing any thing more, than to clear away the little obstructions to the perception of its immobility, and to demonstrate to the world, that its destiny is to break, and not to be broken. Though the theory is the solution of the problem for which atheists, from time immemorial have been seeking, and though it may induce perverse and superficial minds to inquire, "Where is the promise of his coming? for since the fathers fell asleep, all things remain as they were from the beginning of the creation ;" yet on the other hand it carries design through the whole of the universe, and stamps intelligence on all its departments. Should it be asked why comets fly through the system to threaten ruin on its regular subordinates; and mountains lift their barren and inclement heads only to frown on surrounding fertility; the answer is ready. They are the impalpable dust on an exquisite piece of watch work;

mere grains of sand, in the corners of an immense and ma-
jestic edifice. It appears from the observations of Dr. Her-
schel, that most, or all of the stars are collecting into subor-
dinate spherical clusters, and forming what he calls, " the
chemical laboratories of the Universe." The principles of
gravitation will bring the stars in each individual of these
clusters to their common centre of gravity, in about the same
period of time ; and their appearance argue, that such will
be the result in reality. The universe, then, was not intend-
ed to be perfect in its present state : but its various con-
stituent parts are adapted and destined to happier and more
sublime realities. It is the shoot just springing from the
acorn, and pushing its way through the hardy soil, to a no-
bler existence :—a soil not particularly adapted to the ten-
derness of the youthful twig, but to the magnitude and vigor
of the princely oak. It is an infant struggling in its cra-
dle, whose mighty and majestic manhood no troubles or
convulsions shall weaken ; over whose immortal perfections
death and destruction shall never prevail. The astrono-
mer, as well as the prophet, has declared, that its various
parts are advancing to the final conflagration, when the ele-
ments shall melt with fervent heat; when the heavens shall
pass away as a scroll; and a new heaven and a new earth
shall arise to a perfect and an endless existence.

Through the kindness of the Hon. Mr. Bowditch of Sa-
lem, I received, a day or two ago, an extract from the fourth
edition of La Place's Systéme du Monde, which he marked
and permitted to be copied. From that, I learn that in the
foregoing speculations I have been anticipated ; a circum-
stance, of which I was before entirely ignorant. It imme-
diately struck me that it would be useless, and perhaps im-
proper to publish them. But on close examination and
comparison, there appeared sufficient reasons to change that
opinion. It is but justice to myself to say, that prior to the
receipt of that extract, I received no hints on the subject
from any source whatever, which I can now remember, ex-
cept from the letters of Mr. Fisher, which are now in my
hands; Ree's and the Edinburgh Encyclopedia, Dwight's
Theology: some papers of Dr. Herschel in the Philosoph-
ical Transactions ; Bakewell's Geology ; Cuvier's Theory
of the Earth, and the common class books of our schools
and colleges. Still, the mere fact, that the thoughts are ori-

ginal, would not be a sufficient apology for publishing what was published before, were it not, that more than half which I have written, and which cannot well be separated from the rest, is not to be found in the writings of La Place. As Mr. Bowditch, from such an examination as the time permitted, judged La Place's and my own theory to be in substance the same, and as in some of their principal characteristics they are so in reality, it seems proper to point out where they differ. La Place's mode of explaining the sources of motion in the system, is almost entirely dissimilar. So far is he from showing or even supposing them at all regular in their operation, the tenor of his remark evinces, that he considered them otherwise ; he has asserted that the planets would move in the same direction on their axes as in their orbits; but his illustration is totally distinct and diverse from mine. The conditions which he has assumed *might* take place in cases where the condensation of the primary wheel was extremely rapid: in cases of slower condensation my own must be substituted. To the two distinct series of planets; to the regular course of their eccentricity ; to the causes of their relative difference in density; to the causes of their relative degrees of diurnal velocity; to the causes of the obliquity and eccentricity of the orbits of the asteroids ; to the cause of the depression about Saturn's equator; and to the cause of the regular parallel arrangement of the stellar strata, and the plausibility, or perhaps probability of an eternally progressive formation into worlds, as well as a variety of less important particulars, he has in no instance alluded.

With high respect,

Your obedient servant,

ISAAC ORR.

Hartford, Nov. 9th, 1822.

Art. VIII.—*On the formation of cyanogene or prussine, in some chemical processes not heretofore noticed: by* James Cutbush, A. S. U. S. A. *Acting Professor of Chemistry and Mineralogy, in the U. S. Military Academy at West Point.*

In 1815, Gay Lussac, the able experimental associate of Thenard, discovered the gaseous compound called cyanogene, which, from its constituent parts, is also called carburet of

azote, and more lately Dr. Ure has denominated it prussine.
We know that cyanogene is usually obtained from the cya-
nuret of mercury, by heating it in a glass tube, and that it
is susceptible of combining with several substances, forming
peculiar acids; of these, the hydrocyanic (prussic) and fer-
rocyanic, are the most prominent and important. The com-
bination of cyanogene with hydrogen affords a triple prepa-
ration, distinct from that which has been called the ferrocy-
anic acid; for it is known, that prussic acid, *as such* does
not unite with oxyd of iron, as heretofore supposed, to form
Prussian blue, but only a compound of cyanogene and iron,
and consequently the cyanogene is changed into a new acid,
the ferro-cyanic. It is admitted, nevertheless, that the fer-
ro-prussic acid still retains a portion of hydrogen. The hy-
drocyanic acid may be obtained, however, from the ferro-
cyanite of iron, and by distilling the cyanuret of mercury
with muriatic acid; but then we separate all the iron from
the cyanogene, or decompose the ferro-cyanic acid in the
first instance, and in both cases the cyanogene combines
with hydrogen, forming hydro-cyanic acid. The cyanuret,
cyanides, and cyanidides are synonimous terms. We must
suppose, when we admit the formation of an acid, that cy-
anogene unites with the *particular* substance that changes its
character and properties, or acidifies it; hence its union
with hydrogen forms one acid, with chlorine another, with
iron a third and with sulphur a fourth, possessing respec-
tively distinct properties. Can we admit, however, that hy-
drogen is a *constant* ingredient? That we form mere com-
pounds of cyanogene with a base, constituting cyanides, or
prussides, in a variety of instances, as when we calcine
blood, bones, horns, &c. with potash, is obvious; and we are
disposed to believe, that the putrefaction of animal and veg-
etable matter, under particular circumstances, often generates
cyanogene, and probably some of its compounds, as with hy-
drogen, which, in the character of highly deleterious miasmata
may operate powerfully on the animal economy, and produce
malignant bilious fevers. Miasmata of a particular kind it is
known, cause intermittent and other fevers; and the whole
theory of *dis-infecting* air, as with Morveau's preparation, or
chlorine gas, is nothing more than the decomposition of such
miasmata, and in all probability the separation of *hydrogen
from its combination*, the chlorine changing to the state of

hydrochloric, or muriatic acid. ,I believe it will be found, that; that compound (carburet of azote) is the *basis* of the miasmata, which produce malignant bilious diseases; 'and it is equally certain, that *similar causes, acting under like circumstances* will generate it in the cities of New-York, Philadelphia, or Baltimore, as in the West-Indies. We admit, as in the formation of nitric acid in artificial nitre beds, by the concurrent corruption of animal and vegetable substan-. ces, that nascent azote unites with oxygen, furnished by free air, which attaching itself to an alkaline or earthy base, as the case may be, produces an alkaline or earthy nitrate, and that calcareous substances facilitate considerably, the union of azote and oxygen. This is the usual course of that putrefactive process, which generates nitre; but it must be remembered, that previously to the formation of nitric acid, other combinations of gaseous elements take place. The evolution of ammoniacal gas is a well known fact, the pre-existence of which, evidently proves, that azote was chemically combined with hydrogen, and that the hydrogen must have originated as well as the azote from the putrefactive substances. Whether oxygen unites directly with azote in a nascent state, or separates the azote from hydrogen, in ammonia, we will not enquire; but, as the smell of ammoniacal gas ceases when nitric acid is subsequently generated, we may infer, that either the ammonia was decomposed, or that the acid itself combines with it, forming nitrate of ammonia. Here then we have two instances of the combination of azote; the one forming ammonia and the other nitric acid. Whether the prot-and deut-oxide of azote are generated at any period of animal putrefaction is doubtful; but the latter, however, would combine with oxygen, and thus become acidified. Hydrogen, as it is a solvent of carbon, sulphur, phosphorus, &c. may be evolved in combination, as we find more particularly the case in the peculiar miasmata, evolved from marshes, and low wet land, which appear to be produced in such cases by vegetable decomposition. Marsh miasmata are generally the cause of intermittent fevers. Now under particular circumstances of action, may we not admit the generation of carburet of of azote, or cyanogene? And if so, as it readily unites with hydrogen, may it not be the miasma, which produces malignant bilious fevers, since it is known that hydrocyanic

acid is distructive to animal life, and a most virulent poi-
son ? Cyanogene, and its compounds, may be generated in
particular places, and, in fact, in the holds of ships.

It is admitted, I believe very generally, that hydrogen
enters into the composition of gazeous effluvia, but with
what substances, or in what state of combination is not
known ; I mean those effluvia, or miasmata, which produce
disease. Hydrogen combines with sulphur, phosphorus,
carbon, &c. but its combination with carburet of azote ap-
pears to be the most powerful, and at the same time the
most destructive. And if we reason *a priori*, we may con-
clude, that chlorine as a disinfecting gas, which is the most
powerful, acts by decomposing such compounds, thereby
separating the hydrogen, and changing to the state of hy-
drochloric acid. Cyanogene, therefore, may be generated
in putrefaction, and be combined with hydrogen. If that
compound causes the deleterious miasmata, chlorine
must act as we have stated ; but if it be simple cyanogene,
it may destroy its virulence by forming with it the chloro-
cyanic acid. To prevent its influence, and its generation
in sufficient quantity to poison the whole atmosphere of a
district of a city, will be to employ freely chlorine gas, and
the removal of ALL putrescent substances of every descrip-
tion, and to observe cleanliness in yards, streets, alleys, and
bye places. On this subject, as it is one of peculiar impor-
tance with every one, who must feel interested in this in-
vestigation, I would advise an examination into *facts*, as they
have occurred in Baltimore, Philadelphia, and New-York ;
and, in particular, I would refer the reader to a very inter-
esting pamphlet on the subject of the *Yellow Fever* by Dr.
Samuel Jackson of Philadelphia, which must be conclusive
to every candid and impartial mind. The facts deduced
by the Doctor were drawn from personal observation, and
from official documents, as he was at that time President
of the Board of Health. The fact is admitted, that mias-
mata of *some kind* are the cause of yellow fever. For our
own part we believe it to be carburet of azote, or some of
its combinations, and of these that with hydrogene, from its
deleterious character, seems to be the one. This, howev-
er, admits of investigation ; on which it must finally rest.
We stated that when animal substances were calcined with
potash, a cyanide of the alcali was produced. When this

cyanide is dissolved in water, it is changed into the hydro-
cyanite, for the hydrocyanic acid is certainly formed, wheth-
er by the decomposition of water, or otherwise.

When the solution of the cyanide of potash in water,
whatever change it may have undergone during its solution,
is added to a salt of iron in which the metal is peroxydized,
as in the persulphat of iron, the precipitate which is formed
is the perferrocyanite of iron. Admitting the formation of
hydrocyanic acid in the first instance, we would infer, that,
when brought in contact with the salt of iron, the acid it-
self is decomposed, or in other words is changed into the
ferrocyanic acid, before its union with the oxyd of iron.
Porret, however, considers the ferrocyanic acid as a com-
pound of iron, oxydized to the minimum, and hydrocyanic
acid. The conclusion of Dr. Thomson was, that it was mere-
ly a compound of metallic iron and cyanogene, but he sub-
sequently inferred, that it is composed of iron and hydrocy-
anic acid., When the cyanide of potash is dissolved in wa-
ter, and added to the sulphate of the plus oxydized iron, we
obtain a *blue* precipitate, but if we employ the protosul-
phate, properly so called, the result is a *white* precipitate,
which may be converted into the blue ferrocyanite either
by exposure to the atmosphere, or by the affusion of an
acid. If we admit that *metallic* iron enters into the com-
position of ferrocyanic acid, we would infer, that part of
the hydrogen of the hydrocyanic acid, unites with a part of
the oxygen of the oxydized iron, by which the iron is redu-
ced, and the metallic iron then unites with the cyanogen
and the remaining hydrocyanic acid, formerly the ferrocy-
anic acid ;. which, by uniting with the undecomposed oxyd
of iron, produces the perferrocyanite or Prussian blue. It
is known, however, that the Prussian blue used as a pig-
ment, is a mixture of the perferrocyanite and allumina, in
consequence of the addition of alum, which is made previ-
ously to the precipitation.

As prussic acid may be obtained by distilling peach
blossoms, bitter almonds, &c. it is evident, that the veget-
able kingdom will also yield it ; and in many processes of
art, the elements of cyanogene may frequently combine in
such proportions as to form it. This indeed may be the
fact in sundry other processes ; as, for instance, in the pu-

trefaction of certain substances under particular circum-
stances and conditions.

The fact, however, I purpose to notice is, that sometime
since I was exhibiting to my class some experiments on
the decomposition of nitric acid, and of nitrate of potash
by charcoal, in relation to the subject of gunpowder. When
I affused nitric acid on charcoal, there was, as is usual, a
disengagement of the deutoxyde of azote, and on standing,
the acid became thick and brown, and to all appearance
resembled artificial tannin, which we know is obtained by
a similar process. It struck me as a circumstance not im-
probable, that besides the formation of nitrous gas and car-
bonic acid gas, cyanogene might be formed. It appeared to
me, that whilst a portion of carbon combined with a part
of the oxygen of the nitric acid, and the deutoxyde of
azote, was disengaged, a part of the carbon might unite
with a portion of azote, and thus generate cyanogene.
Whether this explanation will hold good, I will not pretend
to say, but it is certain, that cyanogene was generated. By
putting the charcoal and nitric acid into a retort, and col-
lecting the gaseous products in Woulfe's bottles, arranged
in the usual manner, the gases evolved were all, or the
greater part, absorbed; that is to say, the nitrous gas was
converted into nitric acid, by its union with the oxygen of
the air contained in the bottles, &c. I saturated the wa-
ter, thus impregnated, with potash, by which I formed a ni-
trate, carbonate, and cyanide of that alkali, as the latter
was subsequently manifest. To this fluid, I added the com-
mon sulphate, and the persulphate of iron. The colour in-
stantly changed, and became more or less *blue*, proving the
existence of the perferrocyanite of iron, and consequently
of cyanogene, which must have been formed by the union of
carbon and azote. We may conclude then, that during the
action of the nitric acid on the carbon, which caused the
developement of nitrous gas, a part of the azote of the acid
must have combined with the carbon, and that another
portion of the carbon, by uniting with the oxygen of the de-
composed nitric acid, produced carbonic acid. The carbon
in this case must have taken up a part of the azote, as well
as a part of the oxygen.

If the carbon abstracted the *whole* of the azote from
a given portion of nitric acid, the inference would be,

that pure oxygen was liberated; and if it took the oxygen, or a part of it, from the deutoxyde, already generated by the union of carbon and oxygen in the formation of carbonic acid, thereby leaving a compound of azote and oxygen in the state of nitrous gas—it must have reduced it to the protoxyde, or gazeous oxyde of azote, its first degree of oxydizement.

It is known that charcoal, especially when newly made, has the property of absorbing sundry gases, and particularly hydrogen. Might not the charcoal I used have contained hydrogen? If so, might not the nascent hydrogen during the action of the carbon, have combined with a part of the oxygen of the nitric acid, and formed water; whilst that portion of the azote thus set at liberty, by combining with the carbon, may have formed the carburet of azote?

The existence of cyanogene, however, is indisputable, in whatever manner it may have originated. One atom of azote and two atoms of oxygen form the deutoxyde of azote, and two atoms of carbon with one atom of azote form cyanogene. I have not had leisure to repeat the experiment, in order to determine the quantity of cyanogene thus generated.

ART. IX.—*Analysis of a Manganesian Garnet, from Haddam, Connecticut, with a notice of Boric Acid in Tourmalines; by* HENRY SEYBERT.

THIS mineral occurs imbedded in granite, associated with Cymophane and Beryl. In mass it is blood red; the powder is flesh coloured. Lustre, resinous. Small fragments are transparent. The specimen made use of for analysis was a portion of a large crystal. Fragments, indeterminate. Scratches glass and scintillates with steel. Very frangible. Structure lamellar. Specific gravity 4.128. Fusible, before the blowpipe, into an opake black bead.

Analysis.

A. 3 grammes of this garnet, in the state of an impalpable powder, were exposed to a red heat in a platina crucible; after the calcination, the colour of the powder was not sensibly altered, and it weighed 2.98 grammes, there-

fore, the moisture expelled by this treatment, was 0.02 grammes on 3 grammes, or 0.66 per 100.

B. The residue of the preceding calcination, (A) was calcined, at a red heat in a platina crucible, during 30 minutes with 15 grammes of sub carbonate of Soda, the mixture did not enter into fusion, but merely assumed a pasty consistence; when cold the mass was of a very deep green colour, the water which was used to detach it from the crucible was also intensely green—an indication of a large quantity of Manganese. When an excess of muriatic acid was added to the liquor, *chlorine* was abundantly disengaged, the solution was not perfect until the evaporation of the liquor was considerably advanced, it was then of a deep orange colour; to effect the separation of the silica it was evaporated in the usual manner to a dry gelatinous mass, then treated with water, acidulated with muriatic acid, and again moderately evaporated; more water was added, and the solution was filtered; the silica remaining on the filter, after edulcoration and calcination, weighed 1.075 grammes on 3 grs. or 35.83 per 100.

C. The silica having been separated, (B) the excess of acid was neutralized with caustic potash, the solution was treated with hydro-sulphate of potash, this occasioned a precipitate, which at first was black, but the latter portion of it was nearly colourless. The precipitate was well washed and dissolved, in the humid state, in nitro-muriatic acid, the solution was evaporated to dryness to expel the excess of acid, the residue was treated with water, and boiled during one hour and a half with an excess of caustic potash, the filtered liquor was treated with an excess of muriatic acid, then by ammonia there was formed a precipitate of alumina, which, after being washed and exposed to a red heat, weighed 0.542 grammes on 3 grammes, or 18.06 per 100.

D. The residue, which was separated from the alcaline liquor, (C) was of a dark red colour; it was treated while humid, with acetic acid, the solution was evaporated, at a moderate temperature, to perfect dryness, the dry mass was treated with water, the peroxide of iron, collected on a filter, proved to be free from alumina and manganese, it weighed 0.486 grammes; a portion of the pulverized mineral was treated with nitric acid and calcined; the powder, which was flesh coloured, now became nearly black, this

change of colour clearly proved, that the iron and manga-
nese existed in a minimum state of oxidation, therefore,
the 0.486 grammes of peroxide of iron must be reduced to
the state of protoxide, and are equivalent to 0.448 grammes
of protoxide of Iron on 3 grammes, or 14.93 per 100.

E. The filtered liquor, (D) was boiled with an excess of
sub-carbonate of soda, the carbonate of manganese thus pre-
cipitated, was washed and strongly calcined, the tritoxide
of manganese weighed 1.007 grammes, and on examination
was found to contain neither alumina nor iron: the 1.007
gr. of tritoxide are equivalent to 0 929 grammes of protox-
ide of manganese on 3 grammes, or 30.96 per 100.

F. The liquor (C), after filtration was successively tested
with oxalate of potash, and with caustic potash, and thus
proved to contain neither lime nor magnesia.

According to the preceding experiments, the constituents
of this Garnet are

		per 100 parts,			
A. Water,	- -	00.66	containing oxygen		
B. Silica,	- - -	35.83	-	-	18.02
C. Alumina,	- -	18.06	-	-	08.43
D. Protoxide of Iron,	-	14.93	-	-	03.39
E. Do. of Manganese		30.96	-	-	06.79
		100.44			18.61

And its mineralogical formula will be $f S + 2mg S + 2AS$.

Boric acid in Tourmalines.

To detect the Boric acid in the green Tourmaline, from
Chesterfield, Massachusetts, a portion of the mineral was
pulverized, and calcined at a red heat, with three parts of
caustic potash ; the mixture after calcination, was treated
with muriatic acid and evaporated to a dry gelatinous mass,
which was afterwards digested in alcohol; the alcoholic so-
lution, when ignited, burnt with a beautiful green flame, a
proof of the presence of Boric acid ; the same acid was al-
so found, by a similar treatment, in the *Rubellite* and *Indi-
colite* from Massachusetts, and in the *black* Tourmalines
from Haddam, Connecticut, and Chester creek, Delaware
Co. Pa.

ART. X.—*Letter from Dr.* WILLIAM MEADE, *communicating an account of a travelled stone, &c.*

TO PROFESSOR SILLIMAN.

Sir,

In your Journal for June, 1822, an anonymous communication appeared, giving an account of certain rocks supposed to have moved without any apparent cause, in the town of Salisbury in Connecticut. Finding that this account though very circumstantially related, has been generally received with great incredulity, I beg leave to send you the following very well authenticated statement, on a similar subject, which I have copied from the Memoirs of the Wernerian Society of Edinburgh for the year 1819, a publication of great merit and respectability.

You will perceive, Sir, that the circumstances attending the movement of this *Travelled Stone*, as the journalist emphatically calls it, are so very similar to those detailed by your anonymous correspondent, that there can remain no doubt of the main facts, or that they were produced by the same causes.

I am farther induced to send you this paper, from the transactions of the Wernerian Society, not alone from its establishing the fact of the occasional change of position of certain large masses of stone, but from its tendency to explain some Geological facts, which as yet appear to be little understood.

I have the honor to be, Sir,
your very obedient servant,
WM. MEADE.

Account of the Travelled Stone near Castle Stuart Inverness-shire; by THOMAS LANDER DICK, Esq.

[Read 17th May 1819.]

This stone is a large mass of conglomerate, being a concretion composed of distinct irregular fragments of granite, gneiss, quartz, and other rocks of the primitive series, cemented together by a highly indurated and ferruginous clay

slate. I am not aware that any rock of the same nature exists much nearer to it than seven miles. Its present situation is on the sands in the little bay near Castle Stuart on the Mercey Firth. Its size is very considerable, being as near as I could guess above four feet high at its most elevated point, calculating from the surface of the sand and being to all appearance about one foot imbedded in it. It measures between four and six feet one way by six or seven the other; its shape, which is very particular, is peculiarly well adapted to admit of the mode of transportation, it underwent, as it had a projecting edge, all round it, the lower edge of which, is above a foot of perpendicular height from the surface of the sand, and from this edge downwards, the stone is suddenly bevilled off in a form resembling that part of the bottom of a boat which is under the belly and approaching the keel. On as near a calculation as I can make, it may weigh about eight tons.

This large mass is remarkable for having been removed from a situation which it formerly occupied, about 260 yards farther to the S. S. E. by natural means, and in the course of one night to the position where it now stands. It had formerly served as a boundary stone between the properties of Castle Stuart and Culloden, the former belonging to the Earl of Moray and the latter to Duncan Forbes, Esq. As it is too ponderous to have been moved by human power, at least in that part of the country, it must have been originally deposited in that its first place of rest, by causes similar to those which have covered whole countries with boulders, the nature of which bespeaks their having belonged to rocks no where existing in situ in their entire and native state, in the vicinity of their present place of abode. The stranger scarcely recognizes the spot from which it was last removed, it being marked by a wooden post which the two contiguous proprietors were under the necessity of erecting in order to supply the place of the stone, and to serve as an object for defining its line of *march.* At a fishing village situated above a mile to the westward of the stone, I learned several particulars with respect to its extraordinary migration. But it was recommended to me to call on the miller of *Pitly* for a fuller detail of the facts, who, living much nearer the stone, and having it constantly in view for a series of years, not only recollected every circumstance about it, but was

the first person who on the ensuing morning noticed that it had been removed during the night.

I lost no time in seeing the old man whose name is Alexander Macgillivray, and I was lucky enough to find him at home, he informed me that this remarkable circumstance took place on the night between Friday the 19th, and Saturday the 20th of February, in the year 1799. There had been a very severe frost, and the greater part of the little bay had been for some time covered with ice, which was probably formed there the more readily owing to the fresh water from the stream running near to Castle Stuart, emptying itself into the inlet of the sea in the immediate neighbourhood. The stone was, by this means, fast secured by the ledge, which I have described being bound round by a vast cake of ice of many yards in extent, which being froze hard under the projection of the stone, must have produced an admirable mechanical means for its elevation, for which purpose it afforded an extensive draft. The miller told us he had measured some of the ice and found it eighteen inches thick. The stone was then surrounded when the sea left it at its ebb, and the whole of the circumjacent land was left covered by this solid and unbroken glacier. It is evident that as the sea began again to flow, this would be naturally buoyed up by the returning water insinuating itself underneath it on the night of the 19th of February, the tide which happened to be remarkably high, was full about 12 o'clock. About this time, the wind began to blow a hurricane, accompanied with drifting snow. The old man stated that this tremendous storm blew directly from Dulcross Castle, and accordingly I found that by placing myself at the stone and looking at Dulcross, the post marking the former situation of the mass appeared quite in the line between those two points, and that the strait line or furrow described by the stone in the course of its voyage lay in this direction.

When the old miller got up on the morning of Saturday, the 26th, the storm and drifted snow was such that he could hardly make his way to his barns, though they are but a few yards distant from his dwelling house. When the weather had moderated in some degree, and the storm and snow had cleared away, so that he could see across the little bay, he remarked to his wife with much astonishment

and no inconsiderable alarm, " *That the mickle stane was awa,*" and the good woman could hardly believe her eyes, when she saw in reality that it was gone from the spot it had occupied the day preceding and that it had been removed to the position where it now remains. General surprise and curiosity were now excited which were no doubt mingled with superstitious fancies, and the neighbours flocked out to see and examine the subject of so extraordinary a prodigy. To their astonishment the hole in which it had been for so many ages imbedded, still remained to mark distinctly its yesterdays site, whilst its track across the flat oozy sand was very perceptible, extending in a line from its old to its new situation. In addition to these particulars I have since learned from my friend Mr. Bradie that he visited the stone the day after, when he found all the traces remaining quite apparent and an extensive cake of ice adhering to the stone being attracted to its 'outer ledge.

It is evident that this vast mass of stone must have been so far rendered specifically lighter than the water by the great cakes of ice within which it was bound, and by which it was supported, as to be in some degree buoyed up, and that whilst in this state, it was carried forward by the outgoing tide, assisted by the impelling force of a tremendous hurricane blowing in the same direction.

By the correspondence just detailed, we are furnished with a comparatively recent and perfectly well attested example of one mode by which large masses of detached rock may be carried to considerable distances. For although the waters of the tide which fill the bay in question, were on account of their shallowness, incapable of buoying up the extensive float of ice supporting the stone so perfectly as to prevent the keel of it from ploughing the sand in the course of its progress over it, yet there is no reason to doubt if it had been once fairly carried into deeper waters it might have been ultimately transported to a much greater distance. And if we can suppose the float of ice to have been sufficiently tough and tenacious, we may even conceive it probable that the stone might have been deposited upon some remote shore, where no rock of the same nature was to be found, and where it might have fur-

nished future Geologists subjects for more interesting spec-
ulation. These would have been naturally the more puz-
zling that its peculiar mode of transportation would have
precluded all chance of its acute angular projections being
destroyed by attrition and so would have prevented the pos-
sibility of its exhibiting those appearances of its having been
rounded and polished, so manifestly displayed, by most of
those stones usually denominated boulders. How far the
causes which are thus known to have operated in produ-
cing the removal of this vast fragment may appear to tally
with the relative situation of similar masses in other places
which cannot be so easily traced to their parent rock, or to
ascertain whether such means may not have had some share
in transporting these to their new situation, may perhaps
merit investigation, and with such a view an accurate and
well attested narrative of the particulars of the conveyance
of the *Travelled Stone* near Castle Stuart, from its former
to its present place of quiescence, cannot be considered as
altogether useless in the pursuit of Geology.—*Vide Me-
moirs of the Wernerian Society of Edinburgh, Vol. III. p.
250.*

Art. XI.—*Remarkable Balls of Snow, observed at Bruns-
wick, Me. April 1st 1815.*—By Prof. Cleaveland.

 During most of the day, preceding this phenomenon, a
fine mist continued to fall; and, in the former part of the
night, the wind changed to N. W. accompanied by the fall
of nearly two inches of very light snow. On the following
morning, in the fields and roads, were to be seen a great
number of *snow balls,* varying from *one* inch to *fifteen* inches
in diameter. When small, their form was nearly spherical;
but the larger balls were generally somewhat oval, having been
rolled a considerable distance in one direction by the wind.
Their texture was homogeneous; they were extremely light,
and composed of minute prisms of snow irregularly aggrega-
ted. When very small, they would hardly bear examination in
the hand without falling to pieces; when larger, they had
become more compact. The paths, in which they had roll-
ed, were in general distinctly visible. The smaller balls,

however, were observed in the *woods*, and in *small yards* and other inclosures, sheltered from the wind, thus indica- ting that their formation commenced in the atmosphere. Similar balls were observed in most of the contiguous towns. Their appearance on the river Androscoggin was extreme- ly interesting.

ART. XII.—*Miscellaneous Notices by* **Prof. J. F. Dana,** *of Dartmouth College.*

1. *Connexion of Electricity, Heat, and Magnetism.*

The notices which have appeared in your Journal on the connexion between Electricity and Magnetism have indu- ced me to make some experiments, and as they tend to con- firm those made by Mr. Bowen, I will mention them. The apparatus consisted of the Leyden bottle and glass tubes sur- rounded by brass wire. I have not yet had opportunity to repeat any of the experiments with the galvanic battery, ex- cept in one instance when a piece of steel was inclosed in a glass tube half an inch in diameter and surrounded by a spi- ral coil of brass wire, and the influence from my battery, consisting of two hundred plates six inches square, was pas- sed through the coil for one minute, the steel did not appear at *first* to be affected, *but the next day was found feebly mag- netic*—this experiment was made at the same time on anoth- er and similar piece of steel with the same result. With common electricity I have been more fortunate. When the charge from a small Leyden jar was passed through the coil the steel inclosed in the tube was uniformly rendered mag- netic, if the coil passed from right to left the south pole was always found on the negative end, whether the jar was char- ged with positive or negative electricity ; when the coil pas- sed from left to right, the north pole was uniformly formed next the negative, whether the jar was charged with posi- tive or negative electricity. These two experiments con- firm those of Mr. Bowen. In using a tube surrounded by a coil passing from right to left for one half its length, and then in the contrary direction, as in Mr. B's. experiment, I found, when the jar was charged with positive electricity, and the coil began to pass from right to left on the positive, that both

ends of the enclosed steel became north, and the middle south; if on the contrary, the coil began to pass from left to right, on the positive side, both ends of the steel acquired a south polarity and the middle a north polarity. When the jar was charged negatively, and the coil began to pass from right to left on the negative, both ends acquired a south and the middle a north polarity; if the coil begin to pass from left to right on the negative side the polarities are reversed. When a wire is bent into the form of a staple (thus ⊂══════⊃) and inclosed in a glass tube surrounded by a spiral passing from right to left, the ends acquire a north polarity, and the middle a south polarity, if the ends of the staple be next to the positive. If the situation of the staple be reversed, or if the coil pass from left to right, then the ends become south and the middle north. Circumstances did not permit me to make the experiment on a staple surrounded by the coil passing from right to left, and from left to right. We should, a priori expect, that the middle of the staple in such circumstances, would acquire the same polarity as the ends, while at some intermediate points on both sides of the middle an opposite polarity would be found, so that five poles would be formed in one piece, and if the wire was again doubled on itself, (thus ⊂══════⊃) two additional poles would be formed. The above experiments were many times tried with the same result, and have been repeated by myself and my friend Hon. Thos. Whipple, M. C.

2. *Preparation of Euchlorine Gas.*

I perfectly well recollect, when I had the pleasure to be introduced to you at Cambridge, that the conversation turned on the preparation of euchlorine gas; we naturally wish to know whether experienced chemists meet with the same accidents as ourselves, in experiments, and it was no small degree of consolation to learn that the laboratory at Yale had also witnessed accidents in the preparation of this explosive gas. For two years past I have prepared it in the following manner; strong phials capable of holding half an ounce or an ounce measure are provided, into which are put a few grains of chlorate of potash, and then, four or five drops of sulphuric acid, just sufficient to moisten the salt, are added; the phials are then inverted over mercury, ma-

ny air bubbles escape ; but in a few minutes the phials appear filled with the euchlorine, which is readily known by its colour and odour. The gas thus prepared is of course impure, but is doubtless as pure as most gases used for chemical demonstrations ; it explodes violently by heat and on the contact of phosphorus; it is absorbed by water, to which it communicates its peculiar colour. Since I have employed this method, only one accident has happened to me from this gas, it then exploded spontaneously and threw the phial with great force against my forehead, and the mercury in the vessel over which it was inverted was dashed around in all directions.

Memorandum.—The remarks of Professor Dana, induce me to add, that, for several years, I have obtained euchlorine gas, without accident, by the following process. Chlorate of potash and muriatic acid diluted with an equal volume of water, are placed in a small glass flask, furnished with a glass tube, bent twice at right angles, and passing to the bottom of any clean dry phial, flask or tube, rather deep and with a narrow neck ; a spirit lamp, a water bath, or any mild heat, applied beneath the flask, soon disengages the euchlorine gas, which, by its great weight, displaces the common air, from the recipient, and occupies its place. By using tongs, of a peculiar form, furnished with corresponding curvatures on their opposite sides, so as to embrace tubes, or the necks of vessels securely, the glasses filled with the euchlorine gas may be so managed that the operator can perform all the experiments, without touching them with the hands, by which means the danger of premature explosion is avoided.—*Editor. Dec.* 19, 1822.

3. *Concretion from the Tonsil.*

Mr. Bancroft, a medical student, was afflicted with a severe inflammation of the tonsils ; it separated and a small concretion was discharged from it. The concretion was of an irregular form, and weighed less than half a grain. Its colour; light brown ; surface smooth, and through a lens appears composed of smooth rounded grains, exhibiting a *botryoidal* appearance. Before the blow pipe it blackens and then becomes white, and is infusible. Soluble in muriatic

acid; the solution affords a precipitate by oxalate of ammonia, and by pure ammonia—hence it consists of phosphate of lime and animal matter.

ART. XIII.—*Notice of an ancient Mound, near Wheeling, Virginia;* by S. MORTON.

To the Editor.

WHEELING, Aug. 7th, 1822.

My Dear Sir,

Since I attended your lectures, I have resided at Wheeling, Virginia, within twelve miles of the Great Mound, at Grave Creek, on the Ohio river. A few weeks since, I had the curiosity to measure this remarkable monument of antiquity, and as the following results, with a general description of the mound, may not be uninteresting to you, I therefore humbly submit them. J. MORTON.

The plain on which this mound is situated, extends back from the Ohio river about a mile and a half, is of a semicircular form, open towards the river, but enclosed on its back part by high hills. It is nearly level, forming a beautiful site for a town. The soil is a yellowish loam, mixed with a small portion of clay; it is at present, rather unproductive, having been nearly exhausted of the vegetable mould by several years cultivation. The principal mound stands about an eighth of a mile from the river, nearly in the centre of the plain, from north to south. The form of this remarkable tumulus is nearly a circle, at its base, converging gradually like a cone, but terminating abruptly.

The circumference at its base, is about two hundred and fifty yards. The summit is sunk like a basin, making a diameter from verge to verge, of about twenty yards. Judging from this circumstance, it has evidently been much higher than at present, but this is also evinced by the immense quantity of soil about its base, which has been washed from its sides by the rains of ages. Its perpendicular height, is now nearly seventy feet; the slope from base to summit, or verge of the basin, measures about one hundred and twenty-four. From this sunken appearance of

the top, and the form of other mounds in the neighborhood, it is reasonable to conclude that its perpendicular was once twenty or thirty feet higher.

It is composed of a soil similar to that of the plain which surrounds it, but there are no local marks to determine from whence such a quantity of earth could have been taken, as the surface of the plain is nearly level. The mound itself is covered with trees, consisting of white and black oak, beech, black walnut, white poplar, locust, &c. and many of them are of a large size.

A white oak, in particular, on the verge of the summit, measures twelve feet in circumference, three feet above the surface of the ground. From its size, and the decayed appearance of some of its branches, it must have been the growth of four or five centuries. There are several others of nearly equal size. The vegetable mould in the centre of the basin, is about two feet in depth, but gradually diminishes on each side. About one eighth of a mile distant on the same plain, in a northeasterly direction, are three smaller tumuli of similar construction; and several other small ones in the neighborhood. Near the three alluded to, on the most level part of this plain, are evident traces of ancient fortifications. The remains of two circular entrenchments, of unequal size, but each several rods in diameter, and communicating with each other by a narrow pass, or gateway, are to be seen, and also a causeway leading from the largest towards the hills on the east, with many other appearances of a similar nature, all exhibiting marks of a race of men more civilized than any of the tribes found in this section of the country when first visited by Europeans.

Several attempts have been made to open the principal mound, but they were arrested by the proprietor of the ground.

In stamping or striking with a club on the top of this huge heap of earth, a hollow, jarring sound may be heard and felt, similar to that which we feel in walking heavily on a large covered vault.

With regard to the object of these structures, it is now, I believe pretty well agreed, that they were repositories for the dead. A good evidence of this is, that a substance resembling decayed bones has generally been found in those which have been opened, with implements of war

and various articles used by savage nations. Otherwise we
have no certain data; no historical facts to guide us in our
enquiries into this subject. Not even tradition, for the
tribes inhabiting the country when discovered by the
whites, were more ignorant, if possible, of the origin and
uses of these mounds, than we are. They had not even the
shadow of tradition to give them the smallest light on the
subject. All we know of them is derived from a very few
obvious facts, the rest is speculation drawn from slight
probability. Very respectfully, yours,

 J. MORTON.
Wheeling, Virginia.

INTELLIGENCE AND MISCELLANIES.

—

I. DOMESTIC.

1. PROTEST of Mr. Henry Seybert, in vindication of his
claim to the discovery of Fluoric acid in the Chondrodite
(Brucite of Col. Gibbs, Maclureite of Mr. Seybert) in
reference to a passage in the Memoir "on the minerals,
&c. of Patterson, and the Valley of Sparta," &c. by Mr.
Thos. Nuttall, with the reply of the latter.

Remarks by the Editor.

As Mr. Nuttall happened to be present with me, when
Mr. Seybert's communication was handed in, I thought
it but *candid* to show it to him and to receive his reply.
I will not deny that I was actuated also by the hope of
bringing this difference to a prompt issue, *without having it
continued into a subsequent number.*

Letter of Mr. Seybert.

 TRENTON, Nov. 11, 1822.
SIR,
Absence from Philadelphia, until within a few days, pre-
vented my having an opportunity, to peruse the second
number of Vol, V. of your Journal of Science and Arts.

Some of Mr. Nuttall's "Observations and Geological Remarks on the minerals of Patterson and the Valley of Sparta, in New-Jersey," excited my surprize; and I regret, extremely, that the necessity of the case forces me into a controversy; justice, however, demands that I should notice some of the remarks of that gentleman.

When speaking of the Condrodite* Mr. Nuttall says, that it is according to an *unpublished* Analysis, which he made in 1820, "a Silicate of Magnesia, with an *accidental* portion of Fluoric acid and iron,"† thus leading us to believe, that he was the first, who detected Fluoric acid in that mineral: the following facts will satisfy the reader, in how far he has any claim to that discovery. On the 3d of April 1821, a communication, concerning the Condrodite, from Mr. Nuttall was read before the Academy of Natural Sciences, in Philadelphia; in that essay he made known the results, which he obtained from an analysis of that substance, *without enumerating Fluoric acid as one of its constituents;* on the contrary, he satisfied himself that that acid *did not* exist in the mineral in question. These are facts which Mr. Nutall dares not venture to contradict, and they are known to the members of the very respectable institution, to which they were communicated. Why does Mr. Nuttall now pretend, that he detected Fluoric acid in the Condrodite in 1820, when in a paper read before the Academy of Natural Sciences in 1821, he denies its existence, without any allusion to a previous discovery? Mr. Nuttall's Communication was referred to a committee; on account of its chemical imperfections, it was deemed unworthy of a place in the transactions of the Academy!

In March, 1822, I detected the Fluoric acid in the mineral found at Sparta, New-Jersey; this fact was a subject of conversation amongst our Chemists, immediately after it was substantiated; it was announced to you, in a letter dated 18th of April, 1822, and you noticed it in the first number, volume 5, p. 203, of your Journal. On the 17th of May last, my paper, on this subject, was read before the

* The same mineral which I called "*Maclureite*," for reasons assigned in the Journal of Science and Arts, Vol. V. p. 343.

† Journal of Science and Arts, Vol. V. p. 245.

American Philosophical Society, the results of my experiments were noted in their minutes, and to these Mr. Nuttall being a member of that Society, had free access. From the sources abovementioned, he could, in 1822, correct the results, which he had laid before the Academy of Natural Sciences in 1821, and thus pretend, that he anticipated me as early as 1820. He pretends that the Fluoric acid, in the Condrodite, is *accidental*, without informing us of the quantity, or of the method which he followed to detect it. Why did he neglect to publish his analysis in detail? The subject was worthy of such notice, more especially as the Fluoric acid, in this mineral, had escaped the sagacity of the celebrated Berzelius. *To every Chemist, the error of Mr. Nuttall's statement* must be evident, because the 4.086 per 100 of Fluoric acid, which I obtained from this mineral, must be an *essential*, and not an accidental constituent, otherwise we cannot account for the saturation of the bases, which enter into its composition. It was the want of the knowledge of the presence of this acid, that forced Professor Berzelius, to resort to a peculiar formula, *(formule particulière)* founded on the principles of definite proportions, to represent the condrodite, in his system of Mineralogy, as Silicate of Magnesia.*

Mr. Nuttall was mistaken when he told us that "Haüy referred the Condrodite to the peridot.† On the contrary, the celebrated crystallographer remarks, that although, from an analysis of this mineral, made by Berzelius, the results were similar to those afforded by the peridot, *they cannot be referred to the same species.* The following are the words that Haüy employs, when he refers to the analysis of Berzelius. "On en avait même fait l'analyse, dont le resultat se rapprochait beaucoup de celui *que donne* le peridot. Mais ayant entrepris d'examiner la structure de ces cristaux, je trouvai que leur division mécanique conduisait à un prisme rectangulaire à base oblique, *ce qui les rendait incompatibles dans une même espece, avec le peridot qui a pour forme primitive un prisme droit.*"‡

* Annales des Mines, Tome 6, p. 528.

† Journal of Science and Arts, Vol. 5, p. 245.

‡ Annales des Mines, Tome 6, p. 528.

If I was disposed to favor controversy, there are other subjects connected with my name, in Mr. Nutall's paper, that would induce me to make further remarks, but it is with great reluctance, that I offer the above for publication, in the next No. of your Journal, and

'With sentiments of regard and esteem,

I remain your obedient servant,

HENRY SEYBERT.

Prof. Silliman, Yale College, New-Haven.

Letter of Mr. Nuttall.

Philadelphia, Dec. 15, 1822.

Dear Sir,

I have hitherto avoided controversy, and occasionally borne the lash of unjust criticism, in silence, rather than run the risque of trespassing on the patience and temper of the public by the temerity of an appeal. I now, therefore, regret that imperious circumstances, and such as are connected with the support of moral dignity should have urged me to this unwelcome task.

I believe no man can more highly or justly appreciate the scientific character of your correspondent than I do, otherwise I should have suffered his assertions to have passed unheeded.

If I am called upon, as you are aware, by Mr. H. Seybert, to say when and where I had heard of the existence of Fluoric acid in the Brucite or Chondrodite I might refer him back to a period when he was too young to have been acquainted with even the name of Chemistry. I might bring to his recollection, the name of an amiable and scientific man (the late Dr. Bruce) in honor of whom it was called by Colonel Gibbs, and in whose laboratory this result was obtained by Doctor Langstaff,* of New-York, then his pupil. It

* On the subject of this experiment, I received the following note from Doctor L. dated Nov. 27th, 1822. " Agreeably to your request of the 25th inst. I have referred to my notes made on the Sparta mineral, (Brucite) and find that my experiments on the composition of that substance were made in the fall of 1811. A want of time prevented me from making an accurate analysis, but from the experiments then made, I find it yielded about,

Silex, - - - - - - - - '32'
Oxid of Iron, - - - - - - - 6

was announced by Professor Cleaveland in his first edition of. Elements of Mineralogy under the name of Brucite as a Fluate of magnesia without noticing the presence of silex so distinctly obtained by Doctor Langstaff. Nor can I omit the experiments made five years ago by my friend Doctor Torrey, who also found the existence of Fluoric acid as well as the other ingredients mentioned in the analysis of Doctor Langstaff, in the Brucite; but omitted their publication in deference to the prior labors of Doctor L. from whom he expected an analysis.

My assertion that this acid (the fluoric) may be *accidental*, rather than *essential* in the composition of the Brucite, is grounded, I hope with some reason, on its absence in the analysis made by a chemist so celebrated and so accurate as Berzelius. The contiguity of slender veins of fluate of lime to the masses of Chondrodite or Brucite near to Franklin furnace at Sparta was also an additional inducement to consider this acid as accidental. Its variable proportion appears also in corroboration of this opinion.* After all, I am, in no way anxious on the subject, and am perfectly willing that Mr. Seybert should consider the fluoric acid as *essential*, while I, for want of better proof, shall still be inclined to consider it as *accidental*. I would hope, that as lovers of science and of truth, these and many other discrepancies of opinion on matters of this kind, might harmlessly and even honorably be entertained, without any necessary reference to the opinion of the public, who may be inclined rather to ridicule us for contention, than credit us for any claim to merit.

Magnesia,		51
Water,		2 and by abstraction
Fluoric acid,		9
		100

<div align="center">Yours truly, W. LANGSTAFF "</div>

Doctor L. assured me from his minutes made at the time that the Fluoric acid then obtained from the Brucite was sufficient to engrave and corrode a a plate of glass.

* Since publishing the account of this mineral, several other localities of it, particularly at West Point in the state of New-York, have been discovered. I have likewise observed it in several more specimens, with Idocrase and mica from Vesuvius; in these no trace of fluoric acid has as yet been discovered, it is consequently, very nearly related to olivin, in its chemical composition.

Not having an opportunity to refer to the original communication of the celebrated Haüy at the time when I hastily drew up the account you favored me with publishing of the minerals of Sparta, I may possibly have been inadvertently led into some trifling error in the statement of the circumstance alluded to by Mr. Seybert. Indeed

"To err is human,—to forgive, divine."

For assuredly, I never entertained the presumptuous idea, of attempting to grasp at a single leaf of the immortal laurels of the great, and venerable and lamented Haüy!

But, I hope in future, Mr. Seybert will view me with less jealousy, for I should be sorry to be considered any thing less than his friend, or that of any young man of such eminent pretensions to useful science. I have no pretensions to analyitical chemistry, having merely amused myself occasionally with a few imperfect essays, to satisfy an ardent curiosity concerning the character of a few ambiguous minerals. I undertook the task, because, at that time, no one else would engage in it. But I now rejoice to see a spirit of emulation spreading through this interesting country, so honorable and useful to its native genius and physical resources.

I am, Sir, with high respect,

Your humble servant.

THO'S. NUTALL.

2. *Iron Conduit Pipes.*

The increasing efforts which are making in this country to supply our cities with good water, give a peculiar interest to every thing connected with this subject. One of the principal practical difficulties in these undertakings arises from the bursting, leaking and decay of the waterpipes. Many years ago they were formed of cast iron in Scotland, and it appears that cast iron pipes are now in full and successful use in the new river water works near London. We have before us the report of the watering committee of Philadelphia, which contains an important correspondence between the committee and Mr. Walker the engineer of the London new river water works. We are assured by Mr. George Vaux of Philadelphia, to whom we are indebted for these facts, that the information communicated by Mr. Walker, " has been found by experience, during the last four years to be

most correct and important."' It is not possible to do justice to the statements of Mr. Walker without copying his letters entire. The most important results however are that cast iron pipes of any necessary diameter, even to two or three feet, may be employed—that their strength is sufficient to resist any desired pressure, when the thickness of their sides is very trifling, three quarters of an inch being sufficient for pipes of twenty inches diameter—three eights of an inch for ten inches, and three sixteenths for a five inch pipe ; that the pressure, with a head of one hundred and forty feet, is about sixty-two pounds on the square inch, " which is much less than one tenth of pressure which a good casting of one foot diameter and a half inch thick, is capable of resisting : the tenacity of a square inch of the best cast iron, having been found by experiment to exceed twenty thousand pounds"*—that the joints of the pipes can be rendered impervious and secure—that the iron is very enduring—imparts no disagreeable taste to the water,—is, when properly prepared, always to be depended on, and, in the course of years is more economical than any other substance.

The joint used in London, for connecting the pipes is the spigot and fauset, made tight in some cases, by lead cast around, and in others by a cement which is composed of two pounds of sal ammoniac with one hundred pounds of borings of iron, with the addition of a little sulphur. These materials are mixed with water which " oxidizes the iron, and in a short time the mixture becomes extremely hard and quite impervious to water."

When lead is used it is contracted by cooling, and it is necessary to *upset* the joint with a hammer and chisel.

The following extract of a letter to the Editor, dated, December 25, 1822, from Mr. Vaux, contains much valuable information.

" Our experience I consider to be decisive, especially in relation to the all important matter of the joints of the conduits.

* The proof of these pipes and cocks is made by the hydraulic press and those sent out by Mr. Walker to Philadelphia, were proved by a pressure equal to a column of water of three hundred feet in height, that is of the weight of nine or ten atmospheres.

" The pipes of whatever size, are usually cast in sections of nine feet, and are always laid so as to have a covering of earth at least four feet thick. During the last three or four years about thirty thousand feet have been put down by the city of Philadelphia, and between three and four thousand joints have been made. The pipes vary in diameter from twenty-two to two inches, and in no single instance has there appeared any difficulty from the change of temperature, or in fact from any other cause—although our head of water in the highest part of the city, is sixty feet and in the lower parts near ninety—the pressure of which is never removed.

In making the joints the directions of Mr. Walker are pursued, but our workmen instead of stopping the opening between the pipes with clay only, previous to pouring in the liquid lead—clasp the *inserted* pipe with an iron ring composed of two semicircles of common hoop iron bent edgewise and united on one side, by a joint or hinge, and on the other by a thumb-screw—thus ⟨⟩. This ring being placed directly against the end of the *receiving* pipe, covers the space between the two pipes, and the clay is then applied over it. When the lead is poured in, the surface next to the ring will be smooth all round, and the troublesome operation of " chipping" and " dressing" is entirely saved.

The persons engaged in making the joints have acquired such confidence in their work, that they no longer deem a proof necessary, but fill up and puddle the ditch before the water is turned into the pipes.

The information now possesed I consider of great importance, not only to our city but to the country at large, as without it iron could not be used for conduits—there being I believe no other effectual mode of securing the joints; in fact a knowledge of this matter twenty years ago would have saved us at least $100,000. When the water works were first erected by Mr. Latrobe, he put down about a mile of iron pipe, but from the contraction it was found not to succeed. Various attempts were made to obtain information from England, all of which failed previous to the application to Mr. Walker.

Our new water works are not upon the plan recommended by Mr. Walker, though some of his recommendations

have been adopted. There is no description of them in print, and I cannot personally furnish you with answers to your enquiries at this time. In the course of a few weeks, I hope to be able to do. it satisfactorily. Your friend and servant, GEO. VAUX.

B. Silliman, Esq.

3. *American Andalusite.*

To the Editor.

New-York, Nov. 25, 1822.

Dear Sir,

I am much pleased to have it in my power to announce an American locality for well characterized *Andalusite.* I lately discovered in Litchfield, Connecticut, a group of ir-regularly aggregated crystals, the interstices being filled with granular quartz.

They are principally four sided prisms, nearly rectangu-lar, varying in form to the rhombic. One of the pr sms (being very perfect) has an acumination of two of the isol-id angles on the opposite ends of one of the diagonals of that termination of the prism which is in view. This acumination is formed by three converging planes of trun-tion, two of which cut obliquely the two lateral planes, and the other the terminal one.

The solid angles are thus replaced by three faces. There are no lateral truncations. The structure is folia-ted; the laminae of strong lustre; the color is bluish gray. The crystals translucent at the edges. Spec. grav. 32.

The Litchfield andalusite is so very analogous to foreign specimens in our cabinets, that it needs no further descrip-tion. It is more perfect and beautiful, however, than any that I have seen. The largest crystal is in its diameter $1\frac{1}{3}$ inches by $1\frac{1}{4}$.

It appears to have come from granite, but there are no decisive indications of this particular.

Very respectfully, your obedient servant,

J. DELAFIELD.

To Professor Silliman.

4. *Observations on the* BOLETUS IGNIARIUS, *shewing its anal-
, ogy to animal substances in closing its severed parts: by*
PROFESSOR EATON.

TO THE EDITOR.

Sir,

Few persons take the trouble to watch the growth of
Cryptogamous plants; therefore, accidental observations,
may with propriety be preserved.

The *boletus igniarius,* or the commom touch-wood is a
very durable fungus. We often observe it full grown and
generally several years old; but few persons, I presume,
have observed its progress while in the growing state.

A fungus of this species first appeared, growing from the
trunk of a decaying Lombardy poplar, in my yard, about
twelve inchēs from the ground, in July, 1821. During that
season, it grew to the extent of four inches in diameter.
Last June it commenced growing again ; and about the first
of September following, it was fifteen inches in diameter,
measured across the base of the semi-circle. The first sea-
son it approached a globular form; though it presented it-
self as an unfinished, rather shapeless mass. Now it has
assumed its regular form, and seems to have completed its
growth; which, if correct, proves it to be a biennial plant.

The most remarkable fact observed in the growth of this
fungus was its flesh-like property, manifested when parts
were severed. A deep gash was cut in its periphery in Au-
gust; and the severed parts shortly afterwards united, by the
process which surgeons denominate *first intension.* A
piece was broken from another part, in the same month ;
and after lying on the ground two days; it was joined on
again. The piece united, as in the case of the incision be-
fore mentioned, and continued to grow with the other parts
of the fungus. Now there is not even a cicatrice nor any
other evidence left of the incision or of the fracture.

Troy, Dec. 15th, 1822.

5. *Notice of the Plumbago of Ticonderoga:* by PROFESSOR HALL.

Middlebury College, August 27, 1822.

TO PROFESSOR SILLIMAN.

Sir,

I do not remember to have seen in the "American Journal of Science," any account of the Plumbago, Graphite, or Black Lead, found on Cobble Hill in the town of Ticonderoga. That which occurs in the vicinity of Roger's Rock has been frequently described. I visited the locality on Cobble Hill, last week. It is about three miles N. W. from the Upper Falls. The Plumbago is found in numerous places, on the south side of the hill, in deep veins, from one to eight inches in thickness. The veins are, generally, perpendicular to the horizon, and nearly parallel with each other. The gangue is graphic granite.

Near the summit of the hill, the plumbago is disseminated in all parts of the gangue, occurring, sometimes in small nodules, but oftener, in thin laminæ, exhibiting a brilliant metallic lustre. Some of the plates are very large. I measured one which was an inch and one twelfth in diameter. Among the gangue at the most elevated locality, is found a greenish stone, extremely hard, which in its external appearance, resembles Green Hornblende, but it is too hard for that mineral. I am at a loss what it is.

The graphite, in veins, is uncommonly pure. It occurs, here and there, in irregular, hexahedral prisms. I saw very little that was granular. Most of it is foliated. In a few instances, it appears to be *fibrous;* but, on examining it more closely, you perceive that the fibres, which are often long, running across the whole vein, are composed of narrow, thin laminæ. It is removed from its gangue by means of chisels, pick axes, and iron bars, and conveyed to the Falls, where it is pulverized and purified. It has been prepared for the market, chiefly by Guy C. Baldwin Esq. who informed me, that about three tons are disposed of annually. The average price, at which it is sold, is sixteen dollars a hundred.

6. *Notice of a curious Fluted Rock at Sandusky Bay Ohio.*

Extract of a letter to the Editor, from EBENZER GRAN-
GER, Esq. dated

Zanesville, Ohio, July 2d, 1822.

In an excursion which I made last summer, I observed
some most curious appearances on the rock at a place cal-
led Portland, or Sandusky city, on the Sandusky Bay.

The shore of the Bay at the town rises about eight feet
above the water, and ranges nearly east something more
than a mile, and then turns abruptly to the south. The
rock appears to be what is vulgarly called bastard lime-
stone. I do not know what it would be termed by Geolo-
gists, but its base is silex in fine grains strongly cemented
with lime. It contains a great variety of shells, and is un-
questionably a marine deposit.

In digging the cellars on the front street of the town, they
come down, through four or five feet of earth, to this rock.
Its position is nearly horizontal, with sometimes a trifling dip
to the east, sometimes to the west, but more generally to
the east. Its surface is fluted, with lines or grooves, in a di-
rection nearly east and west, and though differing in width
and depth, perfectly straight and parallel with each other.
It appears to have been once polished as if by friction; and
this polish it still retains in a considerable degree. I was
told this rock had been examined by a scientific gentleman
from England, who ascertained the direction of the lines to
be, north 71 degrees east; agreeing exactly in this particu-
lar with a similar appearance, which, as he said, had been
discovered in one place only on the old continent.

I examined the bottoms of a number of cellars, and found
them similar. I also observed the same appearance in the
rock on the shore ; and in more than one place, I observed
this fluted rock overlaid by another stratum of similar con-
sistence. From the shore to the farthest cellar inland, in
which I observed these impressions, must be more than one
hundred feet, and I entertain no doubt that the impression,
at some short distance farther, is overlaid entirely by anoth-
er stratum : what its width is, therefore, it is impossible to
ascertain.

At the shore of the Bay, where as before observed, it turns abruptly to the south, the fluted rock again makes its appearance, running in the same direction. Here the rock dips gently to the east, and disappears with the impressions under the water of the Bay. From the most westerly point where I observed the impressions, to this place, must be more than one mile, there can be no doubt that it is continued all that distance; how much farther west or east it may extend is unknown.

It has to me the appearance of having been formed by the powerful and continued attrition of some hard body. It resembled in some slight degree, the sides of a saw gate, (if you understand the expression) which has been for a long time rubbing against the posts, which confine and direct it. It was said to have been observed, by the gentleman before alluded to, that the cause of this phenomenon had been the subject of various conjectures in Europe; but that the better opinion seemed to be, that it had been effected by the operation of running water. Such an opinion, however, I think, could never have been formed, by one who had himself examined this appearance; for to me, it does not seem possible that water under any circumstances, could have effected it. - The flutings in width, depth, and direction, are as regular as if they had been cut out by a grooving plane. This, running water could not effect, nor could its operation have produced that glassy smoothness, which, in many parts, it still retains.

7. *Extract from the Journal of the Academy of Natural Sciences of Philadelphia, Vol. 2d, Part II.*

Observations upon the Cadmia found at the Ancram iron works in Columbia County, New-York, erroneously supposed to be a new mineral. By WM. H. KEATING. Read Sept. 10th, 1822.

In the second number of the first volume of the New-York Medical and Physical Journal, Dr. Torrey has published a description and analysis of a substance, which he considered as a new mineral, and for which he proposed the name of green oxide of zinc; a specimen of this substance having been handed to me last spring, I immediately

recognized it to be similar in its nature and appearance, to a product of the iron furnaces of Belgium, which has been described by Mr. Bouesnal in the "Journal des Mines," (Vol. 29. p. 35,) under the name of Cadmia. Having had an opportunity of collecting on the spot* the most satisfactory proofs in support of my opinion, I beg leave to offer to the Academy the following account of this substance: It was first noticed at Ancram in the year 1812, when it was found in pulling down a stone wall connected with the iron furnace, which belongs to general Livingston, and is now under the direction of Walter Patterson, Esq. It excited some interest among the mineralogists of New-York, but no public notice was taken of it until lately. Mr. Bouesnel's observations on this subject are very full; these and a few short notes by Messrs. Collet Descotils, Heron de Villefosse and Berthier in the "Journal and Annales des Mines," are the only notices of it I have ever met with; I sought in vain for a mention of it in English works. The cadmia of Belgium is a new and rare metallurgical product, which is formed in iron furnaces about five or six feet below their orifice, and immediately under the charge; it there forms an annular disk or ring, which increases continually in thickness, and which, if not removed, would choke the furnace; it forms in the Belgian furnaces, according to Mr. Bouesnel, a ring of about sixteen inches in height, offering in the profile or vertical section, a curvilineal triangle, the base of which rests upon the sides of the furnace; and the apex which corresponds with its greatest breadth, is but little distant from the lower part of the ring, so that the triangle appears in some cases almost rectangular." I have seen a piece found at Ancram, which presented tolerably well the above described characters, and corresponded exactly with Mr. Bouesnel's description; like the European, it was found in tabular masses, presenting in many cases a distinct slaty structure. The substance has often a striped aspect; its color is grayish, inclining to yellow, green or black. The specific gravity of the European is 5.25, of the American 4.92; this difference is not very great, and may in part be accounted for, by the fact that the former

* These observations were made during a short visit to Ancram, in company with Mr Vanuxem, who likewise, at the first inspection, recognized this substance to be cadmia.

contains a small quantity of lead, which varies from 2. 4 to
6. 0 per 100. 0.

The Chemical analysis of this substance made in New-
York, has rendered it unnecessary for me to undertake that
which I proposed making. I shall merely add a compara-
tive view of the results of the analyses, made upon the Eu-
pean and American.

	Bouesnel.	Drappier.	Berthier.	Torrey.
Oxide of Zinc	90. 1	94. 0	87. 0	93. 5
———— Lead	6. 0	2. 4	4. 9	
———— Iron	1. 6	2. 6	3. 6	3. 5
Carbon	1. 0	. 5	. 6	1. 0
Silex, earth's, sand, &c.	1. 8		3. 4	
	100. 5	99. 5	99. 5	98. 0

These analyses present a remarkable coincidence, except
in the presence of lead in the European, and its absence in
the American cadmia; but this difference is of no impor-
tance; in Belgium Mr. Bouesnel tells us that the iron ore
is visibly intermixed with lead ore, and this accounts for its
existence in the cadmia; we are also told that lead is found
there in the furnaces below the metallic iron. It is not dif-
ficult to account for the presence of zinc with the iron ore,
for in examining the ore bed at Salisbury, (14 miles east of
the furnace) we ascertained that the hematite was found in
the side of a hill, incumbent upon the shist and, as it were,
incased in the decomposed part of it, and that the adjoining
shist was very much broken up and altered ; it does not ap-
pear that the hematite is the result of infiltration alone, for
masses of micaceous iron ore are found connected with it,
which appear to indicate that it results in part, at least, from
the decomposition of oxidule or oligist iron ore. We know
that this shist contains blende or sulphuret of zinc, in some
places at least, as at the Ancram lead works, and this may
account for the presence of zinc.

Mr. Bouesnel has endeavoured to explain the formation of
these cadmia, in a manner which does not appear to me to be
satisfactory, I would rather admit that it results from a reduc-
tion of the oxide or carbonate of zinc, which is intermixed
in small quantities with the iron ore ; that this reduction

takes place in the furnace; that the zinc sublimes and oxydates as it rises, and settles in the form of a ring at the inferior part of the charge, where the temperature of the furnace is considerably lowered by the successive additions of cold ore, charcoal, &c.

This substance is not, it is true, found at present forming in the Ancram furnace; but this may in a great measure be owing to a better roasting of the ore, previous to its introduction into the furnace. It may also be occasioned by the circumstance that all the ore destined for Ancram is picked with great care, at the ore bed. I must not, however, omit to state that I found in the flue erected above the orifice of the furnace, for the protection of the workmen, a red, pulverulent substance, to which the workmen have given the name of *sulphur*, a name which, as the editor of the Emporium has well observed, has been most unfortunately given by furnace and forge men, to every product which puzzles them, and without any regard to its real composition: this powder I supposed to be a mixture of ashes and fine ore, blown out of the furnace by the rapid current of air; I conceived that if there was any zinc with the ore, it would be likely to be detected in this substance, accordingly I found by analysis, about eight per cent. of oxide of zinc, a quantity much greater than I expected. It would require a more accurate study of the progress of the furnace than I could make in two days, and a better knowledge of the methods formerly in use, to determine why cadmia are not formed there at present, as they were formerly. Dr. Torrey has, I believe, never visited Ancram, and the information which he received on the subject may have led him into error. For instance, he was misinformed (I think) when he stated, that "it was found when taking down one of the old walls of the furnace erected in the year 1744." We were told by Mr. Patterson, that it had never been found but in taking down a wall *connected* with the furnace, and which having been built after the furnace, may have contained materials which had been extracted from it at different times. This observation is of more importance than it at first appears; for if, as Mr. Patterson told us, the Ancram furnace was the first erected in the colonies of North America, or at least, the first in the province of New York, and if, according to Dr. Torrey, the cadmia had been found in the wall

of the first furnace erected, the substance must have pre-existed to any furnace known to have been erected there, which we think is not the case.

But, in addition to all the above mentioned proofs, and to those which might be drawn from the circumstance of its being found in the vicinity of a furnace, I have been able to obtain the evidence of men to the fact of its having been formed in it. Having been informed that ore from the same bed was used at the works belonging to Messrs. Holley and Coffing, near Salisbury, I repaired there with a hope of finding the cadmia near that furnace also. After a short search, I found it in its immediate vicinity,, and was informed by Mr. Holley, that he had himself taken it out of his furnace about twelve years ago, when they renewed the stack. He was positive that it was the same ; that it had been found about six feet below the ̦orifice of the furnace, and that if not occasionally removed,⸴ it would have eventually choked it. I even understood him or his partner to say, that this substance was even at present occasionally formed in the furnace in pieces of almost one-eighth of an inch in thickness. One of the reasons why it is still formed at Salisbury, and not at Ancram, is probably owing to the ore used at Ancram, being picked and the other not. Mr. Patterson thinks his ore is also better roasted.

According to Mr. Heron de Villefosse, a similar substance is formed in the copper and lead furnaces of Julius, Sophia, and Ocker, near Goslar, in the Hartz. At Goslar, as well as at Jemmapes in Belgium, this cadmia is considered⸴ as the best material that could be used in the manufacture of brass ; as it is purer than the roasted calamine, it is preferred to it, as well as to all other zinciferous substances. It had not, I believe, been used in Belgium before Mr. Bouesnel described it. Should it be found in any quantity at our furnaces, it would no doubt be equally advantageous to work it with copper for brass.

This substance has not yet been observed in many places. I believe the only spot where it has been noticed, in addition to the above mentioned, is at Verrieres, in France, where I discovered it in the year 1819.* I am inclined to

*As no account of the cadmia of Verrieres has as yet been published, I shall here add the note which I made on the subject in my journal. , " July

think that if more care were taken by our iron masters, in observing the progress of their furnaces, and the, products which they yield, it might be found in many other places; certainly it must have been formed in the old Franklin furnace, in Sussex county, New-Jersey, where so many fruitless attempts were made to work the Franklinite.

Before I conclude these remarks, I must observe, that it does not appear that the presence of zinc affects the properties of iron. In Belgium the iron is of good quality ; and it is an interesting fact, that the bar-iron of Ancram is in great demand at $120 per ton, a higher price than is at present paid for any imported iron. The castings from the Ancram furnace are in such a repute, that no other pigs are used at the West Point foundry for the heavy guns (32 and 42 pounders) now casting for the United States' navy. The Ancram furnace equals, in beauty of workmanship, and economy of means, any that we have seen ; and we entertain no doubt, that all works carried on with such admirable perfection, must and will always prove equally honourable and profitable to their owners and directors.

8. *Inflammability of Ammoniacal Gas.*

I have recently found that ammoniacal gas is much more inflammable than it is described to be in the books. Having filled with this gas, over mercury, some jars* which were eight inches long by two and three quarters in diameter, I found on bringing a pendent candle over one whose mouth was covered with a glass plate, which was withdrawn at the moment, that the gas burned readily as it rose through the

*The same that belonged to Dr. Hare's first deflagrator.

6, 1819. I visited the furnace of Verrieres, in the departmeut de la Vienne, in France. The director mentioned that his ore was good, and that the iron it produced was likewise good. He complained, however, of a substance which formed in the furnace, five feet below its orifice ; it was in the form of a ring. It would, he said, have choked the furnace if not removed, which at times was a difficult undertaking. I mentioned to him that it appeared to be analagous to the cadmia of Belgium. The specimens which I took with me were heavy, compact, and of a dark colour."—I have not had an opportunity of analyzing them since ; but my suspicions on this subject were confirmed, when, on returning to Paris in the autumn of 1820, I was informed that the Engineer of mines De Cressac had discovered calamine in that vicinity the year before.

air, exhibiting a voluminous yellow flame. The reason why, in common cases, it appears nearly uninflammable, is, that it is used in very small quantities, and in narrow vessels, into which the common air can, at the moment, scarcely enter, and the gas is not sufficiently inflammable to burn (like pure hydrogen,) merely at the surface of contact,' at the mouth of the vessel. But if it rise through the air suddenly, in large volumes, and in its ascent, strike the flame of a candle, it is then sufficiently inflammable to be seen through a large room, and forms a handsome experiment.—*Editor.*

9. *Crystalization of Sulphuric Acid.*

It is very well known to every chemist, that sulphuric acid, diluted to about 1780. water being 1000. readily congeals and crystalizes with a moderate cold. It is also well known that this crystalization, when the acid is not fully concentrated, often happens spontaneously, and it is said, that even carboys of sulphuric acid have been broken by the expansion, resulting from the crystalization.

Having occasion, recently, to clean out a neglected carboy, which had been nearly emptied of its sulphuric acid, we found a few cubic inches of liquid in the bottom of the carboy, and on shaking it, to wash out the adhering sulphat of lead, (always found in the bottom of these vessels) we were surprised by the rattling, produced by thirty or forty distinct crystals of great size and firmness. On being withdrawn from the vessel, they proved to be *isolated crystals of sulphuric acid;* some of them were two inches in the greatest diameter; they appeared as firm as crystals of alum—were white and transparent, and their form, which, on account of their corrosiveness and their rapid deliquescence, it was difficult to examine, appeared to be that of very obtuse and flat rhomboids, like the lenticular crystals of calc spar—the tête de clou of the French.

It is evident, in this case, that the little acid remaining in the open carboy, had attracted water enough from the air, to bring it to the degree of dilution, which makes it crystalize most readily, and that the moderate cold which it experienced in a garret, in a mild night in November, had been sufficient to produce that result in the manner above stated.—*Editor.*

10. *Explosion of oxigen and phosphuretted hydrogen.*

The violent action of phosphuretted hydrogen and oxi-
gen, of course, induces every demonstrator to be extremely
cautious in bringing them together. Like others, I have
been accustomed to permit a succession of single bubbles,
of phosphuretted hydrogen, to rise through a column of wa-
ter, into a few cubic inches of oxigen gas, in the upper part
of a bell glass, and thus to exhibit the splendid flashes of
light, which are renewed at every contact of the gases. In
some former years, explosions, attended, however, with no
other injury than the breaking of the vessel, have resulted
ed from the fact that, occasionally, a few bubbles of
gas, probably less charged with phosphorus than others,
have broken in the oxigen gas without exploding, thus pro-
ducing, however, an explosive mixture, which a succeeding
bubble, more highly charged with phosphorus, has kindled,
and thus caused the whole to detonate.

At a recent lecture, the usual arrangement being estab-
lished, a single bubble of phosphuretted hydrogen passed up
into the oxigen, and, as I was afterwards informed by
an observer, remained unbroken. The mouth of the
retort was plunged not more than an inch and a half be-
neath the surface of the water, and this slight hydrostatic
pressure, giving a little condensation to the gas, probably
caused rather a larger volume of it than usual to pass into
the oxigen, when the next bubble rose through the water.
It is not probable that more than three common bubbles of
the inflammable gas were mingled with as many cubic inches
of oxigen gas, when a very bright flash of light, accompa-
nied by an extremely violent detonation, ensued—shatter-
ing all the glass vessels in the vicinity, and projecting frag-
ments of the bell glass in every direction, among an audi-
ence of three hundred persons, and to the extreme distance
of forty feet, slightly wounding a large number of the spec-
tators.

So sudden, violent and unexpected a result from so tri-
fling a cause, appears to me worthy of being mentioned, as
an inducement to the most scrupulous caution in the man-
agement of these violent agents.—*Editor.*

II. Foreign.

1. *Dr. Borré's notices of European Continental Geology, with remarks on the prevailing geological arrangements in a letter to Dr. J. W. Webster of Boston—communicated by him—*

To the Editor.

Dear Sir,

I send you the following extract from a letter I have received from Dr. Borré, whose essay on the Geology of Scotland has been so favorably received in Europe.

"I have been in the northern and southern parts of Germany and in the Hungarian empire. I have only room to tell you the principal results of my travels, without being able to enter into sufficient proofs of the correctness of my opinions, these you will soon learn through the medium of some of our public Journals. First, the primitive class of rocks contains two kinds of rocks, viz. *mica slate* and *gneiss;* no where, even at Freyberg is there a perfect *mantle shaped* stratification; the granite cuts the strata every'where, and for ms veins in it, it is in fact a posterior *Huttonian* rock, perhaps even of the transition period. There is certainly no decidedly primitive granite.

The transition class contains the slate formation associated with quartzose and chloritose rocks, and grau wacké. Some masses of Sienite have protruded through this formation, and nearly all the Sienites known, are newer than the grau wacké, or at least than a great part of it. This is generally acknowledged now at Freyberg as regards the Sienite of Dresden, Weissen, &c. To these Sienites belong the metalliferous Sienites of Hungaria which contain small veins of silver and gold, and are also impregnated with these metals Most of the metalliferous veins seem to belong to the same age, and to have been filled in part from below and in part from above. Every where the theory of Werner is in fault, even at Freyberg it is falling down rapidly, now that its author is dead.

In the latter part of the transition series are masses of limestone, of coral banks, and of *Huttonian* masses, or layers of greenstone with augite. (The encrinal limestone of

England is a deposit of this kind, alternating with the oldest part of the 1st floetz limestone of Werner.) The transition class ends with the porphyries, or the secondary class commences with them. The porphyries and trap rocks (which Dr. B. considers as local igneous formations) appear very differently in many places. In Cumberland, and the Fichtelsgebirge the grau wacké contains masses of porphyritic and trap rocks, beds of reaggregated rocks of this class, with here and there masses of Sienite or sometimes hillocks, often containing hypersthene, or diallage. The superior and inferior surfaces of these masses are often scorified—some cavities appear to have been filled up by infiltration.

In some countries the porphyries have broken out of the primitive schistose rocks, and now form dykes with hillocks of porphyries and of reaggregated porphyritic masses. In some places, as the Erzgebirge, they are mere dykes, as these were once taken for the beds of porphyry in the gneiss, on the contrary gneiss contains no beds of porphyry, and even the greatest part of the beds of granite in gneiss are only veins, as for instance in Sweden and Finland.

In the Erzgebirge, the dykes have much altered the gneiss, and it appears to have been also affected by acid vapors. Sometimes you see below the gneiss or transition clay slate the porphyritic matter, having every appearance as if it had been thrown up from below, and in some places you observe crystals of pyroxene in the gneiss where it is in contact with the dyke.

The coal formation is found *upon* the old red sandstone in Scotland, and Silesia; at Thorandt near Dresden and at Halle it is *below*, and in Bohemia it is *in* the old red sandstone.

On the Rhine and in the northern parts of the Alps, the Zechstein or 1st floetz limestone is imbedded in the coalfield. I explain this in the following manner; the old red sandstone is only a conglomerate of porphyritic matter, when the porphyries have appeared sooner as a local deposit, you find the coal field above the sandstone; when they have appeared during the deposition of coal, the coal field is covered by the sandstone, and when they have appeared through the whole period, there you find hardly any of the sandstone of the coal formation, but the coal field is *in* the old red sandstone. On the other hand where no porphyries

have appeared, the old red and *coaly* sandstone are more
like grau wacké, and a sandstone distinguished by the small
remains of vegetables. Such is the composition of the old
red sandstone of the northern part of the Alps.

On the south side of the Alps, porphyries abound under
the limestones, with the old red sándstone. The Zechstein
is there separated from the sandstone and alternates with
the rocks of the coal formation. When the porphyries have
appeared late, and the old red sand stone presents itself be-
low the coal, there is a great deposit of *red ground* or se-
cond floetz sandstone, as for instance in the Vosges, the
Hartz, &c.

In Germany, you find above the old red sandstone, the
Zechstein more or less compact, porous and magnesian with
Flustrae, Terebatrulæ &c. it is truly the magnesian limestone
of England with the same organic remains. It also contains
the ferriferous limestone of the Germans and the *Hohlenkalk*
of the Thuringewald. This limestone exists in France, also.
Above this rock is the *red ground* or variegated sandstone,
it is the common repository of the salt. In the upper part
there are sometimes beds of oolite belonging to the *muschel-
kalk* or second floetz limestone which lies every where up-
on this *red ground*. This formation is characterized by its com-
pactness and by its encrinites, terebratulites and pectinites,
it is very abundant in Germany—it is found in the north east
part of France, at Nevres &c.—it is unknown in England.

Above the last is the *Quadusandstein* or third floetz sand-
stone, which is also wanting in England; it exists also here
and there in France. It is whitish, yellowish or brownish,
and sometimes ferruginous; it rarely contains mineral char-
coal, pit coal, bituminous wood, impressions of monocotyle-
dons and branches of trees. Pectinites, turbinites, bivalves,
strombites, and gryphites are often found in it. Above this
is the Jura limestone or third floetz limestone, the superpo-
sition is seen in Suabia, Westphalia and France. In Eng-
land, the Jura limestone includes all from the Lias to the
Iron sand. In the true Jura chain, the second floetz lime-
stone appears, here and there, under the Jura limestone, as
near Basil. The Jura limestone is sometimes divided into
first, marles with the *gryphite* limestone, as in the island of
Sky and in Ireland, second, into compact and oolitic lime-
stone, third, into limestone with many organic remains (at

Pappenheim, Eichstadt and in part of Normandy.) It is dis-
tinguished from the second floetz limestone by its *turreted*
form, &c. The green sand is abundantly distributed in
Germany, above the Jura limestone, and also in Bohemia
where it forms the Raüerkalk; it abounds in Westphalia
near the Hartz; it is some times full of hydrate of iron as
in Moravia, in some parts of France, on the borders of the
Hartz, in Pavonia, &c. The chalk is abundant in Polonia,
above the green sand, with all the preceding members, and
also here and there in the north of Germany, especially near
Padesborn in Westphalia. Above the chalk is the *plastic*
clay with sand and rolled masses, forming a great part of the
extensive alluvial tract south of the Baltic; it here and there
contains shells. In the north of Germany you rarely see
the coarse *marine limestone*, but in the southern parts in
Hungary, &c. it is associated with the *plastic* clay, or at
least you observe there, a nagelfluch with a shelly limestone,
plastic clay with bituminous wood and fresh water shells, clay
with many marine shells like those of the subappenine hills,
sand, a kind of coarse marine limestone with shells which
do not exist in the limestone of Nagelfluch, and above these
are fresh water deposits of different ages with Planorbis, &c.
At Pest it is very compact, at Vienna marly, at Baden
tufaceous. Near Nicolshitz in Moravia it contains insects
(diptues.) Basaltic deposits are abundant and *true volca-
noes with craters and scoriæ* exist at Egen, at Hof and in the
Reisingebirge, ancient sub-marine accmulations of lava and
tuff are frequent in Germany, and the scoriæ are often infil-
trated. The dykes are numerous and have produced an ev-
ident alteration in the rocks adjacent. Basaltic cones, ele-
vated as explained by the Huttonians, not by the volcanists,
or in the form of streams, are met with here and there, es-
pecially in Hessia, and the *red ground* and shelly limestone
are much altered in their vicinity and present the same
black aspect as at Sky and in Ireland.

Trachytes are seen in five places in Hungary, on the bor-
ders of the Rhine, and in Stiria. They may be divided in-
to five varieties. Trachytes existing in hills. Trachyte
porphyries (coulées.) Porphyry more or less vitreous (a kind
of coulées.) Silicious porphyries, probably consolidated by
water, and having been once pumice-porphyries. Tra-
chytic and pumaceous tufas (being reaggregated matters

of the age of the coarse limestone of the Parisian formation."

2. *Mineralogy of the Island of Ceylon.*

' A letter reached me, a few days since, from the Rev. Miron Winslow, American Missionary in the East-Indies, dated Oodooville, (Jaffna,) Jan. 11, 1821. It contains a number of facts, relating to the mineralogy and geology of Ceylon, some of which, I suspect, are not generally known to the readers of your valuable work. I therefore copy a large part of the letter, and send the transcript to you for examination; and, if you think it of sufficient importance, for insertion in the "American Journal of Science and the Arts," please give it a place. Yours truly,

FREDERICK HALL.

Prof. Silliman,

Middlebury College, 27th August, 1822.

"I earnestly wish that by delaying so long I could now say something as satisfactory to my own mind on the other subject,—that of the mineralogy of this Island. I did hope, in accordance with your request, to be able to send you some specimens of the *precious* stones, at least; but have as yet entirely failed in my attempts to obtain any ; and had I obtained them, should have found it very difficult to forward them from this corner of the Eastern world,which has very little communication with any other part of India. In coming to the Island we first landed at Trincomale, and afterwards at Point De Galle and Colombo, at all of which places I tried to obtain specimens; but could find none except at Galle, and there only in the hands of the jewellers, who demanded a great price for them. The precious stones are found only in the interior of the Island ; and as very few here pay attention to science of any kind, there have been no considerable attempts to explore mineralogical treasures, that might be there found; and no cabinets of minerals have been formed from which one might borrow. A Society has lately been instituted at Columbo, called the "*Ceylon Literary Society,*" which promises to do something in this way: and I do not despair of being able hereafter to give you a better account of the mineralogy of this Island than I now can.

"As far as my sources of information (which perhaps are not as good as your own,) enable me to state, I can say, that compared with most parts of the world, the precious stones in Ceylon are numerous; but not of a particularly fine quality. The ruby, the topaz and the diamond, are said to be much inferior to those of Brazil and Golconda ; and the tourmalines here are destitute of electric qualities. Without pretending to any thing like an enumeration of all the minerals, I, shall mention some of the more important, and their classification according to the Wernerian system. I. *Diamond Genus.* 1. Diamond. This is inferiour to the diamond of Golconda, or the Coromandel Coast, which is better, even than that of Brazil; but, like the former, I believe crystalizes in Octahedrons, and exhibits all the varieties of that primitive form. II. *Zircon Genus.* 1. Cinnamon stone. I have seen several specimens of this, but am able to say nothing of its comparative qualities. It is rather common, I believe, in the interior. 2. Hyacinth. This is of a reddish color—may be rendered white by fire, and is then called *Jargon.* It is heavier even than the diamond, and like that, exhibits but one refraction, which indeed is common, I believe, to most of the Oriental stones. III. *Flint Genus.*(a) . Garnet *Family.* 1. Garnet. They are of different shades of red; and are magnetic.(b) *Ruby Family.* 1. Sapphires, blue and green, and heavier than those of Brazil. 2. Ceylanite of which I know only the name. 3. Topaz. This assumes the Octahedral form.(c) *Shorl Family.* 1. Emerald. The Emerald of this Island is, I believe, fine. 2. Shorl. 3. Tourmaline. The constituents are alumine, 50. silex, 34. lime, 11. iron, 5. It is said not to be electric, but I cannot answer to the truth of it; especially as I know it is usually reckoned as electric, when heated to 200° of Fahrenheit.(d) *Quartz Family.* 1. Quartz—Amethyst. 2. Rock Crystal, (black and white.) 3. Carnelian. 4. Opal. (1 species) 5. Cats-eye. This has a point, near the middle, from which greenish traces seem to proceed, in a circle. It is rather plentiful. Of the metals, lead, tin and iron ore are found in the interior; the latter only is wrought, and on a small scale. The natives have long been accustomed to work small quantities of the ore in small fires made by the operation of hand bel-

lows; and lately, an attempt has been made by Government to establish a forge in Handy.

Of the above minerals, and of almost all others, indeed, the part of this Island which we occupy is entirely destitute. The District of Jaffna is a perfectly level bed of sand, sometimes of a clayey order, on a continued substratum of a Coral. This species of stone (if it may be called such.) is almost the only one in Jaffna. In those parts of the District where the land is higher and drier, there appears occasionally a kind of stone, a little resembling, at first sight, the limestone; but which, on examination, seems to be composed principally of alumine, with an addition of silex and, perhaps, a small part carbonate of lime. It is of a greyish color, very hard and brittle, without any grit. Wherever found, it is evidently worn by the attrition of the waters, the surface being generally very smooth, but uneven, and in case of any thing like a considerable stone or rock, it is full of holes, and sharp points, as one would expect to find in stones, subjected to the action of falling water. Indeed, there is no want of evidence, that the whole of the District has been redeemed from the sea, and some part of it, at no very remote period. The land is all evidently of secondary formation. In many places near the sea, it is still nothing but a confused mass of coral and sea-shells, with a small mixture of common earth. This is particularly the case on the southern and western shore, where the water is very shallow, and discloses at the bottom increasing beds of coral, which threaten still greater encroachments upon the sea.

What is here called (improperly enough perhaps,) "Coral Stone," appears to be a calcareous formation from coral or coralline, broken and reduced by various degrees of attrition, until it is deposited, with other marine substances, in layers of different consistence, resembling stone. It is light, spongy and easily cut with the axe or saw, but when taken from its watery bed, and exposed to the air, it hardens so as to form an excellent material for building. It is burnt for lime, and when the proportion of shells in its composition predominates, it forms an excellent cement, superiour to that of the limestone of our country. The coralline, which goes into the composition of this stone, is of the most ordinary kind. It grows in the shallow waters all

around the Island, and is commonly washed up on the shores, where it is found of almost every shape, and texture and color, though not of the finest orders. It often resembles in its *texture*, horn, bone, honey-comb, &c.; but generally appears in its vegetable *form*. When growing on the shallow bottoms, the beds, as you pass over them in a boat, appear very beautiful. You might think them beds of various mosses and flowers, so various are the shapes and colors which they present. If you break off a sprig, you will often find it tipped with something like a small flower, with very brilliant colors: red, green and purple; which, however, generally lose their color and become white, on exposure to the air.

I perceive, on recurring to your very kind letter, received just as I left America, you enumerate some minerals, as natives of Ceylon, which I have not mentioned—the *Corundum, Chrysoberyl, spinelle;* also *silver* and *gold.* I can add nothing concerning them, except that the two latter metals are scarce. I do not know, indeed, of any gold *mines* that are wrought at present, but the precious metal is found in small quantities in the mountains of the interior."

3. *Mermaid.*

The following letter is from so respectable a source, that we hesitate not to publish it in this Journal. The Mermaid spoken of in this letter, is, as we are informed, the same that was purchased by Captain Edes, of Boston, and carried to England. As it will probably be soon exhibited in this country, both the credulous and the incredulous, will have an opportunity to judge whether the Japanese have fabricated a Mermaid, or whether it is a genuine production of nature. EDITOR.

Extract of a letter to Mr. James S. Wallace, of New-York, dated BATAVIA, March, 10th, 1822.

"What I have seen with mine own eyes and felt with mine own hands, that I believe." I send you a description of a Mermaid taken on the shores of Japan sometime last year, and brought to this place a few months since, by one of the regular Dutch ships. The measurement I made my-

self, having the animal in my possession an hour, and the description is from my own observation, taking minutes at the time. I regret it is not in my power to give a scientific description, but you must use these facts for that purpose, and lay it before the Society of which you are a member. I offered for it $1000, which was as much as I dare risk. I have heard the animal is taken to Europe, where it is probable a particular account of it will be published. Until this came under my observation, I was a disbeliever in the existence of an animal inhabiting water, so much resembling a human being. *Now* I am convinced—I was only disappointed in its size. I had conceived the idea they were much larger, if they existed at all.

Its extreme length from head to tail, 27 inches. Arms, including hand, $13\frac{3}{4}$ divided thus, $8\frac{1}{4}$ from end of finger to elbow—from thence to shoulder $5\frac{1}{2}$—the hands beautifully formed—fingers tapering and nails long, delicate and white, projecting a little beyond the flesh—it is a female, and from every appearance, full grown. The breasts were of good size, resembling those of a human being, and were relatively situated—immediately under them, commenced the fish.

The head large in proportion, of human form, rather round—the hair upon it coarse and black—most upon the right side—the other appeared inclining to baldness, cheeks project nearly in a line with the nose, which is perfectly human, rather flat, and with large-nostrils. The ears were human, and properly placed—there is a little hair down the back of the neck to where the shoulders set on—eye sockets rather large—the head was so set, that its vision when prostrate was at about an angle of 45° upwards—which as you hold it erect gives it the appearance of a hump-backed person. The neck finely formed, rather long, and upon the *Adam's apple*, a small lock of hair. Lips human—mouth large, and the eye teeth were like tusks—the others were like those of a human being. The line of demarkation between the fish and woman, is at the commencement of the scales immediately under the breasts, where the scales are so fine, you can only see them with a powerful magnifying glass—they gradually increase in size as you approach the tail, where they are little larger than those of a haddock, and adhere firmly. The skin above, was evidently smooth and

tawny. Just under the breasts are two fins, quite small, and above them, say $\frac{1}{4}$ to $\frac{1}{2}$ an inch, a lock of hair. Between the fins and hair, commence the scales—below these, 7 inches, are two others larger than the upper; and lower, one long fin extending nearly to the tail—on the back one long fin just over the two middle ones upon the belly. The outer edge of the fins appear to be of a reddish hue—the backbone shows itself from the neck down to where the scales commence, and is there lost to the sight. The first part, if I recollect right, resembles in its fins the fish of our shores that feed upon the rocks, and is of a dun color. In what position it gives suck I am at a loss about; but am inclined to think, prostrate upon the rocks. I learned from the owner, that the Japanese say they are often seen, but are very wary. This is miserably preserved, having shrunk much, and to accommodate it to a box six inches shorter than the first—they ingeniously bent its tail which cannot now be straightened. **JOHN SHILLABER.**

4. *New edition of Parkes' Rudiments and Chemical Essays.*

'We hear that Mr. Parkes, the author of the Chemical Catechism, has in the press a new and enlarged edition of the Rudiments of Chemistry, printed on fine paper, in a larger size than before, and with newly engraved plates; and that he is also printing a new edition of the Chemical Essays, much enlarged, and with a great part re-written. We understand it was to be published before Christmas, in two thick octavo volumes, with a great number of copperplate engravings, many chemical tables, and a very copious index to the whole. These Essays have been published in French at Paris, and in the German language at Weimar—and a new translation in German is now printing at Leipsic.'

Foreign Literature and Science.

Extracted and translated by Professor Griscom.

5. *New work on Fossil Shells.*—A work in one volume 4to. with eleven lithographic plates, price 12 francs in boards,

on the natural history of fossil shells, has been published
in the present year by those able mineralogists, A. Brog-
niart. and A. G. Desmarest. It is entitled, "*Histoire natu-
relle des crustacés fossiles sous les rapports zoologiques et
geologiques;* savoir, les *Trilobites,* par M. A. BRONGNIART,
membre de l'institut, et les *crustaces proprement dits,* par
M. G. A. DESMAREST, professeur a l' École d'Alfort, &c.

6. *A New Journal* of Natural Science has been commenced
at Copenhagen, under the editorship of professors Œrsted,
Horneman, and Rheinhardt, and Dr. Bredsdorf.

7. *Color of Sea Water.*—The color of the polar seas pre-
sents various tints from intense blue to olive green. These
tints do not depend on the state of the air, but solely upon
the quantity of water. They are divided into bands of va-
rious shades, in which whales are more frequently found
than in all other parts of the sea. It has long been thought
that those greenish waters take their tint from the depth
of the sea. Captain Scoresby however, has discovered in
these waters by means of a microscope, a great number of
spherical globules, semi-transparent, accompanied by de-
tached filaments similar to small locks of very fine hair.
These globules are $\frac{1}{1720}$ and $\frac{1}{1730}$ of an inch in diameter,
and on this surface are 12 nebulosities, composed of brown-
ish points, in 4 or 6 pairs alternately. He considers the
globules as animals of the genus Medusa. The filamen-
tous substance is composed of parts which in their greatest
dimensions, are $\frac{1}{1710}$ of an inch. Examined by the most
powerful lens each filament appears to be a chain of moril-
iform articulations, the number of which in the largest fila-
ment is about 300. The diameter is not more than $\frac{1}{17300}$
of an inch. Though these substances appeared to change
their aspects, captain Scoresby could not determine wheth-
er they were composed of living animals, having the pow-
er of locomotion ; but he is convinced that it is to the
presence of these microscopic beings that the polar seas
owe the various tints of green which are observed in them.
He calculates that one cubic foot of this water may con-
tain 110,592 globules of these Medusæ, and a cubic mile
about 23,888,000 hundreds of millions. He supposes that
these animalculæ furnish nutriment to the Actinia sepia,

Limax and other molluscs very abundant in the polar seas, whilst these in their turn, are devoured by the various species of whales that inhabit the same regions.

8. *Abbeville department of Somme France.*—*Fossil remains.*—There have just been found in several sand pits in the neighbourhood of this town, the bones of Elephants and Rhinoceros, Stagg's horns, and teeth of a carnivorous animal which M. Traulè of that town regards as those of the Lion. These remains have been found at the depth of twenty-five feet detached and mutilated. They consist of an elephant's tusk, an atlas and a metatarsus of the Rhinoceros. The enclosure of these fossils is a bed *of sharp grained sand.*

9. *Singular disease.*—The workmen of a cotton manufactory at Argues, near Dieppe, were attacked in the beginning of February last with nausea, vertigo and convulsions, which so much affected their imaginations, that they thought they saw spectres and other fantastic objects flying at them and seizing them by the throat. The Doctor not being able in time to calm their troubled brains, the villagers and country people did not fail to declare according to custom that *it was owing to a spell that had been cast upon them at the manufactory.* A thousand ridiculous ceremonies were performed to make them believe that the spell was taken off, in order to calm the imaginations of the affected. But this remedy served to confirm an extravagant prejudice and produced only a temporary effect. It became necessary to have recourse to threats, and the fear of being dismissed and thereby losing their means of subsistence, tended at length to restore them to reason.

A memoir on the causes of this malady has been presented to the medical society of Dieppe by M. Nicolle, an apothecary of that town, which contains a very exact and curious recital of the distinguishing traits of these spasmodic affections. The author attributes them to the gaseous oxide of carbon, resulting from the decomposition of the oil by the heat of a cast iron stove on which they were in the habit of placing their vessels of that fluid. This gaseous product as it is well known, is lighter than the atmosphere, and in this way the author accounts for the fact, that it was in the upper stories of the manufactory that the people were first affected

while those on the ground floor were generally preserved
from it.

10. *The preservation of Potatoes* has been lately held up to
view in France, as the best security against famine. An
account has been given by Cadet de Vaux, of an establish-
ment of M. Ternaux at Saint Ouen, for the economical
preservation of grain, potatoes, &c.

The potatoes are pared, (the parings being given to hogs
and other animals) boiled in steam, spread while hot upon
a table, divided by a light instrument, which enables the
moisture to evaporate, cooled, and then passed through a
granulating sieve, and thoroughly dried in a stove, con-
structed advantageously for this purpose. The dry mate-
rial when taken from the stove has the form of vermicelli.
It may easily be reduced either to coarse or fine flour, by
grinding. It is called by M. Ternaux *polenta*, and requires
nothing but a little warm water and salt, to convert it im-
mediately into an agreeable and savoury potage. Two ta-
ble spoonfulls, which cost only the hundredth part of a
sous, are sufficient to make two plates of soup. When
added to bouillon, no time or preparation is necessary, and
it is superior in this respect, to vermicelli or flour.

At Moulins, 550 individuals reduced to want, were fed
during 18 months at the rate of two centimes and a half,
(about $\frac{1}{40}$ of a cent) per day. This Polenta, and the gela-
tine of bones, are in the art of beneficence, a true philoso-
pher's stone. We may therefore apply to the Potatoe an
observation we have seen in *les annales Européans*, " A
single vegetable, when its importance comes to be proper-
ly appreciated, may work an entire change in the fortune,
the habits, the enjoyments, and happiness of a people."

11. *Zodiac of Denderah*—This remarkable and curious spe-
cimen of antiquity, transported with so much labor and ex-
pence from upper Egypt to Paris, has been purchased by the
King, and will be placed in a suitable position in the Louvre.

Mr. Griscom's communications on foreign literature and
science, excepting the above articles, came too late for in-
sertion in the present number; the remainder are una-
voidably deferred. EDITOR.

THE

AMERICAN
JOURNAL OF SCIENCE, &c.

GEOLOGY, MINERALOGY, TOPOGRAPHY, &c.

ART. I.——*A Sketch of the Geology, Mineralogy, and Scenery of the Regions contiguous to the River Connecticut; with a Geological Map and Drawings of Organic Remains; and occasional Botanical Notices. Read before the American Geological Society at their Sitting;* Sept. 11th, 1822; *by the* Rev. EDWARD HITCHCOCK, A.M. of Conway, Massachusetts.

PART II.

SIMPLE MINERALS.

Metallick Veins and Beds.

BEFORE giving a list of the simple minerals found along the Connecticut, it may perhaps be acceptable to the geologist, to present a short account of those veins and beds of ore, that occur in the district, which either have been, or may be wrought as mines.

1. *Southampton Lead Mine.**

This is a vein containing sulphuret, carbonate, sulphate, molybdate, muriate and phosphate of lead, with blende, pyritous copper, &c. The gàngue is quartz, with sulphate

* For a description of this mine, by Professor Silliman, who examined it in May 1810, see Bruce's Journal, Vol 1, p. 63.

barytes and fluor spar intermixed. The vein declines ten
or fifteen degrees from a perpendicular; is six or eight feet
in diameter, and traverses granite and other primitive rocks.
It has been observed at intervals from Montgomery to Hat-
field, a distance of twenty miles: but it is very doubtful,
whether it continues, uninterruptedly, the whole of that ex-
tent; indeed, from what I have observed of other lead veins
in the vicinity, I have sometimes been disposed to ques-
tion, whether the veins observed at many of these intervals,
may not be totally distinct from one another. In Southamp-
ton, eight miles south west from Northampton, is the only spot
where this vein has been extensively wrought. In that
place it has been explored thirty or forty rods in length, to
the depth of forty or fifty feet, and the galena, which is the
principal ore, has been found in masses from a quarter of an
inch, to a foot in diameter. At the depth above mentioned,
the water became so abundant, that it was thought advisable
to abandon a perpendicular exploration, and to descend to
the foot of a hill on the east, nearly eighty rods from the vein,
and attempt a horizontal drift, or adit, and ever since its
commencement, seven or eight years ago, the working of
the vein has ceased. This drift is now carried into the hill,
on an exact level, nearly sixty rods, and the workmen told
me, that not less than 20,000 dollars had been expended
upon it. The rocks that have been penetrated, reckoning
from the mouth of the drift inwards, are geest, the red and
gray slates of the coal formation, ("granulated schistose ag-
gregate." *Eaton.* Journal of Sci. Vol. I. p. 136,) with thin beds
of coal, and mica slate, and granite alternating. Probably
the fundamental deposit of granite is now uncovered; and
the principal vein of galena cannot be far distant. Several
small branch veins of crystallized quartz and galena have
been crossed; and several specimens of these, collected by
Dr. Hunt, were very rich and beautiful; the crystals of pure
galena sometimes exhibit, on their faces, insulated crystals
of honey coloured carbonate of lime. The principal vein
will be found not less, I should judge, than one hundred and
fifty feet below the surface:—and when that time comes, it
is confidently expected, not only that the proprietors will be
rewarded for the great expence they have incurred, but, al-
so, that many a rich specimen will be found to ornament the

mineral cabinets of our country, and to vie in beauty with the lead ores of Europe.

The mouth of this drift is four or five feet wide, and about three feet above the surface of the water. The water is deep enough, the whole length of it, to admit the passage of a loaded boat. The person wishing to explore this internal canal, must fire a gun at the entrance, or beat heavily with a sledge on the timbers that support the soil; in ten or fifteen minutes he will perceive a gentle undulation of the water, and soon after a boat advancing with lighted lamps and a rower; having seated himself on the bottom of this boat, and provided himself with an additional garment, he is prepared for his subterranean expedition. As he enters the passage, he will, for a moment, experience, or imagine he experiences, a little difficulty of breathing. But he will soon become reconciled to his condition; and after passing about one hundred feet in the excavation, for which distance the soil is supported by timbers, he will find occasionally more room, so that he can stand erect. If he looks back, after having advanced several hundred feet, the light at the entrance will appear diminished to the size of a candle; and before he reaches the extremity, it becomes invisible. About half way from the entrance to the end of the drift, he will pass a shaft; down which a small brook is turned, for the purpose of aiding the ventilator. When he reaches the end of the drift, he finds himself to have penetrated nearly sixty rods chiefly into solid rock; a voyage which although inferior to that performed in the celebrated navigation mine, in the Peak of Derbyshire, is still extremely interesting.

The miners do not quit the drift when they blast; but retire behind a breast work thrown up for the purpose. Entering immediately after an explosion, I did not perceive the air to be in any degree more oppressive than when powder is fired above ground. One man told me that he had been an inmate of that dark recess, eight or ten years, without suffering in his health, and when he returned alone into his dreary prison after conducting me to the day light, he struck up a cheerful song, indicating buoyant spirits and a contented mind.

Every mineralogist passing that way, will of course visit this drift. Intelligent gentlemen without professional views,

and even ladies not unfrequently enter this cavity, and find themselves amply repaid for their trouble.*

2. *Vein of Galena in Whately.*

This occurs in the north west part of the town, and I formerly supposed it a continuation of the Southampton vein. But the Southampton vein runs north east and south west, and this in Whately almost exactly north and south. Besides. the Southampton vein must turn almost at right angles from Hatfield, in order to be found in the north west part of Whately.

This vein may be traced at intervals one hundred rods, and extends into the edge of Conway. At the extremities it traverses mica slate ; but in the middle, it cuts through an extensive bed of granite. Its diameter is usually six or seven feet, and the gangue is wholly common and radiated quartz. Galena, which is the only ore found in this vein, is disseminated through this matrix in considerable abundance. Very few efforts have been made to explore this vein, though appearances at the surface are not unfavorable ; and if a horizontal drift were necessary, a deep valley within a few rods on the west, would afford a favourable opportunity for making it. As nearly as I could determine, this vein is not far from perpendicular to the horizon.

3. *Vein of Galena in Leverett.*

In the south west part of the town—traversing granite—only a foot wide—gangue, sulphate of barytes—deviation north and south—galena the only ore.

4 *Vein of Galena, Pyritous Copper and Blende, in Leverett.*

About two miles north of the vein last mentioned ; and it may be a continuation of it. The gangue is quartz, united with sulphate of barytes ; and the galena and pyritous copper are disseminated through it in nearly equal quantities.

* I have often thought Professor Cleaveland must have selected the appropriate motto prefixed to his Mineralogy, when entering this or some similar drift
——————— itum est in viscera terrae &c.

The blende is much less abundant. The vein is several feet wide, traverses mica slate and granite, and has been considerably wrought.

5. *Lead Mine at Middletown.*

I am unacquanted with the geological situation of this mine. I put it down on the authority of Professor Silliman in Cleaveland's Mineralogy.

6. *Vein of Galena at Bethlehem.*

I mention this on the same authority without any personal knowledge of it. It is, however, a little beyond the limits of the map.

7. *Vein of Galena and Pyritous Copper in Southington.*

Same authority—gangue, sulphate of barytes and quartz. I believe this vein occurs in the coal formation.

8. *Mine of Galena, Blende and Pyrites in Berlin.*

This occurs in greenstone, at its junction with the coal formation. The gangue is sulphate of barytes. The galena crystals are small ; those of the blende larger ; the pyrites is the least abundant. The vein is not now wrought. (Vide Dr. Percival's Notice, Journal of Science, Vol. 5. p. 44.)

Copper Mines and Veins.

It has already been mentioned, in the geological part of this sketch, that these ores (like the mine of galena &c. last mentioned,) exist along the junction of the greenstone with the coal formation. The veins frequently pass into both rocks, and are of various sizes and of frequent occurrence. Indeed, they may be found probably every mile or two along the line. where these rocks unite. A few of them, that have obtained some notoriety will be mentioned.

9. *Vein of Pyritous Copper and Green Carbonate of Copper, at Cheshire.*

In greenstone and associated with sulphate of barytes, quartz, carbonate of lime and sandstone. (Silliman in Cleaveland's Mineralogy, Vol. 2, p. 559.)

10. *Mine of the Red Oxide of Copper, Green Carbonate of Copper, &c. Granby.*

This is better known by the name of Simsbury Mines although it occurs within the boundaries of Granby. It was formerly wrought, but being at length abandoned, its shafts and galleries were converted into a state's prison. The mineralogist who explores this spot, must here contemplate the painful spectacle of almost every variety of guilt and crime. Sixty or seventy whites, mulattoes and negroes, scarcely distinguishable through filth, from one another, are here compelled by the point of the bayonet to labour at the anvil; while we read in their sullen and ghastly countenances, the inward workings of hearts rendered desperate by crime and punishment. As we descend into the shaft we observe the offensive recesses in the rocks, where these prisoners were formerly confined during the night. But only a few of the most refractory are now compelled to sleep in these damp and dismal dungeons; the government of Connecticut being satisfied that this kind of rigor served rather to harden than to reform the criminal. About seventy feet below the surface, the conductor pointed out to me a bolt driven into a wet rock, where, recently, one of the prisoners had been fastened for a week or fortnight, as an extra punishment for peculiar obstinacy; and where he lay, I saw scattered, the leaves of a bible, which, in his desperation he had torn in pieces:—thus spurning alike the laws of God and man!

If we judge from the present appearance of this excavation the original vein of ore must have been extremely irregular, forming *bellies* and *twitches*. It passes through the greenstone and enters the red and gray micaceous sandstone of the coal formation, which underlies the greenstone. All the varieties of ore I saw at the place were the red ox-

ide disseminated in sandstone, and mixed with a small proportion of green carbonate of copper. How productive this mine has been, I do not know.

11. *Vein of Green Carbonate of Copper and Pyritous Copper in Greenfield Mass.*

This is found on the west bank of Connecticut River, one hundred rods below the mouth of Fall river, and about the same distance in a direct line from Turner's Falls. It occurs at the junction of the greenstone and red slate of the coal formation, and passes obliquely into the hill of greenstone on the one side, and into the slate on the other in the bed of the river. The principal vein is five or six feet in diameter, and the matrix, toadstone, which is traversed, in the direction of the vein, by several veins of sulphate of barytes, which form *saalbandes.* The principal ore that appears at the surface is the green carbonate, the pyritous copper being rarer.

12. *A similar vein in the same township.*

About a mile below the vein just described, (down the stream,) is another, which I am told is very similar and therefore needs no description. In other places between these veins, I have noticed, in the red slate, veins of the green carbonate of copper, not more than a quarter of an inch thick, while the walls are glazed so as to resemble polished steel; constituting handsome specimens of the *Slickenside* of the Germans.

Mines, Veins, and Beds of Iron Ore.

13. *Micaceous Iron Ore in Veins, in Montague.*

Near the north line of the town, a little south west of the mouth of Miller's river, a granitic hill of considerable extent and elevation is traversed by veins of this ore in all directions; constituting one vast *stock werke.* The principal vein is nearly ten feet in diameter, and the gangue is quartz. I do not see why this ore could not be profitably wrought. See Journal of Science, Vol 1, p. 438, where this ore is described under the general name of specular oxide of iron.

14. *Mine of Magnetic and Micaceous Oxide of Iron, in Hawley.*

This exists in the north western part of the town, in beds, in talcose slate. The folia of the slate are nearly perpendicular to the horizon, and the principal bed of the ore varies from six inches to three or four feet in thickness, and numerous thin beds occur at the sides. The mine has been opened twenty or thirty rods long, and thirty or forty deep. The magnetic oxide is probably most abundant: but the micaceous oxide has not till lately been wrought, through an impression that it could not be smelted! One or two tons of it lie beside the mine ready for the mineralogist. I have never seen any ore of this sort, that will bear any comparison for beauty and richness of appearance with this. It has a schistose, gently undulating structure, and plates of it may be easily obtained, a foot in diameter, possessing a highly glistening aspect. But it is no very easy matter to get at this mine, on account of the extreme roughness of the country for several miles around it.

15. *Mine of Magnetic and Micaceous Oxide of Iron, in Bernardston.*

This occurs in beds in talco-argillite, and is so similar to the last described, that additional remarks are unnecessary. I do not know to what extent it has been wrought.

16. *Vein of Micaceous Oxide of Iron, in Jamaica in Vermont.*

This exists in dolomite, and is very beautiful. It has been used as a substitute for smalt, and answers well. I do not know its extent. It is a few miles beyond the northern limits of the map.

17. *Mine of the Brown Oxide of Iron, in Salisbury in Connecticut.*

This, as well as the two following mines, occurs a considerable distance beyond the limits of the map. I merely mention them, however, because of their interesting nature; and

in giving a list of the simple minerals, I do not intend to be scrupulously confined to the region embraced by the map. This mine is wrought in a bed in clay. For further particulars see Prof. Silliman's account of this ore, in the Journal of Science, Vol. II. p. 212.

18. *Mine of the same ore, in Kent, in Connecticut.*

This is found, like the last, in a bed in clay. See Vol. II. of the Journal of Science, p. 216.

19. *Mine of Carbonate of Iron, in New-Milford, in Connecticut.*

This exists in a vein, in gneiss ; and its gangue is quartz. See Journal of Science, Vol. II. p. 226.

20. *Bed of Bog Iron Ore, in New-Braintree, in Massachusetts.*

This ore is not uncommon along the Connecticut; but I have never examined a bed of it, except in New-Braintree, in Massachusetts. It lies in a valley, in a country of gneiss, only a few feet below the surface; and has been explored to a considerable extent.

21. *Mine of Arsenical Cobalt, in Chatham, in Connecticut.*

It exists in a bed, in mica slate, varying in width from a few inches to a few feet. The matrix is a mixture of hornblende and actynolite, in which the ore is disseminated. It was explored several years since, and has been again opened recently; the undertaking is now, however, abandoned. Arsenical sulphuret of iron, arsenical nickel, and arseniate of cobalt are found in this mine in small quantities.

22. *Mine of Bismuth, Silver, Argentiferous and Common Galena, Blende, Tungsten, Tellurium, Magnetical and Common Pyrites, Spathic Iron, Native Sulphur, Pyritous Copper, &c. in Huntington, in Connecticut.*

The various minerals mentioned above, have been found in a vein traversing gneiss, although it has yet been explored only a few feet in depth. The gangue is quartz. For a more particular description of this interesting spot, see various articles by Professor Silliman, in the first five volumes of the Journal of Science.

In the above enumeration several small and unimportant veins of ore have been omitted ; and probably many important ones are yet undiscovered. In some instances I have met with men who profess to have found beds or veins of ore, but will not disclose the spot, because they intend to render themselves independent by their discoveries. Indeed, were the mineralogist to pay attention to all he will hear on this subject in his travels, he would be led to suppose that every town, and even every farm, is a rich repository of metals. For he will often be told, how in such a mountain the aborigines used to obtain iron, lead or silver; or how, in such a place, the lightning frequently strikes, as a certain indication of metallic ores; or how in such a place *the mineral rod will work;* and a thousand such mummeries, by which honest but credulous men are frequently deluded, and sometimes ruined.

List of Simple Minerals found along the Connecticut.

I have already remarked, that in giving this list, I should not be confined precisely to the limits of the map; but where an interesting mineral has been found a few miles beyond these, I shall notice it. I shall annex to each species and variety, merely the localities and name of the discoverer, except in cases where I am able to add some particulars not heretofore published. To save all further trouble of reference, I have taken the second edition of Cleaveland's Mineralogy as a standard for names and arrangement. And, indeed, I feel as if a better disposition of minerals could scarcely be made, in the present state of the science, than that excellent work presents.

The species and 'sub-species are numbered in order from first to last. The varieties also, whenever they occur, are usually numbered.

1. *Nitrate of Potash.* Efflorescing on the soil under old buildings, &c,

2. *Sulphate of Barytes.* At Cheshire, Southington, Farmington, New-Stratford, and two miles from Hartford. (*Silliman.*) Also at Berlin. (*Percival.*) Also at Hatfield. (*Gorham.*) Also at Middlefield. (*Eaton.*) Also at Southampton lead-mine, at the Leverett lead veins, and at the Greenfield copper veins. At the three last mentioned places it is chiefly the lamellar variety.

3. *Calcareous Spar.*

1. *Crystallized.* At the Marb'e Quarry in Milford, in rhombic crystals; also in the lead mine at Middletown. (*Silliman.*) Also at the lead mine in Southampton, in limpid and straw-colored crystals on galena and quartz. Forms of the crystals. 1. A dodecaedron, composed of two six-sided pyramids, applied base to base. (*hog-tooth spar,*). 2. A short six-sided prism, terminated by three-sided pyramids. 3. The same, with all the solid angles of the prism truncated; forming a crystal of twenty-four faces. Also, in greenstone in Deerfield and Greenfield; and in a coarse limestone in Leyden, Conway, &c. in rhombs.

2. *Laminated.* At Milford Hills. (*Silliman.*) Also, in veins in greenstone, Deerfield.

4. *Granular Limestone.* At Milford Hill, embracing the bed of Verd Antique Marble. (*Silliman.*) In Wilmington, Vt.?

5. *Concreted Carbonate of Lime.*

1. *Calcareous Incrustations.* In the Coal Formation in Sunderland, &c.

6. *Argentine.* At Washington, Litchfield Co. (*Brace.*)

7. *Magnesian Carbonate of Lime.*

ab 1. *Crystalyzed.* (Rhomb Spar.) Near New-Haven, with M estus in Serpentine. (*Silliman.*) Abundant at the Milford arble Quarry. Also at Middlefield, in Soapstone. (*Dewey.*) Also at Southampton lead mine. (*Eaton.*)

2. *Dolomite:* At Washington and Milford Hills. (*Silliman.*) Also at Litchfield. (*Brace.*) Also at Middlefield. (*Dewey.*) Also at Jamaica, in Vermont. (*J. A. Allen.*)

8. *Brown Spar.* At Leverett, in a vein of galena, pyrites, copper and blende, grouped in rhombic crystals on quartz; the lamellae usually curved.

9. *Fetid Carbonate of Lime.* At Northford. (*Silliman.*)

10. *Bituminous Carbonate of Lime.* Near Middletown, with Ichthyolites. (*Silliman.*) Also at Southington, in the Coal Formation.

11. *Phosphate of Lime.*

1. *Apatite.* At Milford Hills. (*Silliman.*)

12. *Fluate of Lime.* Cubic and massive fluor spar occurs in Huntington—also chlorophane in the same place. (*Silliman.*) Also at Middletown, in the lead, &c. vein. (*Brace.*) Also at Southampton lead mine, green and purple. (*Gibbs.*) Also at Deerfield, crystallized in dodecaedrons? purple—in a loose stone, which contained also a crystal of galena. (*Cooley.*) Also at Putney, massive and grass green, forming a vein in bastard mica slate. (*Silliman.*) Also at Westmoreland, light green. (*Hall.*) Also at Conway, massive, light green, in small quantities in a vein in mica slate.

13. *Gypsum.* In amygdaloidal greenstone in Deerfield, in small quantities; "crystallized—white, and retaining its water of crystallization." Found by Dr. Cooley, and determined by Professor Silliman. This has been already mentioned in the geological part of this sketch.

14. *Sulphate of Alumine and Potash.* (Alum.) In Leyden, efflorescing on bastard argillite. Also in Conway, on mica slate.

15. *Common Quartz.*

1. *Limpid Quartz.* At Grafton in Vermont, remarkably pure. (*Hall.*) Also at Plainfield. (*J. Porter.*) Also in the veins of lead, &c. at Southampton and Leverett, and the copper veins in Greenfield, in six-sided prisms. At the latter place it occurs with both the terminations perfect. Also in veins in sienitic granite, at Northampton. Also in geodes in greenstone at New-Haven, Berlin and Deerfield. Also in veins and geodes from one to ten inches diameter, in mica slate in Conway. The crystals are of every size from one tenth of an inch to two inches diameter, and occur in vast quantities. In the same town fragments of crystals occur, as transparent as the quartz from Madagascar.

2. *Smoky Quartz.* At Torrington and Cornwall. (*Brace.*) Also at Plainfield and Brattleborough? amorphous.

3. *Yellow Quartz.* In crystals at the Southampton lead mine; of a honey yellow, resembling the Siberian topaz. The coloring matter appears to penetrate the crystals. Also in small quantities at the lead mine in Leverett.

4. *Rose-Red Quartz.* At Southbury, very abundant. (*Silliman.*) Also at Chatham and East-Haddam. (*T. D. Porter.*) Also at Deerfield; a single specimen in alluvial soil.

5. *Irised Quartz.* At Plainfield. (*J. Porter.*) Also at Leyden, in mica slate.

6. *Milky Quartz.* At Litchfield. (*Brace.*) Also at Cummington and Plainfield. (*J. Porter.*) The specimens that I have seen of this variety (and they are scattered abundantly over the mica slate region west of Connecticut river,) are rather poorly characterized, seeming to be intermediate between limpid and milky quartz.

7. *Radiated Quartz.* In the Southampton, Whately and Leverett veins of galena; in abundance. Also in Conway, in veins and loose masses.

8. *Tabular Quartz.* In greenstone, Deerfield—Lamellae usually applied to one another by their broader faces, and separating as thin as mica, but very brittle. Sometimes, they intersect and produce cells of various forms. Also in Conway, in large loose masses among mica slate. Pieces more than a foot in diameter have been noticed, having both the structures above mentioned. The plates forming the cells are sometimes covered on their broader faces with minute quartz crystals. In some specimens there is a gradation from tabular to common amorphous quartz; the folia becoming less and less distinct, and finally disappearing.

9. *Granular Quartz.* At Vernon, Vermont, forming a bed in argillite. (*J. A. Allen.*)

10. *Pseudomorphous Quartz.* At the Southampton lead mine and in Deerfield greenstone—the impressions being cubical. At the latter locality also, a very curious variety of this mineral occurs. The quartz is the common limpid kind; passing, however, in some parts, into chalcedony; and it contains numerous cavities that diverge from a centre. Their form is that of a four-sided, nearly rectangular prism, generally a little flattened, and, of course, lessening to a point at one end. Their length is from half an inch to four inches. A complete sphere is seldom filled by them; usually not more than a quarter part of it; and at their outer extremity they are so scattered as not to fill half the surface of the sphere. I have sometimes observed these cavities proceeding from different centres, crossing one another. Although it is no uncommon thing to meet with these cavities, yet I have never found any mineral occupying them. An interesting question then occurs; by what were they once occupied? The probability is, that it was some variety of zeolite. Yet no zeolite of this description has been found in the greenstone in the vicinity. It exists in balls perfectly filled; the crystals usually circular, and the concretion never much larger than a musket ball. But the zeolite, it is well known, does occur in radiated masses several

inches in diameter, the outer extremity of which presents the form of the prism. I am rather disposed to believe that these cavities were once filled by a mineral not differing much from the Thomsonite of Dumbarton in Scotland.

Some varieties of quartz occur along the primitive region of the Connecticut that can hardly be referred to any of the preceding. Thus, there is a variety very abundant in beds and tuberculous masses in mica slate and argillite, which differs in nothing from limpid quartz, except that it is colored crimson red; and perhaps it ought to be referred to ferruginous quartz; but it differs from that commonly so called. Another variety is abundant every where, in large rolled masses, of a reddish grey color when broken, with a chonchoidal uneven fracture—the structure being almost granular, and the aspect considerably like hornstone. Another variety, more rare, occurring in pudding-stone, is of a light blue color, and scarcely translucent; but it can hardly be called the *blue quartz* of mineralogists. Another variety is found in granite and in loose masses, and is nearly black, and only semi-transparent. Another variety has a tinge of yellow—another of green, &c.

16. *Amethyst.* At Wallingford, Farmington, Berlin and East-Haven. Also at Mount Tom in East-Hampton. (*Silliman.*) Also in greenstone, Deerfield, forming geodes of a light purple; crystals from one tenth of an inch to an inch in diameter. Also in Westminster, Vermont, in crystals an inch and an half in diameter.

17. *Ferruginous Quartz.* At Litchfield. (*Brace.*)

18. *Fetid Quartz.* I have recently found this in several places, from Woodbridge, near New-Haven, to Bellows-Falls in New-Hampshire, a distance of one hundred and fifty miles, in loose rolled masses. In the vicinity of Conway it is very abundant, and occurs crystallized in the common six-sided prisms; which are sometimes so flattened as to be three times as broad as thick. In Conway it occurs in veins in mica slate and granite; less fetid, however, than that which is found loose on the surface. It is traversed by thin seams, or veins, apparently ferruginous; its color is nearly milk white and its lustre a little resinous. In some specimens the fetid odour is very strong.

19. *Chalcedony.*

1. *Common Chalcedony.* At East-Haven, in greenstone. (*Silliman.*) Also in the same rock at Southington, Farmington, Hadley, Sunderland, Deerfield, Greenfield, Gill, and indeed, in almost every greenstone hillock and ridge from New-Haven to Gill. Its color is light grey, deep grey, brownish, yellowish and greenish grey; it occurs botryoidal, mammillary, cylindrical and reniform, and is often of a cloudy or milky appearance, and frequently, strongly translucent.

2. *Cacholong.* In greenstone, Deerfield. It is associated with common chalcedony, and frequently, envelopes it, or constitutes some of the bands of agates. Its color is milk or yellowish white.

3. *Carnelian.* In greenstone, Deerfield. United with common chalcedony and cacholong, into which it passes. Its color is usually pale or yellowish red. It is not abundant. Also at East-Haven.

4. *Sardonyx?* Some specimens of the carnelian in Deerfield greenstone, being reddish yellow and orange, appear to belong to this variety; but it occurs in so small quantities as hardly to be worth noticing.

Agate. This occurs at East-Haven and Deerfield; and as it is composed of varieties of chalcedony and quartz, this seems to be the proper place to notice it. A description of a part of the agates occurring in these localities has already been given with sufficient minuteness in the American Journal of Science, and in Cleaveland's Mineralogy. But since the publication of those accounts, Dr. Dennis Cooley has discovered a new locality in the Deerfield greenstone, from which he has obtained specimens so much superior to those heretofore found that they deserve a particular notice. The following is a description of specimens in his possession.

No. 1. Longer diameter of the face of the agate, nine inches—shorter diameter, six inches. Outer zone, greenish chalcedony, half an inch broad. Second zone chalcedony,

a little tinged with red, a quarter of an inch broad. The centre is occupied by an amethystine geode of a light purple. Weight of the whole agate, twenty-three pounds.

No. 2. Face seven inches by four—Outer band, one fourth of an inch wide, of yellowish red carnelian; second band greyish white chalcedony, one fourth of an inch. The remainder of the space is occupied by a geode of limpid quartz. The outer coat of carnelian is broken off from a large part of this specimen, leaving bare the whi ish chalcedony, and it has a strong resemblance to the human cranium; exhibiting similar protuberances and concavities.

No. 3. Face three inches in diameter—outer band of yellowish red carnelian—second do. chalcedony a little tinged with red, one tenth of an inch—third do. cacholong, one tenth of an inch—fourth do. light carnelian, one tenth of an inch. The centre is occupied by common quartz, not forming a geode.

No. 4. As it appears at one end : Diameter of the face three inches—outer zone three fourths of an inch thick, of yellowish green chalcedony—second do. carnelian, one fourth of an inch—third do. quartz, having a greasy aspect —fourth do. dark grey translucent chalcedony, a mere line in thickness—fifth do. quartz or milk colored chalcedony, one tenth of an inch—sixth do. dark grey chalcedony, a line broad—seventh do. quartz, one fiftieth of an inch—eight do. dark grey chalcedony, a line broad—ninth do. quartz, one tenth of an inch—tenth do. chalcedony, a line broad—elevvenh do. quartz, one fiftieth of an inch—twelfth do. a line of chalcedony,—thirteenth do. quartz, one thirtieth of an inch—fourteenth do. a line of chalcedony. The centre is occupied by limpid quartz. This is a *fortification agate,* and the parallelism of the several bands is most exactly preserved, and the angles are perfect. Viewed on a face at right angles to that above described, this specimen exhibits a *striped or ribband agate.*

No. 5. Made up of an almost countless number of darker and lighter colored bands of white and grey chalcedony —two or three small agates appearing on the same face.

This appears to be a real *chalcedonyx;* and such specimens are not uncommon.

No. 6. *Fortification and Eyed Agates,* in the same specimen. One of the latter is an inch in diameter, and has six or seven zones of lighter and darker chalcedony and one of carnelian, enveloping a nucleus of light blue chalcedony.

These specimens seem to want nothing but a polish to make them equal to any in the splendid cabinet in New-Haven. The rock in which they occur is not strictly amygdaloidal, but contains only a few large cavities; and so firmly are the agates fastened into their bed that one is often obliged to break them out by piecemeal; thus ruining the most superb specimens The larger ones are not very abundant. The rock, however, has not been penetrated very far.

20. *Siliceous Sinter.* At East-Haddam, in gneiss and incrusting mica slate. (*T. D. Porter and Webster.*)

21. *Opal.* "Common opal has been found in Litchfield, though rarely." (*Brace.*)

22. *Flint.* Near New-Haven and in Woodbridge, in rolled masses. (*Silliman.*)

23. *Hornstone.* At Litchfield. (*Brace.*) At the Southampton lead mine; also in Conway. Also in greenstone at Southington and Deerfield At the latter place it occurs in nodules often four or five inches in diameter. Its colors are grey, green. black with a tinge of red, and dark blue. Its fracture is sometimes a little chonchoidal and glistening, sometimes dull and splintery; and it is scarcely translucent at the edges. Some specimens considerably resemble siliceous slate, and others appear like prase. But Professors Silliman and Dewey (the latter of whom has examined it chemically,) agree in calling it hornstone. Also in Sunderland in greenstone, in narrow veins—well characterised.

24. *Jasper.* Near New-Haven in rolled masses. (*Gibbs.*) Also at Cummington on the banks of Westfield river. (*J. Porter.*) Also on the banks of Deerfield river in Deerfield,

and in Conway, Leyden, &c. in rolled fragments, red, black and yellow.

25. *Corundum.* At Litchfield, massive and in six-sided prisms, imbedded in massive sappar. '(*Brace.*)

26. *Cyanite.* At Litchfield, Harwinton, Watertown and near New-Haven. (*Silliman.*) At the former place a mass of this mineral, associated with talc, sulphuret of iron and corundum, is supposed to weigh one thousand five hundred pounds. (*Brace.*) Also at Middle-Haddam. (*Eaton.*) Also at Chesterfield, Mass. in loose masses in mica slate; where its bladed or imperfect prisms are two feet long. (*Hunt.*) Also at Granville. (*Dewey.*) Also at Plainfield. (*J. Porter.*) Also at Grafton, Vermont, and Charlestown, New-Hampshire. (*Hall.*) Also at Bellows Falls. (*Silliman.*) Also at Deerfield, in mica slate. (*Williams.*)

27. *Staurotide.* At Bolton, East-Hartford, Beacon-Hill, Litchfield, Harwinton and Chatham. (*Silliman, Brace, Eaton and Woodbridge.*) Also at Cummington. (*J. Porter*) Also at Bellows Falls. (*Hall.*) The range of mica slate in which this mineral is found in Bolton, Chatham, &c. extends, with little interruption, into New-Hampshire and Vermont, at least as far as Bellows Falls; and its aspect is very similar throughout, and scarcely a mile of the distance is it wanting in staurotide; or rather, wherever I have crossed it, (in perhaps fifty places,) this mineral occurs; as in Vernon, where it is in vast quantities, in North-Wilbraham, Ludlow, Shutesbury, Leverett, Northford, Hinsdale, Chesterfield, Putney, Westminster, &c. In Chesterfield, New-Hampshire, Dr. J. A. Allen found crystals an inch and one fourth in diameter, and two inches and an half long, in the valley south-west of the meeting-house. A range of similar mica slate extends through Chesterfield, Mass. into Cummington, Plainfield, Hawley, &c. and here also staurotide occurs in abundance. In Chesterfield I noticed a mica slate rock, two or three feet thick, containing seven or eight distinct *layers* of this mineral.

28. *Pinite.* At Haddam, in mica slate and granite. (*Silliman and Webster.*) Also at Bellows Falls. (*Hall.*)

29. *Chrysoberyl.* At Haddam, on both sides of the river, in six-sided prisms and six-sided tables, in granite. (*Gibbs.*)

30. *Zircon.* At Sharon, Litchfield county, in quartz. (*Silliman.*) Also at Brimfield, in gneiss. (*Eaton.*)

31. *Siliceous Slate.*

1. *Basanite.* Sometimes found in alluvial soil on the banks of Deerfield river; but perhaps brought thither by the aborigines, who made use of this and of jasper for barbs to their arrows and pikes.

32. *Pitchstone.* Near New-Haven. (*Silliman.*)

33. *Mica.*

1. *Laminated.* At Leverett, Alstead, &c.

2. *Lamellar.* At Woodbury it is violet. (*Silliman.*) Also at Goshen, Mass. yellowish green and violet, and sometimes in rhombic tables. (*Gibbs.*) Of the same colors at Bellows Falls, in granitic veins. (*Silliman.*) Most of the mica in the granitic veins in Conway, Ashfield, Williamsburgh, Chesterfield, &c. is straw yellow, sometimes rose-red, and in these veins it exists in excess. It occurs in these and other towns also, in granite of a smoky or nearly black color.

3. *Prismatic Mica.* Near Watertown. (*Silliman.*) At Litchfield. (*Brace.*)

34. *Shorl.*

1. *Common Shorl.* At Haddam, in six-sided prisms, terminated by three-sided pyramids. (*Gibbs and Webster.*) It occurs in almost every town in the primitive region along the Connecticut. Localities where it is found abundant, or beautiful, are Pelham, Shutesbury, Orange and Brattleborough. At the latter place it is found abundantly near the centre of the town in mica slate or hornblende slate; and also near the north line of the town (mentioned in Cleaveland's Mineralogy as occurring in Dummerston,) it

exists in crystals half an inch in diameter and often four or five inches long, sometimes terminated by three-sided pyramids, in common white quartz. The contrast renders the specimens quite beautiful, and one large loose mass lies on the surface nearly two feet in diameter, which would be an ornament to a mineral cabinet.

2. *Green Tourmaline.* At Chesterfield and Goshen, Mass. (*Gibbs.*) These interesting localities have been so well described by Col. Gibbs, as to render any farther remarks unnecessary. (Am. Jour. Vol. I. p. 346.)

3. *Indicolite.* At Chesterfield and Goshen. (*Gibbs.*) At Bellows Falls. (*Silliman.*) At Hinsdale, New-Hampshire, in granite, in great abundance. (*J. A. Allen.*) This locality is found most readily by taking the road from Hinsdale to Winchester.

35. *Rubellite.* At Chesterfield and Goshen, Mass. (*Gibbs.*) See his account in the Journal of Science, as above cited.

36. *Feldspar.*

1. *Common Feldspar.* Near Haddam, greenish and translucent. (*McEwen.*) In the same vicinity it is of a light flesh color, and in large masses in granitic veins and beds. Also of the same color in pudding-stone, Deerfield. Also in large, bluish, imperfect crystals, in granite, Leverett. It occurs, of course, abundantly in all that part of the map colored as granite, gneiss and sienite.

2. *Adularia.* At Haddam. (*T. D. Porter.*) At West-Springfield and Southampton lead mine. (*Waterhouse.*) At Brimfield. (*Eaton.*)

3. *Siliceous Feldspar.* (*Gibbs.*) At Chesterfield, Mass. and Haddam. (*Gibbs.*) Also at Goshen—a new variety, discovered by Dr. Hunt.

37. *Precious Emerald.* At Haddam? For a discussion of the subject whether this mineral exists in the United States, see Cleaveland's Mineralogy, Vol. 1. p. 341.

38. *Beryl.* At Brookfield, Huntington and Haddam. (*Sil-liman.*) Also at Litchfield. (*Brace.*) Also at Chatham. (*Mather.*) Also at Chesterfield, Mass. and Goshen. (*Gibbs.*) At Chesterfield and Haddam the crystals are sometimes from nine to twelve inches in diameter. At Goshen some are rose-colored. I found some crystals of beryl four or five miles north of the centre of Haddam.

39. *Garnet.* At Haddam—four inches diameter. (*Silli-man.*) Also at Tolland, nearly rose-red. (*Webster.*) Also at the cobalt mine, Chatham, in mica slate, crystallized in rhombic dodecaedrons, or rather six-sided prisms termina-ted by three sided pyramids—the prisms often considerably elongated—color pale red—size that of a common musket bullet. Also at Plainfield, in limpid quartz, in trapezoedrons, or having at least as many as twenty-four sides—color of the mass nearly iron black. Found by J. Porter. Also at the same place in talco-micaceous slate, in dodecae-drons; color brownish red; size of a pea. Also at the same place, in dodecaedrons, truncated and striated on all their edges by hexaedral faces; presenting thirty-six faces in the whole—color dull red—size of a common bullet. Also at the same place in talcose slate, in dodecaedrons of the same color, sometimes two inches in diameter. Also at Chesterfield, Mass. with sappar, in trapezoedrons; color light rose-red—size of a pea. Also in hornblende and mi-ca-slate, in Conway and Deerfield; color nearly black—crystals dodecaedrons—sometimes as large as a common bullet. Also in Conway, a loose mass, almost wholly made up of small black garnets in dodecaedrons—size less than one tenth of an inch in diameter, and with scarcely any dif-ference in the size of hundreds. Also at Marlborough, Ver-mont, one mile south of the meeting-house, in dodecaedrons of a cherry-red, in chlorite slate; but hardly the precious garnet. They occur at this spot in immense quantities, and beautiful specimens may easily be obtained. A hun-dred other localities of the common garnet might be men-tioned; since it occurs in all our primitive rocks: but the most interesting have been noticed.

1. *Pyrope.* At Brimfield, Mass. in granite, the feldspar of which is light green—in rounded irregular masses of a del-

icate poppy red, much resembling some varieties of the ruby. "It scratches crystallized quartz," says Professor Dewey, "and melts, rather hardly, into a dark enamel." Found in digging a well.

2. *Colophonite.* At Conway?

· 40. *Magnesian Garnet.* At Haddam. (Vide Cleaveland's Min. Vol. 2. p. 777.)

41. *Epidote.* At Milford Hills, in primitive greenstone. (*Silliman.*) Also at Litchfield and Washington, in graphic granite and sienite; crystallized. (*Brace.*) Also at Haddam, crystallized. Also at Tolland. (*Webster.*) Also at Athol, Worcester county, Mass. in prismatic bladed crystals, associated with black radiated schorl and hornblende. Also in Shutesbury, in small crystals in gneiss. It occurs also in a great many other places, disseminated in various rocks, and not very interesting.

1. *Zoisite.* At Haddam. (*Webster.*) Also at Wardsborough, Vermont, in much compressed, greenish grey, prismatic crystals; sometimes a foot long and one or two inches wide. (*Dewey.*) Discovered by Dr. J. A. Allen. Also at Leyden, Brattleborough and Westmoreland. (*Hall.*)

2. *Arenaceous Epidote.* At Haddam. (*Webster.*) Also at Shutesbury, Leyden, Shelburne, Buckland, Whately, Belchertown, Monson, and a great number of places, in hornblende and greenstone slate.

42. *Prehnite.* Near New-Haven, in secondary greenstone, in radiated masses, or in veins. Also at Woodbury, in the same sort of rock, in mammillary, botryoidal and almost globular masses. (*Silliman.*) Also between Simsbury and Wintonbury, in mammillary masses in greenstone. (*Hayden.*) Also in Deerfield, Greenfield, and, indeed, in almost every part of the secondary greenstone ranges from New-Haven to Gill; in all the forms mentioned above. In Deerfield the radiated masses sometimes contain pyritous copper. They occur there, also, on pseudomorphous quartz, having evidently been formed since the decomposition of the crystals originally occupying the cavities. In the same

place, I have found prehnite crystallized in groups on chalcedony; but could not determine the form of the crystal. Also near Bellows' Falls in primitive rocks. I saw specimens in the cabinet of Dr. Wells; but was not informed of the precise locality: yet the mica attached to the specimens indicated their detachment from the older classes of rocks.

43. *Stilbite.* At Woodbury, well characterized. (*Silliman.*) Also at Deerfield in secondary greenstone; usually associated with chabasie. Its crystals appear to be right prisms, whose bases are rhombs with angles of about 60° and 120°. They rarely exceed one tenth of an inch in their longest direction. They are frequently grouped so as to become mere foliated masses. The lustre of the folia is pearly, and they are usually a little curved; color white. On hot coals it whitens and before the blow-pipe intumesces and melts into a white spongy enamel. It is but rarely met with.

44. *Zeolite.* Near New-Haven it is found in secondary greenstone, crystallized, or radiated, or mealy. (*Silliman.*) Also at Deerfield, in radiated fibrous masses, sometimes as large as a musket bullet, or more rarely an inch in diameter.

45. *Laumonite.* In secondary greenstone, also in loose rolled masses of pudding-stone near New-Haven. (*Silliman.*)

46. *Analcime.* At East-Haven, with chalcedony and agates. (*T. D. Porter.*) Also at Meriden, Connecticut. (*Silliman.*) Also at Deerfield, usually in laminated or radiated masses, which are reniform, cylindrical and nearly spherical. Very rarely in trapezoidal crystals—color white, grey and flesh-colored. Associated with calcareous spar, quartz, chalcedony, &c. and frequently effervesces a little with the acids.

47. *Chabasie.* At Deerfield, in cavities and seams in secondary greenstone; usually crystallized in transparent, or brownish, or yellowish crystals; presenting the primitive form, from one twentieth to one fourth of an inch in diameter, insulated and grouped on limpid, pseudomorphous and

tabular quartz, chalcedony, balls of zeolite, &c. Hundreds of specimens have been obtained at this place. To procure them, however, requires much labour.

48. *Apophyllite.* Near Saybrook, Connecticut. (Gibbs.)

49. *Tremolite.* At Milford, Washington, Goshen, Canaan, (Conn.) &c. in dolomite and granular limestone. (Silliman.)

A mineral is found at Leyden in great quantities, associated with quartz, limestone &c. and sometimes forming the gangue of the red oxid of titanium; the same occurs also at West Haven or Orange in hornblende—also at Leyden? at Colrain? at Shelburne? at Conway? at Goshen? (Mass.) at Guilford? and Brattleborough? Vt. and in various instances, in vast abundance: this mineral has generally been called *tremolite*, and sometimes *zoizite*, but it is probably *scapolite*.

50. *Asbestus.* At New-Haven and Milford, in serpentine, very beautiful. (Silliman.) Also at Pelham, Mass. where it occurs with serpentine and talc.

Amianthus. At New-Haven and Milford. Also at Washington. (Silliman.)

51. *Augite.* At Litchfield in dolomite—the whitish variety. (Brace.) Also at Brookfield and Washington in dolomite. (Eaton.) Also at Goshen, Mass. in granite, in flattened greenish gray prisms, sometimes eight inches long and two inches wide. This locality is one mile north of the meeting house, on the road to Ashfield. Also at Deerfield, in secondary greenstone, associated with quartz and calcareous spar, either in irregular veins or imperfect crystals—colour black—not abundant.

1. *Sahlite.* Near New-Haven in serpentine rocks belonging to the formation of verd-antique marble. (Silliman.)

52. *Common Hornblende.* This, of course, occurs in great quantities as a constituent of several rocks marked on the map; indeed, it may be found in a good degree of purity almost every where along the Connecticut, either in place or in rolled masses.

1. *Lamellar Hornblende.* Good specimens are found in
Holland Mass. (Eaton.) Also in Leverett, Sunderland, Con-
way, &c. of a black colour, in Shutesbury it is green.
It is found in sienitic granite and gneiss, in scales that are
easily mistaken for black mica.

2. *Fibrous Hornblende.* At Leyden, the fibres very fine.
Also near Bellows Falls. extremely beautiful, associated with
quartz. Also in Shelburne, Conway, Goshen, &c. in mica
slate, in large and broad fibres or lamellae.

3. *Fasciculite.* This is composed of fibres, or rather in many
instances, of lamellae, frequently more than $\frac{1}{10}$ of an inch
broad, diverging at both ends, so as to occupy usually, as many
as 60° of a circle. These lamellae are commonly inserted
perpendicularly to the folia of the slate in which they occur.
and are applied to each other by their broader faces, being
bent outwards on both sides, somewhat like a bow, and pre- .
senting elegant and very perfect fascicles. The fibres or
lamellae, scarely, if ever, cross one another; yet some-
times they diverge in nearly straight lines, and sometimes
are so much curved as to resemble very exactly a sheaf
of grain when standing erect. (See Plate 9,) The figure in
the plate does not give a representation more regular or dis-
tinct than many of the most perfect specimens present. The
length of the fibres or lamellae varies from one to four inch-
es. It is found i mica slate and talco-micaceous slate in
Hawley, Plainfield, and Conway. Probably this variety is
comprehended under *Fibrous Hornblende* by Cleaveland ;
and perhaps specimens as perfect as those described above
are not unfrequent. But so exact and striking an instance
do these exhibit of the fascicular structure of minerals, that
I could not resist the temptation to denominate them *Fasci-
culite.*

4. *Hornblende Slate.* For an account of this, see the Geo-
logical part of this sketch.

53. *Actynolite.* At Saybrook, and near N. Haven in ser-
pentine. (Silliman.) Also at Litchfield. (Brace.) Also at
Middlefield. (Dewey.) Also at Hawley. (Eaton.) Also at
Cummington. (J. Porter.) Also at Windham in compressed

four sided prisms, in steatite and talc; the specimens superb. (Hall.) Also at Chatham Ct. near the bank of the river opposite the upper ferry in Haddam, in an enormous granitic vein; associated with black schorl, magnetic oxide of iron, &c. Also at Belchertown. Also at Shutesbury in gneiss. Also at New Salem in acicular crystals in chlorite. Also at New Fane, where it was discovered by Dr. J. A. Allen. It occurs in steatite in four sided, sometimes very perfect, sometimes flattened and striated crystals, five or six inches long, often half an inch broad, generally radiated, sometimes curved and crossing one another. The colour is a dark beautiful green, and the specimens are very elegant.

54. *Anthophillite.* It is said to have been found near Saybrook (Cleaveland's Mineralogy.)

55. *Diallage.* In serpentine rocks near New-Haven—well characterised. (Hall.) Also in Conway? in granite.

56. *Macle.* At Bellows Falls, Croyden, Cornish, Charlestown, Langdon and Alstead in argillite. (Hall.) According to Mr. Nuttall, the foliated mineral occurring so abundantly in the mica slate in Chesterfield, Plainfield, Hawley, Heath, &c. being usually inserted in small bronze coloured plates, nearly at right angles with the folia of the slate, may be macle.

57. *Serpentine.*

1. *Precious Serpentine.* At Milford, in nodules or irregular masses in primitive limestone. (Silliman.)

2. *Common Serpentine.* In extensive beds and variously blended with limestone at Milford and New-Haven, forming the Verd Antique. (Silliman.) Also at Westfield in granite. (Eaton.) Also at Middlefield, associated with steatite. (Dewey.) Also at Grafton, Windham and Putney, Vermont, in large insulated masses weighing many tons. (J. A. Allen.) Also at Pelham Mass. in a large loose mass penetrated by asbestus and associated with talc. Also at Leyden, Shelburne, Deerfield, &c. in small rolled masses.

58. *Talc.*

1. *Common Talc.* At Haddam, Litchfield and Southampton. (Cleaveland) Also at Cummington in steatite. (J. Porter.) Also at Middlefield in steatite. (Dewey.) Also at Windham in steatite—laminæ very large and beautiful. (Hall.) Also in New Fane in steatite—specimens laminated and elegant. (J. A Allen.) Also at Pelham, associated with serpentine and asbestus. Also at Rowe.

2. *Indurated Talc.* At Milford marble quarry. (Silliman.)

3. *Scaly Talc.* At Windham and New Fane. (J. A. Allen,)

59. *Steatite.*

1. *Common Steatite.* Near New-Haven and at Litchfield. (Cleaveland.) Also at Middlefield connected, with serpentine and mica slate, and crystallized in six sided prisms terminated by six sided pyramids. (Dewey.) Also at Grafton and Windham. (Hall.) Also at New Fane and Marlborough (J. A. Allen.) Also at Savoy and Cummington (J. Porter.) Also at Westminster, Vermont, where, as well as at Grafton, it is wrought into aqueducts and answers a valuable purpose. Also at New Salem forming a bed in gneiss.

2. *Potstone.* At Grafton, Vermont, in large quantities. (Hall.)

60. *Chlorite.*

1. *Common Chlorite.* Near New-Haven, penetrating quartz and calcareous spar, and in greenstone. (Silliman.) Also at Saybrook, crystallized. (T. D. Porter.) Also at Wardsborough, Vermont, in dark green folia. (Dewey.) Also at Halifax, Leyden, Conway, &c. foliated. Also at Miller's Falls in Montague penetrating milk white quartz. Also at New Salem. Also in greenstone amygdaloid at Deerfield, Greenfield, Gill, &c. It fills two thirds of the cavities in some varieties of greenstone, and to the naked eye has a radiated aspect, but Professor Dewey remarks,

that it does not appear to be radiated under a magnifier, great or small; but to consist of folia curiously arranged often with no regularity and their length somewhat greater than their breadth."

2· *Chlorite Slate.* For an account of this, see the map and the Geological part of this sketch.

3. *Green Earth.* A part of the chlorite described above in the amygdaloid in Deerfield, &c. appears to belong to this variety.

61. *Argillaceous Slate.*

1. *Argillite.*

2. *Shale.*

3. *Bituminous Shale.* For a description of these minerals the reader is referred to the Geological part of this sketch.

62. *Claystone.* This is found in rolled peices in the bed of Connecticut river below where it cuts through the coal formation at Gill; and probably this mineral is worn from thence by the water. The pieces frequently occur in the form of a prolate spheroid, sometimes flattened, even to the shape of a wheel, and sometimes assuming shapes bearing a resemblance to the sculptured images of Persia and India. It is opaque—colour, light gray—scarcely adheres to the tongue, and yields a slight argillaceous odour—fracture dull and uneven, a little conchoidal—easily scratched with a knife and even by the finger nail; yet its particles scratch iron. It does not effervesce with acids.

63. *Clay.*

1. *Porcelain Clay.* At Washington Ct. in small quantities. (Cleaveland.) Also at Plainfield. (Silliman.) Also at Conway and Leyden in small quantities.

2. *Potters Clay.* In the older alluvion along the Connecticut, abundant.

3. *Loam.* In the newest alluvion along the Connecticut.

4 *Fuller's Earth.* At the bed of iron ore in Kent. (Silliman.)

64. *Sulphur.* This occurs pulverulent in small quantities in mica slate, in Warwick, Shelburne, Conway, &c. Perhaps it proceeds from the decomposition of some sulphuret.

65. *Graphite.* At Cornwall, Connecticut. (Brace.) Also at Tolland. (Webster.) Also at Hebron and Sharon. (Cleaveland.) Also between Sturbridge and Holland, *Mass.*

66. *Coal.* At Durham, Middletown, Chatham, Southington, Berlin, Suffield, Enfield, Somers, Ellington and South Hadley. (Silliman.) Also in the drift of the Southampton lead mine. From some of these localities, the coal is highly bituminous, in others scarcely so at all.

67. *Lignite.*

1. *Jet.* At South Hadley. (Gibbs.)

68. *Peat.* In small quantities at Leverett, Mass.

69. *Native Silver.* At Huntington in the bismuth mine. Also at West River Mountain, Chesterfield, New-Hampshire. (Silliman.) After the remarks and explanations given by Prof. Silliman. (Am. Journ. Sci. Vol. III. p. 74. note,) no reasonable doubt can remain concerning this last locality.

70. *Sulphuret of Silver.* In Connecticut it is said to have been found. (Cleaveland's Mineralogy.)

71. *Native Copper.* At Bristol, Connecticut, in a vein with the red oxide of copper. (Gibbs.) Also on the Hamden hills, a mass of about ninety pounds, adhering to the rock. Also twelve miles from New-Haven near the Hartford turnpike, a mass of six pounds in alluvial soil. (Silliman) Also at Whately, Mass. in geest, on the limit between the primitive and alluvial soil, and about five miles

from secondary greenstone or the coal formation. The piece weighs seventeen ounces and very much resembles the last mass above described, exhibiting imperfect rudiments of octaedral crystals on the surface, and being encrusted by green carbonate of copper. The cavities also contain a very little red oxide of copper.

72. *Sulphuret of Copper.* Near New-Haven, at Simsbury mine, &c. (Silliman.)

73. *Pyritous Copper.* At Cheshire, Simsbury, &c. (Silliman.) Also at the Southampton lead mine, where 't occurs amorphous and crystallized in regular tetraedrons which are insulated on calcareous spar. For the specimens containing these crystals, I am indebted to Dr. David Hunt. Also at the Leverett lead mine amorphous. Also in greenstone, Deerfield. Also at Greenfield in veins, in greenstone and sandstone.

74. *Variegated Pyritous Copper.* This occurs sparingly disseminated in calcareous spar in sandstone of the coal formation. In the island in the middle of Connecticut river at the falls in Gill. 1 am indebted to Prof. Dewey for the determination of this mineral.

75. *Antimonial Gray Copper.* Near Hartford, in the red sandstone formation. (coal formation?) (Maclure.)

76. *White Copper.* At Fairfield ?* Connecticut. (Silliman.)

77. *Red Oxide of Copper.* At Bristol, in a vein with native copper. (Gibbs.) Also with native copper in the greenstone mountains extending northerly from New-Haven. (Silliman.)

78. *Green Carbonate of Copper.* At Greenfield, near the Falls in Gill, in two veins with pyritous copper, in considerable abundance near the surface. It is amorphous and even earthy.

* There is great reason to believe that this locality is not correct.—*Editor.*

1. *Fibrous Malachite.* At Cheshire, &c. in small but good specimens. (Silliman.)

79. *Arsenical Iron?* or *Arsenical Sulphuret of Iron?* At Gill in a loose mass weighing several pounds. Found by Dr. Alpheus Stone.

~80· *Sulphuret of Iron.* (Pyrites—Iron Pyrites.) This is found in every town and in almost every rock along the Connecticut; as in the bituminous shale at Westfield and Sunderland, compact and amorphous; also in other rocks of the coal formation Also at Plainfield, disseminated in limpid quartz. Also at Hawley, compact and unmixed with any gangue Also at Halifax, Vermont in an immense mass found in digging a cellar. Also with micaceous oxide of iron at Montague. Also at the Southampton lead mine, beautifully crystallized in octaedrons which are truncated in all their angles. It is grouped or insulated on crystallized quartz, and the crystals are about as large as a small shot, yet perfectly distinct and well marked.

81. *Magnetic Sulphuret of Iron.* At Brookfield, abundant in granite. Also at Huntington with bismuth, &c. (Silliman.) Also near Woodbury in gneiss. (Eaton.)

82. *Arsenical Sulphuret of Iron.* At Derby `Middletown, and the Chatham Cobalt mine. (Silliman.) Also at Leicester, Mass. in gneiss. (Dewey.)

83. *Magnetic Oxide of Iron.* At Somerset, Vermont, in beds from one inch to two feet thick, in mica slate. (J. A. Allen.) At Chatham, near the bank of the river, opposite the upper ferry in Haddam, in a granite vein with schorl, actynolite, garnets, &c. The crystals are octaedrons, well defined, and often nearly an inch in diameter. Also at Plainfield, Shelburne, Athol, Shutesbury, &c. in smaller octaedrons in mica slate and gneiss. Also in beds in talcose slate at Hawley. Also in beds in Bernardstown.

1. *Iron Sand.* At West Haven beach abundant. (Silliman.) Also on the beach near the Light House in East Haven in great abundance. Also a little below Turner's Falls in Gill, on the southeast bank of Connecticut river.

84. *Specular Oxide of Iron.* Sometimes covering quartz and other minerals; as at New Fane and Leyden ; but not abundant.

85. *Micaceous Oxide of Iron.* At Jamaica, Vermont, in dolomite; very handsome. _ (*J. A. Allen.*) Also at Hawley and at- Montague : for a description of which, see the general view of mineral veins and beds that precedes this list of minerals.

86. *Red Oxide of Iron.*

1. *Scaly Red Oxide of Iron.* At Kent, Connecticut. (*Gibbs.*)

2. *Red Hematite.* At Kent. (*Gibbs.*).

87. *Brown Oxide of Iron.*

1. *Brown Hematite.* At Salisbury and Kent, Connecticut. (*Silliman.*) Also at Westriver mountain in Chesterfield, New-Hampshire, in mica slate.

88. *Argillaceous Oxide of Iron.*

1. *Granular Argillaceous Oxid of Iron.* At Salisbury. (*Cleaveland.*)

2. *Nodular Argillaceous Oxide of Iron.* At Putney, Vermont, in beds of common clay. The masses are oval and elongated, embracing an earthy nucleus. Also near the falls in Gill, in a dark hard slate of the coal formation.

3. *Bog Ore.* At New Braintree, Massachusetts, where it is wrought—also at Greenfield.

89. *Carbonate of Iron*, (spathic iron.) At New-Milford, in abundance, (*Silliman.*)

90. *Sulphate of Iron.* Efflorescing on mica slate in small quantities in Conway, Hawley, &c.

91. *Chromate of Iron.* At New-Haven and Milford ; dis-

seminated in the verd Antique marble. *(Silliman.)* Also at
Middlefield in serpentine. *(Eaton.)* Also at Cummington,
well characterized and almost exactly resembling the Bal-
timore chromate ; in a loose mass—Found by Dr. J. Por-
ter.

92. *Sulphuret of Lead.* At Middletown, Southington, and
Huntington, where it is uncommonly argentiferous, and at
Bethlehem, *(Silliman.)* Also at Berlin, (Percival.) Also
at Southampton, Montgomery, Hatfield, Leverett, where
are two localities, and Whately. At these places the struc-
ture of the ore is commonly foliated, sometimes granular
and sometimes in cubical crystals.

93. *Carbonate of Lead.* This exists in the cavities of the
matrix of the lead mine at Southampton. Its colour is
white or mixed with yellow. Before the blow pipe it de-
crepitated and readily yielded a globule of lead. It occurs
crystalized as follows.—1. Two six sided pyramids united
at their bases and deeply truncated at their apices—making
fourteen faces to the crystal.—2. A six sided prism, ter-
minated by four sided pyramids, two of the faces being en-
larged—fourteen faces to the crystal.—3. Tabular prisms
with bevelments on the edges ; but the precise form I
could not determine. - These tables frequently cross one
another.

94. *Carbonated Muriate of Lead.* At the Southampton
lead mine in light green groups of cubic crystals, termina-
ted by tetraedral pyramids. (Meade.)

95. *Sulphate of Lead.* At Huntington with argentifer-
ous galena. (Silliman.) Also at Southampton lead mine,
in plates or tables on galena. (Meade.)

96. *Phosphate of Lead.* At Southampton lead mine, in
light green spherical masses, having a radiated structure.

97. *Molybdate of Lead.* At Southampton lead mine in
tabular, wax yellow crystals. (Meade.)

98. *Sulphuret of Zinc.* At Berlin. (Silliman.) Also at
Southampton lead mine, foliated and crystallized. The

crystals are so grouped that it is difficult, in the specimens which I saw, to seize upon the precise form. I think, however, I found the octaedron with truncated pyramids. Also at Leverett, foliated.

99. *Arsenical Nickel.* At Chatham, associated with arsenical cobalt. (Pierce and Torrey.)

100. *Arsenical Cobalt.* At Chatham. (Silliman.)

101. *Arseniate of Cobalt.* At Chatham. (Pierce and Torrey.)

102. *Oxide of Manganese.* At Leverett, in alluvial soil forming a bed five or six inches thick a few inches below the surface. It is in rounded irregular masses from the size of a pea to an inch in diameter and considerably resembles granular oxide of Iron. Also at Deerfield; forming crusts on quartz and mica slate.

103. *Native Bismuth.* At Huntington. (Silliman.)

104. *Native Antimony.* At Harwinton, Litchfield county, in broad plates. (Silliman.)

105. *Sulphuret of Antimony.* At Harwinton.* (Silliman.) Also near South Hadley. (Gibbs.)

106. *Native Tellurium.* At Huntington, associated with tungsten, bismuth, silver, &c. (Silliman.)

107. *Sulphuret of Molybdena.* At Saybrook. (T. D. Porter.) Also at East-Haddam and Shutesbury. (Silliman.) Also at Brimfield. (Eaton.)

108. *Yellow Oxide of Tungsten.* A new species discovered, analyzed and described by Professor Silliman. At Huntington in a gangue of quartz.

109. *Calcareous Oxide of Tungsten.* At Huntington. (Silliman.)

110. *Ferruginous Oxide of Tungsten.* At Huntington. (Silliman.)

* 104 and 105 need confirmation.—*Editor.*

111. *Red Oxide of Titanium.* Near New-Haven—also at Oxford in large geniculated crystals in mica slate—also at Huntington, at the bismuth, mine;—crystals as large as the thumb and geniculated. (Silliman.) Also at Litchfield, sometimes reticulated on mica slate. (Brace.) Also at Worthington, Massachusetts, in quartz. (Brace.) Also at Leyden, in four or eight sides, often handsomely geniculated, generally striated, crystals; in limpid quartz, tremolite and hornblende. Some of the specimens have several geniculations and are as large as the thumb. Hundreds of good specimens have been collected at this locality. Also at Brattleborough, Colrain, Shelburne, and Conway, in quartz, mica slate and tremolite, At Shelburne I found its crystals penetrating a vein of quartz in mica slate in place. In Conway a few small crystals have been observed exhibiting the primitive form and presenting the "kind of twin crystal," described in Rees Cyclopedia, Art. Rutile. This mineral, indeed, may be found in almost any spot between Conway and Brattleborough, on a strip several miles wide.

112. *Silico-Calcareous Oxide of Titanium.* At Brattleborough, near the north line of the town in a bowlder of granite, which has flesh coloured feldspar—colour dark brown, or chesnut. Some of the crystals appear to be six sided prisms. (Dewey.) These prisms are terminated, if I mistake not by three sided pyramids. I also noticed a four sided, flattened and striated prism, whose terminations could not be determined.

113. *Ferruginous Oxide of Columbium.* At Haddam, in granite. (Berzelius and Torrey.)

Remark:—Since the above list of localities was completed the following have occurred; but as they cannot be conveniently inserted in their proper places they may be mentioned here.

Fibrous Limestone, Satin Spar, in bituminous shale—with Ichthyolites at Sunderland. *Andalusite,* at Litchfield, Delafield.

[To be concluded in the next Number.]

Art. II.—*Notice of the Alluvial District of New-Jersey, with remarks on the application of the rich marl of that region to agriculture.* By James Pierce, Esq.

The triangular peninsula situated in the southern part of New-Jersey is bordered on the south and east by Delaware Bay and the ocean, on the north by the Raritan, and west by the river Delaware. It is about one hundred and ten miles in length by eighty in breadth, and is entirely alluvial. South of the Nevesink hills it seldom rises sixty feet above the sea. These hills border Amboy Bay and the entrance of Shrewsbury creek for several miles, and extend with diminished height to the Delaware. They are elevated adjacent to the sea three hundred and ten feet above its level, and occupy ground where formerly the waves of the ocean rolled. They rest in some places on banks of oyster-shells and other marine relics, blended with clay and sea-mud. Above the calcareous beds is a layer of dark clay. A sandy earth highly colored by oxide of iron and imbedding reddish brown sand and pudding stone cemented by iron, composes the higher strata—large rocks and beds of ferruginous sandstone, apparently in place, of a more recent formation than the alluvial region below, and embracing sufficient metal to be called an ore of iron, are of frequent occurrence.

Particles of iron are blended with the sand of the beach. Some of the streams which descend from the top of the clay strata are red with oxide of iron.

Efflorescences of the sulphates of iron and alumine are often observed. Flame proceeding from the spontaneous combustion of gases probably generated in beds of sulphuret of iron, has been noticed on these mountains.

The strata of the steep eastern declivities are exhibited by frequent land slips. But a small portion of the eastern section of the Nevesink hills is under cultivation. They present a woody region, in which deer are sometimes sheltered. From the summit of these hills a view of the ocean is disclosed in grandeur unrivalled on our sea-board. The coast is presented to the north-east and south as far as vision can reach. The land prospect is extensive and interesting.

Sandy-Hook, situated east of the Nevesink hills, from which it is separated by a narrow bay, is six miles in length; in width it seldom exceeds half a mile. It was formerly an island, but the channel affording a direct water communication between the sea and Shrewsbury river, is now filled up. This peninsula exhibits an alternation of barren sand hillocks, plains and cedar thickets. The sand-banks are often laid low by sweeping tempests. The hillocks of Sandy-Hook and of our southern sea-board are many of them formed by the lodgment of sand around a cedar or other bush, increasing with the growth of the plant, and when the bush is no more the hill disappears. The beach and sandy elevations from a short distance resemble a snow covered surface.

There is no creek or inlet on the sea-shore from the light-house, which is situated on the northern extremity of Sandy-Hook, to Long-Branch, a distance of twelve miles. A walk or ride upon the hard beach at low tide is interesting, particularly by moon-light, when an extensive range of coast is seen; whitened by successive breakers—wrecks of vessels are visible at short intervals, melancholy monuments of the dangers of the sea.

For many miles no houses, enclosures or signs of human occupancy are in view. Long-Branch is much resorted to for sea-bathing; its situation is good. The land adjacent to the ocean is at this place compact, and rises perpendicularly from the beach near twenty feet. Waves in a tempest often roll over this bank, making encroachments by their friction. The neighboring country is level, free from marshes, and under cultivation. The boarding-houses are situated about twenty rods from the water, leaving handsome lawns in the intermediate space. The high banks of the sea and of Shrewsbury river are formed by strata of sand, clay and sea-mud. The clay is in many places white with saline efflorescences, principally sulphate of alumine.

Much of the land situated in the northern part of the peninsula is under cultivation, and in some of the townships of Monmouth county, adjacent to Amboy Bay and the ocean, a considerable portion of the land is good, and has been rendered very productive by the application of marl. Six years since, but one or two small beds of this valuable manure were known in this region, and but few experiments of its utility had been made. The inhabitants, ignorant of its

character and value and of modes of examination, had pass-
ed rich beds without regard; marl is now extensively used
and highly esteemed.

The marl district extends from the hills of Nevesink ad-
jacent to the ocean, to the Delaware, and is in width about
twelve miles. Marl has been discovered in numerous pla-
ces of this tract. It is often noticed on the banks of streams
and breaking out of hills of which it forms the nulceus, wav-
ing with the surface, and thus rendering access easy.

These beds, apparently inexhaustible, are in some places
elevated near one hundred feet above the level of the sea.
This marl is composed of 'sand, clay and calcareous earth,
blended with shells and other marine organic remains, in
different stages of decay. The shells, more or less entire,
are not mineralized. Exposed on the surface they gradual-
ly decay, furnishing fresh manure for the soil.

I visited several beds of marl and found them of a pretty
uniform character. The color is generally grey or greyish
white, and good in proportion to its whiteness, which indi-
cates the quantity of calcareous earth it contains. From
thirty to eighty loads of marl, according to its strength, are
spread upon an acre. It is believed that a good dressing
will last from twelve to twenty years. The lands of Mon-
mouth county, are said to be enhanced in value more than
half a million of dollars by the discovery and use of marl.

A respectable farmer of Middletown mentioned to me,
that five years since he contemplated abandoning his large
farm for land of other districts, as his own was unproductive.
Learning the discovery of marl, he made himself acquainted
with the modes of examining, and found good beds of this
manure in almost every field, and liberally applied dressings
to the soil. In walking over his grounds I observed rich
white marl breaking out of banks and hillocks, and the
streams paved with decaying marine shells. For more than
a century this land had been regarded by the proprietors
as useless.

The farm in its improved state exhibited a gratifying
sight; the hills where formerly thorns, thistles and mullens
disputed the dominion, now supported luxuriant corn. Ex-
tensive verdant meadows were clothed with a rank second
crop of grass; numerous stacks of grain and well-filled
barns evinced the productiveness of these fields, which are
now estimated at three times the former value.

This marl is adapted for both sandy and clay earths. It was remarked to me by farmers of Monmouth county, that lands manured with marl are less affected by dry weather than other grounds. This doubtless arises from its rendering the soil a better medium to retain moisture. When there is too much clay, the numerous shells and fragments in the marl keep the soil loose and suffer water to penetrate —and if too sandy, the calcareous ingredients attract and retain moisture, while the clay of the marl improves the texture of the soil.

The rich marls found in Monmouth county adjacent to navigable rivers, might be advantageously transported to fertilize the sandy lands of the southern part of Long and Staten Islands.

Though marl is now employed in a comparatively small district of New-Jersey, it is probable from the character of the region, that it may be found throughout our alluvial sea-board, and would be very valuable where gypsum is powerless. Strata of marl have been passed through in sinking wells many miles south of Long-Branch, and also near the Delaware.

Shells and the bones of fish are often disclosed by excavations, made far from the ocean. Banks of oyster-shells covering extensive tracts and of unknown depth, have been observed in the interior of the southern States. It is from such calcareous ingredients that marl principally derives its virtue.

Organic remains of the land and sea have been found associated in the marl beds of New-Jersey, at a considerable elevation above the Atlantic. Among these are bones of the rhinoceros and other animals of the eastern continent, some of them of extinct species, elephants' teeth, deers' horns, bones of the whale, sharks' teeth and entire skeletons of fish, together with gryphites, belemnites, cardites and various shell-fish.

The origin of these banks of shells and bones may, I think, with propriety be ascribed to the deluge recorded in sacred history. The events which have since occurred within the observation of man can account for the various phenomena remarked in this alluvial district.

The interior of the peninsula is covered by extensive forests of pitch pine and shrub oak. Settlements are here and

there located in this region of wood. The soil, except on the borders of creeks, is pretty uniformly sandy.

Adjacent to the Delaware river and bay and the sea coast, there are wide tracts of salt meadow which are in a few places improved by embankments. The climate near the coast is so mild that herds of cattle subsist through the winter upon these meadows, and in the neighboring thickets, without expense to the proprietors. Cattle range the forest in a wild state. Deer, foxes and rabbits are numerous, and wolves and bears are sometimes seen in the wilds of New-Jersey. Much fine wood is shipped to Philadelphia and New-York from this region.

The peninsula, four fifths of which is now a useless waste, might by proper cultivation be rendered very productive. Its situation between the two largest cities of America, and nearly environed by navigable waters, would enable the inhabitants readily to bring their produce to a good market. A tract of a few miles in width from the sea-board might be improved by marl, sea-weed, fish, &c.; the remainder by gypsum, which is adapted for sandy soils. Pine lands, situated in the counties of Columbia, Albany and Saratoga, and other parts of the State of New-York of a similar character with those of New-Jersey, have been rendered very valuable by gypsum and rotations of crops, often producing from twenty to twenty-five bushels of wheat to the acre. The sandy soil is in time changed to a rich vegetable mould —gypsum would probably render the pine lands of the southern states productive.

The climate of New-Jersey is well adapted for grain, Indian corn, fruit and melons. Cotton might perhaps be there naturalized and profitably cultivated.

Herds of cattle and sheep can be supported at little expense. The sea-coast is said to be favorable for the production of good mutton and wool.

The creeks and rivers of the peninsula are not numerous or considerable—they are generally bordered by a rich soil.

Salt may be advantageously manufactured on the islands and low Atlantic shore of New-Jersey, by evaporating sea-water.

Extensive beds of the variety of argillaceous oxide of iron called bog-ore, are common in the south-western part

of the alluvial of New-Jersey, from which good iron for
castings may be extracted. It is generally mixed with
mountain ore in the furnace. The phosphate of iron is not
unfrequently found imbedded in the bog-ore of New-Jersey.
A valuable chalybeate spring, is situated in the town of
Shrewsbury. White pipe-clay is abundant near Amboy
Bay and the Delaware. The inhabitants of the New-Jer-
sey sea-board generally subsist by a little farming, wood-cut-
ting, fishing, and grazing of cattle on the salt-meadows.

ART. III.—*On the probable Origin of certain Salt Springs.*
By Professor AMOS EATON.

To the Editor.

Every fact which tends to disclose that hidden operation
of nature by which the Salt Springs of the west are produc-
ed, is interesting to the geologist.[*]

I took a specimen of the rock called *water limestone* from
a hill adjoining Nine-mile Creek, a few miles west of the
Onondaga salt-springs. If this specimen be pulverized and
examined ever so minutely, it presents nothing to the sens-
es resembling common salt, (muriate of soda.) I do not
mean that the elementary constituents cannot be found in
it, but I do not propose here to have any reference to a
chemical analysis of the rock. On exposing a fresh frac-
ture of a specimen from this rock, for two or three weeks in
a damp cellar, it shoots out crystals of common salt, suffi-
cient to cover its whole surface. It may be proper to state,
that I have made the trial only in very cold weather; during
which time a fire was sometimes made in the cellar room.
I do not know, however, that these circumstances had any
influence on the result.

This proves conclusively, that one rock at least, repos-
ing over the floor of the salt springs, contains in itself the

[*]This discovery, made in my first excursion on the canal route, in the
employment of the Patroon of Albany, (the Hon. S. Van Rensselaer,) I take
the liberty to communicate in his absence; because I know it is not his wish
to withhold interesting subjects one moment from the public. As the exten-
sive circulation of your Journal will bring this fact to the knowledge of
scientific gentlemen in the vicinity of other salt-springs, it may induce sat-
isfactory research.

materials for the spontaneous manufacture of salt. I say the *floor*, because I have ascertained that all the salt-springs along the canal route, from Lenox to Montezuma, are supported on the same continuous rock.

It has long been a prevailing theory, that a vast mine of salt exists in the vicinity of these springs, which is continually dissolving, and thus yields the supply of salt water. Much time and money have been spent without success, in boring to great depths with the expectation of discovering this mass of rock salt. But if such rocks as that of Ninemile Creek, be found of sufficient extent, the origin of the salt waters of the west will find a more satisfactory solution. And there may be many kinds of rock, besides the water limestone, which contain the elementary constituents of common salt. I am, respectfully,

<div align="right">

Yours, &c.
AMOS EATON.
</div>

Troy, March 1, 1823.

REMARK.

The observation made by Mr. Eaton is very interesting; but (if we understand him correctly,) the *water-limestone* forms the *roof* of the salt-springs, or, at least, is so situated, that the water can percolate this stratum, by the natural effect of gravity. We can have no doubt, that this is Mr. Eaton's meaning, although there is some ambiguity in his language. *Editor.*

ART. IV.—*On a Rocking Stone in Durham, New-Hampshire.* By. JACOB B. MOORE.

<div align="center">

Concord, N. H. Oct. 22, 1823.
</div>

TO PROFESSOR SILLIMAN.

SIR—Having noticed in the last number of the "American Journal of Science" an account of a Rocking Stone in Putnam county, New-York, in which mention is also made of the rock at Durham in this State,—I take the liberty to enclose you a description of that rock, which you may rely upon as accurate.

"In the town of Durham" says Dr. Morse, "is a rock computed to weigh sixty or seventy tons. It lies so exactly poised on another rock, as to be easily moved with one finger." Curiosities of this kind naturally excite attention, and from their rare occurrence, seem to merit a particular description; for were they the works of *art*, we should be surprised at the human ingenuity which could adjust the mighty balance; and as works of *nature*, they do not fail to excite our admiration. The rock at Durham is a detached block of coarse granite, of about fifteen feet in diameter on the top, and nearly round; and averaging about seven feet in thickness. It is situated on a rise of ground in the southerly part of the town, and in the neighborhood of a chain of granite ledges, which extend through the town and appear to be of primitive formation. The owner of this rock is a man nearly eighty years of age, who was born and always resided in the vicinity. At the age of twenty-four he came into possession of the farm upon which the rock is situated, and has since lived about fifty rods from it. He states, that formerly the wind would move the rock, and that its vibrations thus occasioned could be plainly seen at some distance. It was always easily moved with the hand, until some three or four years since, a party of gentlemen from Portsmouth visited it, and after several hours of labor, succeeded in moving it from its balance with levers. It was a barbarous curiosty, of which it is hoped the persons concerned are now ashamed! The rock cannot now be moved; although, in looking at it on the sides marked 1 and 2 in the following plan, a person would be led to think otherwise.

The left hand bottom figure (See the plate at the end,) represents the rock at Durham as it now lies, thrown to the right from its equipoise, and resting on two points. It also presents the side marked 3. The figures 1 and 2, present views of the sides thus marked, in the figure first mentioned. The figure 4 represents the surface of the rock, fifteen feet in diameter, nearly round. The weight of this stone probably approaches the estimate of Dr. Morse.

Besides this, I know of no rocks of a similar description, excepting one, weighing from fifteen to twenty tons, in Andover in this State, and one of smaller size in Ashburnham, Mass. Both these may be easily moved several inches by the hand; but their appearance is uninteresting, compared with the former situation of the rock at Durham.

ART. V *Miscellaneous Localities of Minerals,* cammunica-
ted *by various persons.*

1. By Professor. J. F. DANA, of Hanover, N. H.

1 *Hornblende.* Superb specimens of crystallized horn-
blende, imbedded in lamellar hornblende, or confusedly ag-
gregated—bladed and promiscuous, in quartz; Iron mines,
Franconia, N. H.

2. *Garnet.* Amorphous and imperfectly crystallized—the
faces of the crystals remarkably smooth and perfect; Fran-
conia mine.

3. *Epidote.* Crystallized; same place.

4. *Green quartz.* Containing hornblende—colored by ep-
idote. These are beautiful specimens. Franconia.

5. *Asbestus.* This mineral has a peculiar appearance. It
occurs in masses or rather sheets of one or two inches thick,
and of various extent. The fibres are intimately united, and
are curved in every direction. Franconia.

6. *Staurotide.* Franconia. *Sulphuret of Copper.* Franco-
nia.

7. *Cyanite.* Of a light bluish grey. Hartford, Vt.

8. *Sulphuret of Iron.* Deeply truncated on the angles of
the cube, forming a solid of fourteen sides. Hartford, Vt.

9. *Galena.* In a vein of quartz traversing mica slate.
Lebanon, N. H.

10. *Granular Argillaceous Oxide of Iron.* Sharon, Vt.

11. *Carbonate of Iron.* In rolled masses of quartz, on the
banks of the Connecticut. Hanover, N. H.

12. *Plumbago or Graphite.* Large specimens—equal to the
Borrowdale. Bristol, N. H. This has just been discover-
ed—it is abundant; five hundred pounds were sent to Bos-
ton as a sample, as the owner informs me.

At the Franconia iron mine, near the furnace, I noticed a
peculiar slag, which resembles perfectly some varieties of
pumice-stone.

2. By Mr. STEUBEN TAYLOR, Preceptor of the Charles-field Street Academy, at Providence.

1. *Quartz Crystals* are found pure and well defined, from
one to two inches in length and from one third to three

fourths of an inch in diameter, in the western part of Granby, in a field a few rods north east of a blacksmith's shop, occupied by Mr. Tracy Cannon. In some of the rocks they form geodes of considerable size. Of these I obtained some specimens which, when placed near the blaze of a candle, exhibit a remarkably brilliant and beautiful appearance.

2. *Black Tourmaline.* Of this mineral there is a remarkable locatity in Barkhampstead, on the farm of William Taylor, Esq. The rock in which it is found is a fine-grained granite, penetrated by a vein of quartz nine or ten inches wide. From this vein elegant specimens may easily be obtained by means of a hammer or sledge. I succeeded in getting one crystal, which is more than an inch in diameter and five inches long. The rock is situated about fifty rods W. N. W. of Mr. Taylor's house, and about the same distance east of the turnpike road leading from Hartford to Albany.

3. *Garnets* of twenty-four sides, of the size of a musket-ball, are found in great abundance on what is called West-Hill, in the town of New-Hartford. The spot which I visited is on the farm of Mr. Silvester Seymour, about forty rods west of the house occupied by Mr. Michael Olmstead. The rocks and stones in which they occur are easily broken in pieces, and the visitor will be detained but a few minutes in obtaining as many specimens as he wants.

3. By Dr. Jacob Porter.

1. *Calcareous Spar,* beautifully crystallized, at Chester. Emmons.

2. *Stalactites* and *Stalagmites*, at the cave lately discovered in Lanesborough. When this cave was discovered, it was filled with stalactites and stalagmites of the most fantastic appearance, some of which were shown at a house near the cave. The most curious have been removed by the visitors; I obtained, however, a plentiful supply of the less interesting ones. There are several turnings or windings in this cave. Breathing is free here and lamps burn perfectly well.*

*The other facts stated by Dr. Porter may be found at p. 41, Vol. IV. of this Journal.

3.. *Black Fluate of Lime*, in Huron county, Ohio.

4. *Gibbsite, of Torrey*, on iron ore, at Lénox. Emmons.

5. *Limpid Quartz*, at Newport, N. Y. ninety-five miles north-west of Albany. The crystals are perfectly transparent, and terminated by pyramids at both extremities. The largest that I have been able to procure is about an inch long and about three fourths of an inch in diameter. These specimens, together with those from Fairfield, which exactly resemble them, are the most beautiful rock crystals that I have ever seen.

6. *Blue Quartz*, in amorphous masses, at Cummington, Bridgewater, Pembroke and Marshfield.

7. *Rose Quartz*, beautiful, and in considerable quantities, in a ledge at the east part of Chesterfield.

8. *Irised Quartz*, in large quantities, at Chesterfield. 'Its colors, which are generally red, yellow or orange, and very delicate, seem to arise from a thin coat of metallic oxid on the surface of the specimen, or in its fissures.

9. *Milky Quartz*, at Abington, the cavities frequently lined with crystals.

10. *Greasy Quartz*, at Plainfield.

11. *Arenaceous Quartz*, at Plainfield and Cummington, often in large masses. It is sometimes burnt and pulverised for sand.

12.. *Stalactical Quartz*, at some falls in a brook in Middlefield. The crystals, which are small and have a slight tinge of red, are formed on serpentine, evidently in a manner similar to that of stalactites. The specimens are singularly beautiful. Emmons.

13. *Amethyst*, a single crystal of a delicate purple, discovered at Abington.

14. *Fetid Quartz*, at Cummington.

15. *Chalcedony*, at Middlefield. It is of a milky or reddish color, with blood-red spots. The cavities are lined with the most minute and beautiful crystals, which are sometimes blood-red, but generally white or bluish. Emmons.

16. *Opal*, at Middlefield. It is covered with small crystals, whose color is white,. slightly tinged with blue or yellow. Emmons.

17. *Hornstone*, at Middlefield. Emmons.

18. *Jasper*, dark-colored and red, on the beach at Marsh-field, many of the specimens beautiful.

19. *Agate*, at Chester.　Emmons.

20. *Kyanite*, very dark-colored, in mica slate, at Chester and Chesterfield.

21. *Mica*, dark-colored, at Savoy.　The layers separate surprisingly on being heated.

22. *Green Mica*, at Cummington and Plainfield.

23. *Black Mica*, associated with garnets, at Plainfield.

24. *Mica*, white and yellowish, abundant at Williamsburg.

25. *Chabasie*, in cuboidal crystals, at Chester.　Emmons.

26. *Tremolite*, well characterised at Chesterfield.

Tremolite, in shining, radiated fibres, associated with white quartz and beautiful garnets, at Cummington.　The rock in which these minerals are contained, has a strong smell of sulphur.

27. *Asbestos*, adhering to a large mass of actynolite, at Windsor, near the Cummington soapstone quarry.

28. *Hornblende*, at Hawley, Plainfield and the neighboring towns.　Many of the specimens, particularly those from Hawley, present crystals resembling bundles of rods tied together near the middle, and thence diverging, which give them a very singular and beautiful appearance.

29· *Serpentine*, in loose masses, at Cummington and Plainfield.　It takes a fine polish.

30. *Chlorite*, abundant and extremely beautiful, at Hawley and Plainfield.

31. *Graphite*, at Hinsdale.

32. *Sulphuret of Iron*, in small but beautiful crystals at Hawley.

33. *Micaceous Oxide of Iron*, beautiful and in large quantities, at the iron-mine in Hawley.　When pulverised it makes a beautiful paper-sand.　At a manufactory in Cummington it is enclosed in tin cylinders, and used for clock-weights.

34. *Brown Hematite*, bearing a striking resemblance to the Salisbury ore, at Richmond.　Emmons.

35. *Chromate of Iron*, at the Cummington soap-stone quarry.　Only a small mass has as yet been discovered.

36. *Plumbago*, at Cummington, Worthington and Chester.

These minerals may be seen in the collection of the writer.　Specimens have also been presented to the cabinet of

Yale College, the Lyceum of Natural History, New-York, and the Troy Lyceum of Natural History.
Plainfield, November 1822.

REMARK by Dr. Porter.

Some of these localities are already known to the public, and are here cited again for the sake of conveying some additional information. For my knowledge of several of them, I am indebted to the gentlemen whose names are annexed.

4. By Mr. J. STUART, of Peacham, Vermont.

1. *Asbestos and Serpentine.* One piece of the latter was from the mountain in Kellyvale, and the other from the streets of Peacham, where it is stated to be very abundant.

Of the asbestos, one kind occurs in rolled pieces, which, when broken, are found to contain a substance in color and texture resembling the finest cotton. The other is discovered in crevices of the rocks of serpentine, and more resembles flax. The place from which they were obtained is in Kellyvale, about twenty miles from Canada. The adjoining country, like most of Vermont, is primitive. The stones are principally granite. Farther back in all directions, are almost Alpine mountains. Approaching the quarry from the south, it is level for some distance, until we arrive upon the top of a steep precipice, about two hundred feet high, at the foot of which there is a very small stream. All along the declivity are masses of serpentine, much of which is rolled to the bottom; and from appearances the same mineral extends to a great distance into the side of the precipice. The quantity of asbestos as well as serpentine, seems inexhaustible. But though the serpentine would make excellent chimney-pieces, &c. yet it will probably never be wrought, on account of the difficulty of transportation.

2. *Quartz.* Finely crystallized as usual in six-sided prisms. Lyndon, Vermont.

3. *Cyanite*, in small quantities, small garnets, and tourmaline, are found in Peacham and its vicinity.

5. By Dr. W. LANGSTAFF.

1. *Quartz,* and a greèn substance which áppears to be augite or coccolite—found in gneiss near Cold-Spring landing.

2. *Coccolite,* in foliated limestone ; same locality with the zircon.

3. Do. in quartz—same locality.

4. { Do. in mass—same locality with the zircon. *Augite,* abundant in the the gneiss rocks at Cold-Spring Landing. Do. containing sphene. Cold-Spring Landing, N. J.

5. *Scapolite,* containing Plumbago. Hamburgh.

6. *Brucite.* Hamburgh.

7. *Black Mica,* in augite. Cold-Spring.

6. By J. P. BRACE.

In Southbury, the greenstone formation visible in Wood-bury continues west of the meeting-house, between the Pompanaug creek and the Housatonic—extending six or seven miles in length, being composed of several ridges, in all about a mile in breadth. The minerals connected with this range are :—

1. *Chalcedony,* resembling that of Patterson, N. J. of a beautiful blue—covered frequently by botryoidal concretions of *cacholong.*

2. *Amethyst.* The crystals of this mineral are often quite regular; with both terminations visible, and the coloring matter more uniformly diffused than is common in the amethyst of Woodbury, New-Haven and Patterson. Some specimens which I saw in the cabinet of Dr. L. Smith were very beautiful.

3. *Common Opal,* of an inferior quality.

4. *Prehnite,* occasionally.

5. The *agates* of this range are in nodules, composed of layers of blue and white chalcedony. These layers are, principally, incrustations of a solid nucleus of quartz, and are often quite handsome.

6. *Agatized Wood,* in the south part of the town—found by Dr. Smith. It presents distinct branches, with their knots, bark and ligneous layers often visible, sometimes four

or five inches-in diameter. It is principally hornstone; its cavities are lined with minute quartz crystals and layers of chalcedony. It is of a grey or black color—specific gravity 2.6.

7. *Fibrous Carbonate of Lime,* in bituminous limestone, exists here.

8. The *Rose Quartz* is south-west of the meeting-house about three miles, and is in great quantities. It requires blasting, however, to obtain good specimens.*

9. *Laminated Feldspar,* of a pearly white color, is found in Bethlem, resembling in external characters the *siliceous feldspar* of Chesterfield.

10. *Plumose Mica,* in Woodbury and Washington.

11. *Zeolite,* in reniform masses of minute fibres, and in fascicular groups of fibrous crystals—in a vein in mica slate. Litchfield.

12. *Fetid Quartz,* in Litchfield, well characterized—of a dark greyish blue, (the common color,) and of a pure white, (the last, I believe, an uncommon color for this variety.)

13. *Pinite.* Litchfield. Specific gravity 2.768—infusible—massive—imperfectly foliated—cross fracture uneven—color dark brownish green—fissures stained by iron—soft, easily scratched with a knife—powder unctuous—streak white. Spangles of a hexagonal or nearly circular form appear on the fracture when held to the light. Lustre of the cleavage, glistening—of the fracture, dull—adheres to the tongue.

Some imperfect crystals appeared on the surface of the mass—apparently six-sided prisms, truncated on all the angles, and, in consequence, having a cylindrical form. Associated with quartz, mica and oxide of iron.

REMARK.

The Editor's opinion being requested, respecting the last mentioned mineral, he has to add nothing more, than that he coincides in opinion with Mr. Brace, and that there is a great resemblance between the Litchfield pinite and that of Haddam.—*Ed.*

*Dr. L. Smith will supply, in exchange, any gentlemen with the Southbury minerals.

ART. VI.—*Notice of a curious Water-Fall, and of Excavations in the Rocks.* By Professor HALL.

To the Editor.

In proceeding from Middlebury to Woodstock, on the directest turnpike road, the traveller, soon after he passes the tavern on the summit of the Green Mountain, notices a small, rapid, pellucid streamlet, which accompanies him nearly the whole distance down the mountain. He constantly hears its music, as it murmurs along its rugged course, and admires the transparency of its waters. This is one of the branches of the *White* river. About three miles from the tavern he crosses a rivulet, a little above, where it empties into the former stream. He advances a few rods farther, and meets another. It comes from the north, and is called by the mountaineers, the North Branch. A little more than a quarter of a mile from the turnpike, up this stream, is an object which merits the attention of the curious. I have recently been in company with the Rev. Professor Keith of William and Mary College, Virginia, to examine it.

There is a road cut, but not much travelled, along the western side of the North Branch, at a small distance from the stream. From the road the water is seldom visible, being concealed by a thicket of evergreens, and, in some places, by the banks which intercept the view of it. Its noise may be distinctly heard.

The better to accomplish our object, we proceeded up this road nearly half a mile, which brought us to the head of a succession of the most singular and interesting *rapids* that I ever saw. Here the student of nature would stand astonished to see how great effects have been produced by an apparently trivial cause.

At the northern extremity of the rapids, the ledge over which the water passes, is a variety of common chlorite rock, of a very dark brownish green color, containing veins of milky and greasy quartz. I have never before seen chlorite in such large masses. The fracture in one direction is extremely uneven. It may be scratched easily with the finger-nail. It is composed of minute scales, which are some-

what unctuous. At numerous places in and near the stream, we saw chlorite slate in abundance. Along the lower part of the rapids, the rocks are chiefly mica-slate. These rocks, as well as the chlorite, are *in situ.* But there are thousands of tons of stones, principally rolled quartz, scattered over the surface, on both sides of the rivulet, forming an irregular pavement, which are evidently *out of place.* They were, unquestionably, transported hither by the impetuosity of the current from higher lands, where they had their origin.

The water, at the time of our visit to the rapids, was uncommonly low. At the head of the falls we measured the brook, and found it only *two feet and four inches wide,* and *three inches deep.* At high water it covers an area about two rods in width. At the point where the rivulet is most contracted, it takes a perpendicular leap of eight feet and ten inches into an oblong basin, which we ascertained to be seventeen feet in width. This capacious basin has, manifestly, been formed in the chlorite rock. solely by the incessant friction of the water. From the south side, where the basin is open, the water flows off calmly in a canal in the rock, a few inches wide, and regular, as if cut by the chisel, for two or three rods, and then precipitates itself into a second cavity, eighteen feet in width and fifteen in depth, produced, evidently, in a manner similar to the first. The water, after travelling about six miles farther, has formed another basin, still larger, but less deep, than the last; its width being twenty-six feet and its depth twelve.

There is a succession of cavities, or basins, at small intervals, for a distance of three hundred and thirty paces, or nearly one fourth of a mile. They are all wrought in the solid rock. Their forms are very dissimilar; some resembling a deep pot, and others an immense oven, inverted. We observed but a few small cavities, such as are generated in the Connecticut river, at Bellows Falls, by the rolling of a single stone.

I am aware, that the traveller who visits this spot at the season we did, will, at once, pronounce this puny brook totally inadequate to the production of these wonderful cavities. But his sentiments will alter, when he considers that a vast stratum of snow falls, annually, on the Green Mountains; which, when it dissolves in the spring, swells this rivulet, during a number of weeks, to a mighty torrent. Marks

of violence are every where visible in the large collections of logs and brushwood, and even of whole trees, accumulated in various places, and in the transportation of ponderous quartzy stones for many miles, and in the heaving of them up, on high masses of chlorite and mica-slate, to which they have no relationship.

Should you, sir, ever find it convenient to cross the Green Mountain from Windsor to Middlebury, I hope you will take the trouble to view this admirable specimen of nature's workmanship. The labor will, I assure you, be richly rewarded. Your very obedient

<div align="right">F. HALL.</div>

BOTANY.

ART. VII.—*Diversity of the two sorts of Datura found in the United States.*

Two sorts of *Datura*, which present considerable differences to the eye, are well known to be common in many parts of the United States. One of these has been generally supposed by botanists to be the *Datura-Tatula*, and the other the *Datura-Stramonium* of Linne. Their specific diversity, as far as I am informed, remained unquestioned till Dr. Bigelow advanced the opinion that they are mere varieties, and stated the concurrence of Sir James Edward Smith, who, it seems, made his decision from an examination of the specimens in the Linnæan Herbarium. Mr. Elliott has since expressed his doubts upon the same subject.

Although most of the principal authorities, such as Linne, Gmelin, Willdenow, Persoon, Turton and many others in Europe, and likewise Muhlenburg and Pursh, in America, are in opposition to the opinion under consideration, yet, as there can be no question that the decisions of the gentlemen above mentioned are entitled to the highest respect, I should not at this time venture to suggest any doubts of their correctness in the present instance, had not long-continued and close observation convinced me, that they are, in fact, perfectly distinct.

I have no hesitation, however, in admitting the inadequacy of the distinguishing marks which have been selected by every writer with whom I am acquainted. The erect spinous pericarps, the ovate or, if flattened, the cordate and sharply dentate and glabrous leaves are unquestionably common to both the American sorts. Even *most* of the additional circumstances which are commonly mentioned incidentally, are nearly uniform in each. The *D. Tatula*, although occasionally larger and less slender than the *D. Stramonium*, is by no means generally so, nor is there a regular and uniform appreciable difference (indeed it is scarcely ever to be observed in American specimens,) between the length of the flowers and the turgidness of the perianth of the two sorts; in both, the stalk is generally smooth and divided at an acute angle, the leaves are as sharply dentate and as much sinuated in one as the other, and in some instances they are both attenuated into the petiole, or both, as it were, truncate at the base. In the smaller plants of each sort, the stem is commonly pithy, and in the larger of each, it is hollow.

The white corol of the one, which verges to a cream color, and the pale blue or light purple of the other, striped with deep purple on the inside, are indeed almost always observable, but not sufficiently prominent for distinction; but the *purple stalk sprinkled with green points* in the one, and the uniform *green stalk* of the other, I have reason to think, are invariable and permanent.

I have been many years in the habit of observing the two sorts and noticing this difference, and for ten years at least, I have viewed them closely, in reference to their distinction of species. My observations have been made both where they grew entirely separate, and where they grew together, and I have cultivated them in both situations, without ever being able to discover the least approximation of the one to the other, or to detect any intermediate specimen; and contrary to my expectations, I have never seen, among the plants produced from seeds, and growing together, any evidence of promiscuous impregnation and the production of hybrids. Even in the spring season, the last year's dead and half decayed plants of each sort, may always be distinguished with perfect facility.

In places where only one sort has been common, time immemorial, I have never known the other make its appear-

ance, when it could not be decidedly traced to some other place, where it was previously known to grow. Thus, there was none of the pea-green sort in New-Haven, till introduced by Professor Ives, nor in Middletown, till brought from the meadows of Wethersfield, where it has long been common, by the ice which was deposited in such immense quantities, by the freshet of 1818.

In fact, I find the strongest reasons for concluding that there are as fixed and permanent specific distinctions between what has been supposed in this country, to be *D. Tatula*, and what has been considered *D. Stramonium*, as are to be found in the science of Botany. I am well aware that the maxim, that for the distinction of species, regard is not to be had to *color*, size, taste, smell, or to the external surface, is, *in general*, correct; but as there is no one of those characters which are commonly the most permanent, that is not occasionally variable, so too rigid an adherence to the above principle, may lead to error. *Color*, at least, when established by sufficient observation to be permanent, I think may be safely assumed as a specific character.

Were I to define the term species, I should say it denoted *all such individuals as are alike in every characteristic which is incapable of change by climate, soil, cultivation, time, or in short any accidental cause, and which is permanent and continued by propagation from seeds.* If this is correct, a species may be distinguished by *any* uniform and invariable peculiarity which is thus perpetuated, and no two differing individuals are to be considered as mere varieties, unless their peculiarities are changeable and evidently occasioned by soil, climate, cultivation, or other accidental causes, and are by no means to be certainly perpetuated by seeds.

If then the colour of the stalks of the two sorts of *Datura* in question is once established by adequate observation, to be permanent and invariable peculiarities, it is, in my view, sufficient. The similarity of the plants in other respects, falls far short of proving them to be only varieties, as it is well known that distinct species often so nearly resemble each other, as that their claim to distinction, can be established only by long-continued, and close comparative examination ; and on the other hand, varieties are occasionally so diverse, that equal pains is necessary to establish their specific identity. The great similarity of the different spe-

cies of *Trillium, Erythronium, Statice, Actæa* and of a vast
number of other genera, has long been a fruitful source of
discrepancy among botanical authors, and a multitude of
instances may be specified, in which plants for a long time,
not even considered as distinct varieties, have ultimately been
found to be different species, as for instance, *Veratrum-album
and viride. Berberis-vulgaris and Canadensis,* etc. etc.

Although I have never seen any other species of the ge-
nus *Datura,* yet judging from the descriptions given by au-
thors, I am inclined to think that there is much of this close
similarity and affinity, between several of them, and al-
though it was not my intention to raise any question at this
time, except respecting the two American plants, yet I can-
not forbear remarking in this place, that if the best represen-
sentations of the European *Stramonium* are correct, there is
some ground for suspecting at least, that the *Stramonium* of
that region, is specifically distinct from either of the sorts
found in America. I have formerly compared our plants
with Woodville's plate, and I now very well recollect the
conclusion, without being able to specify the precise rea-
sons. At present I have only a wood cut of Bewick' before
me, which appears at least, to be very well executed, and
which to the best of my recollection, corresponds to the
engraving of Woodville. In this, the shortness and infla-
tion of the perianth, the companulate rather than the infun-
dibuliform corol, the round-oval form of the anthers, and
the greater width and shortness of the leaf, are prominent
peculiarities. I have certainly never met with any Ameri-
can specimen that possessed, or even approximated to them,
and I think the European and American sorts ought still to
be diligently compared in their living state. If they are
distinct, it is most probable, that more definite peculiarities
may be found, but even if there should not be, still, provid-
ed these should prove uniform, invariable, and permanent,
it might *possibly* warrant considering them distinct. I am
no advocate for the hasty and careless multiplication of spe-
cies, and till decisive and distinct marks can be found, those
which are closely allied, should by all means be considered
as varieties. In the present state of my information, howev-
er, I cannot but view the two American sorts of *Datura* as
specifically distinct, and I believe this has long been the de-
clared opinion of Professor Ives of Yale-College, and some

others whose attention has been particularly turned to the subject for some years past. Under this impression I shall venture to suggest an emendation of the specific characters of the plants in question, in the following terms, viz.

Datura Tatula, caule purpureo punctis viridibus asperso, pericarpiis spinosis erectis ovatis, foliis ovatis dentatis glabris.

Datura Stramonium, caule viridi, pericarpiis spinosis erectis ovatis, foliis ovatis dentatis glabris.

The facts that the corol of *D. Tatula* is generally pale blue, or purple striped with deep purple inside, and that of *D. Stramonium* white varying to cream colour, ought to be added by way of observation.

The *Datura* from the Cape-of-Good-Hope, which has been lately called *Tatula,* must, without doubt be considered as entirely out of the question in this discussion, and even if the European and both the American plants, be ultimately decided to be mere varieties, that ought unquestionably to have another name.

Middletown, (*Conn.*) *Jannary* 1821.

CONCHOLOGY.

—◆—

ART.—VIII.—*On the Genera Unio and Alasmodonta; with Introductory Remarks:* by D. H. BARNES, M. A. *Member of the New-York Lyceum of Natural History.**

(Concluded from pa. 127.)

UNIO.

** Cardinal teeth moderately thick, direct.

OBSERVATIONS.

THE shells of this section are, in general, not *very thick.* They have the *beaks* slightly elevated, or nearly flat. The

[*Read before the Lyceum.]

external surface is neither waved nor tuberculated. The *teeth* are less sulcated than those of the former, and only crenulated, or striated, generally triangular and elevated, and, in magnitude, bear a proportion to the thickness of the shell. The *cavity* of the beaks is small, or none, and neither angular nor compressed. The shells have a smooth and regular appearance, *and five of the seven species have the inside purple.*

SPECIES.

10. UNIO ELLIPTICUS. Fig. 19. ⎰ *a.* outline
⎱ *b.* of
⎱ *c.* four
⎰ *d.* sizes.

Shell regularly oval, thick, convex, glabrous, beaks depressed. Teeth elevated, triangular, striated.

Unio Crassus. *Mr. Say.* Plate 1 fig. 8 ?
Mya Complanata ? *Dillwyn.* page 51.
Inhabits Fox River. *Mr. Schoolcraft.*
Dr. Mitchill's Cabinet.
My Collection.
Diam. 1.0—2.0 Length 1.7—3.2 Breadth 2.5—4.9 inches.
Shell long before, and short behind, equally rounded at both extremities; *beaks* nearly flat; *ligament* elevated above the beaks; *epidermis* yellowish brown, obscurely rayed, rays disappearing in old specimens; slightly flattened on the *anterior slope*; *teeth* deeply divided, elevated, finely striated; anterior *cicatrix* wrinkled; posterior rough; *cavity* of the beaks considerable. *Naker* pearly white, iridescent, and sometimes, of a beautiful flesh colour.

11. UNIO CARINATUS. Fig. 10. ⎰ *a.* inside.
⎱ *b.* outside.

Shell oblong oval, biangulate before, rayed, hinge margin straight, compressed, keel-shaped, teeth finely striate.

Inhabits Fox River. *Mr. Schoolcraft.*
Dr. Mitchill's Cabinet.
My Collection.

Diam. .7—1.3 Length 1.2—2.3 Breadth 2.1—3.7 inches.

Shell transversely elongated, sub-pentangular, moderately thick, rounded behind; *beaks* slightly elevated, approximate; hinge margin straight, elevated, compressed, keel-shaped, longitudinally furrowed, fuscous with submembranaceous (striæ; anterior dorsal margin straight and sub-truncate; basal margin rounded; *epidermis* greenish yellow, with broad dark green rays; *surface* glabrous. Cardinal teeth slightly striated, nearly smooth; posterior cicatrix deep and striated; naker very white, iridescent.

Variety (*a*) *obscurely* rayed, more convex, compressed on the base, and gaping behind.

Inhabits Lake Champlain.

My Collection.

REMARKS.—This is a beautiful species. It cannot be confounded with any of the varieties of the *Cariosus* or *Radiatus*, on account of the primary teeth, which are entirely different. We have so many specimens of this shell, and they are all so perfectly characterized, and so much alike, that there can be no doubt of its being entitled to a distinct appellation. In several of the specimens, the epidermis is worn off, exhibiting a flesh-coloured substance beneath.

12. UNIO ALATUS.—Shell ovately triangular; hinge margin elevated into a large wing; valves growing together on the back of the ligament, inside purple.

Unio Alatus. *Mr. Say.*
Unio Alata. *M. Lamarck.*
American Conchology, plate 4. fig. 2.
Inhabits Fox River. *Mr. Schoolcraft.*
 Wisconsan. *Capt. Douglass.*
 Cabinets of the Lyceum and Dr. Mitchill.

We have every size of this shell from one inch to six inches and nine tenths broad. A full grown specimen measures as follows, viz. -

Diam. 2.0 Length 4.7 Breadth 6.9

A middle aged and very splendid specimen measures
D 1.6 L 4.0 B 6.0

Shell moderately thick; disks flat and compressed, long before and short behind; *beaks* depressed ; *ligament conceal-ed* within the valves; *hinge margin* very much elevated and compressed; basal margin nearly straight; anterior dorsal margin incurved or emarginate; anterior margin rounded and broad ; posterior margin rounded and narrow ; surface deeply wrinkled. Teeth elevated and crenate ; anterior ci-catrix very broad ; posterior composed of three distinct impressions, two small ones before the large one, and also a row of very small impressions across the cavity of the beaks, before the cardinal tooth. Naker red-purple and very bril-liant ; cavity of the beaks small and indented with from six to ten minute impressions in a row nearly longitudinal.

REMARKS.—The hinge margin is less elevated, and the colour less brilliant, in old than in young and middle aged specimens. The former approach the regular oval form, the latter are broad ovate.

None of the specimens in *our* collections exhibit the char-acter mentioned by *Mr. Say*, viz. "the external laminated tooth obsolete, only one in each valve being perceptible ;" and the tubercles, mentioned by him on the inside, appear only in *very old* specimens.

M. Le Sueur thinks that the remarkable union of the valves above the ligament ought to characterize a distinct genus. This union can seldom be observed in Cabinet spe-cimens, as the part is very fragile. Of the numerous speci-mens in our collections, *one only* retains the full elevation of the wing; the rest having been broken in transportation. This is the most splendid species of the Unio yet known, and it is só remarkably characterized as readily to be distin-guished from all others, except perhaps the *Unio Gracilis* ; which, though perfectly distinct, might, at first view, be mis-taken for the young of this species.

13. UNIO PRÆLONGUS. Fig. 11. $\left\{ \begin{array}{l} \text{outline of} \\ \text{three sizes.} \end{array} \right.$

Shell much elongated transversely, narrow, thick, tumid, beaks flat; lateral tooth long, thin ; inside purple.

Unio purpurata? *M. Lamarck.*
Inhabits Fox River. *Mr. Schoolcraft.*
Wisconsan. *Capt. Douglass.*
· Cabinets of the Lyceum and Dr. Mitchill.
My Collection.
Diam. 1.7—2.1 Length 2.5—2.7 Breadth 5.8—6.4
Shell very long oval; anterior side somewhat pointed, posterior side short, rounded, obtuse; beaks depressed; *ligament* elevated above the beaks; basal margin slightly compressed, shortened, or, in old specimens, arcuated; in young rounded; *epidermis* blackish brown, with fine interrupted wrinkles placed in longitudinal rows, having somewhat the appearance of striæ. Young specimens are rayed with yellowish olive, and have the epidermis smooth and glabrous. Naker purple of different shades according to the age or perfection of the specimen, sometimes tinged with irregular spots of greenish, particularly under the beaks, with a row of small muscular impressions in the cavity.

REMARKS.—This shell is probably the *Unio purpurata* of M. Lamarck. (See introductory remarks.) We have every size from the breadth of one inch, to six inches and four lines.
Variety (*a.*) Shell on the *inside striated* longitudinally. Naker red-purple, very splendid.
Variety (*b.*) Naker whitish green on the margin, and purple in the centre. An uncommonly beautiful shell, *tinged with copper?*
My Collection.

14. UNIO GIBBOSUS. Fig. 12. $\begin{cases} a. \text{ inside,} \\ b. \text{ outside.} \end{cases}$

Shell elongated transversely, thick, gibbous; lateral tooth very thick, incurved, inside purple.

Inhabits Wisconsan. *Mr. Schoolcraft.*
My collection. Lyceum's Cabinet.
Mr. Say's Collection. Philadelphia.
Diam. .75—1.3 Length 1.15—1.9 Breadth 2.4—4.0
Shell much elongated transversely, *thick and heavy*, rapidly narrowed and rostrate before, narrow and rounded be-

hind, *sub-cylindrical*, disks somewhat compressed ; anterior side very much produced ; beaks flat ; ligament elevated ; anterior dorsal margin depressed and flattened ; basal margin nearly straight ; *epidermis* blackish brown, finely striated and deeply wrinkled transversely ; naker purple of different shades, often with a purple centre and white margin. Teeth crenate ; lateral tooth rough, very thick, bending downward, terminating abruptly and folded over towards the interior of the shell.

REMARKS.—This shell in many respects resembles the preceding, but it differs from it in being less, thicker in proportion to the size, more attenuated before ; and it may be distinguished from all others by the unusual *thickness* of the *lateral tooth.* It is also more depressed immediately behind the beaks, and the thickness of the *anterior part* of the shell is very unusual, being in some specimens greater than that of the posterior. In one specimen the lateral tooth of the left valve measures *two lines* in thickness, and the channel of the opposite valve is two and a half lines broad.

15. UNIO CUNEATUS.—Shell ovate wedge-shaped, thick, gibbous ; disks swelled, anterior lunule furrowed ; lateral tooth thin ; inside purple.

Inhabits the Ohio. *Mr. S. B. Collins.*
Mr. Collins's collection.
Diam. 1.6 Length 2.3 Breadth 3.8
Shell elongated and sub-triangular, thick and ponderous ; anterior side narrowed, thin, angulated, wedge-shaped, compressed ; umbones large and somewhat elevated ; beaks low and distant ; anterior lunule long-heart-shaped, large, distinct with an elevated ridge and longitudinally furrowed ; posterior lunule small and deep ; basal margin slightly rounded ; anterior margin narrow and angulated ; anterior dorsal, rapidly narrowed ; posterior dorsal impressed ; epidermis blackish brown, somewhat ferruginous ; surface finely wrinkled, an elevated ridge extends from the beaks to the anterior basal margin, and terminates in an angle on the fore part. Cardinal teeth deeply divided and sulcated ; lateral tooth long, curved, and not very thick ; cicatrices deep ; cavity of the beaks small and not angular ; naker brownish purple, iridescent.

REMARKS.—This shell differs from the foregoing one, in its outline, in its greater length, less breadth, and in being more triangular. In *that* the lunules are not distinct; in *this* they are strongly marked. The lateral teeth of the two differ in length, thickness, direction and surface. This shell, if the thickness only were observed, might be mistaken for a variety of the *Crassus;* but the teeth are totally different.

16.. UNIO PURPUREUS.—Shell not very thick, obliquely sub-truncate before; beaks depressed; epidermis without rays, glossy;

> Unio Purpureus. *Mr. Say.*
> Unio Purpurascens. *M. Lamarck.*
> Unio Rarisulcata ? ⎫
> Unio Coarctata ? ⎪
> Unio Rhombula ? ⎬ *M. Lamarck.*
> Unio Carinifera ? ⎪
> Unio Georgina ? ⎭

American Conchology, Plate 3. Fig. 1.
Inhabits Lakes and Rivers eastward of the Alleghany mountains.
Cabinet of the Lyceum. My collection.
The varieties, which are exceedingly numerous, differ very much from each other in the length of the diameter, some measuring 13 lines, and some only 5. The length and breadth are generally in the proportions of 3 to 5. Mr. Say's figure measures length 1·4, breadth 2·6, and many specimens are twice as broad as they are long.
Diameter 1·3. Length 2 5. Breadth 4·5.
Inhabits Stony Creek, near Princeton, N. J. *Mr. Sears.*
　　　　1·1　　　　　　1·8　　　　　3·45
Inhabits the Kayaderosseras.
　　　　·75　　　　　　1·5　　　　　3·0
Inhabits the Housatonick.

Shell sub-oval, ovate-oblong, ovate—rhomboidal, oblong-ovate; thin, or not *very* thick ; disks convex, convex-depressed, or somewhat compressed ; before somewhat angulated or rounded obliquely *;* base rounded, straight, a little shortened, depressed, sub-sinuate, or coarctate-sinuate; *beaks* not prominent; hinge margin elevated, compressed,

carinate or depressed; epidermis has generally a *silky lustre*; surface with smaller wrinkles placed between larger ones, or with transverse elevated distant furrows, or smooth; cardinal teeth small, or not very large, sulcated or striated; naker livid, cerulean, green, purple, red, violet, white, with various shades and mixtures of these colors; no *cavity* under the beaks.

REMARKS.—The terms of the foregoing general description are taken from *Mr. Say's* and from the six species of *M. Lamarck* mentioned above. This is a very common shell, of a regular and uniform appearance, without prominence of parts, or strongly marked characters; which perhaps induced *M. Lamarck* to say "it is nothing remarkable."* Amidst a variety almost infinite, like that of the human countenance, there is still a characteristic identity of this species, which can scarcely be mistaken by an experienced observer. One variety of the *Radiatus* from the Saratoga Lake approaches nearest to this species, but the *least appearance of rays* forbids its association.

* * * *Cardinal teeth small, direct.*

17. UNIO RADIATUS.—Shell broad-ovate, thin, finely striated, glossy rayed, within bluish white, or tinged with red.

Unio Ochraceous. *Mr. Say.*
Mya Radiata. *Mr. Dillwyn.*
Unio Radiata. *M. Lamarck.*
American Conchology, plate 2, fig. 8.
Inhabits lakes and rivers of North-America.
Cabinet of the Lyceum. My collection.
Diam. ·6—·9 Length 1·2—1·5 Breadth 2·0—2·5.
Shell with the anterior side broad, thin and fragile, disks in old specimens somewhat convex; in young, depressed; beaks slightly elevated and approximate; ligament elevated; hinge margin elevated, compressed, carinate; basal margin commonly a little depressed, and sometimes arcuated; anterior margin narrow; posterior broad; anterior dorsal sub-truncate; epidermis greenish yellow or olive-brown, rayed with dark green, and very finely striated trans

*See An. Sans Vertebres, Vol. VI. p. 74, U. Georgina.

versely; surface smooth and shining. ; Cardinal teeth cren-
ulated, cavity of the beaks small; naker bluish white, or
reddish yellow; surface smooth and pearly.

Variety (*a*) very obscurely rayed and much like *Unio
Purpureus* in shape.

Inhabits Saratoga Lake.

Variety (*b*) oval or very nearly as broad behind as be-
fore.

Inhabits the Wisconsan. *Capt. Douglas.*

18. UNIO MUCRONATUS. Fig. 13. } outline of the
shell.

Shell ovate, broader behind; base compressed, fal-
cated; beaks small, elevated, *acute*, inside pur-
ple.

Inhabits the Wisconsan. *Capt. Douglass.*
My collection.
Diam. ·7 Length 1·3 Breadth 2·3.

Shell ovate, moderately thick, produced, narrowed, and
compressed before; rounded and broad behind; disks com-
pressed; anterior lunule long; distinct, with a marginal fur-
row; posterior lunule small, deeply impressed; hinge mar-
gin rounded; basal margin arcuated; anterior dorsal rapid-
ly narrowed and slightly emarginate; epidermis horn-color,
and obscurely rayed; surface smooth; cardinal teeth ser-
rate sulcate; cicatrices deep; naker purplish on the mar-
gin, and whitish in the centre.

REMARKS.—This species has somewhat the outline of
the *Unio Tuberculatus*, but the outside is smooth. The in-
dividual above described is probably not more than half
grown, as the umbones are very little eroded.

19. UNIO INFLATUS.—Shell oval, thick, tumid,
beaks broad, obtuse behind, wedge-shaped be-
fore, inside pearly white.

Inhabits the Wisconsan and Lake Erie. *Capt. Douglass.*
Dr. Mitchill's Cabinet.
My collection.

Diam. 1·4 Length 1·7 Breadth 3·2.

Shell about equally broad before and behind, thick and very much swelled, the diameter being almost equal to the length; beaks broad round and somewhat elevated; posterior side very short and obtuse; anterior side wedge-shaped produced. Hinge margin nearly straight, and parallel to the base; basal margin straight and slightly compressed in the middle; epidermis yellowish-green, rayed; surface wrinkled and striated transversely; cardinal teeth elevated, pointed, sulcated; lateral teeth papillous; posterior cicatrix deep, and somewhat rayed with elevated lines; cavity of the beaks moderate; naker pearly white and iridescent; internal surface papillous.

REMARKS.—This shell is less than the Unio Siliquoideus, and also more rounded and gibbous, shorter behind and proportionally longer before than that species. The varieties of the two species approach each other, and are to be distinguished only by the teeth.

B. TEETH OBLIQUE.

* * * * *Cardinal teeth, broad, oblique, compressed.*

20. UNIO VENTRICOSUS. Fig. 14. { *a* small size. *b* large size. *c* the first variety.

Shell large thick triangularly ovate, convex; umbones large, round, prominent; beaks recurved; cavity capacious.

Mya Radiata. *Dillwyn's Letter to Dr. Mitchill.*
Unio Cariosus. *Mr. Say's Letter to the Author.*
Inhabits the Wisconsan. *Mr. Schoolcraft.*
Mississippi, near Prairie du Chien. *Capt. Douglass.*
Cabinets of the Lyceum and Dr. Mitchill. My Collection. Mr. Say's Collection, Philadelphia.
Diam. 2.5 Length 3.5 Breadth 4.5.
Shell with the anterior side very broad, sub-truncate; posterior side rapidly narrowed, sub-angulated; disks very convex; umbones large, round, elevated; beaks recurved

over the ligament ; ligament large and prominent, passing
under the beaks ; anterior lunule depressed at the margin,
fuscous, broad-heart-shaped, longitudinally waved; hinge
margin depressed between the beaks ; posterior slope car-
inate ; epidermis yellowish olive, becoming chesnut brown
on the umbones ; rayed with green, more conspicuous in
young specimens; in old ones the dark chesnut brown
covers the whole and conceals the rays; surface smooth and
shining, reflecting the face of the observer; young shells
are splendent, having a much stronger lustre on the outside
than on the inside ; cardinal teeth broad, prominent and
obliquely flattened ; lateral teeth broad, elevated and ter-
minating abruptly before ; cicatrices large ; cavity of the
beaks unusually large ; naker pearly white; surface smooth,
but not highly polished.

REMARKS.—There is a remarkable uniformity in the di-
mensions of the full-grown specimens of this species. This
shell is more capacious than any other of the genus hitherto
described. It most resembles the *unio ovatus*, but its great-
er capacity, darker color, its smooth, shining and rayed sur-
face will distinguish it without mistake.

Variety (*a*) shell broader, less ovate, nearly oval and
rounded on both sides.
A fine large shell. It measures
Diam. 2.3–2.8 Length 3.1—3.8 Breadth 4.1—5.4.
Inhabits the Wisconsan. *Mr. Schoolcraft.*
Variety (*b*) shell light green, rayed, compressed.
Inhabits the Wisconsan.
Variety (*c*) shell with the teeth slightly elevated ; cardi-
nal one formed by a serrated edge of the shell, and a slight
projection within.
Inhabits Barbadoes Neck, N. J. near New-York.
Mr. Bradhurst's Collection.
Diam. 2.5 Length 3.5 Breadth 4.8.
Variety (*d*) a shell from the Delaware approaches this
species. The form and colour are similar. It is however
less, the largest measuring scarcely 2.3 inches broad ; ma-
king the shell not more than one fifth the size of those de-
scribed above ; also the beaks and bosses are less promi-

nent, the rays fewer, and the polish less brilliant. It approaches the *Unio Cariosus.*

Inhabits the Delaware at New Hope. *Mr. J. Sears.*
My Collection.

REMARKS.—With the most respectful deference to the two distinguished Naturalists whose names are mentioned above, I have ventured to differ from them both, as they do from each other. I think a slight examination of our Cabinets would convince either of them that this shell requires a separate designation. Two bivalves can scarcely be more unlike than this and the *Unio Radiata* of Lamarck; and the recent discovery, of the variety C, in our own waters, which produce thousands of the *Unio Cariosus,* seems conclusive as to that. This variety it will be observed has *precisely the same diameter and length* as the shell from the Wisconsan, and the difference in the teeth may be accidental. There is the same necessity for distinguishing these as any others. They are totally unlike.

21. UNIO SILIQUOIDEUS. Fig. 15. { outline of the shell.

Shell long-ovate, sub-cylindrical, thick, regularly rounded, rayed, beaks slightly elevated, cavity small; inside white.

Inhabits the Wisconsan. *Capt. Douglass.*
Dr. Mitchill's Cabinet. My Collection.
Diam. 1·3—1·6 Length 1·8—2·1 Breadth 3·3—3·8.
Shell elongated transversely, disks swelled; beaks about one fourth from the posterior extremity; hinge margin straight; basal margin convex depressed; anterior margin rounded; posterior sub-angulated; epidermis yellowish olive rayed with distant dark green narrow lines; surface deeply wrinkled, and somewhat imbricated; striæ dark and lamellar on the anterior slope; smooth and bright on the centre of the disks; cardinal teeth elevated crest-like compressed, and very oblique; in some specimens nearly parallel to the edge of the shell; lateral teeth long and

straight; cavity of the beaks small and rather shallow, naker pearly white and iridescent, surface smooth and polished.

Variety (*a*) shell less, more ovate, broader before, hinge margin more elevated.

REMARKS.–This is a beautiful and elegantly formed shell. It somewhat resembles a *pea-pod;* hence its name. It agrees in color and surface with the Unio Ventricosus, but differs in being of smaller size, longer in proportion, more cylindrical, less inflated, beaks much less elevated, and cavity less capacious.

22. UNIO OVATUS.—Shell roundish-ovate, convex, umbones elevated, beaks recurved, anterior lunule flattened ; teeth crest-like elevated.

Unio Ovatus. *Mr. Say.*
Unio Ovata. *M. Lamarck.*
Inhabits the Ohio. *Mr. Collins.*
Maumee, at Fort Wayne. *Mr. Sears.*
Mr. Collins' Collection. My Collection.
Diam. 1·6—2·0 Length 2·3—3·0 Breadth 3·3—4·0.
American Conchology, plate 2, fig. 7.
Shell usually broader before, and narrower behind the beaks; but in the figure referred to above, the contrary is observed; thin when young, and not remarkably thick when old; disks swelled; umbones prominent; ligament partly concealed; anterior lunule flattened, and fuscous, somewhat waved with striæ and wrinkles becoming lamellar; hinge margin making an angle with the anterior and posterior dorsal; epidermis yellowish, or horn color; surface glabrous, deeply wrinkled, wrinkles appearing on the inside; cardinal teeth crest-like, elevated and compressed; lateral teeth elevated; in some specimens, short, crooked, and apparently deformed; in others, straight; cicatrices smooth and polished; cavity large and rendered somewhat angular by the flattening of the anterior slope; naker pearly, bluish white; surface, in old specimens, papillous, in young, smooth.

REMARKS.—The angular appearance produced by the flattening of the anterior slope, readily distinguishes this

species. It most resembles the Unio Ventricosus; but is less, thinner, " more flattened and even slightly concave on the anterior slope, from the oblique carina to the angle at the termination of the ligament." Mr. Say says the *Ovatus* is not rayed, and our specimens accord with his description, but M. Lamarck mentions a variety with rays from Lake George.

23. Unio Cariosus.—Shell ovate or oval, inflated, not very thick, beaks somewhat prominent, cavity moderate.

Unio Cariosus. *Mr. Say.*
Unio Cariosa. *M. Lamarck.*
Inhabits Lakes and Rivers of N. America.
My Collection.
Diam. 1·6, Length 2·3, Breadth 3·7.
American Conchology, plate 3, fig. 2.

The dimensions and description of this shell vary so much that it is difficult to find a sufficient number of permanent characters by which it may be distinguished. It resembles in this respect the Unio Purpureus; for of the *twelve* characters mentioned by Mr. Say, and the *six* mentioned by M. Lamarck only *four* can be considered as in any degree permanent; and of these M. Lamarck has mentioned but *one*, and that is " *inflated.*" The colour, form and size of the shell constantly vary. It is commonly broader before, but often equally broad at both extremities; and somewhat pointed. It is never very thick; often very thin; commonly a medium. Those from the Hudson are thin and small, from the Raritan thicker and broad; from the western waters middle sized and of considerable thickness; disks swelled, umbones elevated; ligament exterior and elevated; epidermis olive-brown or greenish, and commonly radiated. Internal colour bluish white, reddish, rose, or salmon; surface often warty.

Variety (*a*) Cardinal teeth multipartite.
Inhabits Lake Ontario.
Mr. Bradhurst's Collection.

24. UNIO PLANUS. Fig. 16. { outline of the shell.

Shell rhombick-oval, thin, beaks depressed ; disks flattened, compressed ; teeth slightly elevated, smooth.

Inhabits the Wisconsan. *Mr. Schoolcraft.*
My Collection.
Diam. 1·3 Length 2·8 Breadth 4·8.
Shell with the beaks flat, ligament broad and deeply inserted between the valves ; hinge margin straight and parallel to the base ; basal margin slightly arcuated ; anterior dorsal margin subtruncate ; epidermis brownish yellow ; surface deeply wrinkled ; cardinal teeth smooth, polished and slightly elevated ; lateral teeth long and slender ; cicatrices rough ; cavity very small ; naker bluish white tinged with purple and green. Internal surface wavy and tuberculated.

REMARKS.—The flatness of the shell and the smoothness of the teeth, readily distinguish this species from all its congeners hitherto described. It has been supposed to be the *Unio Anodontina* of M. Lamarck ; but besides being *four times as large,* it has not at all the general habit of an *Anodonta ;* wherereas M. Lamarck observes that his shell " might be mistaken for an anodonta unless it should be *carefully observed.*"

***** *Cardinal teeth small, oblique.*

25. UNIO TRIANGULARIS. Fig. 17. { a inside. b outside.

Shell triangular, gibbous inflated, rayed, gaping ; anterior slope flattened, ribbed, cancellate ; inside white.

Inhabits Bois-blanc Isle, Detroit River. *Major Delafield.*
Dr. Mitchill's Cabinet.
Major Delafield's Collection.
My Collection.

Of this remarkable shell we have four specimens ;
Diam. ·6 Length ·625 Breadth 1·05 inch.
 ·625 ·7 1·1
 ·75 ·8 1·5
 ·8 ·8 1·3

Shell moderately thick, acutely angulated before obtuse
and somewhat angulated behind ; disks inflated ; anterior
slope flattened and forming a right angle with the disk, rib-
bed longitudinally and wrinkled transversely ; beaks one
third from the posterior extremity, decorticated approxi-
mate and somewhat elevated ; anterior lunule oval-heart-
shaped ; posterior lunule not distinct ; basal margin a
little depressed near the anterior extremity ; anterior mar-
gin straight, and its edge not entire ; epidermis yellowish-
green, rayed with dark green, finely striated transversely,
and with from three to six more conspicuous transverse
wrinkles. Anterior slope marked with longitudinal ribs
which are beautifully cancellated by the striæ and wrinkles
passing over them, ribs projecting and forming a dentated
edge ; shell slightly gaping at both extremities ; cardinal
teeth two in each valve, compressed and crenulate, lamellar
teeth short, projecting, finely crenulate, and terminating ab-
ruptly ; naker bluish-white iridescent.

REMARK.—This shell resembles, *in shape,* the *Alasmo-
donta marginata,* but it is a well characterized *Unio.*

26. UNIO NASUTUS.—Shell oblong-lanceolate, thin
 produced and pointed before, hinge margin ele-
 vated, compressed, carinate.

Unio Nasutus. *Mr. Say.*
American Conchology, plate 4, fig. 1.
Inhabits the Delaware.
My Collection.
Diam. ·5 Length 1·0 Breadth 2·2.
Shell thin and slender ; disks compressed ; beaks depres-
sed ; ligament elevated and slender ; anterior lunule dis-
tinct, somewhat depressed at the margin, and with obsolete
longitudinal ribs ; hinge margin straight ; basal margin
nearly parallel with the hinge, slightly divergent ; anterior

extremity pointed, posterior rounded; epidermis greenish brown; surface striated, glabrous; cardinal teeth slender; lateral tooth long and thin; naker bluish-white varied with wax-yellow, and sometimes tinged with violet, and iridescent; cavity of the beaks, scarcely any.

Remark.—This cannot as M. Lamarck supposed be his *Unio Nasuta*, for it has no sinuses on the basal margin, is not " crooked" nor " obliquely attenuated."

27. Unio Gracilis.—Shell ovately triangular, very thin and fragile, hinge margin elevated; valves connate; ligament concealed.

Unio Alatus. *Mr. Say.*
Inhabits the Wisconsan. *Mr. Schoolcraft.*
And the Lakes. *Mr. Say.*
Cabinet of the Lyceum.
My Collection.
Diam. 1·0—1·2 Length 2·2—2·5 Breadth 3·1—4·1.
Beaks depressed, and placed far back; ligament between the valves, and covered; anterior lunule distinct and obsoletely ribbed; hinge margin elevated into a large wing; epidermis sea-green, wrinkled and striated transversely; obscurely radiate and glabrous; cardinal teeth very small, scarcely projecting; lateral teeth very thin and finely striated; channel just sufficient to admit the point of the thumb nail; naker bluish-white tinged with violet, and beautifully iridescent.

Remarks.—This shell differs from Unio Alatus in being much thinner, broader in proportion, lighter color both inside and outside, produced and somewhat pointed behind; anterior slope in a straight line with the alated projection. It differs entirely in the shape and proportion of the teeth.

28. Unio Parvus. Fig. 18. } outline of the shell.
Shell oblong-ovate, small, convex, sides rounded; beaks slightly elevated, inside pearly white, iridescent.

Inhabits the Fox River. *Mr. Schoolcraft.*
Cabinet of the Lyceum.
Mr. Collins's Collection.
Mr. Say's Collection, Philadelphia.
Diam. ·35— 525 Length ·4—·6 Breadth ·75—1·2.
Shell rather thin, beaks placed about one fourth of the length from the posterior extremity, ligament very narrow, anterior lunule distinct and obsoletely ribbed; basal margin slightly shortened; epidermis brownish; an obtuse slightly elevated rib from the beaks to the anterior basal margin; lateral tooth rectilinear rounded at the end, and parallel to the base; naker very brilliant.

REMARK.—The smallest and most beautiful of all the genus yet discovered in America.

Summary of the Unio.

Species described, - - - - -	28
Varieties particularized, - - - -	23
Total of species and varieties, - - -	51
Of which Mr. Say formerly described, -	8
We have given new specific names to -	20
Of which M. Lamarck had *perhaps* previously noticed - - - - - - -	3

End of the Unio.

ALASMODONTA.*

Generick Character.

Shell transverse, equivalve, inequilateral, free; beaks decorticated; posterior muscular impression compound; hinge with prominent cardinal teeth in each valve, but *without lateral teeth.*

* "From α, without, λασμα (λεπισμα?) a scale, and ὀδους a tooth."—*Mr. Say.*

OBSERVATIONS.

This genus was established by *Mr. Say.* The shells are distinguished from those of the genus Unio, by the want of the lateral lamellar tooth, the place of which is commonly occupied by a slightly elevated fold ; but no channel can be perceived, nor any interlocking or matching together of the opposite folds. In many specimens the part is perfectly smooth. The *sinus* at the anterior termination of the ligament is visible in all, and exactly resembles that of the *Unio ;* as do also the colours of the epidermis and of the interior ; but the polish of the inside is generally much less brilliant than that of the *Unio.* The habit of the shells is similar, many of them becoming thick and large.

M. Lamarck seems not to have noticed this genus. He makes the same remark of his Hyria,* that Mr. Say does of this, " that together with the Dipsas† of Dr. Leach it completes the connexion between the *Unio* and *Anodonta.*" But no part of his generick character agrees with the present genus except that the shell is equivalve, which is the case in the whole family.

The auricles‡ of his Hyria and the lamellar tooth forbid the supposition, that he could have intended this shell by his description. It is however properly one of his *Naiades,* and should be placed next to the Unio.

We subdivide the Genus into two sections, commencing with those that resemble the Unio and ending with those that approach the Anodonta.

Sections.

* Shells thick and large.
* * Shells thin and small.

* Generick character of the Hyria of *M. Lamarck.* Shell equivalve, obliquely triangular, auriculate, truncated and straight at the base ; hinge with two teeth slightly elevated ; *(rampantes.)* the cardinal or posterior tooth multipartite, divergent, the interior parts less ; the other or lateral tooth very long and lamellar ; ligament external and linear. (Naker very brilliant.)

† The Dipsas of Dr. Leach, has the lamellar lateral tooth, but no cardinal teeth.

‡ Processes on each side of the beaks, like the scallop, *Pecten opercularis.*

* Shells thick and large.

Species.

1. ALASMODONTA ARCUATA. Fig. 20. $\left\{\begin{array}{ll} a. \text{ young,} & c. \text{ old.} \\ b. & d. \end{array}\right.$

Shell ovate, elongated transversely, thick ; base arcuated ; ligament elevated ; beaks depressed ; cicatrices rough.

Hab. West Canada Creek. *Mr. R. N. Havens.*
A small stream in Tappan. *Mr. J. Sears.*
Cabinets of the Lyceum and Dr. Mitchill.
My Collection. Mr. Say's Collection.
Diam. 1.2—1.6 Length 2.1—2.6 Breadth 4.1—5.5

Shell thick; disks convex above, and compressed below; anterior side very much produced ; beaks slightly elevated; ligament elevated above the beaks ; hinge margin elevated, compressed, carinate ; basal margin *arcuated;* anterior margin narrow and somewhat pointed ; posterior margin rounder and broader than the anteriour ; ant. dorsal margin rapidly narrowed and subtruncate ; post. dorsal impressed behind the beaks ; epidermis brownish black ; surface, in young specimens, smooth and glabrous, in old ones, much eroded, scabrous and broken. Teeth *two* in the right and one in the left valve, triangular, elevated and crenate; muscular impressions rough ; cavity of the beaks small ; naker bluish white, on the fore parts, lightly iridescent, the rest dull. Young specimens have the center of a pale flesh colour, and old ones are frequently marked with irregular greenish spots.

REMARKS.—The remarkable change in the form of this species by age, as represented in the figures, might induce an observer to suppose that the shells belonged to different species; but the specimens in our collections of every variety of form, from those that are straight or even slightly *rounded* on the base, to those that are *deeply arcuated,* show clearly that they *all* belong to the same species. It is surprising that a shell so large, and frequently occurring in our waters should so long have been overlooked. This has

probably arisen from the supposition that it belonged to the genus *Unio*, as in its exterior it resembles some varieties of the U. *purpureus.*

2. ALASMODONTA RUGOSA.—Fig. 21. Shell oblong-oval, anteriour side with deep divergent folds.

Hab.--Wisconsan. *Capt. Douglass.*
 Fox River. *Mr. Schoolcraft.*
 Dr. Mitchill's Cabinet. My Collection.
 Mr. Say's Collection.
 Diam. 1.0 Length 2.0 Breadth 3.7
Shell oblong-oval, about equally broad before and behind; beaks slightly elevated, wrinkled and decorticated, exhibiting a wax colour beneath ; ligament external and as high as the beaks ; anteriour lunule distinct with a slightly elevated ridge extending from the beaks to the ant. basal margin; basal margin a little shortened; the other margins regularly rounded; epidermis chesnut brown, with a silky lustre ; *surface* of the anteriour part folded in a *pinnate* form ; *folds* deeper above and somewhat obsolete below the ridge, curved upward and extending to the hinge and anteriour margins, indenting the edge and visible on the interiour. *Teeth* large and elevated with a fold behind ; cicatrices smooth ; cavity small ; naker pale flesh coloured in the center, pearly white on the margin with a narrow border of dark chocolate colour ; surface smooth and glabrous.

REMARKS.—This is a very beautiful shell, and unlike any of its congeners. In the one figured, the left valve is slightly compressed, the right a little gibbous and the base crooked, which may perhaps be accidental.

3. ALASMODONTA COMPLANATA. Fig. 22. Shell ovately quadrangular, hinge margin elevated into a large wing ; valves connate ; ligament concealed.

Hab. Fox River. *Mr. Schoolcraft.*
 Wisconsan. *Capt. Douglass.*

Cabinets of the Lyceum, and Dr. Mitchill. My collection.
Mr. Say's collection.

Diam. .9—1.4 Length from beaks to base 3.0 Breadth 5.0
Length from the top of the wing 4.3—4.5

Shell very short behind; disks much flattened; umbones depressed; beaks slightly projecting; ligament between the valves; anterior lunule much compressed and folded across the transverse wrinkles; hinge margin elevated into a large wing, straight and forming an obtuse angle with the post. dorsal margin; basal margin slightly rounded, nearly straight; anteriour and posterior margins somewhat angulated; anteriour dorsal margin arcuated, or somewhat emarginate; epidermis chesnut brown, glossy; surface somewhat deeply wrinkled and striated transversely; slightly elevated ridges and furrows diverging from the beaks to the anteriour margin, and distinctly impressing the inside. Teeth elevated, sulcated and radiating from the beaks; cicatrices smooth; cavity small and angular; naker bluish white and iridescent; surface smooth, and polished, in old specimens spotted with green.

REMARKS.—This shell resembles the *Unio Alatus*, in the elevation of the wing and the connexion of the valves, and might at first sight be mistaken for a variety of that species; but it differs in generick character, in shape, and in colour.

* * *Shells thin and small.*

4. ALASMODONTA MARGINATA.—See Mr. Say's description.

5. ALASMODONTA UNDULATA.—See Mr. Say's description and figure.

These two species were the only ones known when Mr. Say published his description. The former of them is very common and assumes a great variety of forms and colours. Those that were brought by the N. W. Expedition are larger than those of our eastern waters. They have the epidermis pale green, rayed; they are gibbous; have the beaks elevated, and base falcated.

Diam. 1.0 Length 1.4 Breadth 2.4

Our thanks are due to the following gentlemen, for spe-
cimens and information.

Gov. Cass of the Michigan Territory.

Capt. D. B. Douglass, Topographical Engineer to the N.
W. Expedition.

Mr. H. R. Schoolcraft, Mineralogist to the N. W. Expe-
dition.

Mr. Thomas Say, Philadelphia.

Doctor S. L. Mitchill,
Major Delafield,
Mr. S. B. Collins,
Mr. J. M. Bradhurst, } of New-York.
Rev. J. Sears,
Mr. R. N. Havens,

Mr. E. Norcross, of the American Museum.

MATHEMATICS.

———◆———

Art. IX.—*Demonstration of a Problem in Conic Sections:*
By Assistant Professor Davies.

Military Academy, West-Point, Jan. 20, 1823.

To the Editor.

Sir—In the first volume of Dr. Hutton's Mathematics,
(second American edition. p. 470,) we find the following
article—" If there be four cones, having all the same ver-
tex, and all their axes in the same plane, and their sides
touching, or coinciding in common intersecting lines ; then,
if these four cones be all cut by one plane, parallel to the
common plane of their axes, there will be formed four hy-
perbólas, of which each two ópposites are equal, and the
other two are conjugates." The intersections of a plane,
and the surfaces of four cones, having a common vertex,
touching each other in right-lined elements, and having
their axes in one plane, are not conjugate hyperbolas, as

asserted by Dr. Hutton ; and the principle which he has adopted as general, obtains in one case only. As I have not seen this error corrected, nor any other method laid down by authors on conic sections for obtaining conjugate hyperbolas by means of intersecting four cones situated as above, I send you the following, thinking that it may possibly merit a place among the mathematical articles of your Journal.

Let LAC, HAF, HAL, and CAF, be four cones, having a common vertex A, their axes in the plane of the paper, and touching each other in the right-lined elements, CAH, and LAF.

If the two cones CAL and FAH be cut by a plane QCBDE, parallel to the line PO, it will intersect the cones in opposite hyperbolas ; and if we take the plane perpendicular to that of the paper, these hyperbolas will be orthographically projected in the line EQ. If through either of the points C, or D, in which the cutting plane meets the right-lined elements AC, AD, another plane be passed parallel to the line KAB, this plane will intersect the two cones LAH and CAF, in opposite hyperbolas, and these hyperbolas will be conjugates to the former.

Demonstration.

Pass any plane as GF perpendicular to the axis of the cone GAF, it will intersect its surface in a circle, and the plane QE in a right line, which will be a common ordinate at the point E, to the transverse axis of the hyperbola, and the diameter GF of the circle. Since the triangles CAB, CGE and DEF are similar, CB is to AB as CE to EG, and CB is to AB as DE to EF; and by multiplying together

the corresponding terms of these proportions, we have CB^2 to AB^2 as CED to GEF. But the rectangle GEF is equal to the square of the ordinate of the circle or hyperbola at the point E, therefore AB is the semi-conjugate axis of the opposite hyperbolas, whose transverse axis is CD. Let now a plane HL be passed perpendicular to the axis AK of the cone HAL, it will intersect its surface in a circle, and the plane DI in a line ; this line will be a common ordinate of the hyperbolas whose transverse axis is DN, and to the circle whose diameter is HL.. Since the triangle DAO, DLI and HIN are similar, DO is to AO as DI to IL, and DO is to AO as IN to IH; by multiplying the corresponding terms of these proportions, we obtain DO^2 to AO^2 as DIN to HIL. But the rectangle HIL is equal to the square of the ordinate of the circle or hyperbola at the point I, and therefore the hyperbolas having DN for a transverse axis have AO for a semi-conjugate. Since CB is equal to AO, and AB to DO, the transverse axis of the hyperbolas whose vertices are C and D, is equal to the conjugate axis of the hyperbolas whose vertices are D and N, as they are respectively equal to QCB and QAO, and the transverse axis of the latter hyperbolas, is equal to the conjugate of the former; the four hyperbolas are therefore conjugates.

It follows from this demonstration that, if either two of the opposite cones, be intersected by a plane parallel to their common axis, the distance of this plane from the axis, is always equal to the semi-transverse axis of conjugate hyperbolas, and that these hyperbolas may be formed by intersecting the other two cones by a plane parallel to their common axis, and at a distance from it equal to the semi-transverse axis of the first hyperbolas. The cutting planes are at unequal distances from the axes of the cones, to which they are respectively parallel, unless those axes make with the right-lined elements of their corresponding cones, angles of forty-five degrees, in which case the hyperbolas are equilateral, and may be cut out by one plane parallel to the axes of the four cones.

<div align="center">

I am, Sir, with great

respect and consideration,

you obedient servant

C. DAVIES,

Asst. Prof. Nat. and Ex. Phi'y.

</div>

To Prof. B. Silliman, New-Haven.

Art. X.—*Elements of Geometry*. By A. M. Legendre, *Member of the Institute and Legion of Honor, of the Royal Society of London, &c.; translated, from the French for the use of the students of the University at Cambridge, New-England. Cambridge, N. E.* Hilliard & Metcalf, 1819. p. 208.

M. Legendre has long been regarded, as one of the great luminaries of mathematical science. His rectilineal and spherical trigonometry, appended to his Elements of Geometry, though not very extensive, is marked with profoundness and originality. His "Essai sur la Theorie des Nombres," (of which the second edition, much larger and more complete than the first, was published at Paris in 4to in 1808,) contains the principal results of Fermat, Euler, and Lagrange, together with the fruit of his own investigations, upon that difficult and important branch of mathematics. It contains also some of the most interesting discoveries of M. Gauss, upon the same subject. The first elements of the "Theory of Numbers," or, as it is sometimes called "Transcendant Arithmetic," are demonstrated in the seventh book of Euclid, with elegance and rigor. We have some other ancient fragments on the properties of numbers, but this branch of mathematics has been much more cultivated by the moderns than by the ancients. Indeed, our system of Arithmetical Notation, which approaches perhaps as near perfection as any in this world, and the resources of our Algebra, have given the moderns an immense advantage over the ancients in investigating the general properties of numbers. Of the "Theorie" of Legendre, M. Gauss thus speaks : Dans cet intervalle, il a paru un excellent ouvrage d'un homme qui avait déja rendu de très-grands services à l'Arithmétique transcendante, dans lequel il a non-seulement rassemblé et mis en ordre tout ce qui a paru jusqu'à présent sur cette science, mais ajouté beaucoup de choses nouvelles qui lui sont propres.* Besides these, he is author of a new method for the determination of the orbits of comets ; Exercises upon the Integral

*Recherches Arithmétiques traduites par Delisle, preface p. 14.

Calculus; and various academical memoirs. In the late great trigonometrical surveys in France and England, operations which have contributed so much to our knowledge of the earth we inhabit, and to the honor of the nations engaged in them; the instruments used were of such exquisite construction, that the angles were measured to a fraction of a second. Hence, the spherical excess, that is, the excess of the three angles of the triangles, measured in these surveys on the surface of the earth, above two right angles, became apparent. It was necessary, therefore, to estimate this excess. The prompt genius of M. Legendre furnished for the occasion a theorem, founded on the fact, that the spherical triangles whose angles are measured in trigonometrical surveys, have their sides very small when compared with the radius of the sphere, which is, in this case, the radius of the earth. The theorem adverted to, reduces the resolution of these spherical triangles, to that of rectilineal triangles, and admirably unites conciseness with a sufficient degree of exactness. The theorem is this : *"A spherical triangle being proposed, of which the sides are very small in relation to the radius of the sphere, if from each of its angles one third of the excess of the sum of its three angles above two right angles, be subtracted, the angles so diminished, may be taken for the angles of a rectilineal triangle, the sides of which are equal in length to those of the proposed spherical triangle."* M. Legendre has given a demonstration of this very valuable theorem, in the appendix to his Trigonometry.

The Elements of Geometry now under consideration, were composed during that period of the French history, when the ancient foundations of society and government were undermined, and the political edifice throughout Europe, rocked with fearful convulsions on its base. The great French philosophers and mathematicians saw plainly, that in order to conciliate the popular favor, and avoid the jealousy of the reigning authority, they must, as far as possible, render their favorite pursuits subservient to objects of immediate and practical utility. They had seen the eminent talents and conspicuous virtues of Lavoisier, insufficient to save him from the scaffold ; and the illustrious but unfortunate Bailly, who had formerly been the idol of the French nation, and who had devoted his life to the inter-

ests of science, and humanity, had fallen a victim of the
most sanguinary tyranny, before their eyes. The subse-
quent organization of a system of public instruction, gave
the French mathematicians an opportunity of rendering
eminent services to the government. The utility of the
exact sciences to the views of the French nation, as con-
stituting the basis of the science of war, called into full ex-
ercise all-the mathematical talents in the kingdom. But
above all, the establishment of the National Institute con-
centrated the talents of the nation, and the pensions and
high honors which were liberally bestowed, especially up-
on those who successfully cultivated the exact sciences,
gave an astonishing impulse to mathematical learning. To
these circumstances we owe the geometry of Legendre,
the numerous elementary treatises of Lacroix, Laplace's
System of the World, Lagrange's Theory of Analytical
Functions, Poisson's Mechanics, and an immense number
of other works of the highest merit, which cannot now be
mentioned. The exact sciences are vastly indebted to the
French revolution and its long train of consequences, what-
ever may be its ultimate effect upon the progress of knowl-
edge in general. The science of calculation is now invest-
ed with such resources, that almost nothing is too compli-
cated, or too stubborn to yield to its power.

Before proceeding to a particular examination of the
work before us, we feel called upon to say a few words up-
on the enquiries,—what ought an elementary treatise of
geometry to contain, in the present state of the pure and
applied mathematics?—and why we should adopt M. Le-
gendre's treatises, or that of any other modern writer, in
preference to "Euclid's Elements," which have been
used, for the most part, as a text-book in the American
colleges.

With respect to the first enquiry, it is plain, that an ele-
mentary treatise cannot contain all the truths within the
compass of elementary geometrical investigation. The
properties which belong to the figures of elementary ge-
ometry, and the relations which these properties sustain to
each other, are innumerable. Some of these properties
and relations have never been applied to any practical ob-
ject, others form links more or less important in a long
chain of connected truths, others are truths important in

themselves, independently of their connections, while a multitude of others, without doubt, remain still undiscovered. The general principles with a view to which an elementary treatise of geometry ought to be composed, in the present state of mathematical science, we think, are these: 1st. All those truths should be selected, which admit of extensive applications as well to ordinary practical purposes, as in the higher branches of mathematics. 2d. The demonstrations should unite, as far as possible, the elegance and rigor of the ancient geometers, with a greater degree of conciseness. 3d. The demonstrations should be so constructed as to exclude, as far as possible, propositions merely subsidiary; that is, propositions which are of no practical importance in themselves, but only steps in demonstrating others. 4th. Indirect demonstrations should be avoided, as much as possible. In general, those proofs are the best, which establish the truth proposed upon an immoveable basis, and, at the same time, clearly shew its connection with other truths already known, and render sensible, the transition from a proposition to that which follows it. 5th. The truths demonstrated should be arranged in the most natural order, and well connected with each other. 6th. The synthetic method of demonstration should be employed, as being peculiarly appropriate to elementary geometry. 7th. Great care ought to be used to preserve a uniformity in the style of the demonstrations, and an analogy between the different parts of the treatise. We shall be better understood on this point, by taking an example. Parallelograms upon the same base, and of the same height, are equal. Also, parallelopipeds upon the same base, and of the same height, are equal. The former of these propositions, has the same relation to areas, that the latter has to volumes. On account of the similarity of the propositions, their demonstrations ought to be similar. The preservation of this analogy not only gives elegance to the demonstrations, but much assistance to the memory.

The question, why students in mathematics should use a modern treatise of geometry, in preference to the Elements of Euclid, is of far more difficult discussion than the preceding. Euclid's Geometry has come down to us clothed with the authority of the high antiquity of two thousand

years, and in this work he appears to have collected all the elementary truths of the science, which had been discovered at the time in which he lived. It was composed under the patronage of the Ptolemies, and in the school of Alexandria. With respect, however, to the influence which antiquity ought to have upon our opinion of any work of science, we entirely agree with Professor Playfair. " The infancy of science," says he, " could not be the time when its attainments were the highest; and before we suffer ourselves to be guided by the veneration of antiquity, we ought to consider in what real antiquity consists. With regard to the progress of knowledge and improvement, we are more ancient than those who went before us. The human race has now more experience than in the generations that are past, and of course may be expected to have made higher attainments in science and philosophy."* Euclid's Geometry is the only elementary work on the subject, that has come down to us from very remote times. But we do not know how it can be proved, that it was the only work of the kind which existed at that period; much less do we know, how it can be shewn that it was the best. If we had other ancient elements of Geometry, our views of Euclid's might possibly be considerably different.

Notwithstanding what is here said, we profess the highest veneration for the genius of Euclid, and we are perfectly aware of the extent of our obligations to this great father of geometrical science. But while we would be foremost to grant him the full measure of his merit, we are convinced that the admiration bestowed on him, has sometimes been extravagant and absurd. His Elements have been represented as absolutely perfect,—incapable of improvement. Take the following passage as an example: " A geometer who has stood the test of more than two thousand years; who has resisted the attacks of so many critics, and supported the weight of so many commentators; whose writings kept alive the sacred fire of science when it was almost extinguished over the whole earth, and now shine with undiminished lustre amidst the greatest splendor of scientific discovery; such an author is not to be moved by the praise or the censure of modern criticism; his place in the temple of fame is irrevocably fixed, and nothing remains for us

*Diss, on Math. and Phys. Science, p. 50.

but to hail him as one of the immortals."* As a specimen of rhetoric, this may be very fine, but we are persuaded that its merit ends here. While a multitude of books, which cost their authors much labor and reflection, are daily passing into oblivion, and while the whole volume of nature lies open to our investigation, it is absurd to say that any human work in any age, or in any department of learning, ever has or ever will put a period to the progress of improvement, and arrive at perfection ; a state which vanity on the one hand, and enthusiasm on the other, have dreamed of, but which the nature and destiny of human things forbids us to expect ever to attain. Dr. Johnson flattered himself for a while, he says, that his Dictionary, which he had labored many years and with so much application, would fix the English language, and put a stop to those alterations which time and chance had before been suffered to make in it without opposition, but he afterwards found, that he had indulged expectations which neither reason nor experience could justify.†

But to be more particular: we shall endeavor to shew, that Euclid's Elements contain many imperfections which are remedied in those of Legendre and Lacroix; and that their Elements contain much valuable information which will in vain be sought for in those of Euclid. Our remarks, however, will be very brief, as it would be inconsistent with our limits to enter into an extensive view of the subject.

One particular in which the Elements of M. M. Legèndre and Lacroix are more valuable than those of Euclid, is, that the latter treats the doctrine of ratios and proportion in B. Vth as a separate branch of geometrical enquiry ; while the former make the usual applications of this doctrine to geometrical figures, without considering the demonstrations of its principles as a subject belonging to geometrical investigation. The demonstration of the first principles of the theory of ratios and proportion belongs to arithmetic; and its full developement to elementary algebra. It is because most of us have learned this theory from Euclid, that we are apt to imagine some almost necessary connection between it and geometry. This has been so much the case, that Euclid's authority has been followed by almost all the

*Edinb. Review, Vol. IV p. 257.　　　†Preface

English writers on geometry to the present time, while the French mathematicians have for a long period investigated the principles of ratios and proportion by arithmetical and algebraic methods. Even the Edinburgh Encyclopœdists, who have made Legendre's Elements the basis of their article Geometry, have in this part entirely deserted him, and have introduced the theory of ratios and proportion essentially after the manner of Euclid. At the same time, the author of the article referred to, confesses, that "it might with propriety be inserted, rather as a preliminary theory, than as forming a part of geometry.*,It was necessity, and not choice, that led Euclid to connect the theory of ratios and proportion with geometry. In his time algebra, to which we have before said that this theory in all its extent belongs, was unknown. When, therefore, Euclid wished to apply proportion to geometrical figures, it was necessary for him to investigate its principles by geometry, as the only, means with which he was furnished. Euclid is not in fault for the course which he pursued. He did all that could be done, in the circumstances in which he was placed. But for us, who are in possession of algebraic methods, at once easy and elegant, to pursue the same course, is entirely a different thing. To do so, is not less absurd than it would be to set about determining the obliquity of the ecliptic to the equator by means of the gnomon, when we have the theodolite and repeating circle; or to pursue Aristotle's method of philosophising, when we have so long followed that of the illustrious Bacon, with such splendid success. The theory of proportion as given by Euclid, is extremely tedious, circuitous and difficult to be understood by beginners. The reason of this is, that geometry in its nature is of very little generality, and in its construction is not sufficiently *flexible* to admit of easy application to the subject. But by making use of algebra, which at the same time accommodates itself to the suject with great facility, and is a language vastly more general than geometry, the whole theory of ratios and proportion flows in the most natural and easy manner, from the simplest properties of equations.

Again, the Elements of Euclid contain too many propositions merely subsidiary, and propositions which are of almost no practical utility, and have no connection with the suc-

* Edinb. Encyc. Vol. IX. pp 658, 669.

ceeding and higher parts of mathematics. The seventh proposition, B. I. difficult for beginners, is given only for the sake of the eighth, and is of no further use whatever. The sixteenth is evidently implied in the thirty-second, and therefore is of no use, except as being subsidiary to the demonstration of others. Propositions forty-fourth and forty-fifth, are not of sufficient use to compensate for the space which they occupy. In B. II. the sixth, eighth, tenth and eleventh propositions, with some others relating to the properties of straight lines variously divided and produced, are very unimportant and tend to discourage beginners by the tediousness and difficulty of their demonstrations. They are omitted by Hutton and other late English writers, as well as by Legendre and Lacroix. Many of the propositions in B. III. are, also, of small practical utility. and are not used in subsequent parts of the science. The demonstrations of many of them are indirect, of some of them, artificial; and the construction of some of the figures, is unnatural and difficult to be conceived. To one or another of these objections, the following propositions are liable ; fourth, fifth, sixth, tenth, eleventh, twelfth, thirteenth. The fourth B. contains an incomplete view of that part of the science which it embraces. It ought at least, to comprise an investigation of the approximate ratio of the circumference to the diameter of a circle. Of B. sixth, we have to say only, that M. M. Legendre and Lacroix have demonstrated the same truths in a more simple and equally rigorous manner, that they have divested them of much technical language which rendered them difficult to be understood, and that they have supplied many propositions of extensive use in the subsequent parts.

Another particular, on account of which we must give the preference to the Elements of Legendre and Lacroix, respects the arrangements. It is by a different and more skillful arrangement, that they have contrived to avoid, much more than Euclid has done, subsidiary propositions, indirect demonstrations, and unnatural constructions. Perhaps we may here be expected to furnish the instances, in which their arrangement is superior to that of Euclid. But by way of excusing ourselves from this, we must beg leave to observe, that a question of arrangement is of so extensive a nature, that we could not do justice to our views of the subject, without en-

tering into long discussions and giving numerous details, which must *be imperfectly understood without diagrams and without a minute comparison of the arrangement adopted by the writers of whom we are speaking. This is a particular upon which a sound opinion cannot be formed without personal inspection. We think that the conclusion at which we have arrived, and which we have stated at the beginning of this paragraph will be inevitable in the mind of every one who will be at the pains of a comparison somewhat extensive and elaborate. All that we ask of our readers on the point now under consideration, is, that they will not conclude us to be entirely and necessarily wrong, until they have given the subject an attentive examination. "In his judices desidero, qui tractarunt in sua amplitudine.* We trust that this will not be considered an unreasonable claim upon their candor.

On the geometry of solids or volumes, also, the elements of Legendre and Lacroix are very much more complete, than those of Euclid. On this point, it is impossible to convey an adequate idea to those who are not, to a considerable extent, acquainted with the subject. At the time of Euclid, the geometry of solids appears to have been quite imperfectly investigated. It is true, that before this period, the five regular bodies had been studied in the celebrated school of Plato; and Archimedes had made his brilliant discoveries in relation to the properties of the sphere and cylinder. But the properties of Polyedrons in general, and their measure, have not received, until within a short period, the attention which their importance merited; and M. Legendre in particular, has contributed much to the elucidation of the subject. M. Cauchy, also, has done considerable towards the perfection of this part of elementary geometry.

We are now sufficiently prepared to enter with advantage upon an examination of the work before us. The definitions and axioms are laid down very much in the usual style. The latter are nearly the same in substance with those of Euclid, and differ from them principally in the circumstance, that the idea of equality is not drawn out into particulars. They are but five in number. It is evident he does not attempt a complete enumeration of them, a thing which no geometer has accomplished. A straight line is defined to be, "the shortest way from one point to

* Valckenaer ad Herodotum, p. 585.

another," which is better than any other definition of it, since it is of more easy and extensive application than any other. We think the most natural way of giving a general definition of a point, a line, and a surface, is, to contemplate a *surface*, as one of the limits terminating a solid. which has necessarily three dimensions; a *line* as a limit terminating a surface; and a *point*, as a limit terminating a line. These definitions flow naturally from the definition of a *solid*, in defining which there is no difficulty. When these definitions are obtained in this way, and viewed in this light, they have less the nature of abstractions, than when stated in the common way ; since the real existence of limits of these different kinds, can no more be called in question, than that of the solid from which they are all ultimately derived.

His definition of an angle, is more happily expressed than usual. " When," says he, " two straight lines meet, the quantity whether greater or less, by which they depart from each other as to their position, is called an angle ; the point of meeting or intersection is the vertex of the angle ; the lines (comprising the angle) are its sides." Very various definitions of an angle, have been given by geometers. That of Euclid, is certainly faulty. In fact, if we define an angle by the inclination of its lines, the expression is both obscure and pleonastic. If we say that an angle is the meeting of two lines, the expression directs the attention entirely to the vertex. On the whole, we believe it best to understand by the term angle, the indefinite space comprised between two straight lines which meet each other. The celebrated D'Alembert proposed to limit this space by an arc of a circle described from the vertex as a centre with any convenient radius, but this is introducing a foreign idea into the definition. The space in question, is perfectly distinguished from all other space. The definition suggested above, comprises all the properties usually ascribed to an angle, such as addition, subtraction, coincidence by super-position, &c. But besides this, the additional valuable circumstance included in the idea of an angle, that it comprises the space included within its sides, prevents the awkwardness and tedious circumlocution, with which every one must have felt the geometry of planes and solids to be invested. This is a point, in which we think Lacroix has the advantage over Legendre. Euclid has

sometimes used the word angle in the sense above defined. (B. XI, 20, 21, 22, &c.) and if any one will make the experiment he will find it more natural to attach that idea to it in all cases. If it is óbjected, that the space which we include in the idea of an angle is indefinite in extent, we answer, so are the sides of the angle of indefinite length according to the common definition. If the indefinite space be an objection in the one case, so are the indefinite sides in the other. But the fact is, that the circumstance of the sides and space comprised being indefinite, has no connexion with any of the properties of an angle, nor with any investigations in which angles are employed.

The elements of Legendre are divided in the original into eight books, four of which treat of plane, and four of solid geometry. These books are changed into sections by the translator, and the principles are numbered from beginning to end, for the sake of more convenient reference. The first section contains the properties of straight lines which meet, those of perpendiculars, the theorem upon the sum of the angles of a triangle, the theory of parallel lines, &c. and corresponds nearly with B. I. of Euclid. The doctrine of parallel lines has long been considered as presenting one of the greatest difficulties which belong to elementary geometry. Euclid treated the subject, by introducing as an axiom, what is more justly considered a proposition. Later writers have uniformly experienced the same difficulty, and some of them have fallen on strange means of passing over it. "Bezout est dissimule' le vice du raisonnement," says Lacroix.* Some writers have transposed and shifted the difficulty, until they have obscured it under long and intricate reasonings. Such a course, we deem entirely inconsistent with the duty of an elementary writer, which is to give peculiarly clear and exact ideas upon every subject which he undertakes to elucidate. We do not think that Legendre himself has shed any new light on this subject; though his management of it, exhibits the immense vigour and grasp of his mind. The eleventh edition of his Elements is different, in this respect, from the preceding editions. He says in the preface, "d'après l'avis de plusieurs professeurs distingués, on s'est déterminé à rétablir, dans cette onzieme édition, la théorie des

* Géométrie, p. 23.

paralleles à-peu-près sur la même base qu' Euclide. Il en résultera plus de facilité pour les étudiants, et cette raison a paru prépondérante, d'autant que les objection auxquelles est encore sujette la théorie des parallèles, ne peuvent être entierement résolues que par des considerations analytiques, telles que telles qui sont exposées dans la note deuxieme. If he had adopted more nearly still the course pursued by Euclid, he would have treated the subject more to our satisfaction. In truth, Euclid's method, we think, admits of but little improvement. Legendre has given in the text a mere graphical proof of the principle involving the difficulty; while in note II, he has connected with, and applied to, this graphical proof, a rigorous demonstration without assuming any new axiom. The demonstration, however, is entirely analytical, and the reasoning will not readily be followed by those who have not considerable acquaintance with the theory of equations and functions.

There is no writer with whom we are acquainted, that has treated the doctrine of parallel lines with so much address, and in so unexceptionable a manner as Lacroix. His method is not much different from that of Euclid, and differs from it principally in the circumstance, that it presents the difficulty *reduced to its least dimensions.* The proposition in which this difficulty is so reduced, is this; a straight line, which is perpendicular to another straight line, is met by all those which are oblique to this other; consequently, upon a plane, there are none but straight lines perpendicular to the same straight line, which do not meet; that is, which are parallel to each other. The imperfection of the theory of parallel lines consists in the difficulty of proving this principle. Lacroix, making use of that definition of an angle to which we gave the preference, has given a demonstration of it taken from Bertrand,* which is short, free from obscurity, and perfectly satisfactory. After all that has been said, we have long been of the opinion, that the difficulty respecting parallel lines, is in a great measure, imaginary. The method by which Lacroix has disposed of the difficulty is much to be preferred to that of any other writer, yet we never examined the subject as treated by any author, when, we think, any one

* Developpment nouveau de la partie élémentaire des Mathematiques, Geneve, 1778, 2 vols. 4to.

could, for a moment have doubted, whether the conclusions
were established with compléte certainty by the evidence
adduced. Those who have objected most to the theory of
parallel lines, as usually laid down, belong to that class of
mathematicians who insist upon a rigour of demonstration
not accommodated to the imperfections attending all hu-
man things, and which aiming at an imaginary perfection,
is very unreasonably dissatisfied with evidence which es-
tablishes its results with perfect certainty. The theorems
that we possess respecting the properties of parallel lines,
we regard as undeniably certain; any difficulties, therefore,
relating to the manner in which they are demonstrated, we
cannot but consider essentially imaginary.

The second section, comprises the elementary proper-
ties of the circle, together with those of chords, of tangents
and the measure of angles by arcs of a circle. This sec-
tion contains all the principles which are of importance in
B. III. of Euclid, and some others both of great use in ordin-
ary practice, and in the succeeding parts of the science.
These two sections are followed by the resolution of a
number of problems relating to the construction of figures.

The third section contains the measure of surfaces, their
comparison, the properties of a right angled triangle, those
of equiangular triangles, of similar figures, &c. In this sec-
tion, he has blended the properties of lines with those of
surfaces, but in this arrangement, he has followed the ex-
ample of Euclid, and the propositions in this way, admit of
being so well connected, that we doubt whether a better
arrangement can be obtained. In giving the definitions
which relate to this section, he says, "I shall call those fig-
ures *equivalent*, whose surfaces are equal. Two figures
may be equivalent, however dissimilar; thus a circle may
be equivalent to a square, a triangle to a rectangle, &c.
The denomination of *equal* figures will be restricted to
those which being applied, the one to the other, coincide
entirely; thus two circles having the same radius are equal,
and two triangles having the three sides of the one equal to
the three sides of the other, each to each, are also equal."
In the use of these definitions, he is followed by Lacroix.
We are persuaded that a distinction between equality by
equivalence, and equality by *coincidence*, is expedient as a
matter of convenience, and as a means of enlarging our

power of expressing the properties and relations of figures. According to Legendre's plan, the meaning of the term *equal*, is unnatural. We should have preferred to apply the term *coincident* to those figures which are proved to be *equal* by superposition, and to have designated by the term *equivalent*, all the remaining part of the common signification of the word *equal*. Coincident and equivalent figures are both equal, but these terms designate different kinds of equality, and, we think, the introduction of them would contribute to the perfection of the language of geometry. Equality by coincidence alone, is comprised in the sixth of his axioms, in which he says, "two magnitudes, whether they be lines, surfaces or solids, are equal when being applied the one to the other, they coincide with each other entirely, that is, when they exactly fill the same space." This section is concluded, by demonstrating, that the diagonal and side of a square, are incommensurable quantities, and by an investigation of the approximate ratio of the one to the other. It is remarkable what could have led Plato,* to attach such an importance to this principle, as to regard as unworthy the name of man, him who was ignorant of it. It is demonstrated in prop. CXVII. B. X. of Euclid, and in several modern treatises of geometry. It is of no great importance, either when veiwed by itself, or in connexion with other truths.

The fourth section treats of regular polygons and the measure of the circle. It is well known, that the problem of finding a square equal in surface to a circle whose radius is given, or as it is usually termed, the problem of the quadrature of the circle, is much celebrated in the history of geometry, and has very much occupied the attention of mathematicians. Now we can easily demonstrate, that a circle is equivalent to a rectangle contained by the circumference and half the radius, and by finding a mean proportional between the circumference and half the radius, we have the side of the square. The problem of the quadrature of the circle, is, therefore, reduced to finding the circumference when the radius is given, and to effect this object, it would be sufficient to know the ratio of the circumference to the diameter, or to the radius. Mathematicians have not been able to obtain this ratio but by approxima-

* Laws, B. VII.

tion, though it has exhausted all the resources of human skill and invention, and it strongly reminds us, that imperfection is attached even to the most certain and most perfect of the sciences. The approximation of this ratio, has, however, been carried so far, that if it were exactly known, it would have no practical advantage over the approximate ratio. It would now be considered absurd, to spend much time in attempting to square the circle.

Archimedes obtained the ratio of $\frac{22}{7}$, which is sufficiently near for common purposes, and has been much used. Metius gave a much more exact value of this ratio in the expression $\frac{355}{113}$. Other mathematicians have found the value of the circumference, when the diameter is unity, 3,141592653 &c. Euler gives an approximation of this ratio which extends to 127 decimal places,[*] and this number has been extended even to 140 places. The roots of imperfect powers are not known with greater exactness, than this ratio.

Legendre has not given the ratio, that has lately been discovered by the English in their researches into the learning of the Eastern Indians, but we think it ought to have a place, both on account of its exactness and its remarkable origin. This ratio, which is $\frac{3927}{1250}$, is contained in a work of the Brachmans entitled *Ayeen Akbery*, and is not only much more approximate, but also is regarded by them as more ancient than that of Archimedes. It is, doubtless, to be regarded as a part of the immense wreck of ancient learning which is scattered all over India. In that interesting country, " we every where find methods of calculation without the principles on which they are founded ; rules blindly followed without being understood; phenomena without their explanation; and elements carefully determined, while others more important, and equally obvious, are altogether unknown."[†] The Indian ratio corresponds to 3.1416, and must have depended on a polygon of 768 sides, whereas that of Archimedes depends upon one of 96 sides.

Two lemmas are given as the basis of the investigation of the measure of the circle, which is otherwise conducted after the manner of Archimedes. Two methods of approximation are there given for its quadrature. An appendix

[*] Introduction á l'analyse infinitésimale, Tome I. p. 92.

[†] Edinb. Encyc. Vol. II. p. 550.

is attached to this section, in which a few of the elementa-
ry properties of isoperimetrical figures are demonstrated.
Among the rest, it is shewn, that among polygons of the
same perimeter and of the same number of sides, that is a
maximum which has its sides equal ; that of all triangles
formed with two given sides making any angle at pleasure
with each other, the *maximum* is that in which the two
given sides make a right angle; that among polygons of the
same perimeter and the same number of sides, the regular
polygon is a *maximum* ; and that the circle is greater than
any polygon of the same perimeter. This is a very beautiful,
interesting and useful addition to elementary geometry.

Until a short time since, it was supposed, that no regular
polygons, except those treated of B. IV. of Euclid, and
the several series depending on them, could be inscribed
in, or circumscribed about, a circle by geometrical means.
The difficulty, however, which had arrested the progress
of this part of geometry ever since the time of Euclid, has
at length been surmounted by M. Gauss, a Professor at the
university of Gottingen, and one of the greatest mathema-
ticians of the present time. The work containing the ori-
ginal demonstration is entitled, "*Disquisitiones Arithmeticæ,
Lipsiæ,* 1801," and a French translation of it was published
by M. Delisle at Paris in 1807. In this demonstration, it is
shown. that the circumference of a circle may be divided
into a number of equal parts designated by the formula
$2^n + 1$, when this is a prime number. Some of the numbers
resulting from this formula are 17, 257, 65537, &c. The
circumstance that M. Gauss' invention is limited to the
cases where the formula $2^n + 1$ designates a prime number,
greatly diminishes its value. No demonstration of this
principle has, we believe, found its way into any elementa-
ry treatise of geometry, and we are not sure, that it is
capable of a strictly geometrical elementary demonstra-
tion.

The first section of part II. contains the properties of
planes and solid angles. This part is intimately connect-
ed with the demonstrations of the properties of solids, and
figures in which different planes are considered. A com-
plete underestanding of it is indispensable, also, in descrip-
tive geometry, where the principal difficulty consists in

conceiving clearly the situation of the various planes used, and their projections. The subject is treated in a clear and rigorous style.

The second section of part II. treats of polyedrons and of their measure. ,We have before suggested, that' ,we feel ourselves unable to convey an adequate view of the merit of this part of Legendre's work. Those who are only acquainted with the geometry of solids or volumes as given by the older writers, we are sure, will be surprised and delighted at the luminous and novel manner, in which this part of elementary geometry is exhibited. On volumes he has made a distinction between two different kinds of equality analogous to that which we before noticed with respect to the comparison of surfaces. "Two solids, two solid angles, two spherical triangles, or two spherical polygons, may be equal in all their constituent parts without coinciding, when applied. It does not appear that this observation has been made in elementary books ; and for want of having regard to it, certain demonstrations founded upon the coincidence of figures, are not exact. Such are the demonstrations, by which several authors pretend to prove the equality of spherical triangles, in the same cases and in the same manner, as they do that of plane triangles. We are furnished with a striking example of this by Robert Simson, who, in attacking the demonstration of Euclid, B. XI. prop. 28, fell himself into the error of founding his demonstration upon a coincidence which does not exist. We have thought it proper, therefore, to give a particular name to this kind of equality, which does not admit of coincidence ; we have called it *equality by symmetry ;* and the figures which are thus related, we call *symmetrical* figures."* We think, as in the case of surfaces, that the defects in the usual language would have been better supplied by calling those figures which would coincide, coincident figures, that is, figures equal by coincidence; and those figures which will not coincide, symmetrical figures, that is, figures equal by symmetry.

In the propositions relating to polyedrons, as well as in those relating to polygons and solid angles, those having re-entering angles are excluded as not belonging to the ele-

* Trans. Note 1. p. 202

ments of the science. The author has very properly con-
fined himself to the consideration of convex lines and surfa-
ces, which are such, that they cannot be met by a straight
line in more than two points. He has completely reformed
the ordinary definition of similar solid polyedrons, though
he has followed that of similar rectilineal figures containing,
as it does, three superfluous conditions.

In the latter part of the note just referred to, Legendre
says, " the angle formed by the meeting of two planes, and
the solid angle formed by the meeting of several planes in
the same point, are distinct kinds of magnitudes to which it
would be well perhaps to give particular names. With-
out this, it is difficult to avoid obscurity and circumlocu-
tions in speaking of the arrangement of planes which com-
pose the surface of a polyedron; and as the theory of sol-
ids has been little cultivated hitherto, there is less incon-
venience in introducing new expressions, where they are
required by the nature of the subject." According to the
suggestion here made, M. Lacroix has introduced into the
geometry of planes and volumes, a very convenient system
of new expressions, and some slight alterations in the nota-
tion, by which much circumlocution is avoided, and our
power of expression much enlarged. The translator has
adopted one of these changes in the notation, which con-
sists merely in placing the letter designating the vertex of
the polyedron first, with a hyphen between it, and the oth-
er letters. This very trifling change, contributes consider-
ably to the facility of following the demonstrations. La-
croix's improvements in general, could not be conveniently
adopted by the translator.

The third section of part II. relates to the sphere and
spherical triangles. This is an important addition to the el-
ements of geometry, as it is not of difficult demonstration,
and is of extensive utility in its applications to geography,
&c. as well as in the succeeding parts of mathematics. It
is designed in particular to be introductory to spherical
trigonometry.

The fourth section of this part, is employed in investiga-
ting the properties and relations of the sphere, cone, and
cylinder. The general method of demonstration in this
section, is that of Maurolycus, a Sicilian geometer, who
flourished in the middle of the 16th century. This meth-

od is indicated in Euclid B. XII. prop. 16th. It consists in assuming two concentric circumferences, and circumscribing about the smaller a regular polygon which does not touch the greater; or inscribing a regular polygon in the greater, which does not touch the smaller. On these polygons, as bases, in case circumstances require it, regular polyedrons are supposed to be constructed, and it is demonstrated, that the assigned measure of the solid or surface in question, cannot be that of one greater or less, without falling into the absurdity of concluding that a figure contained by another is the greater of the two. These demonstrations are long, and on account of the frequent repetition of the same constructions, become somewhat tedious. But they have the merit of being plain, and satisfactory, although indirect; and we think, on the whole, that the method pursued by Legendre is the best. Lacroix's manner as it respects these demonstrations, is much more concise, but it is too abstract, and difficult to be seized; and Cavalleri's method of indivisibles is not sufficiently rigorous to be used in elementary geometry.

After what has been said, it is scarcely necessary to observe, that American mathematical science, is under great obligations to the translator, for giving Legendre's elements in so handsome an English dress. The only fault we have to charge him with, is, that he did not furnish us with the entire work, as it came from the hands of the author. Considerable of that part which in the original is printed in fine type, and almost all the notes, are omitted in the translation. These omissions we very much regret. By preserving the original difference in type, the work would have been equally convenient for academical instruction, and the additional expense of printing the parts omitted, would have been quite trifling. As it now is, we are persuaded, that all lovers of mathematical learning, after having perused the translation, will feel induced to go to the expense of sending out for the original, for the sake of those parts, which the translation does not contain. The notes are a great curiosity, and would be likely to inspire a taste for the higher mathematics.

The translation is executed faithfully, and it is accurately printed. A list of errata, however, to some extent might be made out, though none is given. In the demon-

stration of No. 283, the phrase *at least* is used, where there should be *at most*, and vice versâ. We would suggest whether the reasoning of No. 283 is satisfactory; and whether it would not be better to deduce the lemma immediately, from the definition of a straight line. Such a line being the shortest distance between two points, any line connecting these two points and varying from the straight line, is greater than it ; and the more any line always remaining convex, varies from the straight line between its extreme points, the greater is such line. The Edinburgh Encyclopædists have laid down an axiom nearly equivalent to the lemma under discussion.

PHYSICS, CHEMISTRY, MECHANICS, AND THE ARTS.

Art. XI.—*Remarks concerning the composition and properties of the Greek fire;* by JAMES CUTBUSH, A. S. U. S. A. *and Acting Professor of Chemistry and Mineralogy in the U. S. Military Academy.*

HAVING been engaged for some time in collecting facts, both ancient and modern, in relation to pyrotechny, with the view of forming a complete system on that subject; I necessarily examined all the writings extant on the Greek fire, and other incendiary preparations. Although nothing fully satisfactory, as to the *real* composition of the *original* Greek fire, can be stated, yet we are assured from various authorities, that the principal ingredient was naptha, which with other substances, (camphor appears to have been one,) in consequence of its great inflammability produced the extraordinary effects recorded in history.

The Greek fire was invented by Callinicus of Heliopolis, a town in Syria, who used it with so much skill and effect during a naval engagement, that he destroyed a whole fleet of the enemy, in which were embarked 30,000 men.*

* The *Noveau Dictionaire Historique* par L. M. Chaudon et F. A. Delandine, article *Callinicus*, speaks of him thus :—" Callinique, d' Héliopolis en Syria, auteur de la découverte du *Feu grecque*. L' empereur *Constantin*

It appears that in the reign of Louis XV, a chemist of Grenoble ; *Dupré de Mayen*, discovered a composition similar in effect to the Greek fire of Callinicus, which was exhibited at Brest, and proved successful, but the preparation was kept secret. The original Greek fire was used in 1291, and also in 1679, besides the periods hereinafter mentioned. Writers have defined it to be a sort of artificial fire, which insinuates itself beneath the surface of the sea, and which burns with increased violence when it mixes with water. They also say, that its *directions* are contrary to the course of natural fire, for the flames spread downward, to the right or left, agreeably to the movement which is given. That it was a liquid composition, we may infer from the modes of using it, which were several. It was employed chiefly on board of ships, and thrown on the vessels of the enemy by large engines. It was sometimes kindled in particular vessels, which might be called fire ships, and which were introduced among a hostile fleet; sometimes it was put into jars, and other vessels, and thrown at the enemy by means of projectile machines, and sometimes it was *squirted* by soldiers from hand engines, or, as it appears, blown through pipes. This fire was also discharged from the *fore part of ships* by a machine constructed of copper and iron, the extremity of which is said to have resembled the *open mouth* and *jaws* of a lion, or other animal. They were painted, and even gilded, and were capable of projecting the liquid fire to a great distance.

In the *History of Inventions and Discoveries* by J. Beckman, public professor of Economics in the University of Gottingen, I find the professor has examined the subject of Greek fire. He observes expressly, (Vol. IV. p. 85.) that the *machines* which the ancients employed to throw this fire, were *spouting engines*, and remarks, that " John Cameniata, speaking of his native city, Thessalonica, which was taken by the Saracens in the year 904, says, that the enemy threw fire into the wooden works of the besieged, which was blown into them by means of tubes, and thrown from other

Porphyrogenitus s'en servit pour bruler la flotte des Sarrasins. L'eau qui éteint le feu ordinaire, n'ayant aucun empire sur ce nouveau fléau du genre humain. Cet ingrédient qu'on appeloit aussi *l'huile incendiaire, le feu marin, le feu liquide,* dévoroit, dit-on, le fer and les pierres, suivoit toutes les directions qu'on vouloit lui donner, et ne pouvoit être éteint qu'avec du vinaigre, du sable ou de l'urine," &c. *Callinique* vivait vers l'an 670 de Jésus-Christ."

vessels. This passage, which I do not find quoted in any of the works that treat of the Greek fire, proves that the Greeks, in the beginning of the tenth century, were no longer the only people acquainted with the art of preparing this fire, *the precursor of our gunpowder.* The emperor Leo, who about the same period wrote his *Art of War,* recommends such engines, with a metal covering, to be constructed in the fore parts of ships, and he twice afterwards mentions engines for throwing out Greek fire. In the east, one may easily have conceived the idea of loading some kind of pump with the Greek fire; as the use of a forcing pump for extinguishing fires was long known there before the invention of Callinicus."

Writers differ considerably, as to the composition of the Greek fire, properly so called, as there were many preparations some hundred years after the discovery, which went under that name. It is certain, however, that the Greeks had a knowledge of a very highly combustible preparation, which water could not extinguish, and which from its nature, (reasoning *a priori,*) must have had the property of decomposing water itself; thereby furnishing a *supporter* of combustion, or possessing so much oxygen as to support the combustion of the inflammable substances even in contact with water. Either one or other of these conclusions appears reasonable, if we admit that the composition actually burnt *under* water. Some writers are of opinion, that nitrate of potash was one of the ingredients; but of this we have no positive proof. Mr. Parkes (*Chem. Catech.* p. 465) speaking of some of the uses of saltpetre, remarks, that "it was used by the ancients in that destructive composition of antiquity, the Greek fire. Sulphur, resin, camphor, and other combustibles, were melted with it, and in this melted mass woollen cords were dipped, which were afterwards rolled up for use. These balls being set on fire were thrown into the tents, &c. of the enemy; and as the combustibles were furnished with a constant supply of *oxygen* from the nitre, nothing could extinguish them." He also observes : "For many centuries the method of making this dreadful article of destruction was lost; but it has just been discovered by the librarian of the elector of Bavaria, who has found a very old latin manuscript which contains directions for preparing it." Mr. Parkes is certainly in error when he says that the origin-

al Greek fire, if to such he alludes, was altogether used in balls; he may probably have inferred so from the manner in which our modern war incendiaries are prepared and used, such as the light-ball, various carcasses, &c. some of which are thrown by hand, and some from mortars and howitzes. The compositions used in modern pyrotechny for the purpose of firing buildings and the like, are remarkably inflammable, and from the manner in which they are prepared are almost inextinguishable; all which appear to have originated from the heretofore celebrated *fire rain* of Liemanwick. Even the so called *incendiary rocket of Congreve*, which is nothing more than an ordinary rocket having a sheet iron case, is *loaded* in the head with a similar composition; in fact that, and other descriptions of the Congreve rocket, I can clearly shew was not an original invention of Colonel Congreve. On the subject of incendiary and other military fire works, the French have certainly laid the foundation, for the very preparations now used by the British, for the formulæ for such preparations may be traced to the French service.

It appears, however, that the Greek fire could be extinguished only by urine, sand, &c. The following extract from James's *Military Dictionary* p. 329 is to this point: "It is composed' or made up of naptha, sulphur, bitumen, gum, and pitch; *and it can be extinguished only by vinegar mixed with urine and sand, or undressed leather and green hides.*

Respecting a similar composition to that of the Greek fire, or one which seems to partake of the same properties, I find the author of a French work, entitled *Oeuvre Militaire*, has given the following preparation, which it is said cannot be extinguished by water : Pitch, rosin, tallow, camphor, turpentine, salt-petre, liquid varnish, oil of sulphur (not sulphuric acid) linseed oil, rock oil, flax, and charcoal finely pulverised. After melting the solid substances, as pitch, &c. with the oils and varnish, the charcoal and flax are added, and the composition made into balls, previously mixing with it before it grows cold, some quicklime in powder. This preparation we are told, is susceptible of the most subtile and destructive fire. It is hardly necessary to remark, that a composition of this kind must be highly inflammable, and, with the addition of nitre, burn with great rapidity.

The *fire stone* of the French, an incendiary preparation, is
in some respects analagous; it is used either in bombs along
with powder, or made into carcasses in the usual manner. The
Moors were in possession of the secret for preparing the
Greek fire in 1432, according to the testimony of Brocquire.
Bertrandon de la Brocquire was in Palestine in 1432 as
councellor to the duke of Burgundy. He was present at
Barrat during one of the Moorish celebrations: "It began,"
he remarks, "in the evening at sunset. Numerous com pa-
nies scattered here and there were singing, and uttering loud
cries. While this was passing, the *cannon* of the castle
were fired, and the people of the town launched into the air,
'*bein haut et bein loin, une maniere de feu plus gros fallot
que je veisse oncques allume.*' They told me they made use
of such at sea, to set fire to the sails of an enemy's vessel. It
seems to me that it is a thing easy to be made, and at a little
expense, it may be equally well employed to burn a camp
or a thatched village, or in an engagement with cavalry to
frighten their horses. Curious to know its composition, I
sent the servant of my host to the person who made this
fire, and requested him to teach me his method. He re-
turned for answer, that he dared not, for that he should run
great danger were it known; but there is nothing a man will
not do for money, I offered him a ducat, which quieted his
fears, and he taught me all he knew, and even gave me the
moulds in wood, with the other ingredients, which I have
brought to France."

Although La Brocquire may have brought the secret to
Europe, yet it does not appear to have been used, nor has it
been promulgated. We may infer here, that as moulds were
used, it is very probable that the solid ingredients were first
melted together, and cast in moulds previously to their solu-
tion in some inflammable oil, which in all probability was
naptha; or that the composition was used in a solid state, as
in some of the modern incendiary fire works. But the for-
mer inference is more probable.

Whatever idea we may entertain of the effect of the Greek
fire, or of compositions having a similar character, we may
justly conclude, that the present gun powder possesses ma-
ny superior advantages; and in fact some authors are of
opinion, among whom we may mention the celebrated
French Pyrotechenist, Ruggeri, that the accounts we have

of it, such as its fire *descending*, &c. are incompatible with the nature of things, and consequently exaggerated.

We have some remarks of professor Beckman in relation to salt petre, which have also a bearing on the subject of the Greek fire. Speaking of salt-petre, Vol. II, p. 462 he says: Though it can be certainly proved, that the *nitrum* of the ancients was alkaline salt, it is difficult to determine the time when our salt-petre was discovered or made known. As many have conjectured, that it was a component part of the Greek fire, invented about 678, which, in all probability, gave rise to the invention of gun powder. I examined the prescriptions for the preparation of it. The oldest, and perhaps the most certain, is that given by the princess Anna Commena; in which I find, only resin, sulphur and oil, *but not salt-petre.* K'lingerstein (*Dissertat. de igne Græca,*) therefore, judges very properly, that all recipes in which salt-petre occurs are either forged or of modern invention. Of this kind are those which Scaliger, at least according to his own account, found in Arabic works, in which mention is made of *oleum de nitro* and *sal petræ.* But it does not occur in that prescription of Marcus Græcus, and copied by Albertus Magnus, who died in 1280." Beckman infers, that the first certain mention of salt petre is in the oldest account of the preparation of gun powder, which became known in the 13th century, about the same time that the Greek fire, of which there were many kinds, began to be lost. The work of Albertus Magnus, and the writings of Roger Bacon, who died in 1278, contain the oldest information on gunpowder. But it is somewhat remarkable, that the manuscript preserved in the electoral library at Munich, announced for publication by Mr. Von Arretin, contained, it is said, the true recipe for making the Greek fire, and the oldest for gun powder. The same writing, it also appears, was printed from two manuscripts in the library at Paris; for Professor Beckman observes, that a copy was transmitted to the library at Gottingen by M. Laporte Dutheil, *conservateur des manuscrits de la bibliotheque.** He also adds, that it contains many recipes, with a few variations, as in Alber-

* Liber ignium ad comburendas hostes, auctore Marco Græco; on traite des feux propres à détruire les ennemis, composé par Marcus le Grec. Publié d'apres deux manuscrits de la bibliothoque nationale. Paris 1804, three sheets in quarto.

tus Magnus; that Bacon employed this writing, which was
mentioned by Jebb in the preface to his edition, from a copy
preserved in the library of Dr. Mead; that of *this* Marcus
Græcus nothing at present is known, except that according
to some he lived in the ninth, and according to others in
the thirteenth century; and that Cardan in giving directions
for making a fire which can be *kindled by water,* mentions
Marcus Gracchus, but not Graœcus. It may be sufficient
here to remark, that professor Beckman, after examining
attentively all authors on the subject, is inclined to accede to
the opinion, that gun powder was invented in India, and
brought by the Saracens from Africa to the Europeans. A
knowledge of gun powder may have been brought into Eu-
rope at the time of the crusades. It was employed in 690
at the battle near Mecca. In 1798 M. Langles read a pa-
per in the French National Institute, in which he endeavour-
ed to prove that the Arabians obtained a knowledge of gun
powder from the Indians, who had been acquainted with it
in the earliest periods. The use of it was forbidden in their
sacred books.

Whatever notice has been taken of the Greek fire, in the
manuscript alluded to, whether it really gave rise to our
present gun-power, or whether a knowledge of gun-powder
came indirectly from India to Europe; it is very probable
that it *may* have lead to enquiries, which finally eventuated
in the knowledge and use of gun-powder. Besides the
opinions already given respecting the composition of the
Greek fire, we might enumerate many other authorities.
Porta, for instance, in his *Magie Naturale,* remarks that it
was composed of the charcoal of willow, salt, burnt brandy,
sulphur, pitch, frankincense, flax and camphor, and that
camphor alone has the effect of burning in water. He re-
marks also, that when Constantinople was attacked, the em-
peror Leo burnt the vessels or boats, to the number of one
thousand eight hundred, by means of the Greek fire. The
Journal des Savans, 1676, p. 148, speaks of the origin and
use of the same fire. In 1249, at the siege of Damietta,
the French experienced the destructive effects of it. The
Journal des Savans for 1666, mentions a machine which,
when applied against a vessel, communicates fire to it imme-
diately, without injuring the person who uses it. In the French
Gazettes for 1797, M. Chevalier announced that he had

invented an inextinguishable incendiary fuse, which is thrown by fire arms, and calculated to set fire to the rigging of ships. It appears also, that Dr. Dupre, whose name we have mentioned, published in the French Journals that he had invented a composition, which had the same properties and effects as the ancient Greek fire, and possessed the means of extinguishing it. , An experiment was made at Versailles, to the satisfaction of all, and the secret was purchased by Louis XV. The Rev. J. P. Caste in 1794 laid before the French National Convention, a new invention for the purpose of war, consisting of a *carcass-composition*, which nothing could extinguish, and resembled in that respect the Greek fire.

At the commencement of the late war with Great Britain, several persons directed their attention to the discovery of some new incendiary preparation, which would possess the properties of Greek fire; but none of them proved successful. Of one in particular I was an eye-witness. A preparation of the kind was shown to the corporation of Philadelphia, of which I was then a member, and some experiments made with it. It was nothing more than spirits of turpentine, holding in solution camphor, and mixed I think with turpentine varnish; it was, when used, to be put into bottles, and by means of a fuse similar to that of a grenade, set on fire—the bottle being thrown by the hand into an enemy's ship or among sails or rigging.

Ruggeri, a modern French author, in speaking of incendiary fireworks, mentions also the Greek fire. He observes that it was composed of naptha, sulphur, bitumen, camphor and petroleum, all mixed together; that it was invented by Callinicus, and employed against the Saracens as an incendiary; that Pliny in his time mentioned a combustible substance, which was thrown upon armed men, and burnt and destroyed them in the midst of the battle; that it was employed successfully by the successors of Constantine, and that its composition was kept a state secret; that the Turks used it, or a composition of a similar nature, at the seige of Damietta in 1249, forty-five years after the death of Roger Bacon; and that when the composition and effects of gunpowder became known, it was no longer in use, and the secret of the *original* preparation seemed to have been lost.

Several historical writers have noticed the Greek fire, among whom Gibbon, and our learned and much to be lamented RAMSAY, may be cited. Gibbon, in his *History of the Decline and Fall of the Roman Empire*, Vol. vii. p. 282, remarks, that the deliverance of Constantinople may be chiefly ascribed to the Greek fire. It appears that Callinicus, the inventor, deserted from the service of the Caliph to that of the Emperor; and Gibbon is of opinion that this discovery or improvement of the military art, was fortunately reserved for the distressful period, when the degenerate Romans of the east were incapable of contending with the warlike enthusiasm and youthful vigor of the Saracens. He is also of opinion that little or no credit can be given to the Byzantine accounts, as to the composition of the fire, although from their obscure and fallacious hints, it should seem that the principal ingredient was naptha, a *liquid bitumen which springs from the earth*.* This was mixed with sulphur, and with the pitch extracted from the evergreen firs, according to the testimony of Anna Commena, (Alexid. I. xiii. p. 383,) and Leo, in the nineteenth chapter of his *Tactics*, speaks of the new invention. Gibbon describes the effect of the Greek fire nearly similar to that we have already stated; viz. that the fire was strong and obstinate, and was *quickened* by water—that sand, urine and vinegar were the only substances that could damp its fury; that it was used for the annoyance of the enemy both by sea and land, in battles or in seiges, and was either *poured* from the ramparts in large boilers, or launched into red hot balls of stone or iron, or darted in arrows and javelins, twisted round with flax and tow, which had deeply imbibed the *inflammable oil;* that at other times it was deposited in fire-ships, or blown through long tubes of copper, fixed on a prow of a galley; that its composition was kept secret at Constantinople, pretending that the knowledge of it came from an angel to the first and

*In a note to Gibbon, p. 283, we read—"The naptha, the *oleum incendiarum* of the history of Jerusalem (*Gest Dei per Francos*, p. 1167.) the oriental fountain of James de Vitry, is introduced on slight evidence, and strong probability. The name by which Cinnamus calls the Greek fire, corresponds with the locality where naptha was found, between the Tigris and the Caspian sea. Pliny (*Hist. Natur.* ii. 109.) says it was subservient to the revenge of Medea, and according to the etymology, naptha was signified; a fact which leaves no doubt that naptha was the *principal* ingredient of the Greek fire.

greatest of the Constantines, with a sacred injunction not to divulge it under any pretext, &c. He also remarks, that after it was kept secret above four hundred years, and to the end of the 11th century, it was stolen by the Mahometans, who employed it against the crusaders. A knight it appears, who despised the swords and lances of the Saracens, relates, with heartfelt sincerity his own fears, at the sight and sound of the mischievous engine that discharged a torrent of the Greek fire, the *feu gregeois*, as it is styled by the more early of the French writers. "It came flying through the air," says Gibbon, quoting Joinville, (*Historie de St. Louis,*) "like a winged long-tailed dragon, about the thickness of a hogshead, with a report of thunder, and the velocity of lightning; and the darkness of the night was dispelled by this deadly illumination. The use of the Greek, or as it might now be called the Saracen fire, was continued to the middle of the fourteenth century, when the scientific or casual compound of nitre, sulphur and charcoal, effected a new revolution in the art of war, and the history of mankind."

Dr. Ramsey, our learned historian, (*Universal History,* vol. ii. p. 150,) gives a similar account; and Morse, in his *Universal Geography,* p. 558, after speaking of the Naptha springs of Persia, remarks that, when it is scattered on the sea and inflamed, the flame is often wafted to a great distance.

Thevenot (*Travels in the Levant*) tells us, that in the 52d year of the Hegira, (A. D. 672) Constantinople was beseiged in the reign of Constantine Prognatus, by Yesid, the son of Moauir, the first-caliph of the family of the Ommiades, when the Greek emperor found himself so pressed, that he was almost reduced to despair. But the famous engineer Callinicus invented a kind of *wild fire*, which would burn under water, and by this means destroyed the whole fleet. The fact that the incendiary preparation of Callinicus was extremely destructive, and spread dismay among the enemy, is therefore warranted by the historical accounts we have mentioned.

Pinkerton in his *Petralogy,* vol. ii. p. 148, speaking of the Naptha of Baku, which exists on the western side of the Caspian sea, concludes that this substance was brought to Constantinople, where it formed the chief ingredient of the

noted composition called the Grecian fire; which, burning
with increased intensity under water, became a most formi-
dable instrument against an inimical fleet." The Naptha
springs were visited by Hanway, who has given a detailed
account of them : also by Kempfer, and Gmelin. Hanway
observes, that the quantity is so great, that the Persians load
it in bulk in their wretched vessels, so that sometimes the
sea is covered with it for leagues together ; and that when the
weather is thick and hazy, the springs boil up the higher,
and the naptha often takes fire on the surface of the earth,
and runs in a flame into the sea in great quantities, to a dis-
tance almost incredible.

Besides the former use of naptha for the preparation of
the Greek fire, the ancients, especially the Magi performed
various tricks, or deceptions with it, principally on account
of its extreme inflammability. Some of these deceptions
are recorded in history. According to Plutarch, the great
inflammability of naptha was exhibited to Alexander the
Great at Ecbatana, with which he was astonished and de-
lighted, and the same author, as well as Pliny and Galen in
particular, asserts that it was with naptha, that Medea de-
stroyed Creusa, the daughter of Creon. She sent to this
princess a dress, previously soaked in it, which burst into
flames as she approached the fire of the altar. It is sup-
posed to have been naptha also, in which the dress of Her-
cules was dipped, and not the blood of Nessus, that took fire
in the same manner. When offerings caught fire impercep-
tibly, it is conjectured that this oil must have been employ-
ed.

From the facts thus given we may conclude, 1st. That
the Greek fire, so called, was composed for the principal
part of naptha ; 2d. That the naptha, as it is a powerful sol-
vent of rezins, must have been combined either with liquid
turpentine, or rozin, and probably with camphor, as inflamed
camphor resists considerably the action of water ; 3d. That
the composition of the original Greek fire was fluid, as it
was thrown out by forcing pumps, or through pipes which
could not have been the case had it been solid ; 4th. That
although generally used in a fluid state, it was sometimes
employed like the modern carcass by soaking in it tow, &c.
and then used as an incendiary ; 5th. That it does not ap-
pear upon any testimony extant that nitre, or salt petre en-

tered into its composition; 6th. That as it regards sulphur, that substance might have been employed, as oils will readily unite with it, a fact well known in the proportion of the balsam of sulphur of the old pharmacopeias; and 7th, and lastly, that when gun powder became known, it superceded the Greek fire, the true preparation of which was lost. It is evident, nevertheless, that as we possess a more perfect knowledge of the properties and effects of bodies than the ancients, a composition might be made, or the present incendiary fire works improved, so that water itself would not extinguish flame, but on the contrary facilitate combustion. For this purpose I submit the following hasty interogatories:

What would be the effect of nitrate of potash, camphor, and naptha, if mixed and inflamed, and then brought into contact with water?

What would be the effect if a given quantity of gun powder were added, the naptha being previously thickened by the addition of turpentine, or in its place with tar, or some rosin dissolved in the naptha?

If in lieu of nitre, chlorate or hyperoxymuriate of potash be used, would not the effect be more powerful, and detonation probably follow?

Suppose the ingredients of which gun powder is composed, viz. nitrate of potash, charcoal, and sulphur be added separately, in due proportions, to a compound of naptha and camphor, with or without the addition of spirits of turpentine; would not such a mixture resist very powerfully the action of water?

If to the above be added quicklime in powder, would not the quicklime when brought in contact with water increase the combustion by becoming *slacked*, and consequently evolve caloric, provided that no combination was previously formed with the oil and lime, forming a soap of lime?

What would be the effect, if with the substances before mentioned (the composition being sufficiently thick,) the filings of iron, or in preference zinc were added, especially if the matter in the state of combustion be brought in contact with water?

If phosphuret of lime be used, would it not add to the combustion when water is thrown on, or the inflamed substance put into water, by decomposing that fluid; thus producing phosphureted hydrogen gas?

Not having a sufficient quantity of naptha, prevents our making such experiments, with that substance. As a substitute, we would recommend highly rectified oil of turpentine, which might be employed, in many respects like naptha, and be susceptible of great inflammability. We know it to have been used in incendiary fire works, especially in the experiment we mentioned to have been made in Philadelphia during the late war. Nearly of the same character is the *fire-flask* or *fire-bottle*, which is nothing more than a bottle charged with grain-powder mixed with a composition called fire-stone. The bottle is covered with a cloth and sewed, and then coated with pitch. The mouth is secured with parchment, and when used, a match is inserted, and inflamed. It is then thrown by the hand.

Having mentioned an incendiary preparation invented, or recommended by *Casimer Siemienowich*, which appears to have been predicated on the effects of a Greek fire, and which is mentioned by him in his work, entitled *Artis Magnæ Artilleriæ;* it may not be improper to add, *Siemienowich's Fire-rain,* as the preparation is called, is calculated for firing the houses of a besieged place or city, which are covered with shingles, laths, stubble or reeds. It was named *fire-rain* from its resemblance to a shower of rain. Several formulæ are given for this preparation; but the original appears to have been the following: Take 24 parts of sulphur, and melt it in a copper or iron pot, over live coals without flame, and then throw in 16 parts of nitrate of potash, and mix it with an iron spatula. Remove the vessel from the fire, and when the composition has become rather cold, stir into it 8 parts of grained gun powder. Pour the mixture on a slab, and allow it to cool. Before using it, it is broken into pieces of the size of a walnut, and put into shells along with quick match and gun powder. The shells are discharged from mortars in the usual manner, which burst, and thus the composition is dispersed in the state of inflammation. This composition it will be sufficient to add, is now disused; but it gave rise to prepara-

tions of a more powerful nature, and having the same use, as, for instance, the *roche 'a feu* of the French, usually called fire-stone ; a composition which is either used in lumps and put into shells with powder, or made into car-casses, or fire balls. We do not know of any imitation of the original Greek fire having been used in modern war-fare, but have no hesitation in believing, that naptha prepared as already stated would in many cases prove advantageous. It seems to be well calculated for close naval combat, if the object be to destroy the sails and rigging of an enemy's ship. The rapidity and extent of its combustion, added to the circumstance of its peculiar properties, that of resisting the action of water in particular, contribute altogether to this opinion.

West-Point, Dec. 11*th,* 1822.

Art. XII.—METEORS.*

The appearance of the Meteor, which in March 1822, passed over some of the northern states, brought to our recollection, some statements of similar events, which have been a good while on our files. Perhaps we cannot offer an adequate apology to those who were so obliging as to communicate them, why they have not been published ear-lier. By the delay, they will have gained at least this ad-vantage, that their importance will be increased, by being presented in connexion with the more recent, and perhaps more interesting phenomenon of the same class.—*Editor.*

Meteor in Ohio.

Extract of a letter from Dr. Henry Manning, *to the Editor, dated Youngstown Ohio, Aug.* 9, 1819.

A large meteor made its appearance on the evening of July 24th. I had a clear view of it at the time it exploded

* This article was prepared for the June No. of this Journal 1822, but has been unavoidably postponed to this time, April 1823.

and for a few seconds before. The, pleasing surprise which the view of it occasioned prevented me, from at first attending to the time, but as nigh as I could estimate, it was about three minutes from the apparent explosion until the report was heard. The sound resembled that of a heavy cannon at 3 or 4 miles distance fired in a still evening. The course was nearly north.. A gentleman who was, in the, township of Gustavus precisely 20 miles north from the place- where I-was, saw the light and thought the sound succeeded in something more than a minute.

It is a little more than 40 miles from this place to the south shore of Lake Erie ; and much of the country south of the lake, is still a wilderness, making it, uncertain whether any discoveries will be made if meteoric stones have fallen. If they should be discovered, perhaps they will not be worth sending a distance to analyze, the results of former experiments having been so uniformly the same.

<div style="text-align:right">H. M.</div>

The Pennsylvania Meteor of Nov. 1819.

The following account of the meteor which was seen in Chester county, Pennsylvania, on the 21st of Nov. 1819, we have extracted from the American Watchman. After some introductory observations the Editor remarks :—'

" While standing in the open air, we were surprized, by a sudden flood of light sufficient to enable us to read the smallest print. We soon discovered a fireball in motion in a direction east northeast, and 50 or 60 degrees above the horizon. It passed a little to the south of our zenith, towards the opposite point of compass, and about 30 degrees, above the western horizon it became invisible. This body was, perhaps, about two seconds in progression, before we saw it; from which we infer, that it first appeared about 30 degrees above the eastern horizon ; hence it travelled, whilst within view, about 120 degrees in the heavens, and in a period, we believe, of not less than five nor more than ten seconds. The size of the body, when first observed, might be about half that of the full moon. The tail which projected from it was of a conical shape, well defined, and extending from the ball to the apex, about 4 or 5 degrees.

No sparks were observed. The whole appeared to be a compact mass of fire, in which was combined all the redness of Mars, and the softer light of the moon. The whole appearance was sublime, beyond description. At about 30 degrees from the zenith, westward, it began rapidly to decline, and in two seconds became, to appearance, extinct; its tail, in the mean time, lengthening to 10 or 15 degrees, forming a narrow red streak of evanescent fire. About three minutes after it had disappeared, a noise was heard resembling cannon, or distant thunder, and in *a westerly direction.*"

A letter respecting this meteor, addressed by Mr. Samuel Turney to the Editor, and dated Chester county, Pennsylvania, Dec. 9th, 1819, states:—

"It passed near Easton on the Delaware, and a sound was heard in the direction of the body. Easton lies nearly north from us. It first appeared here in the northeast at an elevation of about 45 degrees. Its light was very vivid—a blaze streaming from it to a considerable distance. When it had arrived at about 40 degrees from the horizon in the south or southwest it suddenly disappeared; and after a lapse of two, three, or four minutes, two reports were heard. The sound continued (a succession of echoes I suppose) for many seconds.

You will not hesitate to pronounce this for the want of a better name a terrestrial comet. That it was a solid body cannot be doubted if we consider its velocity. Its height must have been at least twenty miles, and it passed through our hemisphere in a very few seconds. No gaseous body could be carried at this rate, moving as they uniformly do, I believe, with the currents in the air.

The sound heard at Easton about sixty miles north of us, could not be the same, I think, with that heard here, which came from a point not less than thirty miles to the south. The body then must have been ignited a second time.

I have not been able to get such information as I wish with regard to the apparent size of the body. It is, by many who were capable of judging in such a case, declared to have been of about one third of the apparent size of the moon, by which I understand that its diameter appeared to them

about equal to a third part of the moon's. Taking this apparent diameter and the distance of twenty miles we shall make the body more than one hundred yards in diameter. My estimate of its elevation above the earth is obtained by comparing the observations made by various persons in different positions.

The course of this meteor compares very well with that which passed over Connecticut in 1807. May it not be the same ?* —I now suppose it to revolve round the earth. If it be the same, it is a little extraordinary that it should pass so near to the former meridian. But perhaps it has made several revolutions since that period."

Meteor of March 9, 1822.

As the only sources of information within our reach, we were laying by the newspapers, containing the accounts of this meteor, when we observed with pleasure, that Theodore Dwight, Esq. Editor of the New-York Daily Advertiser, had collected the most interesting of these accounts into one view, of which we gladly avail ourselves on the present occasion, as the facts are worthy of being preserved, and it is only by accumulating well authenticated facts of this kind, that we can hope to solve the phenomena of Meteors.

The Meteor.

The late meteor was seen in this city sometime after 10 o'clock; its direction being from southwest to northeast. It appeared to many persons as large as the moon, emitting a brilliant light, which lasted but a few seconds.

It appears from a statement in the Troy Post, that it was seen by a number of gentlemen in that city. One of them, accustomed to astronomical observations, states, that when he saw it first, it was at the altitude of 46 degrees,

* Its size, as conjectured by Mr Turney, is much less than the estimated size of that meteor.—*Ed.*

bearing north 20 degrees east. It disappeared at the altitude of 22 degrees, bearing south 80 degrees west. The report, supposed to be caused by its explosion, reached the place of observation about seven and a half minutes after its disappearance. To several, who observed it in full view, it appeared equal to about two-thirds of the apparent diameter of the moon, leaving a luminous track in the heavens which was not totally extinguished in several minutes after the meteor disappeared. The same persons heard two distinct explosions, with a very short interval of time between them. The last they supposed to have been caused by the bursting of one of the largest subdivisions, immediately after the main body had been severed by the first explosion.

Mr. Doty has published a letter in the Albany Gazette, communicating his observations on the meteor as it appeared to him. He was on the Mohawk turnpike, near Canajoharie, about 10 o'clock P. M. when he observed it. He first observed a sudden flash of light which appeared to extend from the heavens to the earth, and was followed by a momentary darkness, as if a cloud had passed over and intercepted the light. This darkness was soon dispelled, and the blazing meteor was in full view over his head, appearing to be twenty or thirty feet in diameter, and soon began to extend itself to the northeast and southwest, increasing in extension, and decreasing in its flaming appearance, until nothing was to be seen but two detached parts of it rapidly moving in different directions towards the northeast and southwest. Mr. Doty calculates that it was five or six minutes from the first appearance of the meteor until it finally vanished, and from six to ten minutes from its first appearance before the report of its explosion reached him, which resembled the noise of distant cannon, and was followed by a strong sulphurous smell, that lasted fifteen or twenty minutes. Its explosion, from his statement, also appears to have sensibly affected several houses.

The Cherry Valley Gazette also mentions this remarkable phenomenon. It was seen about 10 o'clock from that place, globular in its appearance and uncommonly luminous, moving with great velocity from northeast to southwest, and when it disappeared its explosion was distinctly heard. It was visible for several seconds, and from its uncommonly

vivid appearance, caused many persons to close their eyes, rendering candles for an instant perfectly useless.

The Oxford (Chenango) Gazette says, it resembled a ball of fire, the apparent diameter of which was about six feet; and that it was more brilliant than the most vivid flashes of lightning, or even the meridian sun.

The Herkimer paper observes, that an explosion was heard from the south, about four minutes after the meteor passed, which resembled the discharge of four or five pieces of artillery.

A writer in the Sangersfield, Oneida, Intelligencer, says:—

"After passing almost in a direction from north to south, for the space of half a mile, it passed me, as near as I could judge, about three hundred yards, when it burst with a violence which seemed to throw all nature into convulsions. It discharged its massy balls of electric fire in every direction, when all disappeared before they reached the ground; leaving in its train an astonishing mass of livid fire, which remained after the explosion, for the space of ten minutes, and then gradually disappeared like the rain bow."

The Sentinel (printed at Saratoga Springs) says:—

"A very large and brilliant meteor passed near this village on Saturday last in the direction of southwest. The light produced, for a few seconds, was sufficient to enable many of the inhabitants to discern, in their dwellings, the most minute objects. A report, like the sound of distant thunder, succeeded."

It was seen about 10 o'clock, at Ballston Spa, and a paper printed in that village, says, its light was so intense "as to arrest persons walking as if they had received an electric shock. At an elevation of about 10 degrees it gave out corruscations like a beautiful rocket—leaving a luminous train, and on its disappearance, two and some say three, reports were heard."

The Montreal Herald, thus notices the meteor as seen at that place.

"As two gentlemen were walking down St. Paul-street about half past 9 o'clock last Saturday night, their attention was attracted by a flash of light that illuminated the atmosphere, notwithstanding the radiance of a full moon. As it apparently proceeded from the south side of the river, and

the line of houses intercepted their view, they turned down one of the little streets leading to the quay, where having arrived, they beheld a little to the westward of Laprairie, an arched chain of fire, vividly delineated in the heavens, and concaving towards the earth. After a minute or two, it disappeared, having been probably caused by the eruption of a ball of that element which emitted the flash."

The Quebec Gazette gives the following description of it.

" The meteor of Saturday evening, the 9th of March, was seen from the vicinity of this city in a southwesterly direction, at about 10 o'clock. It had, when first descried, the appearance of a shooting star, larger than a star of the first magnitude. Its altitude about 45 degrees, its direction in a straight line towards the earth, inclining towards the west; at about half the descent, it divided into numberless pieces, having the appearance of the stars usually thrown from sky rockets, but of a superior brilliancy and beauty, the whole disappearing before they reached the horizon. The sky was clear, the moon nearly at full, in an opposite direction, and the light of the meteor when it divided, was so strong as entirely to destroy the shadows of the moon light and throw them into a contrary direction. From the meteor having been seen at Montreal and Quebec very nearly in the same direction, its distance must have been great."

The Salem (Washington county) Post, says,

" Its first appearance was northeasterly about 20 degrees above the horizon, that it passed above the polar star, disappeared about 30 degrees above the horizon, near the constellation Orion ; was visible about one minute, and that it appeared about as large as the full moon."

In addition to the above named places it was seen a Boston, Bennington, Vermont, Utica, Johnstown, in Montgomery county, Buffalo, various places in New Hampshire, Rhode Island, and Pennsylvania, but no particular observations accompanied the accounts.

The Springfield (Massachusetts) Federalist, states, that an extraordinary meteor was seen on Saturday night, the 9th of March, by several persons in that town and vicinity. It was uncommonly large and brilliant.

The Eastern Argus, printed at Portland, state of Maine, says the meteor was seen in that town at a quarter past 10 o'clock in the evening of the 9th, in a direction nearly west, its magnitude nearly that of the moon—its brilliancy very great—and when it exploded, scintillations, not unlike those of sky rockets, were scattered northerly and southerly.

The same meteor was seen in various places East of New-York. The Bridgeport Courier says, "its size appeared to be that of a large artificial globe, and moved with great velocity in a direction from northeast to southwest, leaving a trail of immense size and peculiar brightness."

It is remarked by a Boston Editor that this meteor must have been very large and the sound at its separation louder than the loudest thunder, as its explosion was not only seen in many opposite places, but heard from Portland, in the state of Maine to 60 miles west of Albany.

A writer in the Albany Daily Advertiser in commenting on Mr. Doty's statement mentioned above, says;

" Eight minutes was the time between its appearance and the report of its explosion, its distance from him must have been about one hundred miles, for sound travels about thirteen miles in a minute. From these data we may calculate that the place where it was vertical must be about seventy miles from Albany in a northwesterly direction, and that its size was near a mile in diameter ; but to enable us to calculate with greater accuracy its height, dimensions, and the tracts of country over which it passed, observations at places to the west as well as to the east of it are necessary."

Remark by the Editor, December 9th, 1822.

The following communication from Professor Dean of the University of Vermont has been recently received, and we give it in connexion with the preceding communications to which it bears an important relation.

To the Editor of the American Journal of Science.

Sir,

The meteor of last March (1822) has ceased to be the subject of general conversation, but it is not the less inter-

esting to those who wish to explore the causes of such phe-
nomena. The following observations would have been
communicated immediately had I not hoped to obtain oth-
ers to compare with them; but in this I have not suc-
ceeded, and I now transmit them with such inferences as
they afford.

Capt. Allen Wardner of Windsor, Vt. states, that on the
10th of March, about 10 o'clock in the evening, he was
walking along the east side of what is called the tontine
building in that village and had just reached the southeast
corner, when the first corruscation burst forth. His first
thought was that a large barn northwest of the tontine had
suddenly burst into a flame, and he hastened on to get a
sight of it across the southwest corner of the building, but
had not proceeded more than three steps when the body of
the meteor came in sight over the south end of the roof,
and he had a full view of it for more than 40 degrees mov-
ing southwest and descending towards the horizon, until it
disappeared behind the ridge of a house forty or fifty rods
distant. It was excessively bright, and sparkles were fly-
ing from it in all directions and left a dusky reddish track
which continued especially about the middle of its length
for two minutes. He thought it was nearly round, and its
diameter somewhat less than that of a ball which surmounts
the dome of the Episcopal Church which was near its ap-
parent path.

The village of Windsor is by estimation in lat. 43° 29′
lon. 72° 29′. I had no theodolite to determine the azy-
muth, but I ascertained the meridian sufficiently near, as I
thought, by the north pole, and measured the sides of a
right angled triangle, one angle of which was contained be-
tween the meridian and the end of the building, and find-
ing the angles by the traverse table, I ascertained that it
declined 20° 30′ toward the west. The second or third
steps taken after the first flash subtended an angle at the
west corner of 3° 45′, so that the bearing of the meteor
when first seen was about north 65° 45′ west. Capt. W.
had no object by which to regulate his recollections of the
altitude, but he fixed on a point the altitude of which I
found to be 29° 30′. I determined the azymuth of the me-
teor at its disappearance in the same manner, and found it
to be, south 67° 30′ west, and its altitude 11° 30′. Then

withdrawing from the ball on the top of the church till
Capt. W. thought its apparent diameter was about equal
to that of the meteor, I measured it with a sextant and found
it 10'.

Col. Lemuel Page, of Burlington, Vt. was in his back
yard at the time above mentioned, and had his attention ar-
rested by what is commonly called a shooting star, no way
differing from such as frequently appear in considerable
numbers. When he first saw it he thought it about in the
centre of the triangle formed by lines joining Mars, Castor,
and Procyon. It moved on southwesterly, passing a little
southeast of Procyon, and about one third of the way from
Procyon to Sirius it suddenly broke out in great splendor,
and continued its course flashing and sparkling, east of Si-
rius, and disappeared, apparently by extinction, near the
tops of some trees about twenty rods distant, considerably
above the mountains in that direction. Col. P. thought its
motion exactly perpendicular to the horizon. The disc
appeared to be nearly circular, and its diameter about
half the breadth of a certain chimney a few degrees east of
its apparent path.

The place of this observation is in lat. 44° 28', lon. 73°
15'. The azymuth of the meteor during its whole course
as determined both by the north pole and the globe, was
about south 34° west. Its altitude when first seen by Col.
P. was about 62°, the first coruscation when it became an
object of general attention, and when Capt. W. first noticed
it 35°, and at its disappearance 6°. Its apparent diameter,
obtained by measuring the breadth of the chimney with a
sextant was 12'.

The places of the meteor computed from these observa-
tions, by Dr. Bowditch's rule given in Mem. A. A. Vol. 3,
are, at its first brilliant coruscation, lat. 43° 54', lon. 73°
47', about fifty-nine miles from Burlington and eighty-three
from Windsor, over the unsettled part of Essex county, N.
Y. about fifteen miles west of Crown Point, and at its dis-
appearance from Capt. W. lat. 42° 45', lon. 74° 49', one
hundred and forty-four miles from Burlington and one hun-
dred and thirty-three from Windsor, over the western part
of Schoharie county, and its motion south 34° west. In
the former place according to Capt. W's. observation it
was about forty-one miles from the earth, according to

Col. P's. only thirty-four; in the latter place Capt. W's. observation makes its height about twenty-nine miles. If these agreed better with each other, and could be depended upon as nearly accurate, it would be easy to compute from them its height and distance at the beginning and end of its appearance to Col. P. But altitudes estimated under the impression which such a phenomenon cannot fail to produce must be considered as very uncertain whatever may be the judgment and fidelity of the observers. The probability is that when first seen by Col. P. it was near the zenith of Essex, a village on the west shore of Lake Champlain thirteen miles from Burlington, and when it disappeared from him it had reached nearly to the zenith of Wilksbarre in Pennsylvania, about two hundred and fifty miles from Burlington.

The absolute diameter of the meteor, computed from the apparent diameter above estimated and the mean distances of the observers respectively amounts to about one third of a mile.

I hardly dare to make any estimate of its velocity. I have heard no estimate of the duration of the appearance of the body of the meteor greater than five seconds and this would imply a velocity much greater than that of the earth in its orbit.

The observation of its first appearances as noticed by Col. Page is I believe rather uncommon, though perhaps they may always commence in the same manner without being noticed till their light is greatly increased.

Much of the country over which it passed being a wilderness, and none of it populous, it is not probable that if any fragments fell from it, they were recognized next day as any thing more than common stones.

The testimony of Mr. Doty who according to the news papers saw it at Canajoharry passing near the zenith confirms the course above computed.

Yours with high respect,

JAMES DEAN.

Art. XIII.—*Pluviometrical Observations, made at West-Chester, Penn. by* Wm. Darlington, M. D. *and communicated in a letter, dated*

Washington City, Feb. 14, 1823.

Sir,

In the year 1817, (on the 20th of June,) I commenced keeping an account of the *quantity of rain and snow* which fell in the borough of *West-Chester,* in the State of Pennsylvania—a statement of which I now submit to you; and if you should be of opinion that it is worthy of preservation in your Scientific Journal, it is entirely at your service. If observations of this description were made for a series of years, in the various sections of the United States, they would undoubtedly tend to furnish us with more accurate conceptions of the nature of our climate, as well as with the means of comparing it with that of other countries. They would also enable us to ascertain, in the course of time, the real character of those *changes* which are supposed to be taking place in the climate of this continent, by reason of cultivation, clearing of forests, and other causes. Some useful data, likewise, might possibly be afforded by such accounts, to assist Medical Philosophers in investigating the causes and character of prevailing diseases, in the country. In the present instance, I have to regret the occurrence of an hiatus in the account, from 29th November 1819, to March 7th 1820, owing to the accidental loss of my memoranda for that period: but the statement for the residue of the time embraced, may be relied upon as being complete, and tolerably accurate. I am sensible that it would have been much more satisfactory, if it had been accompanied with Thermometrical and Barometrical observations; but I had it not in my power to furnish a statement of that sort as fully as could be wished, and have therefore omitted it altogether.

Synopsis of Pluviometrical observations.

Months.	1817	1818	1819	1820	1821	1822	Average.
January	- -	2.1	1.1	- -	4.3	2.3	2.4
February	- -	2.0	4.0	- -	3.9	4.3	3.3
March	- -	3.7	4.35	{ f'm 6th 1.3	1.6	2.4	3.4
April	- -	2.77	2.6	2.1	3.45	3·2	3.5
May	- -	8.8	4.75	7.9	7.2	3.5	6.4
June	{ fr'm 19 5.5	4.6	1.8	3.4	4.15	2.35	3.6
July	2.55	8.25	3.47	4.3	4.0	3.6	4.36
August	7.05	4.7	4.2	2.9	1.9	2.2	3.82
September	4.2	4.4	1.95	4.1	7.9	4.5	4.5
October	2.07	1.2	1.5	10.1	5.4	2.5	3.8
November	5.85	3.45	{ 1.4 to Nov.29	3.8	5.3	7.0	4.5
December	3.6	1.86	- -	3.6	3.5	1.45	2.8
Inches	30.82	48.83	31.12	43.5	52.6	39.3	46.38

Thus it appears that the *average* quantity of water which fell in the time stated, was about *forty-six inches a year.* The greatest quantity, 52.6 inches; (viz. in 1821) and the least, in any *entire* year, 39.3 inches (in 1822.) The quantity, in 1819, was probably still less; being only 31.12 inches from Jan. 1, to Nov. 29.

I find by my notes, that the quantity of *snow* which fell, during the above period, was as follows:

		Inches.		Inches.	
In 1818,	there was *snow*	12.	equal to	1.7	of water
" 1819,	(to Nov. 29.)	45.	-	5.3	
" 1820,	(from March 6.)	4.	-	.3	
" 1821,	- - -	30.	-	3.1	
" 1822,	- -	22.	-	2.2	
	snow	113.		12.6	water

The water which fell in the form of *snow*, is included in the foregoing table of rain.

The number of days of *falling weather*, so called, (including both rain and snow) in those years, is exhibited in the following table: by which it appears that the highest number is 103, (in 1818) and the lowest, in any entire year, 84, (in 1822.) The *average* number of days, on which there

fell either rain or snow, is about 91 out of 365; or about *one day in four*, of the year.

Table, showing the number of days of *falling weather* in each month, in the years noted.

Months.	1817	1818	1819	1820	1821	1822	Average.
January	- -	7	5	- -	8	6	6½
February	- - -	5	8	- -	11	6	7½
March	- -	9	11	{ f'm 6th 5	5	5	7
April	- -	11	6	4	8	10	8
May	- -	13	16	14	13	7	12
June	{ fr'm 19 5	13	5	7	8	7	8
July	9	8	8	9	9	9	9
August	9	10	9	6	5	4	7
September	6	8	8	3	11	7	7
October	9	3	4	5	5	4	5
November	6	6	{ 3 to Nov.29	5	7	10	6
December	6	10	- -	7	9	9	8
Days	50	103	83	65	99	84	91

The latter part of the summer of 1822, was marked by a severe drought—so mnch so, that many wells and springs dried up, which had never before failed within the memory of the oldest inhabitants. Even the rain which did fall, seemed to be speedily dissipated, without producing any refreshing effect upon vegetation. The season was also remarkable for the prevalence of *intermittent fevers*, in the neighbourhood of West-Chester; a form of disease which has hitherto been extremely rare in that vicinity. Along the waters of the Schuylkill, and Susquehanna, fevers of a more malignant type prevailed extensively.

<div style="text-align:center">

I am, Sir,

very respectfully,

your most obed't.

WM. DARLINGTON.

</div>

Prof. Silliman, New-Haven.

Art. XIV.—*Cure of Asthma by a Stroke of Lightning.*
(*Communicated by the Rev.* Ralph Emerson.)

Norfolk, Nov. 25, 1822.

To the Editor.

Dear Sir,

I know not whether electricity has ever been tried for the relief of persons afflicted with Asthma. If not, perhaps the following circumstances may suggest the propriety of making the experiment.

One year ago last August, Mr. Martin Rockwell of Colebrook, Conn. was severely affected by a shock of lightning, which struck his buildings within about ten feet of him. He was standing at the time in a leaning position, looking out at a window, bearing most of his weight on his left foot, and supporting himself by his right arm, with his hand on a moist platform connected with a sink, and these together forming a connection with the part of the building where the charge fell. Without his either seeing the flash or hearing the noise, his right arm and left leg were instantly paralyzed, and sense and reason were for a few moments suspended. On recovery, his first thought was that his arm was gone, and he put up his left hand to feel if it were yet on him. He did not recover the use of his arm or leg for an hour; and they continued sensibly affected for some days. No other part of his body was particularly affected, except the chest. He felt a strong sensation at the lungs, and they continued sore for a number of days. I state these circumstances, as they evince that a heavy charge of electricity passed through the vitals.

Mr. R. is now fifty years of age, and from his youth had been so subject to the asthma as to be often unable to rest in bed for a number of months together, especially in autumn. Since this event, however, he has been entirely free from it, except in one or two instances he has felt a very slight degree of it, after great fatigue, and under the pressure of a severe cold. He has now passed the second autumn in health since this kind preservation of life and removal of disease.

I visited him soon after the shock, and witnessed the de-molishing effects of the lightning. The place where it struck is a projection of one story, at right-angles with the house, which is two stories high, and within a few feet of their junction. Mr. R. was in the house at the time. It was rather difficult to decide whether the lightning ascend-ed or descended—the appearances rather indicated the lat-ter. The side of the building was laid nearly bare of its covering, from the eaves to the ground; and most of the nails in a contiguous door were started, and one window near the angle with the house was completely shivered, and the glass thrown *outward*, I suppose by the concussion, and the pressure of the air or fluid with which the apartment was filled. Much smoke and sulphureous smell were ob-served on entering this apartment. The point at the eaves where the first vestiges of the lightning were perceivable, was directly under the branches, and but three feet from the trunk of a lofty poplar, which remained unhurt—thus affording an additional proof to what is stated in your No. for June last, that this tree is a poor conductor and no safe-guard against lightning. I would remark also, that there was a good rod to the house, sixty-three feet distant from the smitten spot.

Art. XV.—*Galvano-Magnetic Apparatus of* Prof. Dana.

(See Figure 6 in Plate 12 at the end.)

A, is a cork through which passes a strip of sheet copper C, about one quarter of an inch wide and eight inches long, bent at the bottom like the letter U, so as partly to inclose the strip of sheet zinc Z, of the same width as the copper; NS is a steel wire five inches long, around which passes about seventy-five turns of brass wire. One end of this passes through a perforation in the upper part of the cop-per, and the other through a similar perforation in the zinc. The brass wire is covered with sewing silk; when his little apparatus is placed in a tall glass jar containing water, acidulated with sulphuric or nitric acid, the wire NS soon arranges itself in the plane of the magnetic meri-dian; the steel wire becomes a temporary magnet, and will

attract fine iron filings, so long as the apparatus remains in the dilute acid, but instantly loses that power when with- drawn from the liquid. One curious result is presented by this apparatus, which we should not have anticipated from experiments made by myself with common electricity, and which I sent to you when I last wrote, nor from the experi- ments of Mr. Bowen, with Hare's calorimotor; it is this: when the spiral brass wire passes from *right* to *left*, the *north pole* is found on the *negative* or *copper* end; if from *left* to *right*, that pole is found on the *positive* or *zinc* end; this effect is like that noticed by *Van Beck.* It certainly in- dicates *another* point of difference, which Dr. Hare justly asserts to exist between common galvanic instruments and his calorimotor; and the result of Mr. Bowen's experiments, and my own with common electricity, points out an analogy between the effects of the common electrical machine and of the calorimotor. I have tried in vain to communicate such a degree of magnetism to silver and platina wires by this little apparatus as to induce them to assume a north and south direction; and I have in vain attempted to influence delicately suspended galvanic apparatus by the rays of light separated by a prism; but I doubt not that some for- tunate philosopher, in possession of a heliostadt, will be able to produce some effect in this way.

Dartmouth College, Hanover, N. H.

ART. XVI.—*Analysis of the Glassy Actynolite from* Concord *Township, Delaware Co. Penn.* By. H. Seybert.

Color in the mass, emerald green; powder greenish white. Lustre vitreous. Translucent. Fracture in one direction fibrous, in the opposite irregular. Very frangible. Scratch- es glass. Structure fibrous and fasciculated. Specific gravi- ty 2.987. Fusible, before the blowpipe, into an opake greenish enamel.

Analysis.

A. 3 grammes of the mineral, in the state of an impal- pable powder, after exposure to a red heat, with the contact of air, had assumed a reddish tinge, and weighed 2.98

grammes; but as the protoxide of iron contained in the
mineral must, during the calcination, have passed to the
state of peroxide, and as the absorption of oxygen, estima-
ted by calculation, is 0.011 grammes, therefore the moi-
ture expelled by calcination amounts to 0.031 grammes on
3 grammes, or 1.033 per hundred.

B. The calcined mineral (*A*) was exposed to a red heat
during thirty minutes, in a silver crucible, with 9 grammes
of caustic potash.~ The cold mass was of a pale green co-
lor; it communicated to the water with which it was treat-
ed, a lemon yellow color, thus indicating a trace of chrome.
The mixture was treated, in the usual manner, with an ex-
cess of muriatic acid, and the yellow solution thus produc-
ed, was evaporated to a dry gelatinous mass, which was
treated with diluted acid and again moderately evaporated.
The residue was treated with more water, and the solution
was filtered; the silica collected on the filter, after being
washed and calcined, weighed 1.69 grammes on 3 grammes,
or 56.333 per 100.

C. After the liquor (*B*) was neutralized with caustic pot-
ash, on the addition of the hydro-sulphate of potash, a black
precipitate was formed, which, after being washed and cal-
cined with nitric acid, weighed 0.19; this precipitate, when
treated with caustic potash, was found to consist of 0.14
grammes of peroxide of iron, and 0.05 grammes of alumine,
by difference 1.666 per 100. Owing to the green color of
the mineral, the iron must be estimated as a protoxide,
and the 0.14 grammes of peroxide are equivalent to 0.129
grammes of protoxide on 3 grammes, or 4.30 per 100.
The alkaline liquor holding the alumine in solution,
appeared to be yellow from chrome contained in the min-
eral; to detect the chrome, the alumine was precipitated,
by exactly neutralizing the liquor with muriatic acid; on
the addition of acetate of lead, there was produced a precip-
itate of muriate of lead, intermixed with a yellow precipi-
tate of chromate of lead; to another portion of the liquor.
nitrate of silver was added; the muriate of silver was like-
wise intermixed with a red precipitate of chromat of silver,
but the chrome seemed to be very trifling.

D. When oxalate of potash was added to the liquor (C)
it occasioned a white precipitate, which, after a strong cal-
cination, afforded 0.32 grammes of lime on 3 grs. or 10.666
per 100.

E. The liquor (*D*), when treated with an excess of caustic potash, afforded 0.72 grammes of magnesia on 3 grs. or 24.0 per 100.

The constituents of this mineral are, therefore,

Per 100 parts.

A. Water	-	-	1.033	Containing oxygen,	
B. Silica	-	56.333		- - - -	28.33
C. Protoxide of iron	4.300		- - - -	00.97	
C. Alumina	-	1.666			
D. Lime	-	10.666	- - - -	03.84	
E. Magnesia	-	24.000	- - - - -	9.29	
C. Protoxide of chrome a trace.					

$$97.998$$
$$100.000$$

$$2.002 \text{ Loss.}$$

ART. XVII.—*Analysis of Argentine and Crystallized Steatite. by* Professor DEWEY.

Argentine.

At the lead-mine in Southampton, Mass. a mineral is found in considerable quantity, which is a nearly pure carbonate of lime, and has the following characters. It generally consists of undulated, not parallel, laminæ, of a pearly shining lustre, often of a beautiful silvery white. Sometimes it is in thin plates, which intersect and form small cells, containing crystals of calcareous spar. The thin laminæ are translucent. Sometimes it is less laminated and more compact, with less lustre, and the cross fracture is slightly granular. It was supposed to contain magnesia, and three years since I examined it without detecting any of this earth. It was then laid by as a beautiful carbonate of lime, without a suspicion of its being one of the sub-species of this mineral. The characters prove it to be *Argentine.*

It occurs on very compact granite, and is also associated with fetid quartz, which is found in small masses in it and upon it. When it joins the quartz it is more compact and

hard, and a small quantity of silex seems to enter into the composition of the mineral.

Heated to a temperature of 300° or 400°, it did not lose weight. It gave no indications of even a trace of oxide of manganese, which is sometimes found in argentine, and of only a very small quantity of magnesia. At least, only a minute quantity was separated from the lime by carbonate of ammonia. 100 grs. of the mineral yielded, of

Carbonic acid - - 41. grs.
Lime - - - 54.
Silex - - - - 3.25,
Magnesia and Oxide of Iron 0.75
 Loss 1.00 probably carb. acid.
 ————
 100.00

If the the silex is to be considered an accidental ingredi-ent, arising from the specimen being associated with quartz, this argentine is a very pure carbonate of lime.

Crystallized Steatite.

Having ascertained that the mineral contained silex, magnesia, alumine, water, and oxides of iron and manga-nese, one hundred grains of a very large and fine crystal were analyzed to ascertain the proportion of the ingredi-ents. In the previous trials, the proportion of some of them had been found, but as they were not much different from those obtained from this crystal, it was judged proper to rely on the results last obtained. In heating the mineral, there was sometimes more and sometimes less than fifteen per cent. of water liberated; but the water is taken at fif-teen per cent. In heating the mineral with sulphuric acid, there was no indication of fluoric acid, which is sometimes found in a variety of steatite. Indeed, the corrosion of the glass vessel in which the experiment is performed, is some-what equivocal, as sulphuric acid heated to 500° or 600° will act upon the potash or soda in some kinds of glass at least, and an actual corrosion take place. Oxalate of am-monia gave no indication of lime. The method of analiz-ing those magnesian minerals which are decomposed by

acids, is too well known to make a more detailed statement necessary in the present case. Muriatic acid dissolved all the mineral except the silex, which weighed 50.6 grs. From the muriatic solution carbonate of ammonia threw down the oxide of iron, being 3.25 grs. equivalent, according to Brande, to 2.59 grs. of protoxide of iron. Pure potash separated the alumine, estimated at 0.15 gr. The ammoniacal solution contained the magnesia and oxide of manganese. This solution was evaporated, and the ammoniacal salts were separated by sublimation; the magnesia and manganese remained. They were then converted to sulphates; the solution evaporated to dryness, and the dry mass was kept at a red heat for half an hour. The water was thus driven off from the sulphate of magnesia, and the sulphate of manganese being converted to the deutoxide of manganese, a reddish powder was thus diffused through the sulphate of magnesia. The whole weighed 87.5 grs. and dissolved in water except one grain of deutoxide of manganese, equivalent to 1.1 gr. of the peroxide. This contained, therefore, 86.5 grs. for the sulphate of magnesia, equivalent to 28.83 grs. of pure magnesia. The result is,

Water - -	15.00 grs.
Silex - - -	50.60
Oxide of iron -	2.59
Magnesia -	28.83
Oxide of manganese	1.10
Alumine - -	0.15
Loss - - -	1.73
	100.00

This result contains a proportion of ingredients between those given by Klaproth in his analysis of steatite from two different places. There can be no doubt, therefore, that these crystals are *real steatite.*

The *form* of some of these crystals, is that of a six-sided prism terminated by six-sided pyramids, often variously truncated. Some of them appear to be four-sided prisms terminated by a four-sided pyramid. They are unquestionably the crystals intended by Jameson, as they are found in a similar situation to those mentioned by him,

though they seem not to be *pseudomorphous.* The locality
is described, Vol. V. p. 249 of this Journal. They are
sometimes covered with a very fine grained and close brown-
ish steatite, in which, as in the asbestus, the crystals leave
their form. The specific gravity of the crystals is less than
that given to steatite. In the various specimens I have
tried, it has been found very nearly 2, sometimes a little
more or a little less. Their specific gravity may be taken
at 2, water being unity.

ART. XVIII.—*On the Cutting of Steel by Soft Iron.*

Extract of a letter to the Editor, from the Rev. HERMAN DAG-
GETT, *Principal of the Foreign Mission School at Corn-
wall, Conn.*

Cornwall, Feb. 3, 1823.

Dear Sir,

I take the liberty to communicate to you a fact, which has
lately come to my knowledge, and which, I judge, may be
of considerable use in mechanics, and perhaps in philosophy.
It may not, however, be new to you.

Mr. Barnes, (a cabinet-maker of this place) had occasion
to repair a cross-cut saw, (a saw to be used by two persons)
of a very hard plate, which would require considerable la-
bor, in the usual way of filing. He recollected having heard
that the Shakers sometimes made use of what he called, a
buzz, to cut iron. He therefore made a circular plate of
soft sheet iron, (a piece of stove pipe,) fixed an axis to it,
and put it in his lathe, which gave it a very powerful rotary
motion. While in motion, he applied to it a common file
to make it perfectly round and smooth; but the file was cut in
two by it, while it received itself no impression. He then
applied a piece of rock-crystal, (a piece of which, he in-
forms me, he once presented to you,*) which had the desir-
ed effect. He then brought under it, the saw-plate, which,
in a few minutes, was neatly and completely cut through
longitudinally. When he stopped the buzz, he found it had
received no wear from the operation, and that he could im-
mediately apply his fingers to it, without perceiving much

*It was a peice of a very fine and large crystal of smoky quartz.—*Editor.*

sensible heat. During the operation, there appeared a band of intense fire around the buzz, continually emitting sparks with great violence. He afterwards marked the saw, for the teeth, and in a short time cut them out, by the same means. It seemed evident, that the buzz, in effecting the division, never came in actual contact with the plate. Was this fire the electric fluid? If so, might it not be obtained, in greater quantity, and be made more effective for chemical purposes, by some such machine, than in any other way?

ART. XIX.—*On the relations, existing between the Deflagrator and Calorimotor, and between those instruments and the common Galvanic or Voltaic Batteries, in a letter to Professor Robert Hare, M. D. from the Editor.*

<div align="right">Yale-College, April 4, 1823.</div>

Dear Sir,

Through the medium of this Journal, (Vol. 4. pa. 201, and Vol. 5, pa. 102,) I have already communicated to you and to the public, the singular fact, that your Deflagrator will not act with the common Galvanic Batteries, in whatever mode they may be connected, and that, although belonging to the same class of instruments and evolving the same imponderable agents, there still exists between them a total incompatibility. This incompatibility, it will be remembered, does not begin to be overcome, until the pairs of galvanic plates are reduced to twenty, in number, when the power of the Deflagrator *begins* to pass, and increases until one pair only is interposed, when it passes apparently without diminution.

I am induced again to call your attention to this fact, for the sake of connecting it, with some observations which I have recently made, upon the relations between the Calorimotor and Deflagrator, and between these instruments, and the common Galvanic Batteries, for it is only by varying our observations and experiments, that we can hope to arrive at a just explanation, of the singular phenomena exhibited by these instruments.

1. I connected the zinc pole of the Calorimotor, with the copper pole of the troughs, and vice versa, and then dividing the troughs (containing three hundred pairs of four inch plates,*) at another place, connected them at these new poles by points of well prepared charcoal; the sparks passed freely and vividly, nor did it, apparently make any difference, whether the plates of the Calorimotor, were immersed in the fluid, or not. I then disconnected the troughs from the Calorimotor, and connecting them together, received the spark, which was quite as vivid, as when the Calorimotor formed a part of the series. I now immersed the Calorimotor, and found that it acted by itself, with its appropriate energy, readily igniting iron, and displaying its usual magnetic activity.

2. The Calorimotor and Deflagrator were connected in such a manner, that the former was interposed between the two equal divisions of forty coils each, contained in the two troughs of the Deflagrator; in different trials, the connexion was varied, sometimes the zinc poles, and sometimes the copper poles of the two instruments, being connected, and at other times, the zinc of the one being joined to the copper of the other, and vice versa.

When the metals of both instruments were in the air, only a very feeble spark passed through the charcoal points connecting the proper poles of the Deflagrator. When the plates of the Calorimotor were immersed, those of the Deflagrator being in the air, the spark was not increased, but remained feeble as before. The coils of the Deflagrator being then immersed, the usual splendor of light, instantly burst from the charcoal points, and all the dazzling brightness and intense heat of the instrument were displayed, *but without any increase of power derived from the Calorimotor.* The plates of the Calorimotor were now raised from the fluid, those of the Deflagrator remaining immersed, but the light and heat were equally brilliant as before. The Deflagrator and Calorimotor were now separated; and each produced its appropriate effects, in full energy.

3. The Calorimotor—the Deflagrator and the troughs, containing the three hundred pairs of four inch plates, were now connected into one series, in such a manner, that the Calor-

* Cemented in the usual manner, into mahogany boxes.

imotor was interposed between the two halves of the Defla-
grator, the proper poles of the latter instrument were con-
nected with the two divisions of the troughs ; first, zinc, with
copper, and copper with zinc, and then the reverse, and the
power was received at the proper poles of the troughs, char-
coal points being used as before.

When the metals both of the Deflagrator and Calorimotor
were in the air, a spark passed, such as corresponded with
the power of the troughs only; when the Calorimotor was
immersed, this power was neither increased nor diminished ;
but when the Deflagrator was immersed, its power flowed
freely through the batteries, and was received apparently
undiminished at the charcoal points, but did not appear to de-
rive any increase from the troughs. This was the fact,
whether the Calorimotor was, at the moment immersed, or
not, but the lifting of the coils of the Deflagrator out of the
fluid, immediately reduced the spark, to that which the
troughs alone would afford.

The several instruments being now disjoined, each acted
by itself, in its own appropriate character.

4. The original experiment of connecting the troughs
with the Déflagrator only, was now again repeated, and
with the same result as before; the power of both instru-
ments was so destroyed, that only a very minute spark could be
seen, and that with difficulty.

From these experiments, and those formerly related, the
following conclusions may be drawn :—

1. The galvanic troughs and the Deflagrator paralyse
each other, and cannot be made by any means hitherto tried,
to act in concert.

2. The Calorimotor does not impede the action of the
troughs; it allows their energy to pass through itself, but
contributes nothing to aid their power and cannot be made
to project its own power through the troughs.

3. The same fact is true of the Calorimotor in relation to
the Deflagrator; the powers of these instruments cannot be
made to unite, only the Calorimotor allows a transit to the
power of the Deflagrator ; but the Deflagrator does not in
its turn, transmit the power of the Calorimotor.

4. The Calorimotor, however, when connected, at once
with the troughs and with the Deflagrator enables *them* so
far to unite, that the deflagrator acts through the troughs,

but without deriving any increase of power from them or from the Calorimotor; the Calorimotor then is an intermedium for the troughs and the deflagrator otherwise incompatible.

5. It is impossible as far as experiment has gone, to obtain any increase of power by combining the different kinds of voltaic apparatus, and indeed it may be doubted whether, when the power passes at all, through the instruments of different kinds, there is not always some loss, from the increased extent of connecting surface.

6. These various facts are probably all referable to the different powers, belonging to different proportions of the calorific, electrical, and luminous influence, excited by these different instruments, agreeably to the theory, which you have ingeniously proposed and ably defended; this view accords also with the known results of the combinations of ponderable elements, in different proportions, as of nitrogen and oxigen, and of carbon and oxigen, and of carbon hidrogen, and nitrogen.

7. We are thus sent back, to study our imponderable elements anew, and to learn, that the voltaic power is not electricity alone, nor heat alone, nor light alone, but a compound of these three agents, variously proportioned in different cases, and in different modifications of apparatus. This, it appears, is also true, of the common mechanical and atmospheric electricity.

REMARK.

As the magnetic influence attends all the modifications of electricity, natural and artificial, and of the voltaic power, including your new instruments; and as it is exhibited also by the solar beam, we are left in doubt, whether to regard it as a mere appendage of these powers, or of some one or two of them, or as a distinct influence or energy, *incidentally* associated, with the colorific—calorific and electrical powers.

But, as the magnetic influence is marvellously more powerful, in the Calorimotor, than in the case of any voltaic, electrical or optical instrument, and as the Calorimotor evolves chiefly heat, and produces its magnetic effects *best* when it produces *no light* and *no perceptible electricity*, it would seem, as if the magnetic influence were rather an at-

tendant, on caloric, or at least in a greater degree, than on any other power.

It is extremely obvious, that, on all these-subjects, we are still very humble learners; we may however, confidently hope, that out of these diversified results, and from others still to be obtained—some *grand simplification* will hereafter arise, which will reconcile all apparently discordant facts, and perhaps evince, that all the imponderable influences are merely modifications of one power—that they constitute the *atmosphere*, which connects physical existence with its author, and exhibit to us in the natural world, the most immediate and wonderful efflux of his omnipotent energy.

<div style="text-align:center">

Your friend and servant,

B. SILLIMAN.

</div>

<div style="text-align:center">

Art. XX.—*Fusion of Plumbago.*

</div>

Notice of the Fusion of Plumbago, or Graphite, (commonly called black lead,) in a letter to Dr. Robert Hare, M. D. from the Editor, dated March 26, 1823.

My Dear Sir,

In a former letter published in this Journal, (Vol. V. pa. 108,) and in an additional notice, (pa. 361 same Vol.) I gave an account of the fusion and volatilization of charcoal, by the use of your Galvanic Deflagrator. I have now to add, that the fusion of plumbago was accomplished yesterday by the same instrument, and that I have, again, obtained the same results to-day. For this purpose, from a piece of very fine and beautiful plumbago, from North-Carolina, I sawed small parallelopipeds, about one eighth of an inch in diameter, and from three fourths of an inch to one inch and a quarter in length; these were sharpened at one end, and one of them was employed to point one pole of the deflagrator, while the other was terminated by prepared charcoal. Plumbago being, in its natural state, a conductor, (although inferior to prepared charcoal,) a spark was readily obtained, but, in no instance, of half the energy which belongs to the instrument when in full activity, for the zinc coils were very much corroded, and some of them had failed and dropped out; still the influence was readily convey-

ed, through the remaining coils. As my hopes of success, in the actual state of the instrument, were not very sanguine, I was the more gratified to find a decided result in the very first trial. To avoid repetitions I will generalise the results. The best were obtained, when the plumbago was connected with the copper, and prepared charcoal with the zinc pole. The spark was vivid, and globules of melted plumbago could be discerned, even in the midst of the ignition, *forming* and *formed* upon the edges of the focus of heat. In this region also, there was a bright scintillation, evidently owing to combustion, which went on where air had free access, but was prevented by the vapor of carbon, which occupied the highly luminious region of the focus, between the poles, and of the direct route between them. Just on and beyond the confines of the ignited portion of the plumbago, there was formed a belt of a reddish brown color, a quarter of an inch or more in diameter, which appeared to be owing to the iron, remaining from the combustion of the carbon of that part of the piece, and which, being now oxidized to a maximum, assumed the usual color of the peroxide of that metal.

In various trials, the globules were formed very abundantly on the edge of the focus, and, in several instances, were studded around so thickly, as to resemble a string of beads, of which the largest were of the size of the smallest shot; others were merely visible to the naked eye, and others still were microscopic. No globule ever appeared on the point of the plumbago, which had been in the focus of heat, but this point presented a hemispherical excavation, and the plumbago there had the appearance of black scoriæ or volcanic cinders. These were the general appearances at the copper pole occupied by the plumbago.

On the zinc pole, occupied by the prepared charcoal, there were very peculiar results. This pole was, in every instance, elongated towards the copper pole, and the black matter accumulated there, presented every appearance of fusion, not into globules, but into a fibrous and striated form, like the half flowing slag, found on the upper currents of lava. It was evidently transferred, in the state of vapor, from the plumbago of the other pole, and had been formed by the carbon taken from the hemispherical cavity. It was so different from the melted charcoal, described in my former communications, that its origin

from thè plumbago could admit of no reasonable' doubt. I am now to state other appearances which have excited in my mjnd a very deep interest. On the end of the prepared charcoal, and occupying, frequently, an area of a quarter of an inch or more in diameter, were found numerous globules of perfectly melted matter, entirely spherical in their form, having a high vitreous lustre, and a great degree of beauty. Some of them, and generally they were those most remote from the focus, were of a jet black, like the most perfect obsidian; others were brown, yellow, and topaz colored; others still were greyish white, like pearl stones with the translucence and lustre of porcelain; and others still, limpid like flint glass, or, in some cases, like hyalite or precious opal, but without the iridescense of the latter. Few of the globules upon the zinc pole were perfectly black, while very few of those on the copper pole were otherwise. In one instance, when I used some of the very pure English plumbago, (sawed from a cabinet specimen, and believed to be from Borrowdale,) white and transparent globules were formed on the copper side.

When the points were held *vertically, and the plumbago uppermost*, no globules were formed on the latter, and they were unusually numerous, and almost all black, on the opposite pole. When the points were exchanged, plumbago being on the zinc, and charcoal on the copper end, very few globules were formed on the plumbago, and not one on the charcoal; this last was rapidly hollowed out into a hemispherical cavity, while the plumbago was as rapidly elongated by matter accumulating at its point, and which, when examined by the microscope, proved to be a concretion in the shape of a cauliflower—of volatilized and melted charcoal, having, in a high degree, all the characteristics which I formerly described as belonging to this substance. Indeed, I found by repetitions of the experiment, that this was the best mode of obtaining fine pieces of melted charcoal.

In some instances, I used points of plumbago on both poles, and always obtained melted globules on both; the results were however, not so distinct as when plumbago was on the copper and charcoal on the zinc pole; but the same elongation of the zinc and hollowing of the copper pole took place as before. I detached some of the globules, and part-

ly bedding them in a handle of wood, tried their hardness and firmness; they bore strong pressure without breaking, and easily scratched, not only flint glass, but window glass, and even the hard green variety, which forms the aqua fortis bottles. The globules which had acquired this extraordinary hardness, were formed from plumbago which was so soft, that it was perfectly free from resistance when crushed between the thumb and finger, and covered their surfaces with a shining metallic looking coat. These globules sunk very rapidly in strong sulphuric acid—much more so than the melted charcoal, but not with much more rapidity than the plumbago itself, from which they had been formed.

The zinc of the deflagrator is now too far gone to enable me to prosecute this research any farther at present; as soon as the zinc coils can be renewed, I shall hope to resume them, and I entertain strong hopes, especially from the new improved and much enlarged deflagrator, which you are so kind as to lead me soon to expect from Philadelphia.

April 12.—Having refitted the Deflagrator with new zinc coils, I have repeated the experiments related above, and have the satisfaction of stating that the results are fully confirmed and even in some respects extended. The Deflagrator now acts with great energy, and in consequence I have been enabled to obtain good results when using Plumbago upon *both* poles. Parallelopipeds of that substance, $\frac{1}{5}$ of an inch in diameter and one inch or two inches long, being screwed into the vices connecting the poles, on being brought into contact, transmitted the fluid, with intense splendor, and became fully ignited for an inch on each side; on being withdrawn a little, the usual arch of flame was formed for half an inch or more. Indeed when the instrument is in an active state, the light emitted from the plumbago points, appears to be even more intense and rich than from charcoal; so that they may be used with advantage, in class experiments, where the principal object is to exhibit the brilliancy of the light.

On examining the peices in this, and in numerous other cases, I found them beautifully studded with numerous globules of melted plumbago. They extended from within a quarter of an inch of the point, to the distance of $\frac{1}{4}$ or $\frac{1}{3}$ of an inch all around. They were larger than before and per-

fectly visible to the naked eye; they exhibited all the col-
ours before described, from perfect black, to pure white,
including brown, amber, and topaz colours; among the
white globules, some were perfectly limpid, and could not
be distinguished by the eye from portions of diamond. In
different 'repetitions of the experiment with the plumbago
points, there were some varieties in the results. In one in-
stance only, was there a globule formed *on* the point; it
would seem as if the melted spheres of plumbago as soon as
formed, rolled out of the current of flame, and congealed on
the contiguous parts. In every instance, the plumbago on the
copper side, was hollowed out, into a spherical cavity, and
the corresponding peice on the zinc side, received an accu-
mulation more or less considerable. In most instances and
in all when the Deflagrator was very active, besides the glo-
bules of melted matter, a distinct tuft or projection was form-
ed on the zinc pole, considerably resembling the melted
charcoal, described in my former communications, but ap-
parently denser and more compact; although resembling
the melted charcoal, as one variety of volcanic slag resem-
bles another, it could be easily distinguished by an eye fa-
miliarized to the appearances. In one experiment the cav-
ity, and all the parts of the plumbago at the copper pole
were completely melted on the surface, and covered with a
black enamel. The appearances were somewhat varied
when specimens of plumbago from different localities were
used. In some instances it burnt, and even deflagrated,
being completely dissipated in brilliant scintillations; the
substance was rapidly consumed and no fusion was obtained.
This kind of effect occurred most distinctly when there was
a plumbago piece on the copper side, and a piece of char-
coal on the zinc side. I have already mentioned the cu-
rious result which is obtained when this arrangement is re-
versed, the charcoal on the copper, and the plumbago on
the zinc side; this effect was now particularly distinct and
remarkable, the charcoal on the copper side was rapidly vol-
atilized, a deep cavity was formed, and the charcoal taken
from it, was instantly accumulated upon the plumbago point,
forming a most beautiful protuberance, completely distin-
guishable from the plumbago, and presenting when viewed
by the microscope, a congeries of aggregated spheres, with
every mark of perfect fusion and with a perfect metallic lus-

tre.. I would again recommend this arrangement when the object is to attain fine. pieces of melted charcoal.

April 14.—In repeating the experiments to day, I have obtained even finer results than before. The spheres of melted plumbago were in some instances so thickly arranged as to resemble shot lying side by side; in one case they completely covered the plumbago, in the part contiguous to the point on the zinc side and were without exception white, like minute, delicate concretions of mammillary chalcedony ; among a great number there was not one of a dark colour except that when detached by the knife they exhibited slight, shades of brown at the place where they were united with the general mass of plumbago. They appeared to me to be formed by the condensation of a white vapour which in all the experiments, where an active power was employed, I had observed to be exhaled between the poles and partly to pass from the copper to the zinc pole, and partly to rise vertically in an abundant fume like that of the oxid proceeding from the combustion of various metals. I mentioned this circumstance in the report of my first experiments (see Vol. 5, p. 112 of this Journal,) but did not then make any trial to ascertain the nature of the substance. Although its abundance rendered the idea improbable, I thought it possible that it might contain alkali derived from the charcoal. It is easily condensed by inverting a glass over the fume as it rises, when it soon renders the glass opaque with a white lining. Although there was a distinct and peculiar odour in the fume, I found that the condensed matter was tasteless, and that it did not effervesce with acids, or affect the test colours for alkalies. Besides, as it is produced apparently in greater quantity, when both poles are terminated by plumbago, it seems possible that it is white volatilized carbon, giving origin, by its condensation, in a state of greater or less purity, to the grey, white, and perhaps to the limpid globules.

The Deflagrator having been refitted only at the moment when a part of this paper had already gone to the press, and the remainder is called for, I am precluded by these circumstances from trying the decisive experiment of heating this white matter by means of the solar focus in a jar of pure oxygen gas, to ascertain whether it will produce carbonic acid gas.

This trial I have this morning made upon the coloured globules obtained in former experiments,; they were easily detached from the plumbago by the slightest touch from the point of a knife, and when collected in a white porcelain dish, they rolled about like shot, when the vessel was turned one way and another. To detach any portions of unmelted plumbago which might adhere to them I carefully rubbed them between my thumb and finger in the palm of my hand. I then placed them upon a fragment of wedgewood ware, floated in a dish of mercury, and slid over them a small jar of very pure oxygen gas, whose entire freedom from carbonic acid, had been fully secured by washing it with solution of caustic soda, and by subsequently testing it with recently prepared lime-water: the globules were now exposed to the solar focus from the lens mentioned volume 5, page 363. It was near noon, and the sky but very slightly dimmed by vapour; although they were in the focus for nearly half an hour, they did not melt, disappear, or alter their form; it appeared however, on examining the gas that they had given up part of their substance to the oxygen, for carbonic acid was formed which gave a decided precipitate with lime-water. Indeed when we consider that these globules had been formed in a heat vastly more intense, than that of the solar focus, we could not reasonably expect to melt them in this manner, and they are of a character so highly vitreous, that they must necessarily waste away very slowly, even when assailed by oxygen gas. In a long continued experiment, it is presumable, that they would be eventually dissipated, leaving only a residuum of iron. That they contain iron is manifest, from their being attracted by the magnet, and their colour is evidently owing to this metal. Plumbago, in its natural state, is not magnetic, but it readily becomes so, by being strongly heated, although without fusion, and even the powder obtained from a black lead crucible after enduring a strong furnace heat, is magnetic. It would be interesting to know, whether the limpid globules are also magnetic, but this trial I have not yet made.

I have already stated, that the white fume mentioned above, appears when points of charcoal are used. I have found that this matter collects in considerable quantities a little out of the focus of heat around the zinc pole, and occasionally exhibits the appearance of a frit of white enamel,

or looks a little like pumice stone, only, it has the whiteness of porcelain, graduating however into light grey, and other shades, as it recedes from the intense heat. In a few instances I obtained upon the charcoal, when this substance terminated *both* poles, distinct, limpid spheres, and at other times they adhered to the frit like beads on a string. Had we not been encouraged by the remarkable facts already stated, it would appear very extravagant to ask whether this white frit and these limpid spheres could arise from carbon, volatilized in a white state even from charcoal itself, and condensed in a form analagous to the diamond. The rigorous and obvious experiments necessary to determine this question, it is not now practicable for me to make, and I must in the mean time admit the *possibility* that alkaline, and earthy impurities may have contributed to the result.

In one instance contiguous to, but a little aside from the charcoal points, I obtained isolated dark coloured globules of melted charcoal, analagous to those of plumbago.

The opinion which I formerly stated as to the passage of a current from the copper to the zinc pole of the deflagrator, is in my view, fully confirmed. Indeed, with the protection of green glasses, my eyes are sufficiently strong, to enable me to look steadily at the flame, during the whole of an experiment, and I can distinctly observe matter in different forms passing to the zinc pole, and collecting there, just as we see dust, or other small bodies driven along by a common wind; there is also an obvious tremor, produced in the copper pole, when the instrument is in vigorous action, and we can perceive an evident vibration produced, as if, by the impulse of an elastic fluid striking against the opposite pole.

If, however, the opinion which you formerly suggested to me, and which is countenanced by many facts, that the poles of the deflagrator are reversed, the copper being positive and the zinc negative be correct, the phenomena, as it regards the course of the current, will accord, perfectly well, with the received electrical hypothesis.

The number of unmelted substances being now reduced to two, namely, the anthracite, and the diamond, you will readily suppose I did not neglect to make trial of them, as however, the diamond is an absolute nonconductor and the anthracite very little better, I cannot say I had any serious hopes of

success. I have made various attempts, which have failed, and after losing two diamonds, the fragments being thrown about with a strong decrepitation, I have desisted from the attempt; having, as I conceive, a more feasible project in view.

I trust you will not consider the details of the preceding pages, as being too minute, provided the subject appears to you as interesting as it does to me. The fusion of charcoal and of plumbago, is sufficiently remarkable, but the evident approximation of the material of these bodies towards the condition of diamond, from which they differ so remarkably in their physical properties, affords if I mistake not, a striking confirmation of some of our leading chemical doctrines.

I remain as ever your faithful friend and servant,

B. SILLIMAN.

Art. XXI.—*Experiments upon Diamond, Anthracite and Plumbago with the compound Blow Pipe, in a letter addressed to Prof. Robert Hare, M. D. by the Editor.*

Yale College, April 15, 1823.

My Dear Sir,

Having last year, caused to be constructed, an apparatus, capable of containing fifty-two gallons of gas, for the supply of your compound, or, oxy-hydrogen blow pipe, and capable of receiving a strong impulse from pressure, I have been intending as soon as practicable, to subject the diamond, and the anthracite to its intense heat. Although their being non-conductors, would be no impediment to the action of the blow pipe flame on them, still, obvious considerations have always made me consider the success of such experiments, as very doubtful. I allude of course, to the combustibility of these bodies, from which we might expect, that they would be dissipated by a flame, sustained by oxygen gas.

My first trials were made by placing small diamonds in a cavity in charcoal, but the support was, in every instance, so rapidly consumed, that the diamonds were speedily displaced, by the current of gas. I next made a chink in a peice of solid quick lime, and crowded the diamond into it; this proved a very good support, but the effulgence of light was so daz-

ling, that, although, through green glasses, I could steadily
inspect the focus, it was impossible to distinguish the dia-
mond, in the perfect solar brightness. This mode of con-
ducting the experiment, proved, however, perfectly manage-
able, and a large dish, placed beneath, secured the diamonds
from being lost, (an accident which I had more than once
met with) when suddenly displaced by the current of gas ;
as however, the support was not combustible, it remained
permanent, except that it was melted in the whole region of
the flame, and covered with a perfect white enamel of vit-
reous lime. The experiments were frequently suspended,
to examine the effect on the diamonds. They were found
to be rapidly consumed, wasting so fast, that it was necessa-
ry in order to examine them, to remove them from the heat,
at very short intervals. They exhibited however, marks of *in-
cipient fusion.* My experiments were performed upon small
wrought diamonds, on which there were numerous polished
facets, presenting extremely sharp, and well defined solid
edges and angles. These edges and angles were always
rounded and generally obliterated. The whole surface of
the diamond lost its continuity, and its lustre was much im-
paired ; it exhibited innumerable very minute indentations,
and intermediate and corresponding salient points ; the whole
presenting the appearance of having been superficially soften-
ed, and indented by the current of gas, or perhaps of having
had its surface unequally removed, by the combustion. In
various places, near the edges, the diamond was consumed,
with deep indentations, and occasionally where a fragment
had snapped off, by decrepitation, it disclosed a conchoidal
fracture and a vitreous lustre. These results were nearly
uniform, in various trials, and every thing seems to indicate
that were the diamond a good conductor, it would be melt-
ed by the deflagrator, and were it incombustible, a globule
would be obtained by the compound blow pipe.

In one experiment, in which I used a support of plumba-
go, there were some interesting varieties in the phenomena.
The plumbago being a conductor, the light did not accumu-
late as it did when the support was lime, but permitted me
distinctly to see the diamond through the whole experiment.
It was consumed with great rapidity ; a delicate halo of blu-
ish light, clearly distinguishable from the blow pipe flame,
hovered over it ; the surface appeared as if softened, numer-

ous distinct but very minute scintillations were darted from it in every direction, and I could see the minute cavities and projections which I have mentioned, forming every instant. In this experiment I gave the diamond but one heat of about a minute, but on examining it with a magnifier, I was surprised to find, that only a very thin layer of the gem, not much thicker than writing paper remained, the rest having been burnt.*

I subjected the anthracite of Wilkesbarre, Penn, to similar trials, and by heating it very gradually, its decrepitation was obviated. It was consumed, with almost as much rapidity, as the diamond; but exhibited, during the action of the heat, an evident appearance of being superficially softened; I could also distinctly see, in the midst of the intense glare of light, very minute globules forming upon the surface. These when examined by a magnifier, proved to be perfectly white and limpid, and the whole surface of the anthracite exhibited, like the diamond, only with more distinctness, cavities and projections united by flowing lines, and covered with a black varnish, exactly like some of the volcanic slags and semi-vitrifications. The remark already made, respecting the diamond, appears to be equally applicable to the anthracite, i. e. that its want of conducting power, is the reason why it is not melted by the deflagrator, and its combustibility is the sole obstacle to its *complete* fusion by the compound blow-pipe.

I next subjected a parallelopiped of plumbago to the compound flame. It was consumed with considerable rapidity, but presented at the same time, numerous globules of melted matter, clearly distinguishable by the naked eye, and when the piece was afterwards examined, with a good glass, it was found richly adorned, with numerous perfectly white and transparent spheres, connected also by white lines of the same matter, covering the greater part of the surface, for the

* In Tilloch's Phil. Mag. for November 1821, Vol. 58, page 386, I observe the following notice by Mr. John Murray. " By repeatedly exposing a diamond to the action of the oxy-hydrogen blow-pipe in a nidus of *magnesia*, it became as *black* as charcoal, and split into fragments which displayed the *conchoidal* fracture.

It will be found, that this gem affixed in magnesia soon, flies off in minute fragments, exhibiting the impress of the conchoidal form.

In lately exposing the diamond fixed on a support of pipe-clay, to the ignited gas, I succeeded in completely *indenting* it :—examined it after the experiments, it exhibited proofs of having undergone *fusion*."

space of ½ an inch at, and around the point, and presenting a beautiful contrast, with the plumbago beneath, like that of a white enamel upon a black ground.

In subsequent trials, upon pieces from various localities, foreign and domestic, (confined however to very pure specimens,) I obtained still more decided results; the white transparent globules became very numerous, and as large as small shot; they scratched window glass—were tasteless—harsh when crushed between the teeth, and they were not magnetic. They very much resembled melted silex, and might be supposed to be, derived from impurities in the plumbago, had not their appearance been uniform in the different varieties of that substance, whose analysis has never, I believe, presented any *combined* silex, and neither good magnifiers, nor friction of the powder between the fingers, could discover the slightest trace of any foreign substance in these specimens. Add to this, in different experiments, I obtained very numerous perfectly black globules, on the same pieces which afforded the white ones. In one instance they covered an inch in length, all around, many of them were as large as common shot; and they had all the lustre and brilliancy of the most perfect black enamel. Among them were observed, here and there, globules of the lighter coloured varieties. In one instance the entire end of the parallelopiped of plumbago was occupied by a single black globule. The dark ones were uniformly attracted by the magnet, and I think were rather more sensible to it than the plumbago which had been ignited but not melted. We know how easily, in substances containing iron, the magnetic susceptibility is changed by slight variations of temperature. I am aware, however, that the dark globules may contain more iron than the plumbago from which they were derived, as the combustion of part of the carbon, may have somewhat diminished the proportion of that substance. I find that the fusion of the plumbago by the compound blow-pipe is by no means difficult, and the instrument being in good order, good results may be anticipated with certainty. As the press is waiting while I write, it is not in my power to determine the nature of all of these various coloured globules, and particularly to ascertain whether the abundant white globules are owing to earths combined with the plumbago, or whether they are a different form

of carbon. If the former be true, it proves that no existing analysis of plumbago can be correct, and would still leave the remarkable white fume, so abundantly exhaled between the poles of the deflagrator, and so rapidly transferred from the copper to the zinc pole, entirely unaccounted for. I would add, that *for the mere fusion* of plumbago, the blow-pipe is much preferable to the deflagrator, but a variety of interesting phenomena in relation to both plumbago and charcoal are exhibited by the latter and not by the former.

Hoping that if these subjects have not already engaged your attention, they will speedily do so, I remain my dear Sir, as ever, your friend and servant.

B. SILLIMAN.

POSTSCRIPT, April 18. FUSION OF ANTHRACITE.

The anthracite of Rhode-Island is thought to be very pure. Dr. William Meade, (See Bruce's Journal, pa. 36) estimates its proportion of carbon at ninety-four per cent. This anthracite I have just succeeded in melting by the compound blow-pipe. It gives large brilliant black globules, not attractable by the magnet, but in other respects not to be distinguished from the dark globules of melted plumbago. The experiment was entirely successful in every trial, and the great number of the globules and their evident flow from, and connexion with, the entire mass, permitted no doubt as to their being really the melted anthracite.

The Kilkenny coal gave only white and transparent globules; but it seems rather difficult to impute this to impurities, since this anthracite is stated to contain ninety-seven per cent. of carbon.

I have exposed a diamond this afternoon to the solar focus in a jar of pure oxygen gas, but observed no signs of fusion, nor indeed did I expect it, but I wished to compare this old experiment with those related above.

The diamond is now the only substance which has not been perfectly melted.

I inserted a piece of plumbago into a cavity in quick lime, and succeeded in melting it down by the blow-pipe into two or three large globules, adhering into one mass, and occupying the cavity in the lime; these globules were limpid, and nothing remained of the original appearance of the plumbago except a few black points.

Vol. VI.—No. 2. 45

ART. XXII.—*Fluoric Acid of Gay Lussac, and its application to the etching of glass.*—EDITOR.

As we have not seen any notice, that this powerful acid has been obtained in this country, we will briefly mention, that we procured it in full strength, during the late winter, and comparing it with the account given in the memoir, in the "Recherches Physico-Chimiques," of Messrs. Gay Lussac and Thenard, observed with much satisfaction that its properties fully justify their statement; not that we think their researches or those of Sir. H. Davy, needed confirmation, but, notices of interesting facts by different persons especially in different countries are not without utility.

The leaden apparatus, recommended for procuring pure fluoric acid, we have found so liable to fusion, and besides the failure of the experiment, and the loss of the apparatus, the fumes are so noxious and even dangerous, that we were induced to resort to the use of vessels of pure silver. For this purpose, an alembic* was made of the capacity of 16 fluid ounces, with a head and tube of the capacity of two and a half, and the tube was made to fit accurately the mouth of a silver receiver of the capacity of three and a half ounces. The latter (see the apparatus represented at fig. 7, plate 10.) was made, in the form of a bottle, and furnished with a silver stopper, ground so as to fit air tight; it being intended to serve, both as a receiver, and a containing vessel, for the acid, thus obviating the necessity of transferring it into another vessel.

Two ounces, of very pure fluor spar from Shawneetown were introduced into the alembic, and four ounces of sulphuric acid were added; there should be no excess of acid, lest it should attack the silver. The whole apparatus was placed under a flue; the receiver was kept cold by ice, and a few live coals being applied beneath the alembic, served to disengage the acid, which was condensed in the receiver, *without the aid of water.*

*The alembic was made thick and heavy, and furnished with a silver cap, so that it might be used without its head, as a large crucible.

The cost of the entire apparatus, alembic-head, tube, cap and receiver, was about sixty dollars.

An ebullition was soon heard in the alembic, and occasionally there was a puff of dense fluoric acid vapor, from the mouth of the receiver, which, to avoid explosion, was allowed to remain a little loose around the tube. We did not measure the acid which we obtained, but judged that it was about one ounce in quantity.

The fumes that occasionally broke out from the apparatus, instantly and powerfully corroded some articles of glass that were near by, and the contact of them with the skin or lungs, was most anxiously avoided. For this purpose, the hands were covered with very thick gloves, and the acid was never poured from the bottle, except under the flue.

Whenever the bottle was opened, a dense cloud of white vapor appeared, and when a drop of the acid was allowed to fall into water, it produced much the same commotion and noise as red hot iron; exciting great heat and ebullition. A few drops placed in a small concave copper dish, instantly inflamed potassium, which burnt with a bright light, and was immediately dissipated.

A drop of the acid, let fall into a dry wine-glass, or upon a dry glass plate, promptly corroded and dissolved the surface, with as much energy as that with which sulphuric acid acts on potash.

For the purpose of procuring an acid adapted to the purpose of etching on glass, the experiment was repeated, with this difference, that half an ounce of water was placed in the receiver. This acid however, proved too powerful for this purpose, as it corroded and destroyed the varnish* used to protect the glass. When it was diluted with three or four parts of water, it acted in the happiest manner. Plates of glass being properly prepared, with the composition of bees' wax and turpentine, and surrounded at the edge by a rim of the same substance, were perfectly etched in the course of a minute or two. The progress of the corrosion in the parts denuded by the graver, could be distinctly seen. The same portion of acid, by pouring it from one plate to another, served to etch several in succession; and indeed with

*The common *engravers' varnish* is very apt to be destroyed, even by a very weak acid; but we found that the varnish or mastick recommended by Gay Lussac and Thenard, made by melting together common turpentine and bees' wax, formed a perfect protection while the acid was of proper strength.

this active agent, even when largely diluted, it is necessary to be very much on our guard, lest the corrosion go too far, and attack the plain parts of the glass.

In this manner, the rich and beautiful picture, representing the Oto Council, as delineated in the atlas, illustrating the narrative of Major Long's expedition, was elegantly etched in two minutes.

We have, for a course of years, tried many experiments upon the etching of glass, by the fluoric acid *vapor*, and have usually succeeded more or less perfectly; but we can confidently recommend the *pure diluted acid*, as being entirely superior, in energy, neatness, and ease of management. Although the strong acid is violent and dangerous, in the extreme, and should be by no means allowed to touch the skin, either in the fluid or vaporous state, the diluted acid may be managed with ease and safety. Still, a pupil, who incautiously dropped some of the latter upon his hand, experienced inconvenience for six weeks—that period having elapsed before the sore was healed.

It is proper to remark, that whenever the acid was poured from the receiver, the latter was firmly grasped by tongs of a peculiar construction, in order to avoid the danger of having the liquid come in contact with the hand.

INTELLIGENCE AND MISCELLANIES.

I. Domestic.

1. Vindication of Mr. Henry Seybert's claim to the discovery of fluoric acid in the condrodite, (Maclureite of Mr. Seybert, yellow mineral of Sparta, N. J.)

Philadelphia, Feb. 25, 1823.

Sir,

But for some erroneous statements in Mr. Nuttall's reply to my letter of the 11th November, 1822,* our Controversy might have terminated. I feel it, however, a duty to

*See Journal of Science and Arts, Vol. VI. p. 168, & seq.

correct these statements, and the more especially, as it will be done with the aid of facts that are important in the history of the mineral in question.

Mr. Nuttall says, " If I am called upon, *as you are aware,* by Mr. H. Seybert to say when and where, I had *heard* of the existence of Fluoric acid in the Brucite or Condrodite, I might refer him back to a period when he was too young to have been acquainted with even the name of Chemistry."* I put no such questions to that gentleman : on a former occasion he told us, that " the condrodite, or Brucite, almost peculiar to Sparta, discovered likewise by the celebrated Berzelius, in Finland, accompanied by gray Spinelle is (*according to an unpublished analysis which I made in* 1820,) a Silicate of Magnesia with an *accidental* portion of Fluoric acid and Iron."† Mr. Nuttall did not then refer to any analysis made prior to that which he pretended to have made ; my protest was therefore *directly* against his being the discoverer of the fluoric acid in this mineral. From the fact contained in my letter, above referred to, Mr. Nuttall, *as far as concerns himself,* has been obliged to renounce every pretension, heretofore made by him, on that subject. Mr. Nuttall seems still disposed to believe, that the fluoric acid in this mineral is an *accidental* ingredient, and he attributes its presence to "the contiguity of slender veins of fluate of lime to the masses of condrodite or Brucite near to Franklin furnace, at Sparta."‡ The fact, however, is that *Sparta* is six miles distant from Franklin furnace, and I do not know, that any one has hitherto announced that *fluate* of lime, lies contiguous to the carbonate of lime in which the Maclureite at *Sparta* is imbedded. I found none of it when I examined that locality. What influence the fluate of lime, at Franklin furnace, may have had in the composition of the Sparta mineral, I must leave to be determined by those who are more disposed than I am, to speculate on this subject. Again, if fluate of lime had been found *contiguous* to the Maclureite of Sparta, what chemist would pretend, that the magnesia in the latter

*See Journal of Science and Arts, Vol. VI. p. 171.

†Ibid, Vol. V. p. 245.

‡Ibid, Vol. VI. p. 172.

would have decomposed the former, to combine with its fluoric acid. In support of this belief, Mr. Nuttall tells us, that this mineral has been found at West-Point, in New-York, and that it has been observed with idocrase and mica from Vesuvius : he then says, " in these no trace of fluoric acid has as yet been discovered." To obviate this seeming objection, I will ask Mr. Nuttall if he knows, that the constituents of the specimens from the localities which he has cited, have been ascertained. As far as my knowledge, extends, no chemist has yet analyzed them, and I confidently anticipate, that when they shall be examined they will all prove to be *fluo-silicates of magnesia.* Analogy authorises such anticipations. *If we even admit,* that no fluoric acid has yet been discovered in the cases cited by Mr. Nuttall, we are not thence to infer, that this acid does not exist there, because we know that, that acid escaped the notice of Berzelius, when he analyzed the condrodite, found in Finland, and that I afterwards detected it in that mineral, though no *fluate of lime* accompanied the specimen which I examined.*

In the next place Mr. Nuttall tells us, that the Sparta mineral " was announced by Professor Cleaveland in his *first* edition of Elements of Mineralogy *under the name of Brucite.*" I am surprised at this assertion and will thank Mr. Nuttall, to point out the page in Cleaveland's *first edition,* where the word " *Brucite*" is imprinted. I maintain that it cannot be found in any part of that valuable work.

The term " Brucite" was announced, for the first time, in 1819 to be " a new species in mineralogy, *discovered by the late Dr. Bruce.* We hope to publish in the *next* number a description and analysis of it."† Notwithstanding the anxiety for an analysis of what some now pretend to be this mineral, none was published prior to mine, in 1822,‡ although *eight* numbers of Professor Silliman's Journal, appeared subsequently to its being mentioned in that work. I maintain, that Dr. Bruce considered the Sparta mineral, a *silico calcareous oxide of titanium.* For my proofs, I refer

*Journal of Science and Arts, Vol. V. p. 366.

†Ibid, Vol. I. p. 439.

‡Ibid, Vol. V. p. 336

to the Mineralogical Journal of Dr. Bruce,[†] to Professor
Cleaveland's works,[‡] and the late illustrious Haüy.[§] The
last named philosopher has told us, that he received some
specimens of this mineral from *Doctor Bruce*, with the in-
formation that it was a *Silico Calcareous Oxide of Titanium*,
and that he, relying upon the Doctor's account of it, adopt-
ed the error, until it was removed by his own crystallo-
graphical investigation, and by Berzelius' account of the
analysis which he made of it; he then considered it a *Sili-
cate of Magnesia*,[||] substituting one error for another. Such
was the state of their knowledge, on the continent of Eu-
rope, concerning the composition of this mineral, at the
close of 1821, and in Great-Britain, they had made no fur-
ther progress concerning it in 1822.[*]

Notwithstanding the facts above referred to, Mr. Nuttall,
in his reply, relates that Dr. Langstaff, of New-York, as
long ago as 1811, analyzed the Sparta mineral, and he then
gives the doctor's account of it as follows, viz. "it yielded
about,

Silex	- -	32
Oxide of Iron	-	6
Magnèsia	-	51
Water	- -	2 and by *abstraction*,
Fluoric Acid	-	9
		100

The reader will estimate the value and necessity of the
word "*about*" in the foregoing statement, when the num-
bers given conduct us to so exact a result! Dr. Langstaff
was a pupil in Dr. Bruce's Laboratory, and it is *now* as-
serted, that the above analysis was made there in 1811.
Is it probable, if such had been the fact, that Dr. Bruce
would have remained, until his decease, ignorant of it? or
that, if he had known it, he would, several years thereaf-

[†]Bruce's American Mineralogical Journal, Vol. I. 239.

[‡]Cleaveland's Mineralogy, p. 158, *first* edition, 1818.

[§]Annales des Mines, Vol. VI. p. 527.

[||]Ibid.

[*]Journal of the Royal Institution of G. B. Vol. XII. p. 329.

ter, consider this mineral a *Silico Calcareous Oxide of Ti-
tanium*, and make a misstatement to Haüy? Can we sup-
pose that Dr. Langstaff would have withheld this information
until December, 1822, *eleven years* after he claims
to have made the discovery? Why did he not add his
analysis* to the short notice of the Brucite, when it
was first announced in 1819? It was then named to
the world, without an indication of any one of its *phys-
ical* or *chemical* characters; not a word was even said
about the bed where nature had cast it! These gentlemen
might with equal propriety claim any new substance con-
taining fluoric acid and magnesia. Notwithstanding all
their efforts, not one of them has cited a single experiment
which he made with this mineral! When Mr. Nuttall first
claimed the discovery of the fluoric acid, in the Sparta min-
eral, he at the same time said, that his results were con-
firmed by Dr. Torrey's experiments.† Why did he then
neglect the more important one which he now urges in fa-
vor of Dr. Langstaff? he alone can account for the omis-
sion. In his late reply to me he says, that Dr. Torrey, *five
years ago,* " also found the existence of fluoric acid, as
well as the other ingredients mentioned in the analysis of
Dr. Langstaff."‡ From these statements it would seem,
that Dr. Langstaff, in 1811, made an analysis of the
mineral from Sparta, and that his results were confirm-
ed by Dr. Torrey in 1817; still the *Brucite* was introduced
to the scientific world in 1819, only with its name, without
character, and regardless of its birth-place! Now they even
dispute who discovered this mineral. Whilst Dr. Bruce *liv-
ed,* that merit was given to him; but since the decease of
that gentleman, his former pupil, Dr. Langstaff, claims the
discovery for himself! This might be considered of no
consequence to the question, did it not prove, how opinions
concerning facts, that we supposed long ago well establish-
ed, have been changed to answer temporary purposes.

When the name " Brucite" first occurred in the Journal
of Science and Arts, I supposed it was intended to desig-

*The annunciation of that mineral was made, not at the instance of Dr.
Langstaff, but by the request of Col. Gibbs; the promised analysis was,
however, never forwarded.—Ed.

†Journal of Arts and Science, Vol. V p. 245. ‡Ibid, Vol. VI. p. 172.

nate the *red oxide of zinc,* discovered near Sparta, and first analyzed by the late Dr. Bruce; there was great reason for this opinion, because we derived our knowledge of that new species from the labors of that gentleman. In conclusion it is presumed, that no new claimants will urge further pretensions, and I flatter myself, that the facts which have been stated will satisfy every candid reader. I have to express my regret for the necessity of this appeal, but, at the same time, hope you will consider it entitled to a place in the next number of the Journal.

With sentiments of regard and esteem,

your obedient servant,

H. SEYBERT.

2. *Abstract of the Proceedings of the Lyceum of Natural History, New-York.*

Mr. Pierce read some "observations on the Geology of the Catskill Mountains," (pub. in No. 9, of this Journal,) and presented a collection of minerals and fossils from the district described.

Dr. Van Rensselaer presented a perfect specimen of the Cyperus papyrus, collected by himself from the river Anapo, near Syracuse, in Sicily, accompanied by a paper illustrative of its natural history, and its uses in the arts.

Dr. Dyckman, in the name of Dr. Stevenson, presented a collection of Plants, and a box of minerals from France.

A letter was received from Mr. Pierce, announcing the discovery of a copious chalybeate spring near Litchfield.

Mr. Blunt presented some fine specimens of Zoophites from Bermuda.

A paper was read by Dr. Dekay on a new and beautiful species of Sertularia, from the bay of N. York, the *S. utricularis,* with the following specific characters. S. caule simplici, vesiculis utricularibus diaphanis, ore stricto, margine nigro, &c. it is nearest allied to the S. cupressina. By a letter since received from the celebrated Lamouroux, it appears he has adopted the name and description.

Mr. Emmet read a report on an ore of iron from the Highlands of N. York, which was referred to him for examination. It is a magnetic oxide of a granular texture, mixed with a substance resembling quartz in appearance, of

a yellowish white colour, and nearly opaque. This substance Mr. Emmett submitted to a number of experiments, and determined it to be a phosphate of lime. It is probably the cause of that property of iron, called *red-short.*

A note was received from Mrs. Mitchill, accompanying a valuable donation of Shells.

A paper from Mr. Jacob A. Vandenheuvel was read on the domestic origin of N. American Bees, and many interesting particulars of the Honey Bees of Guiana, S. America accompanied by a case containing twenty species, collected by himself. Pub. in No. VII, this Journal.

Dr. Akerly presented a suite of Potter's clay from different States.

Dr. Torrey presented specimens of plants collected by himself on Long-Island, among which were several new species of the myriophyllum and Fuirena.

Mr. Halsey presented a collection of plants from the vicinity of New-York.

The committee reported a new species of Sphex carolina, and another species of Sphex from parasitic chrysalids.

A letter was read from Mr. Prince, communicating the fact of a new chesnut produced by the intermixture of the castanea vesca, and the castanea pumilla. Specimens of the Hybrid were shown. Pub. in No. VII, this Journal.

Dr. Torrey presented a collection of plants made by himself in the Pine Barrens of New Jersey.

A letter was read from Mr. Schoolcraft containing observations of himself, and others during the Exploring Expedition to the N. West, with a drawing of the Sand tree of Michigan, described in his Journal, since published.

A memoir on the cetaceous animals was read by Dr. Dekay. It would appear that out of twenty species belonging to this order, thirteen are found occasionally in our waters.

Col. Gibbs presented, through Dr. Torrey, some fine specimens of Iron ore, and of the corundum of Naxos.

A communication was received from Major Delafield with a valuable donation of minerals and organic remains, collected by him on the northern boundary of the U. S. The fossils and sulphates of Strontian are peculiarly beautiful.

President Mitchill communicated some interesting particulars of the Xyphias Gladias.

Dr. Van Rensselaer presented a collection of dried plants from the Alps of Savoy.

Mr. Anderson presented specimens of graphite from Pensylvania and some pencils manufactured from the same, on which a committee reported favourably.

President Mitchill communicated a description of an animal brought by Mr. Schoolcraft from the regions situated around the sources of the Mississippi. It is a beautiful animal, and resembles the Sciurus Striatus, or ground squirrel. Dr. Mitchill terms it *S. tridecem lineatus,* or *Federation squirrel,* in allusion to its thirteen stripes and numerous spots. A detailed account has been published in the New-York Med. Repos. new series, Jan. 1821. The President at the same time exhibited a dried specimen of the mus bursarius, gopher or pouched rat, (brought by Capt. Douglass,) from Lake Superior, with some observations upon it. Pub. No. IX, this Journal.

A communication was received from Dr. Dekay, with a collection of minerals made by himself in France and Great Britain.

A letter was laid on the table from Mr. J. Blunt, accompanied by a bone of a Mastodon from Catskill Mountains.

Dr. Dekay communicated a description of a species of Ophisaurus, from the borders of Lake Michigan, brought thence by Capt. Douglas. It was conceived to be a new species and was named O. Douglasii.

Some remarks were read from President Mitchill on the Proteus Anguinas of Carniola and on the Siren Lacertina of Carolina, and a letter from Judge Woodward on the tides of Lake Erie.

A paper was read by President Mitchill on the Coca of Peru, *Erythoxylon Coca,* much used by the natives for food and medicine.

Mr. Schoolcraft presented some minerals and fresh water shells collected during the Exploring Expeditions to the N. West, under Gov. Cass. Mr. Barnes, from the committee on these shells, reported several new species and varieties, particularly of the genus Unio, and announced his determination of a more detailed report.

Collections of minerals from New South Shetland, and one of pumices from the same place was presented by Capt. Mackay and Capt. Johnson.

Dr. Torrey read a report on the ceraphron destructor, a parasitic animal that preys upon the cecidomya destructor, and which has been supposed erroneously to be injurious to wheat.

A communication was received from Dr. S. P. Hildreth on a species of Spatularia from the Ohio, supposed to be new.

A valuable donation of Scientific books received from Mr. J. Eastburn.

President Mitchill presented a description and specimen of a new species of Scomber, which he named *S. quinque aculeatus.*

A donation was received from Dr. Hosack of a splendid copy, of Wilson's Ornithology in 9 vols.

Mr. Barnes read an Essay on the Geology of the region around New Lebanon. Published in No. XI this Journal.

The Rev. Mr Schaeffer read a paper on a fossil bone (head of the tibia) of a mammoth found in Lancaster Co. Penn. Ten large bones were found, but most of them were too much decomposed to be preserved.

Mr. Halsey read a paper on the cheirostemon pentadactylon of Humboldt.

Mr. Barnes read a paper on a new species of bivalve molusca, found by Mr. J. Cozzens near New-Orleans, and which Mr. B. names *Mytilus Striatus.*

Dr. Torrey communicated a locality of cyanite, discovered on the island of New-York, by Mr. J. Cozzens. This mineral had not before been observed in, the vicinity of New-York.

A drawing and description of the Balenopterus acuto-rostratus was presented by Dr. Dekay. This animal was taken off Sandy Hook, and exhibited as a curiosity in this city.

Mr. Barnes read an Essay on the Genera Unio and Alasmodonta. Pub. in No. XIII this Journal.

Dr. Van Rensselaer read an Analysis of Dr. J. W. Webster's Work on the Geology of the Azores, accompanied by Observations on the Lavas and Pumices of the Lipari Islands, in the Mediterranean.

Dr. Torrey read a description and analysis of a new mineral from Richmond Mass. It is nearly a pure Hydrate of Alumine, and is named Gibbsite, in honor of a distinguished American Mineralogist. Pub. in the New York Med. and Phys. Journal.

President-Mitchill communicated an account of his dissection of the Balenopterus acuto-rostratus lately exhibited.

A communication was received from Dr. Beckwith accompanying specimens of the natural wall in North Carolina.

Dr. Torrey reported that a mineral from Hudson, N. Y. presented by Mr. Barnes, was a variety of Jade, called Nephrite. It much resembles the Nephrite of Rhode-Island, being infusible by the blow pipe.

Dr. Torrey read a memoir on the Usnea fasciatà, a new cryptogamic plant from New South Shetland, with an accompanying letter from Dr. Mitchill. Pub. in No. XIII this Journal.

A communication was received from Major Delafield, detailing information of a gun of ancient construction found in the Chesapeake, covered with siliceous pebbles, forming puddingstone.

A valuable donation of books was received from Col. Gibbs, and another from Dr. Dekay.

The President read a communication on the progress of Natural History during the recess of the Lyceum since May last.

Mr. Barnes read a description of a new species of Mytilus, from New South Shetland, which he names *M. Antarcticus.*

Dr. Torrey communicated an account of a new locality of Stilbite and Laumonite. They occur in small crystals in a cellular felspar near cold spring in the Highlands of New York. The Stilbite was described in No. XII. The Laumonite is disseminated with the Stilbite, but is in much smaller quantity. It occurs in small white four sided prisms, nearly right-angled, with summits very obliquely truncated. The lateral planes are distinctly striated longitudinally.

Mr. J. Cozzens read a paper on the acid existing in the berries of the common sumac, (Rhus glabrum) detailing the experiments by which he has ascertained it to be *malic acid* in nearly a pure state.

Dr. Torrey laid on the table specimens to illustrate his intended paper on the minerals of Sparta, N. J.

A combination of unavoidable circumstances has prevented the earlier appearance of this abstract. It is intended to give a notice of the proceedings of the Lyceum, in each succeeding number of this Journal.

3. *Efficacy of Prussic Acid in Asthma.*

To the Editor.

From THOMAS HUBBARD, M. D. President of the Medical Society of Connecticut.

Sir,

By your politeness I was furnished, about three years since, with a vial of Prussic Acid, prepared by M. Robiquet, according to the directions of Dr. Magendie of Paris.

Since that time, I have made use of that, and several other portions of that medicine. The disease in which I have found it most useful is Asthma, and for the purpose of recommending trials of that medicine in this disease, I am induced to make this communication.

Without going into the detail of the cases, I barely state the fact, that I have not failed to relieve the disease in a single instance, in which I have prescribed the prussic acid, and some of the cases have been very severe, and many other means of relief had been tried in vain.

I do not think proper to mention the particular doses of the medicine, as it is found of unequal strength in the shops, and being a medicine of great power, it ought not to be administered without the direction of a physician. Suffice it to say, that the medicine should be given three, four, five, or six times in twenty-four hours, in such doses as may produce its peculiar effects, in some degree, on the system.

In a few days the symptoms will probably abate, when the medicine may be given in smaller or less frequent doses, and if the symptoms entirely disappear, the medicine may be wholly omitted.

I do not pretend that the disease may not recur; but in each subsequent occurrence, by an early administration of the medicine, the paroxysms may be abated in violence and duration, by which means the general health of the patient will in most cases improve.

This I consider of great consequence in such a distressing disease as this is, in some instances. I know a gentleman

who has usually kept it by him for two years, and resorts to it with, as much confidence of relief, as a patient whose pains had been repeatedly relieved by opium, has recourse to that medicine.

Sometimes he has not had occasion to use the acid for three or four months in succession.

Pomfret, March 24, 1823.

4. *Notice of Dr. Beck's Gazetteer.*

(Communicated.)

"*A Gazetteer of the States of Illinois and Missouri,*" 8vo. pp. 352. by Lewis C. Beck, A. M. has lately been published by C. R. & G. Webster, Albany. Dr. Beck is a Member of the New-York Historical Society, and has resided sometime in Missouri. By traversing a considerable portion of these States, by the aid of several intelligent gentlemen in them, by access to the records of the States, and by other means, Dr. B. had accumulated a mass of materials which he has formed into this work, and which make it very valuable to the citizens and travellers, and very interesting to all who desire information respecting this important section of our country. The Gazetteer contains a "general view of each State—a general view of their counties—and a particular description of their towns, villages, rivers, &c. &c." It is accompanied by a map, " protracted from manuscript surveys, obtained at St. Louis and Vandalia," which appears to have been formed with great care. There are also several other engravings. illustrative of the descriptions of particular objects. The "general view" of each State embraces those particulars which belong naturally to Geography, as well as antiquities, land districts, history, minerals, &c. The botanical names of the principal genera of plants in Missouri, and of the trees of Illinois, are also given, and will be relied on by all who know the success of Dr. B. in the science of Botany. A Gazetteer must of necessity be, to a certain extent a compilation; but the reader will find abundant proof of Dr. B.'s diligence, research, and originality. The arrangement would perhaps be improved by placing all the towns, &c. in both States, in one alphabetical arrangement instead of two. The work is

well composed and neatly printed, and deserves the patron-
age of the public. The article, *Military, Bounty Tract*, p.
128, and p. 291, contains much very important information
to the settlers, and those who propose to remove to these
States. The articles, *Pike County, Fort Chartres, Fort
Dearborn, Monk Mound,* and *Vandalia,* under Illinois ; and
Fenton, Noyer Creek, St. Louis, Strawberry River, under
Missouri, are particularly interesting.

On page sixteen, the length of the Ohio River is stated
to be one thousand one hundred miles, but the true length
is, by actual measurement, according to Mr. Darby*, nine
hundred and forty-eight miles.

On p. thirteen, is a correction of a mistake in Mr. School-
craft's "Narrative Journal," which was repeated in the
North-American Review, No. 36, respecting the average
descent of the Mississippi. Mr. S. states the elevation of
the source of the Mississippi to be one thousand three hun-
dred and thirty feet about the tide water of the Hudson,
and the length of the river, three thousand and thirty miles.
This would give an average descent of nearly forty-four
hundredths of a foot, or about five and a quarter inches a
mile. This is a far less descent than is given either by Mr.
S. or the Reviewer. This mistake was early pointed out
to the latter, and is too considerable not to merit attention,
especially as this descent is to account for the rapid current
of the Mississippi, whose velocity is generally estimated
from three to four miles, and by Dr. Beck, from two to
four miles an hour. The velocity acquired in falling, with-
out resistance, through five and a quarter inches, is about
one foot and a half a second, and would be the velocity of
the river, if there were no resistance. Allowing this to be
the mean velocity of the river, it would be only one mile
and one forty-fourth an hour. But considering the resist-
ance from the bends, sand-banks, counter-currents, &c. it
cannot be supposed that, with only this descent a mile, the
velocity can be more than one mile an hour. Mr. Darby
thinks that the velocity of the current has been much over-
stated, and that "below the Ohio the entire mass does not
move as much as one mile an hour,"—that even the veloci-
ty of the upper current is much less than has been general-
ly stated. He also estimates the descent of the Mississippi

*Art. Mississippi River, in the New Edinb. Encyc.

below the Ohio, at only three and a half inches a mile,
which would produce, were there no resistance, a velocity
of only eighty-five hundredths of a mile an hour. He also
estimates the elevation of the source of the Mississippi* to
be less than that given by Mr. Schoolcraft; and, if the tide
water of the Hudson is lower than the waters of the Gulf
of Mexico, the descent of the Mississippi must be propor-
tionally diminished. It seems pretty evident that the al-
lowed velocity of the river is too great for the estimated
descent. It is certain, at least, that a more accurate de-
termination of the velocity of the current, as well as of the
elevation of the source of the Mississippi, is very desirable;
and it is to be hoped that the remarks in Dr. Beck's Gazet-
teer will lead some of the western gentlemen to a satisfac-
tory result on one or both of these particulars. D.

5. *Dr. Comstock's Grammar of Chemistry.*

In the fifth volume of this Journal, the publication of this
work was mentioned. We by no means hold ourselves
responsible to give opinions of new works, but we owed the
respectable author of this manual, good-will enough to have
sa;d a few words on the merits of his book, had it not been
postponed from *mere inability to peruse it.*

If our opinion be of any consequence in this case, we are
gratified in saying that Dr. Comstock has executed his
work with very creditable ability and address. It is concise,
perspicuous and select, and bears strong internal evidence
of being the offspring, to a great extent, of a *practical man,*
who writes with the precision which can be derived from
experience alone. Those chemical compilations which are
made by men who have never performed what they describe,
resemble the fictitious travels of imaginary adventurers, who
delineate countries which they have not seen. In chemis-
try, the *audivi* may give a man many good ideas, useful to
himself; the *vidi* will still more enlarge his knowledge—
but it is only the *feci* which qualifies him to instruct others.
Dr. Comstock's experiments are well chosen, well-describ-
ed, and made intelligible and *practicable* by wood cuts in-
serted in the pages of the work.†—*Ed.*

* Art. *Navigation Inland,* in the New Ed Encyc.

†Perhaps it is a mark of his good judgment and prudence that he has omit.

6. *Mineral Caoutchouc.*

This remarkable mineral, hitherto nearly or quite confined to the Owdin mine at Castleton, in Derbyshire, has been recently found at Southbury, twenty miles N. W. of New-Haven. This region is a secondary trap basin (see Vol. II pa. 231 of this Journal) and although only six or eight miles in diameter, it presents all the characteristics of the great trap region of Connecticut and Massachusetts described by Mr. Hitchcock. Among other things, it contains slaty rocks with bituminous minerals; these have induced a research for coal which is now going on. We understand that they find bituminous slate or shale with small veins of coal. Specimens confirming this statement are now on the table, and they exhibit fibrous limestone, forming very distinct veins, or rather layers, running parallel with, and lying between those of the slate. The fibres of the satin spar or fibrous limestone, are one inch and more in length; they are often cracked in the direction of the fibres and between them there are veins occupied by the mineral caoutchouc. It has but little elasticity, it is soft, easily impressible by the nail, and compressible between the fingers like potassium, and can be formed into a perfect ball; its colour is jet black; some varieties of it are a little harder, and have a resinous and splendent lustre, and a flat conchoidal fracture; it burns with extreme brilliancy with much black smoke and an odour between that of a bitumen and that of an aromatic; during the combustion, drops of liquid fire fall in a stream, or in quick succession, and with a whizzing noise exactly like the vegetable caoutchouc and it melts precisely as that substance does. Rubbed on paper it leaves a black streak and acquires a high polish, it does not remove pencil marks from paper. The veins containing this mineral are about one quarter of an inch wide and several inches long.—*Ed.*

April 10, 1823.

ted to describe the most dangerous fulminating preparations, lest his readers should incur injury from attempting the experiments. There are a few typographical errors; the most important which we observed is, that hydrogen stands as the basis of nitric acid, (p 21.) We do not observe any table of errata. This little work cannot fail to be very useful in schools, and to private experimenters, and contains a great deal in a small compass.

7. *Hudson Marble.*

The territories of the United States are rich in marbles, well adapted by their beauty and firmness, to architectural and sepulchral and other ornamental, as well as useful purposes. We have omitted as yet to mention one which is wrought by Mr. Charles Darling at Hudson, and is obtained from the vicinity of that town. We did not see this marble *in place*, but no geologist would hesitate on inspecting it, to refer it to the transition class, and indeed Hudson is in the midst of that strip of transition country, which Mr. Maclure designates in his geological map, along both sides of the Hudson.

This marble is of a greyish colour, with a slight blush of red; its structure is semi-crystalline and in some places highly crystalline, especially in and around the organized bodies, which, in vast numbers, it embraces. Among them, the encrinite, is very conspicuous, and frequent, and when the marble is polished, the organized bodies, congealed in a bright calcareous bed, and often more brilliant themselves than the medium in which they are fixed, give it a very fine effect; this is particularly true in large slabs, which present great diversity of appearance and could scarcely be distinguished from the similar transition marble of the Peak of Derbyshire which it greatly resembles, and quite equals in beauty and firmness.—*Ed.*

8. *Thermometers.*

We have observed with satisfaction, the progressive improvement in this country, in the manufacture of glass in its most important branches, and especially of thermometers, so indispensable to all researches on heat, and to many arts, depending on its laws. Mr. Fisher of Philadelphia, Mr. Pool of New-York, and Mr. Pollock of Boston, (besides probably others not within our knowledge or recollection) are advantageously known to the public, as manufacturers of thermometers, and of various articles, of philosophical apparatus. Their situation, in our principal cities, gives them facilities for being known, and for introducing their articles to the public approbation which they have justly obtained.

Perhaps it is not generally known, that in one of our villages, excellent thermometers, of every variety of construction, may be obtained. They are the work of a self taught artist, Mr. Thomas Kendall Jr. of New Lebanon, whose ingenious device for graduating tubes of unequal bore, is mentioned at pa. 398, Vol. 4, of this Journal.* We have several of Mr. Kendall's thermometers, constructed for particular purposes, and with which, as regards both the neatness and accuracy of their execution, we have every reason to be well satified. Some of them are particularly convenient, as they are constructed with naked balls, and with the contiguous part of the tube descending below the scale, which fits them for immersion in liquids, at the same time that they are conveniently packed in travelling cases, and will answer well for chemical, medical, and meteorological observations.

We are assured that upon Mr. Kendall's plan of graduation, if the bore of a tube is of a regular *taper*, there is no more difficulty in making a correct thermometer of it (even if it varies so much, that the space necessary for three degrees at one end makes but two at the other,) than of one that is uniform throughout.

The substance of Mr. Kendall's improvement, we understand to be, a method of dividing right lines into any number of parallel divisions, with equal ease and accuracy, whether equal or unequal: applicable to the manufacture of mathematical instruments, but more particularly to the graduation of thermometer scales, which almost universally require unequal divisions. This method may also be applied to the division of circles, and would be of great use to the artist in manufacturing machinery which required a great number and variety of cogs, as with an engine constructed on this principle, one number would be as easily obtained as another.—*Ed.*

9. *Salem Manufacture of Alum, &c.*

We contemplate with particular satisfaction, every advance made in our domestic arts and manufactures, and re-

* It will not diminish the value of that notice, if we mention, that it was written by the late Professor Fisher, after mature consideration of the subject.

gard every new step of this kind, as an addition to our national resources.

Excepting the natural alum of the caverns in Tennessee and of some other regions of the West and South, and that, occasionally found, in our schistose rocks, and used in these cases, more or less, for domestic dyeing, and other purposes, we were not aware that the United States possessed any resource for this article independent of the foreign markets.

Some time since, we were informed that a manufactory was established at Salem in Massachusetts, and the proprietors have recently put us in possession of a set of specimens, which prove that the effort has been completely successful.

Among the crystals of alum, are some of great size, and exquisite beauty and transparency, exhibiting to the naked eye, in a very striking manner, the successive layers of super-position and the progressive increments and decrements. A part of an octaedron lies before us, complete, except on the side where it adhered to the mass. It measures nearly five inches by four, and has the most perfect finish on its faces, and solid edges and angles, which are in every part, replaced by truncations. Some crystals of rather smaller size are quite or nearly perfect. We are aware that fine crystals of alum are not rare in manufactories, but we have not seen these equalled even by the similar productions of the celebrated establishment near Glasgow. There can be no question from the appearance of these crystals, as well as from that of the amorphous masses, of the extreme purity of these materials. Perhaps they are even purer for this reason, that the alum is not manufactured (as we understand,) from the usual source, namely, the decomposed alum slates, but from the direct synthetical union of sulphuric acid with the argillaceous earth.

The sulphate of copper, (blue vitriol,) made at this establishment, is equally perfect in its kind, presenting crystals of extreme finish and beauty.

The skill manifested in the manufacture of these articles, clearly evinces, that the persons conducting this establishment, are quite equal to the task which they have undertaken, and are fairly entitled to the public confidence.—*Ed.*

10. *Geological Survey on the Great Canal.*

The patroon of Albany, the Hon. Stephen Van Rensselaer, with his usual liberality, has undertaken the expense of

procuring a Geological survey, to be made of the whole re-
gion, contiguous to the great canal, and of all the interesting
tracts in its vicinity, extending from Albany to the Falls of
Niagara. For this purpose, he has employed Professor Amos
Eaton, with the aid of several assistants, and their task is al-
ready advantageously commenced. Mr. Eaton is well known
to the public as an active, industrious, and faithful observer,
and we look to a happy issue of this great enterprise, which
we trust will be honourable to all concerned.—*Ed.*

11. *Expedition of Major Long and party, to the Rocky Moun-*
tains.

We have recently perused, with great satisfaction, the
narrative of the expedition of Major Long and party to the
Rocky Mountains, by order of the government of the Uni-
ted States. This narrative is contained in two large octa-
vo volumes, illustrated by an atlas with maps, geological
sections, and perspective views. The happy and success-
ful execution of this arduous enterprise reflects equal honor
upon the government who patronized, and upon the gentle-
men concerned in the expedition.

Their commission included the geographical and physic-
al features of the country, the details of Botany, Zoology,
Geology and Mineralogy, the condition of the native tribes,
the climate, and in short every thing which could be inter-
esting, either to science or politics. This difficult task was
most ably and faithfully executed, and if it were consistent
with the design or limits of this work to attempt an analysis
of the volumes in question, we should find the task very dif-
ficult, because it is scarcely possible to abridge the interest-
ing and important details with which they abound.

A successful generalization may indeed be exhibited, with
respect to the geological features of the country; but it
would be unhappy to exhibit the subject in a state less per-
fect than that which it assumes in the narrative itself.

We perused with no small regret the account of the vast
sandy desert which, for the distance of five hundred miles
from the feet of the Rocky Mountains, presents a frightful
waste, scarcely less formidable to men and animals, than
the desert of Zahara; and we contemplated with admira-

tion and sympathy, the toils and sufferings and perils, encountered by the adventurers, who, on more than one occa-sion were near starvation, or on the point of being over-whelmed by hordes of barbarians.—*Ed.*

12. *Philadelphia Water Works.*

This fine city is now abundantly supplied with good water, from the Schuylkill, 'and a magnificent establishment for that purpose is completed at Fair Mount, five miles above the city at the falls of the Schuylkill. The entire expense including the purchase of the scite is $426,330, but the money appears to have been well bestowed, as the success of the experiment is complete. The river at the falls is about nine hundred feet wide; the depth at high water is thirty feet; its average rise and fall is six feet, and it is liable to sudden and violent freshets. "The whole length of the overfall is one thousand two hundred and four feet, and the whole extent of the dam- including the western pier about one thousand six hundred feet," backing the water up the river about six miles.

The water power created, is calculated to be equal to raise into the reservoir by eight wheels and pumps, upwards of ten millions of gallons per diem. The river, in the dry season, will afford four hundred and forty millions every twenty-four hours;--and as it is calculated, that forty gallons upon the wheel will raise *one* into the reservoir—eleven million of gallons may be raised each day.

Many interesting particulars, detailed in the last report of the watering committee,* which is illustrated by a large copper plate sheet, exhibiting a plan and perspective, we must omit—and proceed to state, that the machinery in actual operation, is able to raise upwards of four millions of gallons in twenty-four hours into the reservoir, which is of such an elevation as to afford the hydrostatic pressure of ninety-two feet, throwing upon the pumps a pressure of seven thousand nine hundred pounds. There are two reservoirs, one of which is one hundred and thirty-nine feet by three hundred and sixteen, and twelve feet deep, having the capacity of three millions of gallons; It is connected with another reservoir which contains four millions of gallons. The water being raised into these, one hundred

* Forwarded by the kindness of Mr. George Vaux.

and two feet above low tide, and fifty-six above the highest ground in the city ; is thence conveyed in the iron pipes described in our last Number, (page 173,) the whole extent of which is now thirty-five thousand two hundred and five feet, " and in no instance has a leak been discovered." The greater part of the pipes now laid are of American manufacture, none ever having been imported except as samples.

The system obviously admits of indefinite extension. The committee justly remark that "the uses and importance of this water, it is impossible sufficiently to value. The additional cleanliness of the city, (which with the suburbs contains between 120,000 and 130,000 people,) the supply of the neighboring districts for culinary purposes, as well as for purposes of refreshment—the great advantage in case of fire—the ornament of fountains in the public squares so wisely provided by our great founder—the benefit to manufactures, and the establishment of water power in the city for various purposes, may be named among the advantages of this new work ; but above all we are to place its effect upon the health of a great and growing community, which of itself would justify a much greater expenditure."—*Ed.*

13. *Test for Platinum.*

In the course of various trials, with hydriodic acid, upon metallic solutions, we were recently much impressed with its remarkable effect upon the muriate of platinum. If dropped into a solution of this salt, even when extremely dilute, it produces, almost immediately, (and *immediately* if the solution be of only moderate strength) a deep wine red, or reddish brown colour ; by standing a few minutes, it grows much more intense, and becomes very striking, after the lapse of ten minutes. It much resembles the effect of the recent muriate of tin, but is a more delicate test than that, as it produces decided results where that gives but a faint change of colour. By standing a day or two, the solution becomes covered on the top, and on the sides of the vessel, with a film of perfectly metallic platinum. From this circumstance, it appears that the test operates by reducing the solution to the metallic state. Perhaps this effect was favoured by the manner in which the hydriodic acid

was prepared. It was done by putting phosphorus to about an equal bulk of iodine placed under water, in a glass tube ; an immediate action ensued consisting, apparently, in the decomposition of water—oxygen being thus imparted to the phosphorus and hydrogen to the iodine. The hydriodic acid, thus formed, of course remained mixed with phosphoric acid, containing perhaps an excess of phosphorus. I did not make the trial with the pure hydriodic acid, and cannot positively say what agency the phosphorus might have had,in producing this effect. Even if the phosphorus should prove to be essential, perhaps the observation may be still worthy of being preserved. No other metallic solution gave similar results.—*Editor.*

14. *American Geological Society.*

From its munificent President William Maclure, Esq. the society has recently received a box of the lavas of Vesuvius—Beudant's Geological travels in Hungary 4 volumes with maps—a continuation of the Revue Encyclopedique, and of the Journal de Physique—Conybeare and Philips' Geology. of England, and a case of the Glauberite of Spain.

Major Delafield has presented to the society a box of minerals consisting principally of the boulder stones found on the shores of the upper lakes, but embracing also various domestic and foreign specimens.

15. *On Animal Fat.*

Stearine and Elaine.

[Communicated by Professor Eaton.]

An intelligent tallow-chandler, Mr. W. Parmelee of Lansingburgh, informed me, a few days since, that the tallow of beeves, which are slaughtered during, or at the close of the hot season, makes much harder candles, than of those which are kept until the weather becomes cold. This fact, he said, had always been known to tallow-chandlers; but he gave a reason for this difference, which I believe you will think worthy of scientific investigation.

Mr. P. had not noticed the distinction made by chemists between the olive-oil-like part, called *elaine*, which lique-

fies at 60° Fahrenheit, and the hard part, called *stearine*, which remains solid at 100° Fahrenheit. But he had separated the two substances, and re-combined them in various ways. Without any chemical analysis, he had compared the *elaine* of tallow with the sweat of cattle, and found a great resemblance in their sensible qualities; though the latter contained a larger proportion of water and of muriate of soda. From these observations he infers: that during the hot part of the season, when cattle sweat profusely, such a large proportion of the *elaine* is evacuated through their skins, that the *stearine* is left in a much larger proportion than that which is found in their tallow after the sweating season has passed.

With Mr. P.'s permission, I communicate these observations, in the hope that some American chemist, who has sufficient leisure, will compare the results of an accurate analysis of the *elaine* and sweat of beeves. It may throw some light upon the science of animal economy, and of the proximate principles of animal matter.

Troy, N. Y. Jan. 13, 1823.

16. *Additional Notice on the Fused Carbonaceous Bodies.*

If melted charcoal, plumbago, and anthracite do really approximate towards the character of diamond, we ought to expect that, in consequence of fusion, there would be a diminution of conducting power, with respect both to heat and to electricity. This I find to be the fact. As soon as the point of charcoal is fused by the deflagrator, the power of the instrument is very much impeded by it; but as soon as the melted portion is removed, the remaining charcoal conducts as well as before; and so on, for any number of repetitions of the experiment, with the same pieces of charcoal.

The globules of melted plumbago are absolute non-conductors, as strictly so as the diamond. This fact is very pleasingly exhibited, when a point of prepared charcoal, connected with the zinc pole of the deflagrator, is made to touch a globule of *melted* plumbago, however small, still adhering to a parallelopiped of plumbago, in its natural state, screwed into the vice connected with the copper pole; not the minutest spark will pass; but if the charcoal point be moved,

ever so little aside, so as to touch the plumbago in its common state, or even that which has been ignited, without being fused, a vivid spark will instantly pass. This fact is the more remarkable, because it is equally true of the intensely black globules which are sensibly magnetic, and therefore contain iron, as of the light colored and limpid ones, which are not attractable.

The globules of melted anthracite are also perfect non-conductors. This may appear the less remarkable, because the anthracite itself is scarcely a conductor; at least, this is the common opinion, and it certainly is strictly true, of that of Wilkesbarre and of that of Kilkenny; for, when both poles are tipped with those substances, there is only a minute spark, which is but little augmented when charcoal terminates one of the poles. But the fact is remarkably the reverse with the *Rhode-Island* anthracite; *this* conducts quite as well as plumbago, and I think even better, giving a very intense light, and bright scintillations. I have now no doubt, that the deflragrator will melt it, but have not had time to complete the trial.

If it should be said that the conducting power of the R. I. anthracite may be owing to iron, we are only the more embarrassed to account for the fact, that its black melted globules are insensible to the magnet, and are perfect non-conductors.

It will now probably not be deemed extravagant, if we conclude that our melted carbonaceous substances approximate very nearly to the condition of diamond.—*Ed.*

April 23, 1823.

17. *New Journal.*—The first No. of the Boston Journal of Philosophy and the Arts will be published in the month of May.

18. *Ittro Cerite.*—Col. Gibbs has discovered the, Ittro Cerite at Franklin in New-Jersey.

II. Foreign.

1. *Stereotype Edition of Newton's Principia.*—A very elegant stereotype edition of the " Principia"* has made its appearance from the University Press at Glasgow, conduct-

*Of which a copy is now in our hands.

ed by Messrs. Andrew and John M. Duncan. It is a reprint
of what has been known by the name of the " Jesuit's edi-
tion of the Principia," first published at Rome by two learn-
ed French ecclesiastics, Thomas Le Seur and Francis Jac-
quier; and embracing their celebrated commentary. The
objects of this commentary are, as explained by the authors
themselves, " to throw light upon such parts of the work
as are difficult or obscure; fully to demonstrate those truths
which Newton has announced, but neglected the proof;
and to bring into clearer view some of the less obvious
beauties that abound in the demonstrations."

The authors of the commentary have enriched their work
with occasional treatises, taken from the writings of distin-
guished men, on various subjects, both mathematical and
physical; as, the tract on the Conic Sections—a concise,
but elegant specimen of geometrical reasoning, which ap-
pears to be the production of a professor at Geneva; and
the well-known essays of Bernoulli, Euler and M'Claurin,
on the motions that prevail in the waters of the globe. To
these are added dissertations on the general principles of
Mechanics, and the elements of the fluxionary calculus;
together with many of the observations, experiments and
reasonings of philosophers, both before and since the days
of Newton. Solutions also, of ingenious and useful prob-
lems often recur.

Perhaps it is the chief fault of the work, that its authors
have too carefully attempted to explain every point that
seemed in the least degree obscure, and thus increased its
bulk, without adding proportionally to its value. The
present edition is published in the Latin, and comprises
four handsome octavo volumes.

When the value of the Principia and the scarcity of for-
mer editions are considered, this must be deemed an impor-
tant addition to the list of new publications; and the influ-
ence which original works of this high character always ex-
ert upon the progress of useful science, renders it desirable
that, if introduced into this country, the work may meet
with encouragement equal to its merits.

2. *Travels in America.*—J. M. Duncan, A. B., of the
University Press, Glasgow, author of "A Sabbath among
the Tuscarora Indians," is preparing for publication an

account of Travels through part of the United States and Canada, in 1818, and 1819, intended chiefly to illustrate subjects connected with the Moral, Literary, and Religious condition of the country.

Those who enjoyed the pleasure of Mr. Duncan's acquaintance, while travelling in this country, will expect much from his intelligence and candor, and we confidently believe they will not be disappointed.—*Ed.*

3. *Fossil Vegetables.*—We have received from Mr. Adolphus Brongniart of Paris, a work "Sur la classification et la distribution des Végétaux Fossiles"—illustrated by lithographic plates. It is an elaborate and valuable work and an analytical notice of it by Dr. J. G. Percival will appear in our next number.—*Editor.*

Communicated by Dr. Jeremiah Van Rensselaer.

4. *Fresh water formations.*—From the new edition of Cuvier's work on Organic Remains, it appears that the fresh water formations of Paris and Rome are precisely similar : presenting the following order of succession from below upwards.

1. A compact limestone analogous to the Jura limestone, or even perhaps to chalk—rarely containing petrifactions.

2. The coarse sandstone formation, composed at its lowest part of bluish argillaceous marl, with shells, and towards its upper part of reddish sandy limestone, and sometimes of marine sandstone.

3. The volcanic breccia, in all its modifications, lying above this formation.

4. The fresh water formation.

Messrs. Brongniart and Brocchi, who have examined together these formations, conclude that there are two kinds of fresh water formations, very distinguishable by external characters, which indicate their difference of origin. The *one* produced by solution and precipitation, more or less pure and crystalline, has issued from the interior of the earth with the waters which have carried them to the surface of the soil. They may be formed at all elevations where similar waters may have issued, and the height at

which they occur is not always a proof of that to which the fresh water has been elevated. These are the most extensive.

The *other*, of a coarser texture, resulting from the abrasion and washing of the surface of the rock, is formed by means of sediment at the bottom of still waters into which they have been carried. They are much less diffused, less pure, and may contain remains of marine bodies. A part of the Limagne of Auvergne, the fresh water formation of the Swiss Molasse, and probably the plastic clays and lignites are of this formation.

5. *New Atmometer.*—Mr. Anderson, of Scotland, has invented a new Atmometer, or *Evaporometer*, for measuring the evaporation from water, in any given time. It is said to be superior to those heretofore invented by Mr. Leslie, and to equal in simplicity and accuracy the method employed by Mr. Dalton to discover the evaporation from the ground.

6. *Turquois and Lazulite.*—Berzelius announces the calaite or Turquois to be composed of phosphate of alumina, phosphate of lime, silica, oxide of iron, and oxide of copper. The Lazulite is a compound of phosphate of alumina, phosphate of manganese, and of phosphate of iron and oxide of iron.

7. *Translation on Natural History.*—Mr. J. S. Miller has published a prospectus of his intended translation of the "*Natural History* of Alcyonia, Spongia, Corallina, Sertularia, Eschara, and Corals, from the French of Lamark." Mr. Miller is well known by his work of the Crinoidea.

8. *West or Lost Greenland.*—The indefatigable Capt. Scoresby is about publishing his discoveries on the coast of West Greenland Since the setting in of the Polar ice in 1406, the fate of near 300 villages or plantations, with 16 churches, 2 convents, &c., has remained in obscurity, as all attempts to reach the coast have been unavailing. The perseverance of Capt. Scoresby, however, has enabled him to land several times 'in different places, in nearly all of

which he discovered traces of inhabitants, but saw no people. He was within two hundred miles of the presumed site of the lost colony. He has accurately surveyed the coast from lat. 75° to 69° including nearly 800 geographical miles of the indented coast. He finds an error in the position of the land in lat. 74°, as laid down in charts, of about 15°, or 900 miles of longitude. In August 1821 he found the weather oppressively hot, and the air swarmed with bees, butterflies and musquitoes. The coast was highly picturesque, but it was seldom that the ice allowed him to approach nearer than 15 leagues from the shore.

Ed. Philos. Jour. Jan. 1823.

9. *On the limits of the occurrence of Fishes in high situations.*—According to Raymond, the only fishes that occur in the waters of the Pyrenees, at heights of from 1000 to 1162 toises are Salmo trutta, S. Fario and S. Alpinus. Higher up all fishes disappear. The water Salamander ceases to live at the height of 1292 toises; probably because the higher lakes are half the year frozen. But cold is not the sole cause of the disappearance of fishes in high altitudes, since Humboldt mentions that in the equatorial regions of America, where the mean temperature of the freezing point begins 1500 toises higher than in the Pyrenees, the fishes disappear earlier in lakes and rivers. No Trouts occur in the Andes. At a height of 1400 or 1500 toises there still occur Pocilien, Pimelodes, and the very remarkable new form Evemophilus and Astroblepus. Under the equator, from 1800 to 1900 toises, where the mean temperature is still $+9°$ 5′ cent., and where few lakes ever freeze, fishes are no longer met with, with the exception of the remarkable Pymelodes Cyclopum, which are thrown out in thousands with the clay-mud, projected from fissures in the rocks, at the height of 2500 toises. These fishes live in subterranean lakes.—*Id.*

10. *Iodine.*—After the beneficial results obtained by Dr. Coindet, from the use of Iodine in the cure of Goitre, the Clinical Institute of the Royal University of Padua, have used it with a view of different effects. They detail the cases of persons submitted to its action, and conclude

that Iodine, besides its being endowed with the property of increasing ‘vascular action, restoring sanguification and re-establishing the ordinary sanguineous excretions, particularly from the uterine vascular system, on which it would seem to exercise a direct action, excites the activity of the gastric functions, so that under its use the appetite is renewed and active, the work of digestion goes on with celerity and without inconvenience even in delicate females, and those with weak stomachs.—*Lon. Med. and Phys. Jour.*

Articles of Foreign Literature and Science, extracted and translated by Professor Griscom.

11. *Preservation of Anatomical Preparations.*—Dr. Macartney of the University of Dublin employs for his anatomical preparations a solution of alum and nitre, which he finds, has the property of preserving natural appearances much better than spirits of wine, or any other fluid hitherto employed. The proportion of the two salts, and the strength of the solution must vary according to circumstances; and in order wholly to impregnate the preparations the solution should be renewed from time to time. This solution is so highly antiseptic, that it destroys entirely, in a few days the fetor of the most putrid animal substances.

12. *A Chain Bridge* is in a state of forwardness, over the *Menai* an arm of the Irish Sea which separates Anglesea from N. Wales. It will have the unprecedented length of 560 feet, between the two supports, one on each shore; and its height above the water will be 126 feet, so that vessels may pass beneath it under full sail. The abutments are of masonry, surmounted by wood pyramids 50 feet high, over which the chains pass. The bridge is 28 feet wide containing a foot path of four feet wide in the middle. It will cost £70,000 sterling.

13. *Vegetable Analysis.*—Dobereiner describes in his *Phytochimie pneumatique* a little apparatus very convenient for obtaining vegetable extract, through the medium of water, alcohol, ether, &c. from 10 to 200 grains. It consists of a glass tube A of 4, 6 or 9 lines in diameters, and from 4

to 9 inches long destined to receive the substance to be acted upon by the solvent. It is closed at bottom by a cork $a, a,$ (see pl. 10, fig. 5,) through which passes the small tube $b, b,$ open at each end, except that it is covered with muslin at x to prevent the pulverised substance from passing into it. One half of the tube A is filled with the vegetable powder, and the other half with the fluid. The small tube is adapted by means of a cork to the small globe B, freed from air by a few drops of alcohol, which by the application of heat expands into vapour and expels the air. The small tube is then tightly pressed into its neck, and the apparatus is set in a cool place. As the alcoholic vapour contracts and then forms a vacuum, the pressure of the air forces the liquor through the pulverised mass and thence into the globe. In a few minutes a portion of extract is thus obtained, which being withdrawn, the vacuum may be renewed by alcohol, and the process thus continued at pleasure.

14. *A Steam Boat* either has been, or is about to be constructed on the Lake of Geneva in Switzerland by our countryman Edward Church ; who was the first to bring steam navigation into successful operation in France by the establishment of a steam boat on the Garonne. The Swiss boat, (the first, it is believed, yet attempted in that romantic country) will ply between Geneva and Lausanne, stopping a few minutes at Copet, Niou, Rolle and Morges, and perhaps extending her voyage occasionally to Vevey and the Chateau de Chillon. A more picturesque and delightful navigation can scarcely be conceived.

15. *Vesuvius.*—By a letter from Naples dated November 5th, 1822, published in the Bib. Univ. of Geneva for the same month, it appears that the eruption of Vesuvius which took place on the 22d of October was as terrific as any that has occurred since A. D. 79 described by Pliny. Day was turned into night by the clouds of ashes and other volcanic matter, which at a distance from the mountain, fell to the depth of 5 and 6 feet. The writer collected several pounds of the ashes from his Balcony in Naples. It was at first of a reddish brown, and then more white, and appeared to him like pulverised pummice stone. He states that it had been analysed by M. Pépé who found in it sulphate of potash,

sulphate of soda, of lime and magnesia, sub. sulphate of alumine, hydro-chlorate of potash and of soda, much oxide of alluminum, of calcium, of silicium, and of magnesium, much tritoxide of iron and of antimony, and a little gold and silver. The writer thinks that this result strengthens the hypothesis, which ascribes volcanic fire and explosion to the infiltration of sea water to masses of potassium, sodium, and other metallic bases.

16. *The Mean Temperature* of the climate at Salem Mass. and at Rome in Italy, nearly in the same latitude, was for the 33 years, ending in 1818 as follows :

		Lat.	Temp.	
Rome,	- -	41° 53'	60° 44'	Far.
Salem,	- -	42° 33'	48° 68'	
			Diff. 11° 76'	

17. *Skeletons of the Mammoth and Elephant* have been recently discovered in the district of Hontes in Hungary.

18. *Academy of Inscriptions and Belles Lettres at Paris.*— A literary fête, the first of this kind in France, was celebrated on the first of April last, at the termination of the general session of the Institute. The members of this Academy united at a banquet around their venerable perpetual secretary M. Dacier, the Nestor of letters and of French erudition, to celebrate at the same time, his 50th Academic year, the 42d of his perpetual secretaryship, the 80th of his age, and his happy convalescence after a serious indisposition, which had much alarmed his numerous friends. This union was a true family feast, each of its members offering the homage of his affectionate wishes to the worthy chief who for half a century has been charged with the interests of literature, and who has conducted the concerns of the Academy with as much honor to that body as advantage to letters and solid studies.

19. *City of Odessa.*—This city which in 1792 consisted of only a few hovels, now contains 40,000 inhabitants, Rus-

sian, German, French, Greeks, Jews, Americans, and Poles. It contains a French and Italian theatre; a lyceum founded by the duke de Richelieu, which affords numerous advantages; schools of law, navigation, commerce, &c. eight churches, two thousand houses and numerous public buildings.. In summer, Odessa is visited by a great number of families from the north of Russia and Poland, for the purpose of sea bathing. The population of the suburbs is continually increasing.

20. *The Greek Seminary* founded at St. Petersburgh in 1775 by Catharine II, acquires every day, fresh importance. It educates about 200 young Greek and Albanian officers. There are 25 professors. But, besides military science, the French, Italian, and German languages are taught. When the students have finished their course, they may choose either the station of an officer, the place of interpreter in the colleges of St. Petersburgh or Moscow, or a return to their own country. There are now in the Seminary many young people from Scio, Lesbos and Naxos.

21. *A House of Refuge* was founded in the month of April 1817 in the Rue Grès Saint Jacques at Paris, and has been ever since supported by charitable donations, for the purpose of receiving from the prisons, those juvenile offenders whose good conduct while in confinement, may entitle them to this favour. The Refuge is placed under the immediate direction of a person who generously offered to devote himself to this work of mercy. The boys are taught in six work shops directed by skilful masters. Cabinet makers, shoe makers, joiners, tinmen, painters on metal, workers in bronze, are here in full activity. The exposition which is annually made at St. Louis of the products of these children's labour, proves their rapid progress and improvement. An experience of five years leaves no doubt of the success of the institution. Since 1817, one hundred and eighteen children have been received from the prisons. Their conduct has responded to the solicitude of those who have not ceased to watch over them. If a few among them who have deceived the expectations of the administration, have been sent back to the authority, the greater number have justified

them. Twenty-one young people have been restored to the society in a condition to provide for themselves, and even to assist their parents. To render more certain the perseverance of those who annually leave the refuge, the administration gives them a protector-selected from among its own members. This protector watches over his pupil, informs himself of his conduct, of his work, of his wants, and of his success. During five years, those discharged pupils, may, if they are worthy of it, receive pecuniary assistance from the house. Every month, the council distributes rewards to the best workmen, and at St. Louis, utensils and other useful things are given to the children, who have distinguished themselves by their good behaviour, docility, and love of labour. A multitude of children are exposed in the prisons to all sorts of danger. Resources are wanting to extricate these unfortunate creatures from that melancholy indolence, and corrupting example to which they are exposed.

22. *Conservatory of Arts and Trades.*—M. Charles Dupin, member of the Academy of Sciences, terminated on the 9th of June, the course of Mechanics applied to the Arts, of which he is professor in this fine establishment, by giving a summary of the objects of which he has treated this year. He exhibited a table of the ameliorations which the mechanic arts may produce in the most important branches of our industry. We remark particularly that which regards the application to the means of transport, upon the highways, and the services rendered by the steam engine, and those which French industry may expect to derive from it. We recognize in these considerations, the learned engineer, who has written upon the maritime arts, and upon navigation by steam. We cannot too earnestly invite the directors of mechanical concerns, whether in Paris or in the departments, to send their children and their foremen, to attend the course which is annually given at the Conservatory, commencing in the month of November.

23. *Sugar from Beets.*—Extract of a letter addressed to the Editor of the " *Revue Encyclopedique.*"
The good of France, the prosperity of our native soil, is what occupies incessantly every noble mind. I seek among the libraries, and journals, every thing that relates to na-

tional character and public utility, and I attend very assiduously the discussion of the Chamber in order to inform myself, by the light which is often there thrown 'upon' objects of the greatest·interest. I listened with extreme impatience to the discussion of the law relative to the tariff, because I foresaw that sugar would certainly be the grand war horse, against which, the lances of the strongest combatants* would be broken. All that I could there collect which amounted to demonstration, is that France consumes one hundred millions pounds of sugar; that our colonies produced in 1821, forty-four millions kilogrammes, and that the surplus is drawn from foreign countries. This consumption proves that of the whole of Europe must exceed six hundred millions of pounds of sugar annually, and that in 'adding to this the value of the rum made from the molasses of this same sugar, it results that the new world, raises for this single object, an annual impost of six hundred millions of francs upon ancient Europe. Disgusted at not hearing in this solemn discussion a single word relative to the richest discovery of the age, the fabrication of European sugar, I opened the eighth number of *Annales Europeenns*, and I there found a statement which demonstrates with mathematical evidence, 1st. that the sugar of beets, is made with the same facility as bread. 2d. That this sugar may be easily obtained, of a quality superior to that of the finest American sugars. 3d. That France may not only fabricate enough for its own consumption, but that it might dispose of perhaps a hundred millions to its neighbours. 4th. That this would be the means of employing very happily more than a million of poor persons, of producing a harvest upon many millions of acres left unemployed, of fattening annually a hundred thousand cattle; in short, of realizing new treasures in favour of France, and of producing a great extension of comforts in every class of the nation.

I could say much more upon this important subject, as well as upon many others of the same kind, but if you have the goodness to admit this letter into your Journal, I shall make it a duty to add something hereafter.

24. *Statistics of Egypt.*—Every traveller in Egypt attributes to the Vice Roy, all the qualities of a statesman.

(*In the MS. competents.)

The christians who live under his laws are under many obligations to him; and enterprizing travellers of all nations and religions may now traverse Egypt with a security before unknown in the Ottoman dominions. The army of the Vice Roy consists of not less than 45,000 men, comprehending infantry, cavalry and artillery. His naval force is composed of 22 vessels, and the navigation of the Nile is protected by a great number of gun boats, each of which carries 40 men; The revenues of Mohamet Ali, as Vice Roy, amounts to 25 millions of Spanish piastres. They arise from custom house duties, taxes, tolls, fisheries, public domains, contributions from conquered countries, and from caravans, &c. The Vice Roy pays in title of vassal 2,400,000 livres to the Sultan; he sends the same sum to the Treasury of Mecca; 800,000 measures of rice, &c. to Constantinople, furnishes provisions to the caravans of Cairo; keeps a brilliant court, and often sends presents to the Sultan, to the favourite Sultana as well as to the ministers of his highness and to persons in credit at the Seraglio. The actual population of Egypt does not exceed 3,000,000. It contains 2,496 towns and villages, of which 957 are in Upper Egypt, and 1,539 in the Delta.

25. *Poland.*—Nathan Rosenfeld, a Jew merchant at Warsaw, a very learned man, has recently published a history of Poland, written in Hebrew. This new historian has examined the best sources of information, and has left nothing to be desired with respect to the authenticity or arrangement of his facts.

26. *Copenhagen.*—M. H. Faber who has been three years in Iceland, and has examined every portion of that mountainous island, has formed an ample collection of its birds and their eggs, which is now in the Royal Museum. He has recently published in Latin a preliminary notice of his discoveries under the title of a Prodroma of Icelandic Ornithology.

27. *Fine Arts.*—Albert, duke of Saxe-Teschen, has left to one of the princes of the imperial family his rich collection, consisting of 300,000 engravings, from the earliest essays in this art, to the most finished modern productions;

82,000 portraits, and more than 40,000 original designs. This collection is one of the finest and most considerable in Europe.

28. *Calligraphy.*—Gov. Frederick Spang, has exhibited in his house at Augsburg a collection of 550 specimens of elegant penmanship of the late Abbey Werner. They consist of models of all the different kinds of writing; choice reflections from the best writers in French, German, Italian, English, Latin, Greek and Hebrew; representations of artificial objects, portraits of sovereigns, philosophers, and celebrated men, all wrought simply with pen and ink.

29. *Switzerland. Canton of Argovia.*—The grand council of our Canton, decreed last year the establishment of a *normal school for the formation of school-masters*, destined not only for those who may desire to embrace that profession, but also to furnish the means of perfecting those who have already entered the career of public instruction. A sum of 6000 Swiss livres (about 1,780 dollars) has been appropriated which will provide for the appointment of professors, and afford also the means of instruction. The pupils, the number of whom is not to exceed 30, must possess on entering, the knowledge usually acquired in the primary schools. This instruction will continue two years, and will embrace the German language, arithmetic, geometry, natural history in its relations to rural economy, to the mechanic arts, and to the daily wants of life; geography, national history, music and drawing. Particular attention will be paid to the religious and moral instruction of the pupils, who will also be alternately exercised in giving instruction in the different branches of knowledge.

30. *Abau.*—The *Society* formed a few years since in this town, for furnishing instruction during the winter months, to the young people of the Canton over eighteen years of age, continued last winter its course of gratuitous instruction with complete success. The subjects treated of in this course, were the history of the Swiss confederacy, combined with modern history; physical geography; the principles of natural law; geometry; mineralogy; and the fundamental principles of mechanics. The pupils have been

exercised in linear drawing; as well as in compositions in the German language. Those who wish to profit by this instruction, are at liberty to choose the course which they will follow, under the condition however that they are to remain at least three months.

31. *Canton of Geneva. Society of the friends of the fine arts.*—Of all the tastes which spring from that luxury which is inseparable from an advanced state of civilization, there is none which affords a pleasure more pure and more durable, than that which is inspired by those arts which in delighting the eye by their brilliant productions, recall places and facts, the recollection of which interests us, or of persons who are dear to us. These mild enjoyments are not the only fruits which we derive from the culture of the fine arts ; they contribute at all times to the prosperity of cities, and the glory of their people. The most direct means of favouring them is to encourage artists and increase the number of amateurs. Such is the design of the Society, " *Des amis des Beaux Arts,*" which has just been formed at Geneva, in imitation of those which have for some years existed at Zurich, as well as in many of the large cities of France. By means of these establishments, those things become of easy attainment which would be onerous or even impossible to individuals. It is to this noble spirit of union and joint labour that the city of Geneva is indebted for the greater number of its institutions. We may even say that to this it owes its existence as a Republic. The first general meeting of the society of fine arts, took place on the 17th of May last. A committee of ten managers was appointed and bye laws established for its government. The society consists of stockholders, each of whom take what number of shares he thinks proper. Each share costs $5 annually. The funds of the society will be employed nearly in the following proportion. 1st. Three fourths of the income after the payment of incidental expences are applied to the purchase of pictures, designs, and sculptures, the original work of living Swiss artists. 2d. The other fourth is expended in engravings. The articles thus acquired will be sufficient in number to be divided by lot among the stockholders at the rate of one lot to every ten shares. Every share not favoured by the lot, will have

a right to a proof of each of the plates purchased by the society in the course of the year. The objects of art, acquired by the society will be exposed to view, before the drawing of the lots. Although the society is in its infancy the number of shares subscribed for already, amounts to 150. A number of distinguished foreigners have taken shares.

32. *Wire Drawing.*—The common method of drawing cylindrical wire, consists in forcing the metal through circular openings in plates of iron, steel, or some other metal; but it is soon observable, that the whole gets worn or deformed, and that the wire then ceases to have the desired regularity. Mr. Brookedon of London has nearly remedied this inconvenience by passing the metallic thread through conical holes made in diamonds, sapphires, rubies, or other hard gems. It appears to be unimportant whether the wire be introduced at the large or the small opening of the conical hole, but the best results, upon the whole, are obtained when the wire is entered by the smaller base, and drawn through the larger one.

33. *Hops.*—The valuable discovery of Dr. Ives of New-York, on the powder of the Hop, as announced in his memoir, published in volume II. p. 302 of this Journal, has excited considerable attention in Europe. M. M. Payen and Chevalier, two French chemists, have made some researches upon the yellow powder (the Lupulin of Dr. Ives,) which they consider as composing one tenth of the hop. They recognize in it the following principles.

Essential Oil, about	.02
Sub. Acetate of Ammonia	
Gum	
Malate of Lime	
A bitter principle	.125
A well characterised resin	.525
Silex	.040

Traces of a fatty matter, and some salts.

We limit ourselves (say the editors of the Annales de Chimie,) to a statement of these results, without any other

detail of the proceedings which furnished them, because if,
on the other hand, we consider them as sufficient to excite
the interest of chemists in a plant so eminently useful as
the hop; on the other, the various labors which we have
cited, still leave much to be desired.

34. *Electro-Magnetism.*—M. Assiot, Professor of Natural
Philosophy at Toulouse, states an instance in which, during
a heavy thunder-storm in that city, on the 22d of June last,
a metallic tube that extended from the top of the house to
a well or cistern, served as the channel of a heavy discharge
of the electric current. The tube was much rent, and oth-
er damage sustained by the house, which was a small one,
and contained fourteen or fifteen persons, none of whom
were injured. The magnetic effects of the stroke were the
most remarkable. A spike which the fluid met in its way,
was sufficiently magnetised to lift a table knife, and was
used in magnetising other things. A tailor's boy, at the mo-
ment of the explosion, was smoking his pipe, with the back of
his chair leaning against a post near the conducting tube ; he
experienced no disturbance, but was greatly surprised on
the next Monday, in taking his needle-case out of his pock-
et, to find that the needles were so magnetised that seven
or eight of them would hang together in a chain. Another
case, placed on the chimney, twenty feet from the tube,
and containing five needles, was also strongly magnetised.
M. Assiot says that he shewed those good tailors who brought
him their needles, that two or three discharges from a sin-
gle jar through a wire wrapt spirally round a tube, would
produce the same effects upon the needles it contained, and
that evidently without their forming part of the current.

35. *Velocity of Sound.*—A very careful experiment was
made on the 21st and 22d of June last, at Paris, by order
of the Board of Longitude, in order to solve this problem
with greater precision than heretofore. The experiment-
ers were Humbold, Gay Lussac, Bouvard, Prony, Mathieu and
Arago. The former three stationed themselves at Montlhery,
and the latter three at Ville-Juif, two situations distant from
each other, by the most careful geographic measurements,
9549.6 toises. The experiments were performed in the
night, by means of two six pounders, one at each station,

charged with from two to three pounds of powder. The number of seconds which elapsed between the flash and the sound, was noted by chronometers furnished by Breguets, one of which denoted even the sixtieth of a second.

A singular fact in the course of the experiments was, that the firing was distinctly heard at Ville-Juif, by all the gentlemen, without difficulty, while at the other station not one half the sounds were audible. Very little wind prevailed, and what there was, was in favor of the persons stationed at Montlhery. The reporters do not undertake to explain the cause of this difference; for, say they, we can only offer to the reader, conjectures void of proof. The result of their trials, after all due allowances, is, that at the temperature of 50° F. the velocity of sound is 173.01 toises, 337.2 metres, 1106.3026 English feet per second.

36. *Steel.*—The Society of Encouragement at Paris, has decreed a gold medal to M. Pradier, who has brought his steel instruments to the highest degree of perfection. He has discovered the valuable art of rendering steel very hard, and at the same elastic. His steel blades can be bent double, and are yet so hard as to cut *iron*, without any injury whatever to the edge, however fine and thin it may be. This operation was many times repeated by M. Pradier, in presence of the committee, and always with success.

37. *Sal-Ammoniac.*—By the accidental combustion of a bed of coal in a mine near St. Etienne in France, in a situation where it could not be extinguished, there is exhaled, in addition to the usual products of the combustion of coal a vapour which becomes condensed on the adjacent substances, in the form of a white salt. It was considered by the country people as salt-petre, and some of the physicians supposed it to be alum. But from experiments made in the laboratory of the school of mines it proved to be very pure sal ammoniac, (hydro-chlorate of ammonia.) During a few dry days the ground becomes covered with an efflorescence of this salt, and it continues to increase till dissolved by rain. In the interior of an uninhabited house, are found those fine specimens which now make a show in some cabinets. During the years 1818 and 1819, the production

of this salt was so abundant, that several pieces detached from the walls of the house weighed near a kilogramme, $2\frac{1}{4}$lb. With proper attention, the collection of it might certainly be rendered lucrative. Whence proceeds the hydro-chloric acid of this ammoniacal salt? This question it does not seem easy to resolve ; but one thing is certain, all the water of the coal pits of St. Etienne contains among other salts a notable quantity of hydro-chlorates with earthy bases.

38. *Vaporisation of Ether.*—Cagniard de la Tour has shewn by experiment that Ether is susceptible of being reduced to vapour in a space less than double its primitive volume, and alcohol in less than three times its volume. In these cases the former exerts a pressure equal to 37 or 38 atmospheres, and the latter, a pressure equal to 119 atmospheres. To effect such a vaporisation ether must be heated to 320° F. and alcohol to 405° F.

39. *Paper Hangings.*—To guard against the effect of dampness in the injury and destruction of paper hangings, a method has been adopted in London which proves to be very effectual. Very thin sheets of Lead are fastened to the walls by copper tacks, and to this the paper is pasted without any difficulty. The lead is as thin as the sheet used in the lining of tea boxes, and effectually excludes the moisture of the wall.

40. *Brick-making.*—A patent or privilege has been obtained at St. Petersburg for a press for making bricks, which is not only to diminish the labor, but to perfect the forms of the bricks. By means of this machine, not only bricks, both solid and hollow can be made, but tubes straight or crooked, cornices, flutes for columns and other architectural ornaments. The patentee is a M. Chomas who proposes to establish a model brickyard with improved ovens for baking the bricks. Three or four men can produce, it is said, with this machine from 10 to 12 thousand bricks, daily, of different forms.

41. *Leipsic.*—The number of students attached to the University of Leipsic, during the last winter session was 1102, of whom 480 applied themselves particularly to the-

ology, 381 to jurisprudence, 163 to medicine, and 74 to philology.

42. *Composition of meteoric stones.*—The presence of Nickel, as one of the ingredients of aerolites, has been so generally ascertained, that it is considered almost as an essential or invariable characteristic. Laugier, however, has given an analysis of the large stone which fell at Juvenas on the 15th June, 1821, in which he states the entire absence of Nickel, and the existence of a portion of chrome. One hundred parts of the stone afforded

Silex, - - - - -	40.
Oxide of Iron, - - - -	23.5
Oxide of manganese, - -	6.5
Alumine, - - - - -	10.4
Lime, - - - - -	9.2
Chrome, - - - - -	1.
Magnesia, - - - -	.8
Sulphur, - - - - -	.5
Potash, - - - - -	.2
Copper, - - - - -	.1
Unavoidable loss, - -	3.0
Loss not accounted for -	4.8
	100.00

A previous analysis of a meteoric stone which fell at Jonzac the 13th June 1819, afforded this able chemist the same results and confirmed him in the accuracy of his examination. Vauquelin, also, who examined the aerolite of Juvenas discovered no nickel, but recognized the existence of chrome, as well as the other ingredients, stated by Laugier.

The complete absence of nickel, and the almost entire disappearance of sulphur and magnesia, replaced by an abundant quantity of lime and alumine, establish between these two meteoric stones and those which have been previously known, a very marked difference.

Another example of the non existence of nickel occurs in a stone which fell in Finland, on the 13th of December, 1813, analysed by Nordenskiold, a pupil of Berzelius.

43. *Preservation from rust.*—It has been ascertained by Arthur Aikin, secretary to the Society of arts and manufactures, that melted Caoutchouc is an excellent material for the above purpose. Plates of iron and steel, half covered with this substance, were exposed six weeks in a laboratory, and at the end of this time the uncovered parts were almost entirely corroded, while the varnished parts were completely preserved.

Caoutchouc must be melted in a close vessel. It requires about the same temperature for fusion as lead. When melted it must be stirred by a horizontal agitator, the handle of which rises through the cover, to prevent its being burnt at the bottom.

Mr. Perkins has perfected this process, by dissolving the caoutchouc in spirits of turpentine. The varnish thus obtained, after being suitably dried, becomes firm and does not change by exposure to moisture. It is laid on with a soft brush, and may be removed at any time by dipping the brush in hot spirits of turpentine. Mr. Perkins uses this varnish to preserve his engraved steel plates.

44. *Geology.*—There is found in the northern provinces of Russia, besides the bones of the mammoth and some other remarkable objects of natural history, a kind of fossil wood, in part petrified, and in part decomposed or rotten.

Professor Kounizin remarks that he formerly entertained the popular opinion that these trees had been blown down and gradually covered with sand and mud in or near the places where they grew. But he is now convinced that this is an error, and that they must have had an origin, quite remote from their present situation. For 1st. They are covered to a great depth with earth, in the form of beds parallel to the surface. 2d. All the trees have their tops directed toward the same quarter, and they are only inclined. 3d. Almost all have been broken by an irresistible force, the oaks alone retaining their roots. 4th. The bed of earth under which they are found is so thick that the waters of the rivers do not reach them. This earth is partly sand and partly clay. The trees that are covered with dry sand are quite rotten and moulder speedily into dust. Those under moist sand are still in good preservation. The pines and firs are more decomposed than the others, but

the species can be easily recognized by their position, their bark, the form of their fruits, seeds, and capsules. In the argillaceous soils, the trees are much better preserved, especially where the ground is moist, and it is in these cases that they are often found petrified. It is singular that trees which lie along side of each other are not equally well preserved; and there are some petrified at one extremity and still tender at the other. The oaks which are not petrified, are susceptible of being split into staves, and the country people convert them into axle trees, and cabinet makers employ them on account of their hardness. A remarkable fact is, that these oaks are found in a country where none at present grow, and which has been cleared from time immemorial. It would be very interesting to discover the epoch in which these trees were buried, and by what events they were overthrown and buried. Perhaps it was by the same force that transported so many blocks of granite in the north of Russia—and perhaps at the same time in which the entire race of the mammoth was annihilated, animals which might have had their abode in these sombre forests. The tops of the trees are inclined either towards the south east or south west, and consequently the force which destroyed them must have come from north to south.

These fossil trees are found in the whole of northern Russia, not only near rivers, but at a very considerable distance from their borders.

45. *Cooking Apparatus.*—Thenard & Fourier made a very favorable report, on the 26th of August last, to the French Institute, relative to a new boiler (nouvean calefacteur) invented by Lemare. It appears to consist of a bottom or grate which contains charcoal, and from which the heated air ascends into the space between two concentric cylinders both of which contain water. The water in each vessel is heated at the same time, and that in the interior vessel, being surrounded by another vessel of hot water will retain its elevated temperature a great length of time. By means of a damper, the combustion of the charcoal can be regulated at pleasure. The current of hot air can also be intercepted or left free as necessity requires. The exterior vessel has but three small openings. One at the top for pouring in water, one at the bottom with a cock for draw-

ing it off, and another, for which the first may easily be substituted, for receiving a bent tube which conveys the steam out of, doors. The exterior vessel does not rise higher than the interior, but it descends lower and rests upon the grate.

From an experiment of the reporters, one part of charcoal is sufficient to vaporize 9.42 parts of water from the freezing point. Now, according to theory, charcoal can evaporate only 10.8 times its own weight of water, hence it appears, that, taking into consideration the heat communicated to the vessels themselves, the actual loss of heat is only $\frac{1}{10}$ which is very trifling.

The superiority of this instrument for culinary purposes, especially for soups, vegetables, &c. is attested by these scientific reporters, who assert that they intend habitually to use it, as it is attended with an economy of time, and fuel, an improvement in the quality of the food, and a certainty of success.

46. *Salt Petre.*—M. Baffi, an able chemist, born at Pergola, has received from the Vice Roy of Egypt, a present of 100,000 crowns, and the title of Bey, for having discovered a method of making salt-petre by the sun's heat alone, without the aid of fire. Before this discovery every cwt. of salt-petre cost the Vice Roy ten crowns, an expense which is reduced by the new method to one crown. The manufactory erected by M. Baffi on the great plain of Memphis furnished last year, to the Egyptian army, 3,580,000 lbs. of salt-petre.

47. Dr. Brewster has published (in the Trans. of the Cambridge Philos. Soc.) an interesting paper on certain peculiarities in the structure and optical properties of the Brazilian topaz illustrated by colored figures:—also (in the Trans. of the R. Soc. of Edin.) a description and drawings of a Monochromatic lamp with remarks on the absorption of the prismatic rays, by coloured media—also an account of the native hydrate of Magnesia discovered by Dr. Hibbert in Shetland, and, in a separate pamphlet, additional observations on the connexion between the primitive forms of minerals and the number of their axes of double refraction. Dr. Brewster's researches on the optical properties of minerals continue to present very extraordinary results.

INDEX.

A.

B.

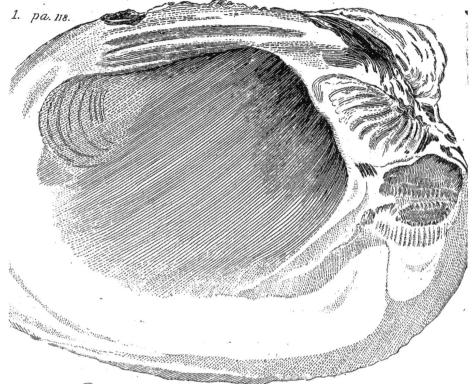

Unio Crassus

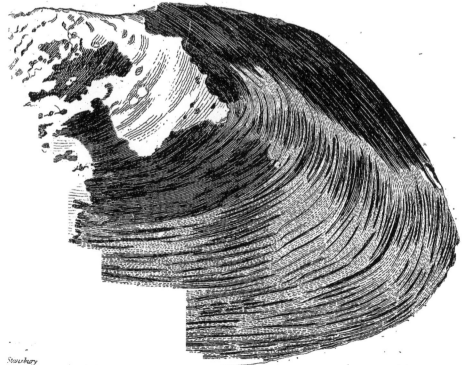

Stansbury

A. Doolittle sc.

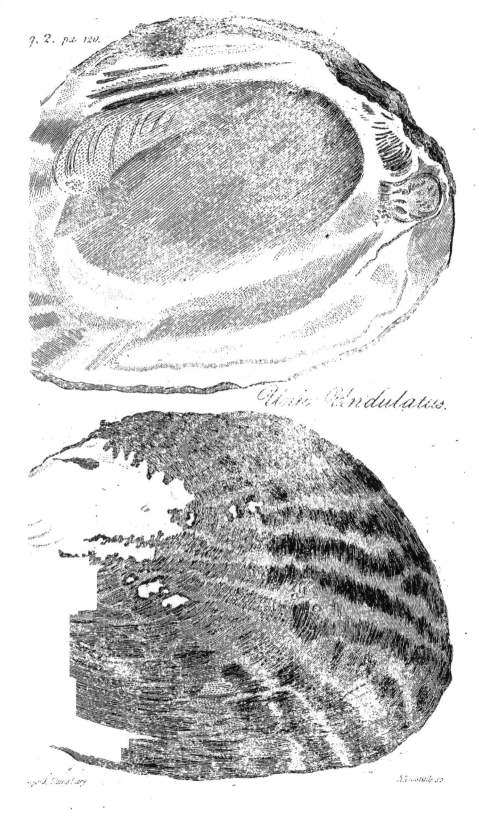

Unio Undulatus.

Fig 3. pa 120.

a

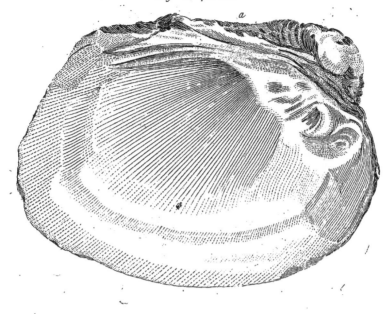

b

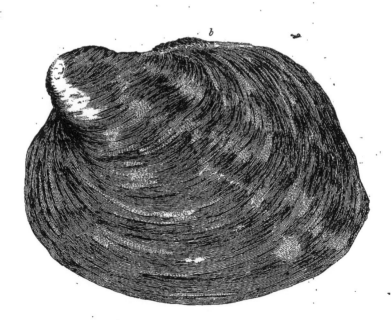

Unio Plicatus.

Drawn by Arthur J Stansbury A. Doolittle sc.

Fig. 5.

Fig. 4 pa. 121

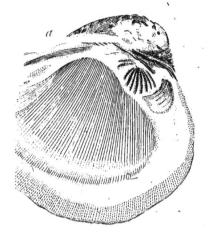

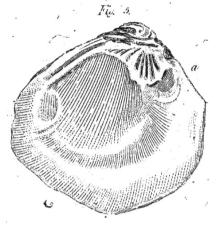

a

b

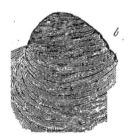

b

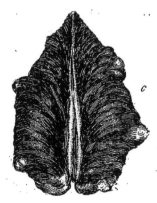

c

Unio Undatus.

Unio Cornutus.

A. Doolittle sc.

Fig. 6. pa 123

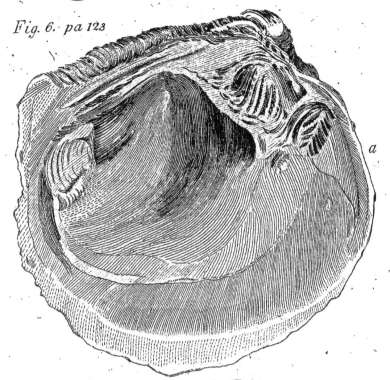

a

Unio Verrucosus

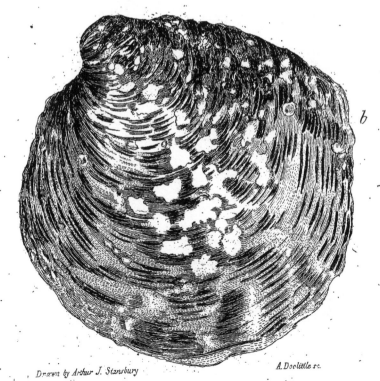

b

Drawn by Arthur J. Stansbury A. Doolittle sc.

Fig. 7. pa. 124.

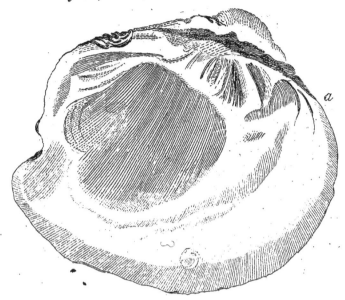

a

Unio Nodosus

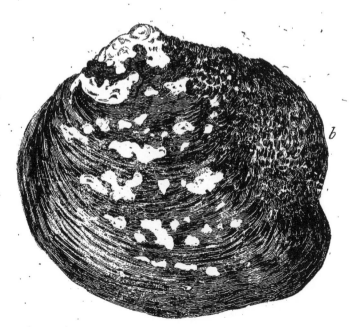

b

Drawn by Arthur J. Stansbury

A Doolittle sc

Fig. 8. pa. 125.

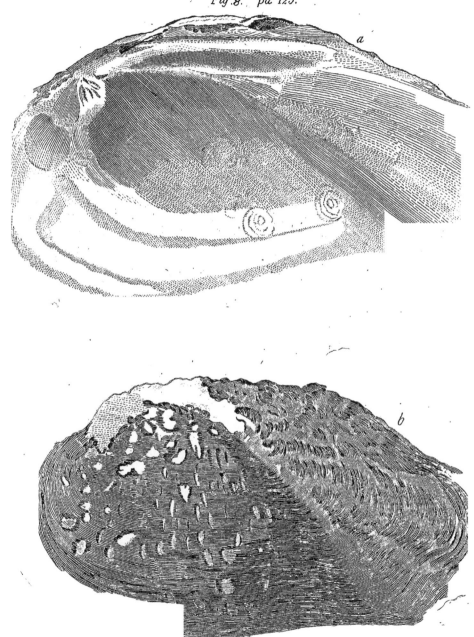

a

b

Fig. 9. pa. 126.

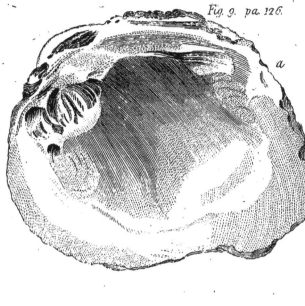

a

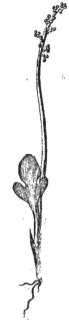

b

Botrychum Simp

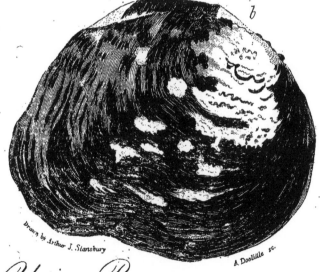

Drawn by Arthur J. Stansbury

A. Doolittle sc.

Unio Rugosus

16

15
14.

13

12
10 11

8 9

7

6

5

4

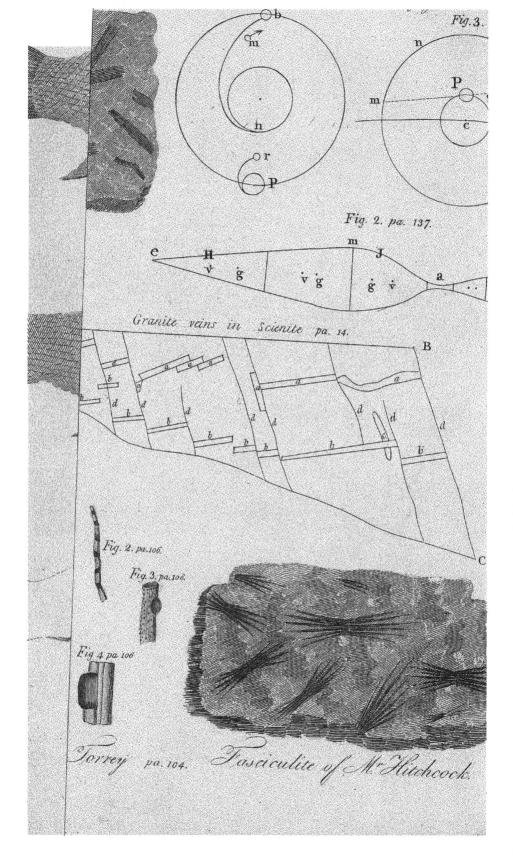

Fig. 3.

Fig. 2. pa. 137.

Granite veins in Scienite pa. 14.

Fig. 2. pa. 106.

Fig. 3. pa. 106.

Fig. 4. pa. 106.

Torrey pa. 104.

Fasciculite of Mr Hitchcock.

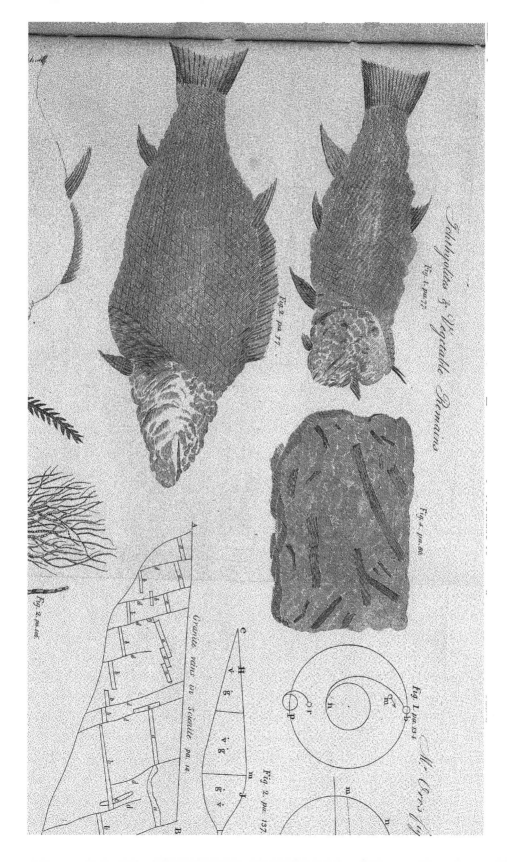

Ichthyolites & Vegetable Remains

Fig. 1. pa. 75

Fig. 2. pa. 77

Fig. 4. pa. 80

Fig. 2. pa. 106

Granite veins in Scienite. pa. 14.

Fig. 1. pa. 134

Fig. 2. pa. 137

Fig. 1.

Durham Rocking Stone
pa. 243

PL.

Fig 4

4

3

2

Fig. 2.

N

S

a a

B

Silver Apparatus for
Fluoric Acid pa 354

Fig. 12.

a

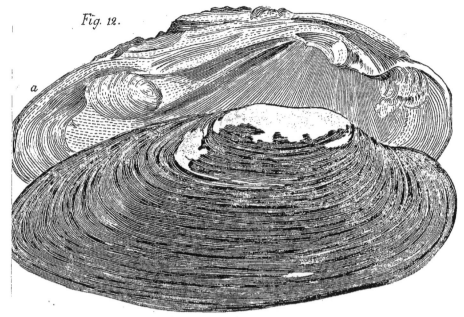

Unio Gibbosus.

Fig. 10.

a

b

A.J.Stansbury del

A.Doolittle sc

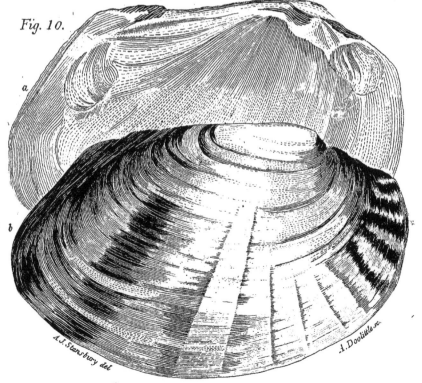

Unio Carinatus

Fig. 20.

a

b

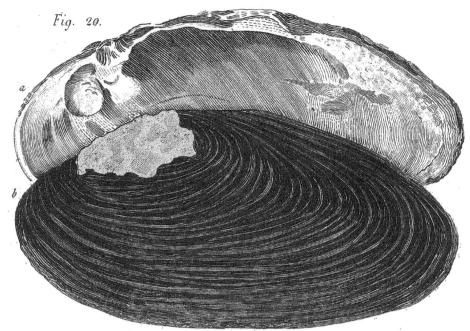

Alasmodonta Arcuata (young)

Fig. 20.

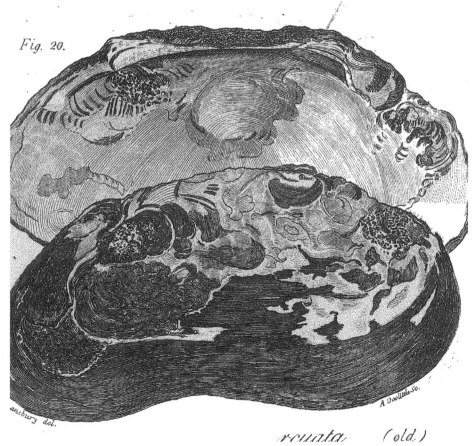

ansbury del.

A Doolittle sc.

rcuata (old)

PLATE 1

Fig. 21.

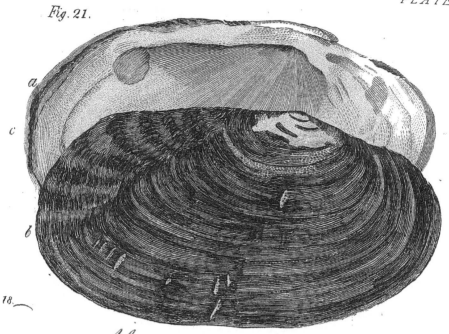

a

c

b

18.

Alasmodonta Rugosa

Fig.11

Parvus

Unio Prælongus

Fig. 16

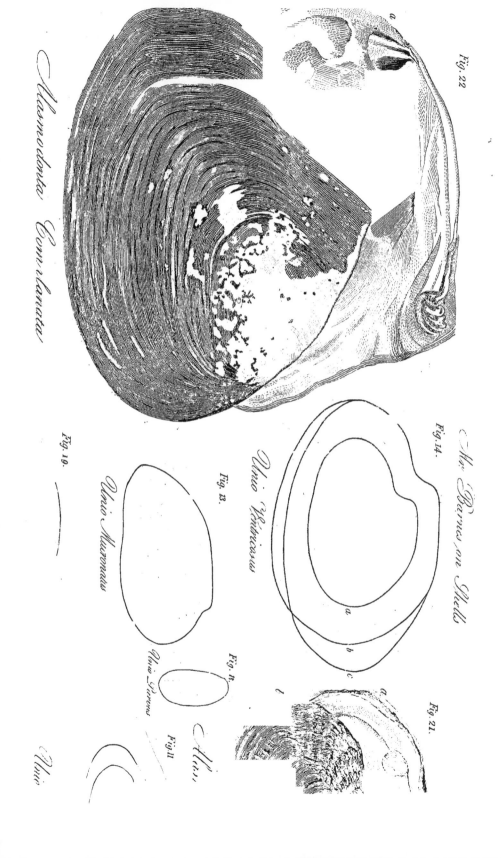

Fig. 22.

Fig. 14.

Mr. Berne, or Shell

Fig. 21.

Unio Fibricosus

Fig. 13.

Unio Marginatus

Fig. 19.

Unio

Fig. 12.

Fig. 11.

Alas

Unio Ovens

Mesnodonta Convolarata

AMERICAN

JOURNAL OF SCIENCE,

AND ARTS.

CONDUCTED BY

BENJAMIN SILLIMAN,

PROFESSOR OF CHEMISTRY, MINERALOGY, ETC. IN YALE COLLEGE; CORRES-
PONDING MEMBER OF THE SOCIETY OF ARTS, MANUFACTURES AND COM-
MERCE OF LONDON, MEMBER OF THE ROYAL MINERALOGICAL
SOCIETY OF DRESDEN, AND OF VARIOUS LITERARY AND
SCIENTIFIC SOCIETIES IN AMERICA.

VOL. VI.....No. 1.....JANUARY, 1823.

ENTIRE NUMBER XIII.

NEW-HAVEN:

PRINTED AND PUBLISHED BY S. CONVERSE, FOR THE EDITOR.

Sold by the Publisher and Howe & Spalding, New-Haven; E. Littell, Phil-
adelphia and Trenton, (N. J.); Davis & Force, Washington, (D. C);
Huntington & Hopkins, Hartford; Cummings & Hilliard, Boston ; Good-
ale Glazier & Co. Hallowel, Maine; A. T. Goodrich & Co. New-York;
Caleb Atwater, Circleville, Ohio; Thomas J. Ray, Augusta, Geo.; Henry
Whipple, Salem, Mass.; Edward J. Coale, Baltimore; Timothy D. Por-
ter, Columbia, S C.; Miller & Hutchins, Providence, R. I.; Thomas R.
Williams, Newport, (R. I.); William T. Williams, Savannah, Geo.; Luke
Loomis, Pittsburgh, Pa.; Daniel Stone, Brunswick, Me.; Professor D.
Olmsted, Chapel Hill College, N. C.; John Miller, No. 69, Fleet-street,
London.

CONTENTS.

GEOLOGY, MINERALOGY, TOPOGRAPHY, &c.

BOTANY.

CONCHOLOGY.

PHYSICS, CHEMISTRY, &c.

INTELLIGENCE AND MISCELLANIES.

I. DOMESTIC.

II FOREIGN.

Notices from Professor Griscom.

URNAL

OF

SCIENCE AND THE ARTS,

CONDUCTED BY

PROFESSOR SILLIMAN,

OF YALE COLLEGE,

IS PUBLISHED AT NEW-HAVEN, FOR THE EDITOR, BY

SHERMAN CONVERSE, PRINTER AND AGENT.

IT is issued in quarterly numbers, of which two make a volume, stipulated to contain at least three hundred and twenty pages; the six volumes, already published, have averaged over four hundred pages, and have been very fully illustrated by engravings.

TERMS.

Three dollars a volume in advance. An omission to remit for a new volume is *of course* a discontinuance.

☞ Term of credit to general agents, 6 months, from the publication of No. 1. of each volume.

TO CORRESPONDENTS.

Several communications came too late for this number.

We are requested to mention that a paper from Dr. Wm. Meade announcing the discovery of Idocrase and other minerals will appear in our next.

Communications for No. 15, to be in hand by the middle of June.

ALL our correspondents, and especially BOTANISTS, are *entreated* to write *legibly; every technical word* in *every science* should be so plainly written, that it *cannot* be misread; and every author of a memoir, intended for publication, who does not write *a plain hand*, should cause his piece to be fairly copied.

ERRATA.

Pa. 240, line 4 from bottom, for *can*, read *cannot*
245, 1 top, for *cammunicated* read *communicated*
302, bottom line, in a few copies, for *auter*, read *auteur*
330, line 14 from bottom, for 12, read 10
341, 17 top, for *Dr.* read *Prof.*